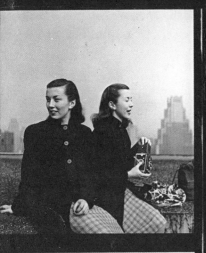

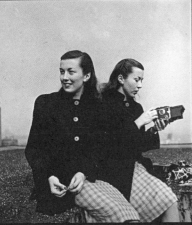
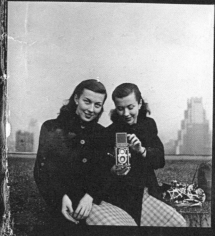
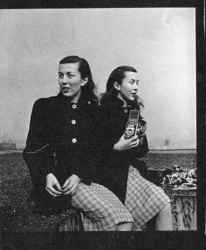
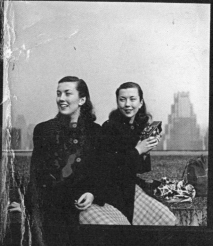

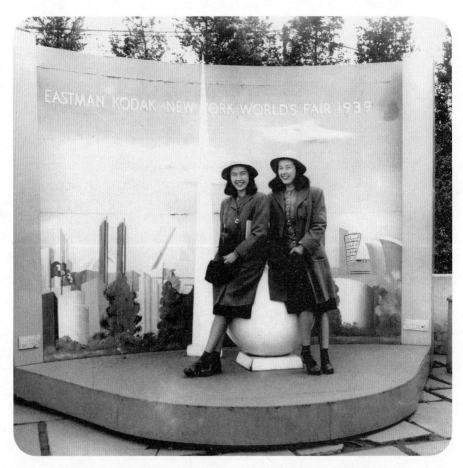

Kathryn and Frances McLaughlin at the 1939 New York World's Fair, posing in the Photo-Garden behind the Eastman Kodak Building for their photography teacher, Walter Civardi.

DOUBLE CLICK

TWIN PHOTOGRAPHERS IN THE
GOLDEN AGE OF MAGAZINES

CAROL KINO

SCRIBNER

New York London Toronto Sydney New Delhi

Scribner

An Imprint of Simon & Schuster, LLC

1230 Avenue of the Americas

New York, NY 10020

First Scribner hardcover edition March 2024

SCRIBNER and design are trademarks of Simon & Schuster, LLC

Simon & Schuster: Celebrating 100 Years of Publishing in 2024

For information about special discounts for bulk purchases,
please contact Simon & Schuster Special Sales at 1-866-506-1949
or business@simonandschuster.com.

The Simon & Schuster Speakers Bureau can bring authors to
your live event. For more information or to book an event,
contact the Simon & Schuster Speakers Bureau at 1-866-248-3049
or visit our website at www.simonspeakers.com.

Interior design by Kyle Kabel

Manufactured in the United States of America

1 3 5 7 9 10 8 6 4 2

Library of Congress Cataloging-in-Publication Data is available.

ISBN 978-1-9821-1304-9
ISBN 978-1-9821-1306-3 (ebook)

This book is for
my father
Gordon S. Kino
who didn't live to see it
my mother
Dorothy Beryl Lovelace Kino
who was with me every step of the way
and all the women who have accomplished much
yet have still been forgotten by history

When history is written in real perspective of the last twenty or thirty years, and by real perspective I mean several hundred years hence when historians will be far enough away from the events of this time not to be misled by passing events . . . this emancipation of women, this new and more important status of one-half of the inhabitants of the globe, will be considered the one significant fact of our times.

—Kenneth Collins, assistant to the
general manager of the *New York Times*

Speech to the Fashion Group
Tenth Anniversary Lunch
New York City, February 10, 1941

Contents

CONTENTS

Reader Advisory

The twins and their contemporaries lived in a time when young women were commonly referred to as girls, typically until they married and had children, at which point they metamorphosed into women. (Young men were often referred to as boys, too, even when they went off to war—it was a period when, in the words of the famous Katz's Delicatessen ad, one might want to "Send a Salami to Your Boy in the Army.") Sometimes women were also referred to as ladies.

In this book, both in my descriptions and direct quotes, I have tried to strike a balance between the texture of the times and the way we refer to women today. Whatever they were called, the "girls" of the McLaughlin twins' generation were the first American women to grow up being able to vote, use legal birth control, and obtain divorces relatively easily. Suddenly, they had power—so much so that publishers were motivated to recognize them as a market, creating magazines that focused on their lives and careers.

Twins on Twins

The McLaughlin twins were at the beginning of a several-months-long publicity tour for their book, *Twins on Twins*, when they appeared on *The Dick Cavett Show* in March 1981. They had already launched a highly praised show of pictures from the book at a New York gallery and had been widely interviewed, by the *New York Times*, *Good Housekeeping*, the *Philadelphia Inquirer*, and NBC's *Today Show*, among others. They would conclude the tour a few months later with a joint lecture and slide show at Manhattan's International Center of Photography, located in a mansion on the upper reaches of Fifth Avenue's Museum Mile, where they were introduced by the organization's founding director, the photojournalist Cornell Capa. He had known both twins for years, he said, but now, confronted by them both in the same room, he confessed he had no idea which was which. "I'm completely befuddled," Capa said. "I can't make out the difference." He finally advised the audience that the one in pink was Kathryn, the other was Frances, and that if anyone bought a book that night, they would "get two signatures for the price of one." Frances tartly chimed in, "But no cut rate on the price."

Yet the high point of the twins' tour arrived on March 30, 1981, running over into the following night, when they received a full hour of airtime as subjects of a two-part interview hosted by Dick Cavett,

the thinking person's talk show host, whose face, as a *New Yorker* ad promised, had "launched a thousand quips." Cavett was known for hosting some of the world's most revered names in music, politics, and show business, from Groucho Marx and Katharine Hepburn to Bobby Seale, the cofounder of the Black Panthers. Cavett did one two-part interview a week: just before the twins, he devoted it to the African American novelist Toni Morrison, who had recently won the National Book Critics Circle Award for *Song of Solomon*; just after, to the Italian director Federico Fellini.

Now, as upbeat theme music played, photographs of twins flashed across the screen—twin cheerleaders, twin pianists, twin ballerinas, twin basketball players—until twin Cavetts appeared, a double image produced on the monitor by engineers in the control room. The audience laughed hysterically.

"This is Dick Cavett saying good evening, and don't touch your TV set, there's nothing wrong with your picture," said the host in his flat Midwestern accent. "You're not having double vision either. You may have deduced by now that you are looking at pictures of twins."

The camera panned straight to his interview subjects, Frances McLaughlin-Gill and Kathryn McLaughlin Abbe, the twins who had taken the pictures.

Still beautiful at sixty-one, they looked remarkably alike, with the same strongly modeled cheekbones, arched eyebrows, and carefully coiffed shoulder-length blond hairdos—although Frances's was more of a pageboy, with the ends turned under, and Kathryn's more of a bob, with the ends flipped up. They were dressed almost identically, too, in pink flowered blouses and tan skirts, differentiated only in that Frances wore a scarf around her neck, while Kathryn wore a vest.

Yet as soon as the conversation began, their dissimilarities became clear. Kathryn smiled and gushed, telling Cavett straightaway, "I *like* you as twins!" Frances looked politely bored, her eyebrows raised in a slightly haughty fashion, as if echoing the supermodels she had photographed for three decades at *Vogue*. She only warmed up when

Cavett asked which twin jokes they hated most. As Kathryn offered up lots of ideas—"The worst thing you can do is call them 'twinny' or make up nicknames" or tell them, "I must be drunk, I'm seeing double!"—Frances tersely said, "Which twin has the Toni?," a reference to the old home-permanent ad campaign featuring twins, then lapsed back into silence.

Both McLaughlins were among the fairly small group of women to have enjoyed long and successful careers as photographers. Frances had spent thirty years as a photographer for the Condé Nast publishing empire—ten as the only woman among an otherwise all-male top-level staff. Kathryn, after a brief career in fashion, was best known as a photographer of children, with lucrative projects at general-interest magazines such as *Good Housekeeping* and *Parents'*.

They were not on the show, however, to discuss their unusual careers. They had been invited to talk about being identical twins, and about their book, for which they had photographed twenty-six pairs of twins and talked to hundreds more about their relationships. Twins such as Samuel and Emmanuel Lussier, who at the age of one hundred were then the world's oldest identical twins; Fay and Kaye Young, pro basketball players, who had told the McLaughlins how shocked their mother had been by their birth; Peter and Paul Frame, dancers with the New York City Ballet, who spoke of the difficulty of always being seen as the same person, rather than as individuals; and the Rowe and the Richmond twins, who had married one another and lived together in the same house.

"I think if you're going to go off and marry twins, you set yourself up for quite a bit of attention," Kathryn said.

"Of course everyone wants to know about the living arrangements," Frances said to Cavett. "I'd like to know about yours, but you don't get asked."

At that moment in New York creative circles, twins were regarded as somewhat freakish curiosities. The photographer Diane Arbus, whom Frances had photographed several times before Arbus

committed suicide in 1971, was now celebrated for her pictures of "social and biological oddities—identical twins, dwarfs, nudists, transvestites, carnival freaks and retarded women," as Hilton Kramer, the *New York Times* art critic, had written, on the occasion of her 1972 Museum of Modern Art retrospective; Arbus's most famous picture depicted a pair of eerie-looking identical girls. The previous year, in Stanley Kubrick's horror movie *The Shining*, the central character, played by Jack Nicholson, had experienced a vision of twins as he descended into madness.

But the McLaughlin twins had written their book, Kathryn said, because, while there had been many scientific studies of twins, nothing had been written that looked at the world from the twins' perspective, on their own terms.

"We're not scientists—we're photographers who've written a book," she told Cavett. Their approach, she continued, "is emotional, or really letting the twins speak for themselves."

"Would you say one is lucky to be a twin?" Cavett asked.

"We think so," Kathryn said.

Frances disagreed: "Twins are not born by choice." Most of their subjects had achieved "an equilibrium, where it isn't completely a burden or completely a pleasure."

Then the host stepped into more adventurous territory. "Do you know—I blush to even mention this on such a polite program—that there's a pair of twins who make pornographic films?"

If he thought he'd get a good answer, like the time he'd asked Bette Davis how she'd lost her virginity, he was sadly mistaken.

Both twins looked at him steadily, as though he'd made one of those bad twin jokes they'd heard many times before.

Kathryn politely feigned surprise. "No!"

"Really?" said Frances coolly, as her eyebrows notched somewhat higher. "Men or women?"

Cavett claimed not to recall.

Then Frances stepped in and took control of the interview. "We haven't talked too much, Dick, about twins in the same career. And as you know, we are both photographers. We decided to become photographers at about the age of eighteen and have never had any other career interest."

Finally, he asked what they had clearly wanted to discuss all along: How did it begin?

THE DECISIVE MOMENT

World of Tomorrow

The McLaughlin twins decided they wanted to be photographers in their second year of art school at the Pratt Institute in Brooklyn, right after they had talked their way into part-time jobs as assistants in the photo lab. Franny had recognized her destiny as soon as she took her first picture of a Myrtle Avenue el train, thundering over the rusty steel tracks that cast bars of light and shadow onto the storefronts and people below. At that moment, she said, "I knew instantly I was hooked." Kathryn, known to everyone as Fuffy, felt the thunderbolt the first time they walked into the studio. "Right from the beginning we somehow sensed that it would be our chosen career," she recalled later. "It seemed to be the wave of the future."

It's hard to know with certainty what it was about photography that grabbed the twins, how they became "enslaved by the *djinn* in the black box," as the photographer Lee Miller once put it. People didn't make a habit of dissecting their emotions in those late-Depression years. But it probably had something to do with the puzzle-like challenge of figuring out how to compose a shot with the twin-lens reflex camera they had received as a high school graduation present and traded back and forth: when they peered down into the viewfinder, the camera returned a mirror image of the scene they were aiming at; there was no way for them to see what they'd captured the right way around

3

until they developed the negatives. Then came the empowering transformation that they could bring about as they printed the pictures in the darkroom—the "magic of light and lens," as Fuffy once described it—where a skillful deployment of chemistry, temperature, time, and light could change the way the final image came out.

There was also the sheer excitement of experiencing the luck involved in capturing the "decisive moment," the photographer Henri Cartier-Bresson later called it—being in the right place at the right time, as a group of teenagers walking in a park wheeled around to face the camera, or a mother and child stepped off a sidewalk onto a broad expanse of paving stones, or the instant the sun raked light across the brick walls of a factory at twilight as women poured out of its doors.

For the twins, who had already spent their teenage years making paintings, it must have been electrifying to suddenly be able to fix reality on the page in a more immediate way than by daubing oils on canvas. Among the American avant-garde of the time, the all-important task was to define an art that was their own and distinct from that of Europe, and some photographers felt they were working in the perfect medium to depict a country that was brash and new. In 1935, Dr. M. F. Agha, the longtime art director of *Vogue*, who had helped push photography onto the pages of that magazine, described photography as the quintessential American art form—"a Real American Native Art," he called it—in the introduction to the first edition of *U.S. Camera*, an annual that compiled two hundred of the year's best pictures.

"Romanticism in art is dead," he wrote. "The skyscraper is the thing to admire. . . . The poster is better than the fresco; the saxophone is to be preferred to the hautbois; the movies to the theatre; the tap dancing to the ballet, and the photography to the painting."

Sure, Agha was being somewhat arch and ironic—but he also meant it. Even then, in one of the worst years of the Great Depression, Americans were such passionate camera and photo buffs that the annual, filled with more than two hundred photos of every

variety—nudes, tarantella dancers, stargazing couples, sailboats, carefully composed still lifes, landscapes, family scenes, fashion shots, in color as well as black and white—sold out its fifteen thousand copies, at $2.75 each (more than $60 today), in only a month. Its publication was followed by a *U.S. Camera* exhibition of seven hundred pictures that opened at Rockefeller Center, a glamorous new office complex of limestone towers that was rising in midtown Manhattan. The show attracted huge crowds and continued to draw hundreds of thousands more viewers as it toured, going on view in department stores and exhibition halls in seventy-five cities around the country. The display and its tour became an annual event.

More photography shows, annuals, and magazines followed. In 1937, the eight-year-old Museum of Modern Art opened a huge survey that put the medium of photography in historical perspective; it toured the country for two years. An even larger show, the International Photographic Exposition, arrived in 1938, across town at the Grand Central Palace near Grand Central Station, where during a single week over a hundred and ten thousand people came to see about three thousand pictures, ranging from Mathew Brady's Civil War daguerreotypes to pictures of starving migrants by Dorothea Lange, who had been commissioned by the federal government to chronicle the ravages of the Depression.

Photography was also infiltrating American magazines, replacing etchings, watercolors, and woodcuts as the snappiest and most up-to-date way to illustrate anything, whether it was a newspaper story, a work of fiction, or a fashion spread. Soon a new sort of magazine that told stories in pictures instead of words became the rage. The first of these, *Life*—styled in its offering prospectus as "THE SHOW-BOOK OF THE WORLD"—was launched in 1936 by Henry Luce, the publisher and editor in chief of *Time* magazine, the year before the McLaughlin twins entered art school. Its opening cover pictorial focused on the gritty Wild West frontier towns that had sprung up in Montana around Fort Peck Dam, one of the great

Depression-era work-relief projects on the Missouri River. It had been shot by an intrepid woman photojournalist, Margaret Bourke-White, who brought the hamlets' sheriffs, mechanics, barkeeps, hash slingers, laundresses, and ladies of the night straight onto city newsstands and into American homes.

Life was followed by the pocket-size *Coronet*, which boasted thick portfolios of great historical artworks in color, brand-new black-and-white photographs, and thumbnail biographies of contemporary photographers and sold out its first quarter-million run in two days. In contrast to *Life*, which typically published all-American pictures, *Coronet* often featured works by Europeans, such as Cartier-Bresson, André Kertész, and Erwin Blumenfeld, who used experimental developmental processes to create exhilaratingly arty shots of nude women, their bodies floating alluringly in water or veiled in clouds of tulle.

By 1938, the year the twins decided on their profession, the leading women's magazines had also begun to feature photos of women, in color, on their covers—magazines such as *Vogue*, *Mademoiselle*, and *Ladies' Home Journal*—so while walking past a newsstand, instead of seeing a watercolor of a lady lying on a chaise or peeking out from behind a bouquet, one saw a row of real faces looking back.

But perhaps the moment that most dramatically demonstrated photography's importance, at least in New York City, was the opening of the 1939 World's Fair in Queens, an exposition designed to lift America out of the Depression and bring nations together under the theme "Building the World of Tomorrow," even as war raged overseas. There, amid displays of futuristic new products such as plastics, air-conditioning, and television, pavilions that advertised the art and culture of different lands, and a diorama called the Democracity—a model of the town of the future that showed the astonishing ways in which Americans would one day live, travel, and work when the world had moved beyond hunger and war—the Eastman Kodak Company celebrated the hundredth anniversary of the medium's invention with the "Cavalcade of Color," a twelve-minute long show

of Kodachrome slides projected onto a towering curved screen wider than a football field. As brilliantly colored pictures—of people, families, brides, fields, mountaintops, animals, flowers—circulated and dissolved into one another, music played and a man's voice spoke of the wonders of American life and Kodak technology:

Our camera fan, like a Rembrandt, sees beauty everywhere and helps us to see it, too. . . . Photography brings to us the beauty and majesty of this great country of ours. This great country where centuries ago men began to build with a spirit, with a tolerant reverence which is a part of our national life today.

Photography also permeated many other aspects of the fair. There were picture exhibitions throughout, and booths where visitors could watch photos being developed and printed. Every one of the fair's seventy-five thousand workers carried an identification card emblazoned with a snapshot of his or her face, and anyone buying a multiple-entry ticket likewise got his or her photo on a pass—one that was shot, developed, printed, and sealed to the card on-site, before crowds of eager onlookers.

U.S. Camera, in addition to its annual, had also launched a monthly magazine that year, one of several new photography publications. It dedicated its entire fifth issue to the fair, pointing out which displays were most photogenic, and which lenses and film would work best for which photo ops. Cameras had sold well throughout the Depression—a small camera store specializing in minicameras and their accessories could be as profitable as a car dealership—and the *New York Times* described comical scenes of greenhorn lensmen stumbling into one another as they rushed to pose shots, and then running to the many camera shops at the fairgrounds for help when their equipment didn't behave as expected. "Amateurs Swarm over Grounds . . . but Expert Click Is Rare," the story proclaimed. "The prevalence of cameras at the Fair has become something of a major phenomenon, almost as impressive in quantity as the number of hot dogs eaten daily and the number of girl shows on the midway."

The McLaughlin twins were entranced by the fair, visiting it many times, each trip costing them a nickel for the subway ride out to Queens, seventy-five cents for admission, and a quarter to enter each booth. One of their friends, another art student, was working as a mermaid at a booth in the Amusement Zone, in a fun house created by the surrealist artist Salvador Dalí called "Dalí's Dream of Venus," which was part artwork, part girlie show. Behind a pale pink plaster facade, beyond a doorway flanked by a pair of monumental female legs, bare-breasted girls in lace-up corselets, fishnet stockings, fish tails, and other mermaid-like attire splashed through water tanks around a nude actress who lay sleeping in a bed, covered to the waist by a red silk sheet, playing Venus. The twins' visits to see their friend were endlessly thrilling. "You can imagine that we felt truly a part of the art scene when we went to the Fair and watched her," Fuffy recalled.

So when they returned to the basement of Pratt's Home Economics building, down into the school's newly completed photography studio—one of the few places in an American school where students could learn to click expertly—the twins leapt at the rare chance to participate. Henry Luce, the powerhouse editor of *Life*, had written in the magazine's original business plan that he viewed photography as a way for ordinary people "to see the world; to eyewitness great events; to watch the faces of the poor and the gestures of the proud; to see strange things—machines, armies, multitudes, shadows in the jungle and on the moon." Photography was a magic carpet, out of the Depression and into the future.

And for girls with larger ambitions than getting married—or working as secretaries, or teaching children, or swimming topless in a fish tank wearing lingerie—mastering the art of professional photography must have seemed like a pretty good way to make a living. As Fuffy told Dick Cavett on television nearly forty-three years later, while her twin, Franny, looked on, "We just liked it. We didn't even discuss it. That's what we were going to do."

CHAPTER 2

Kodak Childhood

The year before the twins were born, Spanish flu had raged through the world, taking vast numbers of people with it—a quantity that would eventually exceed 50 million, far beyond those who had died during the Great War. But by the fall of 1919 the disease finally seemed to be in abeyance, at least in New York, and the city's mood was relatively peaceful. In Brooklyn, in a small row house in a rapidly growing middle-class section of Brooklyn, not far from Ebbets Field, the twins shattered this calm, at least for their immediate family, by arriving two months early, on September 22, 1919, just as their parents were preparing to move to a somewhat larger house nearby. Only one child was expected, and when two arrived instead of one, it came as a massive shock to everyone who'd hurriedly assembled for the birth, not least of all their mother.

Franny emerged first, and the doctor was busy tending to the tiny creature, who weighed less than four pounds, when a second, identical baby made a surprise appearance: it was Fuffy, a slightly smaller look-alike. She was hurriedly wrapped in cotton and nestled in the kitchen by the stove while the doctor continued working to keep the first child alive.

"Not an auspicious beginning," Fuffy pointedly observed later in the twins' joint autobiography, *Twin Lives*, "but the assisting nurse

9

assured my mother I would grow up to be energetic. Lucky for me, she was right."

The fate of the twins' father, Frank, a fire insurance underwriter, was far less rosy—although nobody saw it coming, least of all Frank himself. Their mother, Kitty, might have been aghast at having two children instead of one, but Frank regarded it as part of his run of wonderful luck. He had adored his wife since they'd first met as children in grammar school, and he rallied swiftly from the shock of the dual birth. Soon, he was telephoning his friends to crow about this wonderful turn of events, telling them delightedly, "A flock of girls just arrived at our house."

The couple named the twins after themselves, christening the older one with a variant of Frank's given name, Frances Marie, and choosing a variant of Kitty's for the younger, Katherine Marie. Yet when the twins were barely five months old, a final, deadly wave of influenza swept through New York, taking Frank with it. He died less than a week before Saint Valentine's Day—just as the city had come out of hiding and officials, declaring the pandemic over, let theaters and businesses return to their normal opening hours.

A month or so after Frank's death, Kitty dressed up her twins in white lace, put them into their wicker carriage, and brought them outside onto the street. From this protected perch, they gazed out intently upon the universe as a neighbor took their photograph. Although they never fully recalled their father, his loss would cast a shadow over their lives.

From that point forward, Kitty, a devout Catholic, focused all her attention on the twins. She consecrated them to the Virgin Mary and dressed them up like living dolls, always in showy, perfectly matched clothes, while she herself began to sport increasingly elaborate hats. Kitty's father, an Irish policeman, still walked a beat in Prospect Park, but she had always fancied herself a fashion plate and naturally wanted no less for her daughters. She also consecrated herself to the twins, steadfastly refusing to marry again—for their sake, she said— although she did start to entertain suitors. Fanatically overprotective,

and preternaturally fussy about hygiene and neatness, she kept the twins in their double stroller for well over a year, unwilling to let them even test their legs on their own, for fear that they might soil their spanking white leggings and ermine-trimmed coats.

Around the time of their second summer, the twins were liberated by a babysitter, their teenage cousin Flossie, who, bored by the prospect of dragging them around in their carriage for months, pulled them out and tempted them into taking steps by holding out ice cream cones. Before long, they were toddling around in matching white fur bonnets. By the age of two, Fuffy had renamed herself so that she, too, like her twin, now known as Franny, and their babysitter, Flossie, could all have names that started with *F*.

The twins grew up being photographed, always in tandem. Pictures from those early days show them standing together arm in arm, smiling shyly as they show off their multilayered bloomers, frilly dresses, and perfect bathing costumes. Garbed in matching capes, they pose solemnly next to identical dolls in identical baby carriages, suggesting miniature student nurses.

When they were about four, Kitty sold the brownstone and moved with the twins to a dark green clapboard house in Wallingford, Connecticut, a pre-Revolutionary farming and factory town outside New Haven that one of her favorite aunts called home. And so the twins grew up surrounded by a lot of fun, boisterous cousins, in a universe of horse-drawn carts, church bells, and white picket fences, where their uncle Jim was the fire chief, their uncle Tom owned the grocery store, and their uncle Jack owned the pub, which the family referred to as "the saloon." The Downeys were a big noise in town, and they grew bigger when Uncle Jim's son Morton, an Irish tenor who had started out singing in the pub, found fame and fortune in New York and then became one of the country's biggest radio and recording stars, known as the Irish Thrush.

Throughout the town, the twins were photographed tangoing on a lawn in layers of lace, stretching out in the park with their tennis

rackets crossed, or standing before Wallingford's Civil War monument, their identical hair bows tilted toward its stubby iron canon. They even posed with an old folding Kodak, Fuffy holding it and smiling and Franny affecting a fashion model stance, with one hip jutting out.

Most of these pictures were made by Kitty's devoted maiden sister, the twins' aunt Anna O'Rourke, who had stayed behind in Brooklyn when they moved to Connecticut. Like many Americans during the Depression, Anna was an avid camera buff—a Kodakfiend, or a snapshooter, in the parlance of the time—who took her Brownie camera everywhere.

The Brownie, the first mass-market point-and-shoot, had revolutionized picture taking when it came on the market in 1900, priced at a dollar. Suddenly, Americans could take photos of each other, anytime and anywhere. Soldiers could send snapshots home from the front. Amateurs could make their own memorable pictures of newsworthy disasters, such as the 1906 San Francisco earthquake, or the rescue of passengers from the *Titanic*. The Brownie had transformed life for doting families, too, who no longer needed to hire a photographer to set up a glass-plate camera on a tripod and gather everyone in their Sunday best to pose. Instead, they could be captured on the spur of the moment, preserving their adorable tykes for posterity.

By 1919, when the twins were born, it cost as little as $2.13—about $32 today, or somewhat less than the price of a dinner at a good Brooklyn steak house—to buy a Brownie, with roll film included. Kodakfiends took their cameras to the drugstore, turned over their exposed rolls of film to be developed, and could purchase new rolls for less than a quarter. Those fiends who were more ambitious could even purchase processing kits, create home darkrooms, and develop the film themselves. As the 1919 product catalog claimed, "Anybody can get as correctly developed negatives by developing films in the Kodak Film Tank as an expert can by any known method of development." More elaborate Brownies were available, too, such as the Folding

Autographic Brownie, which for $13.33 (about $240) included a clever feature that allowed the owner to write the title, date, and time on the negative; and all the cameras came with irresistible accessories, such as cases, printers, masks, trimmers, albums, paste, or kits that combined everything.

Aunt Anna sent her film to the drugstore to be processed and printed by Kodak, and throughout the twins' childhood, as Fuffy recalled, one of their great pleasures was dropping off the rolls for her every Friday night, walking to the drugstore "with great anticipation" to collect the previous pictures, and opening the package excitedly "to see what moments in time had been captured on film."

The twins' lives were also well-documented in print because they were extremely academically gifted—with accomplishments that routinely made the papers because they were identical twins, and exceptionally gorgeous ones at that.

When the twins graduated from eighth grade in 1933, wearing frilly white dresses, matching white cloches, and corsages as large as their heart-shaped faces, the *New Haven Register* broadcast the news that they had become Holy Trinity Roman Catholic Parochial School's highest-ranking students in its largest class ever, with Franny edging out Fuffy for the top spot: "Francis [*sic*] barely beat out her twin sister Katherine for the first place honors."

The following year, when the twins entered Wallingford's public high school, Lyman Hall, named for a native son who had signed the Declaration of Independence, Fuffy overtook Franny and shot to the top of the entire school. "Honor Students at Lyman Hall Are Announced," blared the front page of the Wallingford edition of the *Meriden Daily Journal*. "Kathryn McLaughlin of Freshman Class Heads List." The next year, Franny was in the lead; then Fuffy; then they shared the top spot. So it continued throughout their high school years. (By this time, Fuffy had changed the spelling of her given name, from *Katherine* to *Kathryn*, perhaps to sound more modern or to differentiate herself from her mother.)

Yet despite the papers' suggestion that the twins were always in competition, Franny and Fuffy may not have experienced it that way. Only when they'd entered grade school had they realized there was something unusual about them, when they arrived for class with their older boy cousin, one of the Downeys, and noticed they somehow stood apart. "As we saw all of our classmates and teachers it suddenly dawned on us—we look alike!" Fuffy wrote later. "Everyone was fascinated with the identical twins, and we were made to feel special. But there was also a feeling of separation from the other children. . . . The bond between us grew closer through our school years. We went everywhere together."

They did everything together, too. They went to the movies twice a week, taking advantage of fifteen-cent Saturday matinees, and then kept scrapbooks of ads and programs from their favorites and acted out the stories at home, inhabiting the roles of strong female stars such as Marlene Dietrich and Greta Garbo. Kitty often took them into New Haven to see Broadway tryouts. "Mother must have been stage-struck," Franny wrote later. "When other nice children were playing on their swings and bikes, we went with her to Saturday matinees." Their other passion was fashion magazines: they spent hours poring over their mother's subscriptions to *Vogue* and *Vanity Fair*, which inspired them to design, sew, knit, and crochet their own clothes. (They were taught how to sew by their next-door neighbor, a Mrs. Wolf, whose family operated a small dress factory near the train station.) And they made reams of drawings of the sort of woman who filled those magazine pages, as she stood on deck with her scarf flying in the ocean breeze, or leaned against a rustic fence in riding gear, or proffered her jewelry-bedecked hand to a man, who appeared to be standing just offstage. They painted, too, taking their easels out into the fields to make landscapes that were hung in the school library. Though the world still considered the twins alike in all things, a slight difference in their styles began to emerge: Franny's drawings were heavily marked, with sure and decisive pencil lines, while Fuffy's were airier.

But these nuances would have been easy to overlook because at school they were involved in everything, together and apart—tea committees, hop committees, prom committees, fashion shows. They worked devotedly on the school's magazine, the *Chronicle*, with Franny joining the literary staff, and Fuffy editing art and jokes. (Sample: "Player: 'This linament [*sic*] makes my arm smart.' Coach: 'Try some on your head.'") Both joined the Daubers, an after-school art club full of specially selected students "wearing brightly colored smocks looking extremely artistic," as the *Chronicle* described them. "Some are cutting block prints, others viewing their work at a distance, and a few waiting for inspiration to come." Franny became the group's secretary and Fuffy its treasurer. The *Chronicle* was illustrated with the Daubers' linoleum block prints, and both twins produced them, too, although Fuffy's made the cover more frequently. The magazine ran one boundary-shattering photograph instead of a linocut, for Christmas 1936, and both twins collaborated in its creation: it pictured a toy Santa squeezing himself into a chimney.

The twins were growing up to be beautiful, with dark hair and fetchingly tilted blue-gray eyes, and as crazy about boys as they were about school activities. But Kitty was vigilant in this area, even more so than was typical of the time, just as she had been about holding them back from walking. Outside of school, they weren't allowed to talk to boys unchaperoned, although that didn't stop them. "They were two very definite beings," recalled their schoolmate Mildred Rossi, whose older sister Edie was in the twins' class and often came home talking about what the pair had gotten up to that day. "Edie mentioned them all the time," said Julia, another Rossi sister. "They were very pretty girls, very popular with the boys, and, of course, they were very smart."

The twins quickly became adept at finding ways to reel in potential suitors, especially boys from Choate, one of the country's most exclusive prep schools. As luck would have it, Choate was located in Wallingford, about a twenty-minute walk from Lyman Hall.

One of their favorite methods was to take their knitting to Wilkinson's, the local movie theater, and roll a ball of yarn down the aisle, aiming it toward a group of Choate students. After making a great hue and cry, the twins would find themselves with no choice but to climb over the boys to retrieve it. Using such tricks, they forged friendships with a lot of students and faculty, relationships that endured long after they had left the town for college.

One student they became friendly with in high school was another Irish Catholic, Jack Kennedy, the second son of a Boston political family, who is said to have escorted them to church, played tennis with them, and taken them to a dance at his school. (By this time the twins' famous cousin, Morton Downey, was great friends with Jack's father, Joe, an enormously successful businessman.) Kitty had strict dating rules: permission for an outing was rarely granted, and if a boy wanted to date one twin, he had to find a friend for the other or escort both twins himself. "Frances and I were often exasperated by her old-fashioned notions of courting," said Fuffy. Jack Kennedy, undaunted, is said to have chosen the latter option, offering each twin an arm—a pattern they repeated into adulthood. Even in high school, the twins were training their sights on older, more sophisticated men: in their graduation yearbook, Franny's chief interest was listed as "Twins of Yale" while Fuffy's was "New Haven."

Much as the twins might have enjoyed male company, however, they had more on their minds than dating. In 1937, they graduated at the top of their class, separated by a fraction of a point. Franny was valedictorian, Fuffy was salutatorian, and both twins, dressed in matching dresses and berets they had knit themselves, gave speeches on the same subject: Horace Mann, the nineteenth-century educational reformer who had championed state-sponsored public education in the United States. The underlying theme in both their talks was the importance of hard work—not surprising for girls whose graduation yearbook quotes read "Honors come by diligence" (Franny) and "Let knowledge grow from more to more" (Fuffy).

Their valedictorian-salutatorian double act was so newsworthy that it was covered not only by the local Connecticut papers, which ran front-page pictures of them smiling, all dimples and curls, but also by the *Brooklyn Daily Eagle*, which ballyhooed the twins as "former Brooklyn girls." Their graduation also made the *New York Times*. Their honors were "unusual," the paper wrote, seeing as they were twins whose highest-ranking marks were separated only by "a fraction of a point." Kitty, who professed to live only for her twins, was over the moon when the story appeared. "It was the happiest day of my mother's life," Franny said.

Yet behind those dimples and curls, and the twins' predilection for wealthy, well-educated schoolboys, they must have known that their own hard labors lay ahead, because Kitty's money was running out. Although Frank had left his family well provided for, the Great Depression had wiped out much of his estate. "Mother really had lost a lot of money in the crash," Franny said. "My sister and I knew we *had* to work."

The plan was for the twins to attend art school at Pratt Institute in Brooklyn, not far from the town house where they'd been born. Upon graduation they intended to become theatrical designers, a profession that combined their love of art and of theater. At least, that's what they told the *New Haven Sunday Register*, one of several papers that interviewed them upon their graduation.

More likely, they expected to teach: they were entering the school's Teacher Training program, a four-year course of study that included academic as well as art classes and, unusually for Pratt, resulted in a bachelor of fine arts degree instead of a professional certificate. "That was the whole goal," Franny said. "My mother and my aunt wanted us to get that degree." Aunt Anna, who lived near Pratt and had a job in New York City's government, volunteered to pay the fee.

Although most Pratt students boarded near the school, Kitty, who still signed her letters "Kitty and the twins" ("We sound like a family of kittens," Franny used to complain), was determined to keep her

household intact. She sold the green gabled house in Wallingford to a relative and rented an apartment a block from campus, partway between the western entrance gate and a Catholic convent. She also chose a unit whose living room windows overlooked the street, so she could keep an eye on her double act as they left in the morning and returned from class at night.

But then, as a last gesture to frivolity and childhood, and moved by her own passion for photography, Aunt Anna gave the twins a camera as a joint graduation gift. And not just any old camera, but a Voigtländer Brillant—a fashionable German import, not far below professional grade. At $35 (about $730 today), it was an astonishing extravagance for the time, costing more than a fifth of Pratt's annual $170 tuition. Without knowing it, Aunt Anna had opened the door to their future.

PART II

COLLEGE DAYS

CHAPTER 3

An Experimental Education

The twins entered Pratt Institute on September 13, 1937, when they were nearly eighteen and the school was embarking on its fiftieth anniversary year. It had been founded as a grand interdisciplinary experiment in 1887 by a self-made oil magnate and philanthropist, Charles Pratt, whose dream was to enable American workers to get the education he'd never obtained for himself. Part vocational school, part fine arts academy, part liberal arts college, students could study everything, from traditional building trades such as stone carving and bricklaying, to new technologies such as electrical engineering. It also had a museum filled with four thousand objects from around the world, among them specimens of Limoges and Sèvres porcelain, Etruscan and Roman antiquities, Venetian glass and mosaics, and contemporary Mexican pottery.

Pratt believed that the intellect could be sharpened by making art; that the eye could be improved by looking at exemplary international examples of art and design; and that students stood the best chance of acquiring jobs if they learned their trade from practicing professionals. Although some thought him a crackpot, he turned out to be a visionary. The school's first class, a group of drawing students, numbered only twelve, but the next year a thousand turned up. The magazine *Scientific American*, which dedicated a cover story to the

institute that year, decreed it "the most important enterprise of the kind in this country, if not in the world," and its art classes, together with some of its special classes for women—in dressmaking, cooking, and millinery—were featured on the cover.

By 1937, when the twins arrived, the institute had five thousand students, and its redbrick classical buildings, which included Brooklyn's first free public library, had come to occupy two city blocks. Its traditional building trades had been incorporated into a modern engineering school; it already had the nation's second school of library science and one of its earliest schools of household science and arts.

And in those waning years of the Depression, its fine and applied arts school, where the twins would study, had an extraordinarily high job-placement rate: according to the *New York Times*, 97 percent of the 1936 class found employment, likely because Pratt, as well as offering courses in illustration, advertising, and architecture, had just become one of the first places where students could train for America's newest creative profession, industrial design. The field had taken shape in the Depression, as manufacturers began seeking out artists to transmute their products—everything from planes to cameras—into something tantalizingly contemporary that consumers needed to buy. Alexander Kostellow, who cofounded the department, later described it as "the art which enters every home in one form or another, be it a glass or a lamp, a flat-iron or a washing machine."

Industrial design was tailor-made for an interdisciplinary place such as Pratt, for its practitioners had emerged from a surprising range of creative fields. The three big names of the period were Raymond Loewy, a former fashion illustrator and costume designer who had multiplied sales of the Sears Coldspot refrigerator by transforming it into a sexy, futuristic machine; Norman Bel Geddes, a theater designer who applied his "streamlining" aesthetic to planes, trains, and automobiles; and Walter Dorwin Teague, a onetime typographic consultant who made Kodak cameras hot commodities during the Depression.

To serve the industrial design department and the rest of the Fine Arts School, Pratt was also building something fairly rare in art schools of the time: a fully equipped photography lab. The famous Clarence H. White School of Photography had originally been founded nearby, at the Brooklyn Institute of Arts and Sciences, which ran the Brooklyn Museum, but generally if a school had a studio, it was in the science department. Most students learned by joining camera clubs, taking commercial classes, or apprenticing themselves to established photographers. Pratt had begun setting up their lab in 1935, in the basement of the Household Science building, the same year that *U.S. Camera*'s annual was introduced and the medium's importance to mass media became too obvious to ignore; the lab was completed by 1938, the year the twins began working there. But before they arrived in that dark, dank basement, they had to grapple with the fundamental lessons of art school.

FROM THE VERY START the twins' schedule was punishing, with classes six days a week. Mornings were mostly spent on academics and the subject they were ostensibly there to study—teaching children—while afternoons and Saturdays were largely devoted to the Holy Grail, art and design. The sculptor Beverly Pepper, then called Beverly Stoll, who entered Pratt soon after the twins, recalled getting the chance to work with "every kind of material, tool, technique," and studying "everything from industrial design to fashion design." All students took some version of the school's pioneering Foundation course, instituted at around that time, in which they learned basic compositional principles—line, shape, volume, and color—and were taught to deploy them with different media, from pencils and cardboard to cloth, steel, and clay. Pratt "was very focused on your finding your own way of thinking," Beverly recalled, and "on teaching you how to 'look.'"

In their first year, the twins were trained in looking by Dorothy Mulloy, a ceramicist and jewelry designer who had been mentored

by the stained-glass master Louis Comfort Tiffany. Fuffy recalled her as a taskmistress, forcing them to "use our eyes and be decisive." They spent a lot of time drawing, not just objects and flowers but live models. Sometimes a teacher would tell the model to pose while the students stared; then the model would be dismissed and they'd draw from memory. They also studied art history and took field trips to the Brooklyn Museum, a brisk half-hour walk from the school, which they visited twice a week to sketch and study artworks.

Another beloved early instructor, the painter and illustrator Tom Benrimo, opened Franny's and Fuffy's eyes to the European avant-garde, starting with surrealists—artists such as Salvador Dalí and Max Ernst—who were using techniques that involved chance, including free association and collage, to unlock the potential of the subconscious. Benrimo also lectured on the artists and designers of Germany's radically experimental Bauhaus school, founded in Weimar in 1919, which like Pratt had intermingled fine and applied arts.

In 1933, before Pratt's industrial design program began, the Nazis had deemed the teachings of the Bauhaus "degenerate" and shuttered the school, which by then was in Berlin, and the Bauhauslers began to flee Germany. And as Hitler stripped rights and statehood from the country's Jews, annexed Austria, and moved into Czechoslovakia, teachers and students who'd been associated with the Bauhaus fled, many ending up in America, including the color theorist Josef Albers and the photographer and painter László Moholy-Nagy.

Nonetheless, from the students' point of view, this rout of Europe's artists was "a strange 'good fortune,'" Beverly recalled, "like having da Vinci come!" In 1938, Moholy-Nagy, who had just founded the New Bauhaus in Chicago, visited Pratt to give a talk. (Although there was some talk of collaboration between the two schools, they were never able to work it out: asked by the director of Pratt's merchandising course to explain his school's philosophy, Moholy-Nagy had acidly responded, "Does everything have to mean something?") Other European artists also joined the faculty, such as the Hungarian-born

ceramicist Eva Zeisel, who taught an early course in mass production, and the Cologne graphic designer Will Burtin, who had skipped out on an offer to join Joseph Goebbels's propaganda ministry and arrived to teach his concept of total communication design (now known as corporate branding).

The twins were soon making forays into Manhattan to see this new European art in person. The city, with its galleries, museums, movies, and theaters, soon became "an equally important component of our art education," Fuffy recalled, "gritty and exhilarating at the same time," and a rush "after our sheltered years in a small town," especially as it became the de facto center of the art world. During their freshman year, the city offered a cornucopia of new contemporary-art museums, such as the Museum of Modern Art, which had opened in 1929 at Fifth Avenue and Fifty-Seventh Street, just after the Crash, and moved around between different temporary spaces before building its own permanent home ten years later. In 1936 it had mounted a giant survey, *Exhibition of Fantastic Art, Dada and Surrealism*, which triggered the public's growing fascination with surrealism, imprinting Dalí's melting watches, Joan Miró's biomorphic blobs, and René Magritte's bowler-hatted men on America's popular consciousness. By the time the twins arrived at Pratt, the museum had moved temporarily to Rockefeller Center, and in their sophomore year it opened an enormous Bauhaus show, using hundreds of examples of works by teachers and students—paintings, photographs, woven textiles, tubular-steel chairs, and architectural models of glass and metal houses—to demonstrate how the school and its influence had transformed modern life.

Another thrilling place to visit was the gallery of Julien Levy, the dealer who had introduced Dalí and the surrealists to New York—and also an early dealer of photography. In 1937, Levy opened a spectacular space on Fifty-Seventh Street—the thoroughfare known, in the words of *Vogue*, as "the bridge over which most of the picture-buying public crosses happily into the art world." There, the twins would

have encountered an environment dramatically different from the sedate velvet-walled picture showrooms more typical of the time. Levy wrote in his memoir that he had designed the floor plan to resemble a painter's palette. The front door led to a long undulating passageway lined with wine-red carpeting, its walls fairly pulsating with artworks: "One could move along a line of paintings, seeing each one individually while the others were around the curve, instead of lined up regimentally along straight walls."

Levy's shows also jumbled together high and low culture, much in the fashion of popular photography magazines. One month, artists like Magritte and Ernst would be featured; another, the Walt Disney Studio gouaches for the film *Snow White and the Seven Dwarfs*. There was even an exhibition dedicated to all the different talents who put on the productions at the School of American Ballet, including set designers, choreographers, and musicians. That show included a copy of a Sears, Roebuck catalog, whence the school had purchased the costumes.

The gallery also showed a lot of women. During the twins' time at Pratt, Levy gave a North American debut to the Argentinean-born surrealist Leonor Fini, and a first solo show to a new young Mexican artist, Frida Kahlo, the wife of the famous Mexican muralist Diego Rivera, whose fantastical self-portraits portrayed her dressed in traditional Tehuana clothing. Levy also showed the "surprising"—so he called her—comedienne Gracie Allen, of the comedy duo Burns and Allen, who exhibited surrealistic paintings "executed in her spare time from the microphone," as the *New Yorker* reported. Because it was a charity event for Chinese war relief, prompted by Japan's invasion the previous year, admission was a quarter, but even a fee couldn't keep the crowds away.

The twins soaked up plenty of American art, too, which was finally coming into its own after years of playing second fiddle to that of Europe. Before long, like many other Pratt students, the twins were supplementing their education with art classes in Manhattan. Both

of them studied painting at the New School for Social Research, a progressive institution in Greenwich Village, where their teacher was Yasuo Kuniyoshi, a Japanese émigré who was one of the few noncitizens regularly included in the annual exhibitions of another new museum, the Whitney Museum of American Art. Formed from a New York artists' studio club, it had opened only a few years before, in 1931, and was around the corner from the New School, in three conjoined row houses on West Eighth Street.

Kuniyoshi, known as Yas to his friends, was one of the city's most respected contemporary artists and also one of its most popular teachers. He "was born in Japan, arrived here at twelve, and now, at forty-three, is famed for his immaculate detail, the grotesqueries of some of his proportions, and the exquisite delicacy of his palette," *Vogue* enthused. Another critic, most likely Henry McBride, writing in the *New York Sun*, observed that his way with paint "must be peculiarly impressive to the multitude of art students who populate the schools and who find it so incredibly difficult to make the paint forget that it is paint."

Kuniyoshi was known for being scrupulously attentive to detail and also for loving parties, and in the photos the twins took of each other and others in his classes, his students seem similarly torn between seriousness and high jinks. In many he is seen bending over their easels; but in others, he laughs uproariously or mugs for the group with a giant hand, perhaps created from papier-mâché, flapping wildly above his head. His aim as a teacher, Kuniyoshi himself wrote, was "in helping the art student develop his own individual approach . . . as well as psychological approach, based on reality."

But Kuniyoshi's importance to the twins may have lain less in his method than in his subject matter. He had started out painting "most strange square cows, solemn top-heavy babies and lustrous still-life combinations with twist loaves predominating," said *Mademoiselle* magazine in 1936, "paintings which the cognoscenti, if no one else, could appreciate. Today his painting has come within range of average

understanding, for its theme is Woman." Namely, circus aerialists, mothers surrounded by their families, and young urbanites gazing pensively into space, thinking their own thoughts, in the coffee shops and bars of New York City.

"The young lady in the picture lives and dominates the composition entirely on her own rights," McBride wrote again in the *Sun* in 1937 of Kuniyoshi's new oil painting, *Cafe*, which appeared in the Whitney's annual exhibition that year. "It may be that she is 'keeping a date' and it may be that she is no better than she should be, but just the same, she exerts that mysterious interest that the lonely young woman in a cafe invariably puts forth."

This choice of subject matter probably surprised no one who knew him, for Yas loved women, and women loved him, to the point that his wife "was always mad about something," said a family friend. But for the twins, the vision of these women, still and introspective amid the city's tumult, set a powerful example that they would later follow in their own photographs.

Franny also took an intensive daily painting class for several weeks in the summer of the twins' junior year with the master painter of New York City life, Reginald Marsh, who taught at the venerable Art Students League on West Fifty-Seventh Street, where he had studied in the 1920s after graduating from Yale. Marsh was famed for his earthy, rollicking, Rabelaisian urban scenes, which he often sketched out on the spot at movie theaters, burlesque houses, the el—the elevated railway that snaked its way overhead above the streets—and Times Square. He, too, was known for depictions of women, but of a stronger, more commanding, Rubenesque variety. And the women in Marsh's paintings didn't ruminate—they strode through the streets. "Marsh considers the girls of 14th Street one of the real triumphs of the American experiment," wrote the critic and dealer Gordon Ewing some years after Franny took her class with Marsh. "They walk easily, and there is independence in their gestures."

Although the twins still did almost everything as a unit, Fuffy never studied with Marsh. Yet she still accompanied Franny to class, just to observe. Afterward, they often joined the famous painter, who had an eye for pretty girls, at a restaurant near the school. "Marsh made sketches of us while we sat there," Fuffy recalled later, "but I never thought to ask him for one."

But by then the twins were already obsessed with photography, and in a sense they wound up with something better—their first exposure to a professional photographer and their first experience on a film set, with the event documented in several different series of photographs. This came about because sometime that summer, Marsh, who also took photographs constantly himself and used them as sketches for his paintings, asked Franny to appear with him in an MGM short made by his friend Alfredo Valente, a famous theatrical photographer. The experience also allowed the twins to spend more time with Marsh, visiting his studio on Fourteenth Street, one of the locations, and accompanying him to others, including the Third Avenue el and the Brooklyn Bridge, where his scene with Franny took place.

Valente, a Calabrian immigrant who had been trained in the old country as an opera singer and painter, had started his new career as a house photographer for the Group Theater, an avant-garde troupe cofounded by Lee Strasberg. (Franny, still crazy about theater, had also been studying directing with Strasberg at the New School, possibly another reason she was chosen for the film.) Valente's main job now was photographing Broadway actors for *Stage* magazine. He also went out to Hollywood twice a year to shoot stills for Columbia Pictures.

The film, *Art Discovers America*, promotes the growing popularity of American painting, unfurling like a Horatio Alger success story as it makes the case that while American artists were once poor and neglected, they now attracted a growing audience. "Today there's a boom in art," a dramatic voice-over declaims. "There's a

new nationwide art moment which critics say is greater in scope, greater in public interest than anything since the Italian Renaissance." As scenes of artists, their students, and their studios scroll by, the viewer is treated to a brief history of American modernism, starting with John Sloan and the Eight—men who in 1908 "laid the foundation for a true national art" by opening "the eyes of other artists to everyday American life as a subject." The film then examines the working methods of urban painters such as Marsh and Raphael Soyer—another New York City scene painter—and regionalists such as Thomas Hart Benton and Grant Wood, seen plying their trade among farmers in the countryside.

At the very end, we see Franny standing beside Marsh as he paints something on an easel beneath the Brooklyn Bridge. "Perhaps this new interest in painting and painters means that America has come of age," the voice intones, as Franny gazes solemnly at the great man's canvas, looking very much the brave young pioneer. Suddenly, she cracks a tiny smile, and we cut to broad skies and soaring skyscrapers.

This triumphal scene about the importance of painting was captured on film multiple times—not only by Valente with his movie camera, but by two photographers, Fred Frater, a professional whose older brother, the painter Hal Frater, was directing the film, and Gene Pyle, who later worked for *Life*, but was then a young painter making a series of shots of Marsh at work. Fuffy also went along to shoot stills. All the photographers took pictures of the twins, and once, while Fuffy was photographing Valente and his camera with the Voigtländer, Valente borrowed it to photograph her and Franny and Marsh. Much as the twins were excited to be in the presence of a legendary painter, they were also clearly overjoyed to be on a real movie set, sharing space with three more experienced cameramen.

CHAPTER 4

The Discovery
of Photography

The twins had spent the summer after their freshman year back at home in Wallingford, living in the St. George's Inn, where Kitty took rooms every summer and Christmas. During the day they prowled through town with the Voigtländer, taking pictures everywhere, of everything—friends, family, cars, the train station, boys at Choate.

Fuffy photographed women pouring out of one of the town's silver factories at the closing bell, an old man in a field walking past a rusty Works Progress Administration sign, and a boy on a bike in an intersection, staring at a horse and buggy and a car, as if contemplating the march of time. Franny documented the elderly lady who lived in the oldest house in town, a woman with a baby walking beneath the jagged shadow of a telephone pole, and Fuffy, lounging within the artful geometry of a ruined barn on Choate's property. (Because they were trading the same camera back and forth, they didn't always remember who had taken which picture, and the names they wrote on the back of the contact sheets weren't always accurate; often the only way to know for sure who'd taken the picture later was if the other twin was in it.)

At summer's end, they showed their pictures to Walter Civardi, a young faculty member only eight years older than the twins, who had been appointed director of the photography department the previous spring. Later, Franny recalled his domain, the photo lab, as being "down in the basement and damp. Everybody would go in with their summer pictures, then go away. He'd throw them out, throw us all out. . . . After about a month of showing people out, he'd let five people come in and work in the lab."

The twins set about pressuring Civardi for lab privileges. They already worked together seamlessly as a team, using a kind of informal divide-and-conquer strategy in which the one best suited to the job would ask a question, handle a project, or raise a particular point. (An assistant who worked with them on joint projects later noted that this double-teaming gave them "a commercial advantage, because people see twins as a unit," while in fact they "might think separately.") "We were so persistent," Franny said. "He said we wouldn't get any credit for it. Then he said, 'Okay, you can come back.'"

"They knew how to get what they wanted," Civardi recalled. Later he realized that it had probably never occurred to them that they might not be able to find work easily in a male-dominated field. "I could see that no matter what they were going to be, they would become successful." He gave in. Ultimately, every one of the five students he chose that year, including the twins, became a professional photographer.

When Civardi had taken over the fledgling department in the spring of the twins' freshman year, it was still something of a red-headed stepchild, its directorship shunted between faculty members who liked taking pictures but had more important things to do at work. The first director was the head of Interior Decoration, who quickly handed it off to J. Gordon Lippincott, a faculty member in Industrial Design. When he grew too busy, responsibility had finally been punted over to Civardi, his "technical assistant." (Lippincott, who today is known for coining the term *corporate identity*, later

opened his own design consulting firm; his first big project was modernizing the label of the Campbell's soup can.)

Although Civardi's own work was technically proficient, it wasn't widely exhibited or renowned—unlike that of Berenice Abbott, who was teaching two photography workshops at the New School, had already shown to acclaim in Paris and New York, and would soon see the publication of her influential book of street views, *Changing New York.* The year he became director, Civardi published the book *Sailing Made Easy: Told in Pictures*, with the associate editor of *Yachting* magazine, a primer illustrated with pictures of a smiling couple demonstrating how to sail a knockabout across the Long Island Sound. "Each and every one," Civardi writes in the introduction, "was staged and rehearsed as carefully as a Broadway show." As was the fashion, he also went into great detail about the technical gear required to make them, all borrowed from Pratt's studio.

Civardi's work was published in *Collier's* and *Life*, and his book remained in print for decades. But he mostly devoted himself to building out Pratt's photography department, which provided photographic services for the entire school, making publicity shots, photographic murals, lantern slides for lectures, and photos for the yearbook, annual reports, books and magazines, and posterity. (To prove the department was effectively self-supporting, ledgers were maintained noting what these services would cost on the open market.)

Yet although Civardi's reputation was not illustrious, students loved his classes—and they all knew photography was becoming important. "It was the experimental thing being taught so we were all very attracted to it," recalled Beverly Pepper. "Everyone took photography class." Civardi taught them to make photograms, "which was thrilling," she added. Created with a technique discovered in the early 1800s, at the dawn of the medium, it meant working directly on developing paper and had been revived in Europe in the 1920s by the avant-garde.

Moholy-Nagy, who had coined the term *photogram* in 1921, explained the method to Americans in *Popular Photography*, one of the new photography magazines, in a how-to piece that ran in December 1939, along with stories on glamour and war-propaganda pictures. "If you want to come to the most intimate understanding of how your camera operates," the famous Bauhausler wrote, "lay your camera aside for a while and try taking pictures without it." One places an object, such as a rose or a fork, on photosensitive paper and floods the composition with light. This creates a negative image, which turns the background black and renders the objects in gray and white halftones; how black and how gray depends on the length of exposure and the opacity or transparency of the objects. Producing photograms, the story promised, will "give you an understanding of the basic principles of photography and composition," and so it was for Pratt students.

Because the school focused like a spotlight on getting students jobs, Civardi's studio also offered hands-on camera and darkroom experience. Both twins learned to use a large-format four-by-five Graflex, the seven-pound professional workhorse carried by press photographers such as Arthur "Weegee" Fellig, who began documenting New York City crime scenes and nightlife for newspapers in the 1930s. Instead of using roll film, it was loaded with sheet film that took one picture at a time, producing a four-by-five-inch negative with enough detail that it could be enlarged for publication. (The first book on Graflex technique, *Graphic Graflex Photography*, came out the twins' junior year, with chapters by well-known photographers of the time, such as Ansel Adams, who explained enlargements; Berenice Abbott, who delivered "the first modern treatise on the use of the View Camera"; and Barbara Morgan, then documenting Martha Graham's modern dance company, who wrote about the way in which speed film and faster cameras had made life easier for photographers who sought to record "the modern dance, ballet, and folk dances" to "the dances of the American Indians." There were

also chapters on equestrian, advertising, aerial, news, and publicity photography, among many others.) The studio was also stocked with the eight-by-ten view cameras used in professional studios, which took higher-resolution pictures suitable for magazines, and even a movie camera. For all the still cameras, the photographer had to get used to working with a mirror-image scene shown upside down.

The twins spent a lot of time binding slides in the lab with Beverly, who worked there, too, on a grant from the National Youth Administration, a New Deal agency that provided work-study jobs for students. The three of them weren't the best of friends. Franny recalled Beverly being "a redhead" and "really a snappy girl," but Beverly, already feeling isolated by the anti-Semitism she had encountered at Pratt, regarded the twins as "'fashion' people" and kept her distance. "They looked astonishingly alike," she recalled, adding that she found them intimidating because they struck her as being "from high society."

Mostly, they spent time in the darkroom—Civardi gave them a key, so they could use it on nights and weekends—and taking pictures. "He encouraged us to learn and experiment," recalled Fuffy. "We spent every free moment exploring New York with our cameras and in the darkroom discovering new techniques."

Some of their subject matter came from the Brooklyn Museum, where they checked out nineteenth-century bags from the costume collection and photographed them looking like up-to-date accessories, possibly for a fashion course. ("Can you imagine that the Brooklyn Museum let us take these bags home?" Fuffy wrote on the album later.) As warships began massing at the Brooklyn Navy Yard, and boys at Pratt began to enlist, the Industrial Design department developed one of the country's first camouflage classes, and Fuffy and Franny photographed the student camoufleurs at work. The twins tried out their portraiture technique on Mr. Civardi, who sat patiently for them in the studio, surrounded by cameras and lighting equipment.

The twins also photographed families walking in Prospect Park and the children at the Manhattan Settlement House, where they did charity work. One picture, of children gathered in a gym, seems especially well done: taken from overhead, their bodies create a striking composition against the lines and circles painted on the floor. Shots such as these suggest the twins had been looking at the work of the Photo League, a socially conscious photographers' cooperative whose members aimed to document the human condition without forsaking aesthetics or design.

The twins turned the Voigtländer on each other, too. Franny captured Fuffy posing at the campus gallery, surrounded by student work. Fuffy photographed Franny standing on the platform of the DeKalb Avenue el train, looking tiny against giant ads for shoes and tomato juice. When Lord & Taylor opened its first suburban branch store in Manhasset, on Long Island, a curvaceous two-story pavilion designed by Raymond Loewy with plenty of glass and natural light, the twins visited with their mother and used its stainless steel, glass, and flagstone walls as the setting for an amateur fashion shoot. And they were clearly getting inspiration from magazines, such as the newly launched *Glamour of Hollywood*, whose tagline was "the Hollywood Way to Fashion, Beauty, Charm," and offered tips from the stars about life, entertaining, makeup, romance, and clothes. *Glamour*'s models sometimes posed in front of movie posters, and the twins photographed each other that way, too, although they relied instead on the posters for Broadway musicals that hung at the Wallingford train station.

OF COURSE THE TWINS ALSO made photographs at the 1939–40 World's Fair, which they visited many times, not only by themselves but also with their friends and teachers, marveling at its two hundred miles of boulevards and exhibition halls and its fantastical landscape of towers and fountains. Once they went with Mr. Civardi and Mr.

Lippincott and a group of boys to take photos that they pasted in an album. They captured the Trylon and Perisphere, the gigantic glowing white modernist spire and globe that were the symbols of the fair. Next, the Con Edison Building, whose facade rippled with a water ballet dreamed up by a young sculptor, Alexander Calder. Inside was a diorama of New York City, which cycled from dawn to dusk in twelve minutes, complete with moving subways and twinkling lights. Someone photographed the group atop the Ford Building, which held another awe-inspiring exhibit, the Ford Cycle of Production, a giant revolving turntable that presented the eighty-seven steps in a car's production, from the moment its metals were mined to the day it rolled off the assembly line. They were transfixed by the sheer stockings displayed at Du Pont, organized around the theme "The Wonder World of Chemistry"; the stockings were spun from nylon, a new synthetic fabric made of "carbon, water and air."

Then there was the Eastman Kodak Building, which in addition to the "Cavalcade of Color" had regular fashion shows in which models paraded in clothing made from the same plastic as the company's cameras. In back was a Photo-Garden, filled with sets where visitors could take snapshots, ideally with the souvenir Baby Brownie created specially for the fair. The twins chose to pose against a miniature Trylon and Perisphere and smiled delightedly as Mr. Civardi and Mr. Lippincott photographed them from different angles.

MANY OF THESE BOOTHS and exhibits had been designed by Walter Dorwin Teague, the only industrial designer on the fair's board, who had become famous after Kodak hired him in 1928 to make its cameras more stylish. He had started with a Vest Pocket camera, produced in five colors, and followed it up with the Vanity Ensemble, a ladies' camera that came with a matching lipstick, compact, and change purse. During the Depression he appealed to consumers with family-oriented Brownies; for Boy and Girl Scouts,

brightly colored Brownies; and cameras covered with exciting new art deco designs. Then came the concept store, in gray and silver to set off the colorful products, "designed as a background for modernly designed merchandise," as he had told *Forbes.*

The twins had an interest in Teague because Fuffy was lucky enough to be dating his youngest son, Lewis, a Pratt architecture student. The tall, charismatic young man also appeared in many of their pictures, smoking a pipe, often with Fuffy beaming beside him.

They likely met through the Playshop, Pratt's drama club, which the twins joined their freshman year. By that time, Lewis's parents were divorced. His mother lived in an apartment at Sutton Place South, overlooking the East River docks, where Lewis painted Fuffy's portrait, and Franny photographed her standing next to it, and Lewis photographed both twins as they stood looking out over the water and the piers. They sometimes went out to visit his father in New Jersey, too. Walter Teague, who believed good modern design should be rooted in the simplicity of the past, lived in a Pennsylvania Dutch farmhouse, which he and his wife were outfitting in a streamlined, up-to-date style with local folk art and antiques.

A year into Fuffy and Lewis's relationship, an art professor told Lewis his true talent lay with painting rather than architecture, so he quit Pratt to study at the Art Students League, and Fuffy began sneaking out of class to spend time with him in Manhattan—and perhaps also to evade Kitty's questions and prying eyes. The twins divided and conquered to make it happen, with Franny taking Fuffy's place in class so that she would not be missed.

Although Fuffy considered Lewis her fiancé, the twins had dating energy to spare. They still loved Yalies, and for a while they enjoyed double-dating twins, so when the chance arose to attend the Yale Junior Prom with another identical pair, they took it. One of Fuffy's old Choate swains from high school, who was now at Virginia's Washington and Lee, invited them both down for the weekend for a dance, having mollified Kitty by securing a date for Franny, too.

"Your mother need not worry about you, as you will be with lots of other girls," he wrote. "Please don't be too hard on me if I get you and Fran mixed up at first."

Also on the trip was a Choate master they were fond of, who presumably came along as some sort of chaperone. The twins were photographed on the trip with their dates, but also with him, one sitting on either side. Later he sent them a limerick about a poem they'd written. It read in part, "And now a word / to Fuff and Fran / Who were with me / When I began / To violate / The act of Mann"— a joking reference to the 1910 Mann Act, a federal law that had criminalized the interstate transportation of "any woman or girl for the purpose of prostitution or debauchery."

And of course there were all the other boys they had known from Choate. Whenever the twins returned to Wallingford, they photographed each other in Choate buildings, or at the Choate skating rink or at Choate games, surrounded by Choate boys, and occasionally Choate masters. Kitty might have thought she had them well controlled, but now the Voigtländer seemed to serve the same purpose as the ball of wool at the movie theater: they could always say they were going out to take pictures and use it as an excuse to be among a crowd of boys and, increasingly, men.

IN THE TWINS' JUNIOR YEAR, they were profiled in the *Prattler*, the newly founded school newspaper. The story became the model for a column that would cover exotic personalities who were making a mark on campus. Future subjects would include Isabelle Suarez, a Brazilian émigré who was the only girl in the engineering school; Mieko Fuse, a Japanese American dietetics student with an incongruous Boston accent; and Maurice Hunter, the art school's most renowned model, a Harlem-based dancer known as the Man of Many Faces, who had posed for so many famous artists and illustrators that his likeness was known nationwide.

The story about the twins, entitled "McLaughlin Twins Bare Souls for *Prattler* and Posterity," primarily conveyed that they were nearly indistinguishable from each other and loads of fun. "They were born in Brooklyn twenty-one years ago this September," it begins, "and, for our money, they're a bigger attraction than the Dodgers." They "make their own clothes, knit sweaters by the dozen," and other than that Fuffy liked pineapple and Franny didn't, "they think and feel exactly the same way about everything." As for their love lives, "double dates are their usual rule, but occasionally they'll go out singly, or both with the same man—who usually recovers." According to the story, they intended to return to Wallingford after graduation, to teach in a tiny school run by a family friend.

Yet that future must have seemed unlikely even then, considering the twins' larger-than-life presence on campus, where they had thrown themselves into student activities even more fervently than they had in high school. As well as being in the Playshop, where they were once assigned the same part, playing it on consecutive nights, Fuffy got involved in politics, becoming class secretary her freshman year, and eventually president, of Art Education, the tonier name bestowed upon Teacher Training in fall 1939, while Franny zeroed in on art activities, becoming head of Pratt's art exhibition committee and president of the girls' arts club, the Paletteers. They won prizes, starting with an honorable mention for costuming dolls, an activity the Paletteers undertook each Christmas for the children of patients at the Brooklyn Naval Hospital. They posed gleefully for school publicity shots, smiling side by side in matching coats with armfuls of books, or pushing each other in a wheelbarrow.

After joining Civardi's gang of five, they also joined the yearbook, the *Prattonia*, with Fuffy becoming photo editor, and Franny one of her assistants. They had already been featured in it as freshmen, shown walking past a couple of staring boys in their matching plaid Peck & Peck collegiate coats, headscarves, saddle shoes, and ankle

socks, above the caption "Yes, THE Twins!" They were named "has done most for Pratt" in their junior year.

They frequently appeared in the *Prattler*, too, though more for their looks than their academic prowess. The gossip columnist announced spring had sprung because "the McLaughlin twins have donned anklets and put their knee socks on the shelf." After Wrigley gum launched its wildly successful Doublemint twins campaign, another writer mentioned the McLaughlins' similarity to the stylish twins in the ad and wondered whether they liked chewing gum, too. Their presence at parties was noted: "The Twins, cute as ever," attended the school's first Engineering dance, and "the Twins were there in cute blue prints with Lew Teague and Tick Tichner," president of the Artsmen, the male counterparts of the Paletteers, when the two groups held their dance. They also got ink when Robert Smallman, another Civardi acolyte, shared first prize with another Pratt student in a fabled poster competition for Dartmouth's Winter Carnival—the fifth year in a row Pratt had won—with a design based on a picture of Franny in ski goggles looking like the "typical carnival date," the *Brooklyn Daily Eagle* reported. The *Prattler* reported that Dartmouth "was even more pleased when they discovered she had a twin sister."

As school progressed, the twins divided their homework, with one taking over the other's assignments so they could focus on their favorite subjects. Some might have considered it cheating, but they regarded it as "helping each other," as Fuffy put it. "We saved time and concentrated on art and photography."

They also had a lot happening outside school: as well as designing and making their own clothes, they had begun entering competitions, modeling, and planning for their future. For beyond the Pratt campus, there was a burgeoning market for the talents of young women such as the twins.

CHAPTER 5

College Bazaar

Throughout the Depression, college girls—what they wore, bought, thought, and worried about—had become a growing fixation among fashion retailers and magazines. Youth culture had begun making its mark on popular culture during the Jazz Age, and college attendance among both sexes was on the rise. Even though only a fairly small percentage of Americans attended college, and even fewer young women attained bachelor's degrees, the college girl somehow came to replace the flapper in the American imagination as the symbol of youth, at least for beauty and in fashion marketing. The two trends combined to bring about the "college shop" craze.

In New York City, the phenomenon was likely pioneered in 1930 at the Fifth Avenue department store Stern Brothers, already known for its attention-grabbing promotions—the brainchild of the store's advertising director, Estelle Hamburger, who'd launched the city's first woman-run advertising business two years earlier soon after giving birth to twins. She came up with the idea when a Mount Holyoke senior named Sally, interviewing for a summer job, mentioned that she'd love to sell clothes to young people, especially college coeds. When Hamburger asked why, Sally patiently explained, "They buy all the wrong things because nobody knows what they really need," and a light bulb switched on in the marketing maven's

43

head. She consulted with New York City college clubs to find the most popular seniors in each school and hired an advisory "college board" comprising twelve of those students to advise her buyers, with Sally representing Mount Holyoke.

Soon afterward, Stern's sports department was transformed into America's first department store College Shop. On Sally's advice, it had jettisoned the usual S.S. and G.—"sweet, simple, and girlish"— clothing typically marketed to college girls; instead, it was stocked with skirts whose backsides didn't "sit out," good sweaters in subtle, sophisticated colors, saddle shoes "for running to classes over the pebbles," and Harris Tweed topcoats that would last four years. There were also evening clothes—many in red, a color boys could easily spot at a dance from the stag line, Sally had said; warm bathrobes and slippers, to satisfy anxious mothers; and plenty of gadgets, because coeds "adore" them. These goods were displayed in trunks packed by the college board members themselves. On the walls hung enlarged snapshots of the members wearing the clothes—but no college pennants. "They're old hat," the board had pronounced.

The shop was swiftly thronged by "undergraduates and freshmen-to-be who wanted to discuss their clothes problems with the editor of the *Smith College Weekly* or the captain of the Vassar hockey team," Hamburger wrote in her 1939 autobiography, *It's a Woman's Business.* "We could hardly supply the College Shop with merchandise fast enough to keep pace with its sales." After that, "college shops sprouted every August thereafter in almost every New York store and in stores throughout America." Lord & Taylor, New York's oldest and grandest department store, followed suit in 1933, stocking theirs with "authentic" East Coast college fashions, such as the cashmere sweater sets produced by the New York clothiers Peck & Peck.

Soon, college girls were hotly pursued for their design expertise. Chicago's Marshall Field launched a Young American Fashion contest in 1934. By the late 1930s, the Young America Fashion Guild, a New York consortium, was pairing would-be designers with

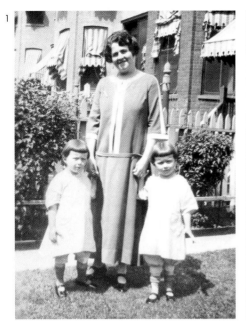

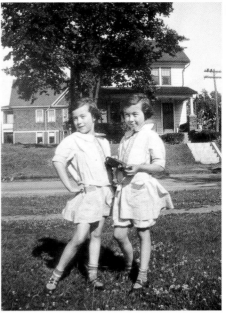

The twins, age three, in Brooklyn with Kitty—Fuffy on left, Franny on right. (Anna O'Rourke, ca. 1923)

The twins in Wallingford at about age ten. Franny is on the left striking a pose, while Fuffy holds the camera. (Anna O'Rourke, ca. 1929)

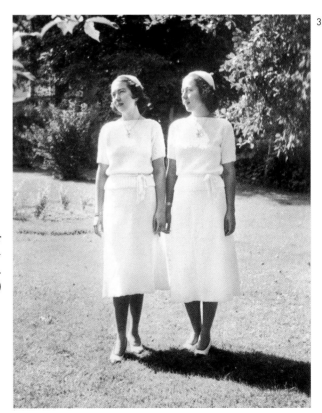

The twins at their senior high school graduation— Fuffy at left, Franny at right. (Anna O'Rourke, 1937)

4

Fuffy and Franny preparing their Prix de Paris competition entries.
(Unknown photographer, ca. 1941)

5

Franny poses for Fuffy before the 1941 Dartmouth Winter Carnival poster (designed by their classmate Robert Smallman), which features her picture.
(Kathryn Abbe, 1940–41)

6
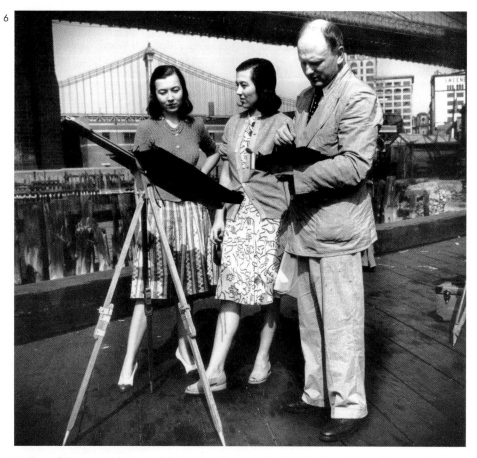

Fuffy and Franny with Reginald Marsh, photographed by the Broadway photographer Alfredo Valente while filming his MGM short *Art Discovers America*.

Jimmy's cover for
the same issue.

Jimmy's picture of the twins
in slightly different evening
dresses for the August 1940
issue of *College Bazaar*.

The sign in the window
says GOING MY WAY.
(Kathryn Abbe,
*Portrait of James Abbe Jr.
in Sag Harbor*, 1944)

Franny and Fuffy (with spyglass) on Jimmy's property in Montauk, soon after he purchased it. They wear matching sundresses by Claire McCardell.
(James Abbe Jr., ca. 1944)

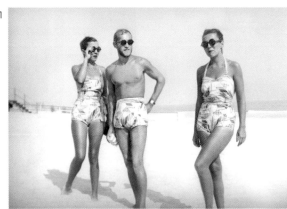

The twins and Jimmy in matching swimsuits. Taken by Carolyn Tyson on the beach at the Surf Club in Montauk.

An early picture of the Montauk house, taken about a year after it was built.
(Kathryn Abbe, mid-1940s)

Self-portrait of
James Abbe Jr.
and Kathryn
Abbe on their
wedding day,
May 15, 1946.

This was taken overseas during the war, likely in Italy.
On a smaller version, Franny wrote, "I like."
(Unknown photographer, *Portrait of Leslie Gill*, ca. 1944)

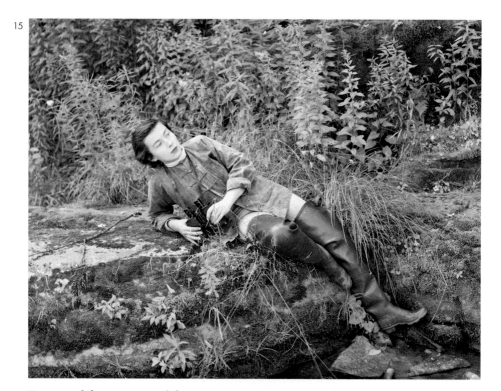

Franny in fishing gear on a fishing trip. (Leslie Gill, *Portrait of Frances McLaughlin-Gill in the Hewitt Woods*, 1950)

Matching contact prints of the twins and their partners: the one on the left, taken by Leslie, became the Abbes' Christmas card. (Leslie Gill and James Abbe Jr., ca. 1946)

One of several group shots taken by Jimmy and Lisa in the studio. (James Abbe Jr., *Group Portrait of Kathryn Abbe, Fernand and Lisa Fonssagrives, Leslie and Frances Gill*, 1949)

Franny and Leslie's wedding day lunch at the house in Montauk, July 18, 1948. *Left to right:* Lena and Erwin Blumenfeld; Anna Wibberley (editor of *Everywoman*) and her husband, Edward Clark; Franny; Leslie; Fuffy; Henry (Lena and Erwin's eldest son). (James Abbe Jr., 1948)

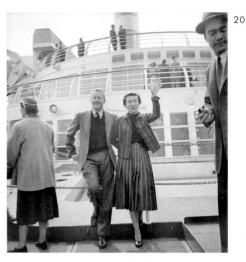

This photo was taken by Franny in August 1950 for the Abbes' Christmas card and later repurposed for a story in *Glamour*. Tom is in the driver's seat with Fuffy; Jamie and Lucinda are in back. (Kathryn Abbe and Frances McLaughlin-Gill, *Christmas Card: Portrait of Kathryn with Abbe Children, 1950*)

Leslie and Franny, about to sail away on the SS *Independence* for their European honeymoon; Bob Cato with camera at right. (Kathryn Abbe, 1951)

manufacturers, who paid $10 to $25 for an idea and brought the designs to market with individualized hang tags advertising each coed's name and school. *Mademoiselle*, a new fashion and career magazine, began holding college design competitions in 1936.

Indeed, the collegiate trend soon spread to magazines, which began featuring guest editing contests and back-to-school sections geared toward college coeds. *Mademoiselle* was the leader. It published its first college issue in August 1936, the same year as its design competition, and began regular "College Board" columns soon after, featuring correspondents who reported on campus fads and fashions and occasional photography and modeling competitions. In 1939, the magazine held its first Guest Editors competition, inviting a group of thirteen to spend a summer in New York, during which time they edited the back-to-school issue themselves. (*Mademoiselle*'s Guest Editors competition became a storied tradition, birthing literary talents such as Sylvia Plath in 1953, Joan Didion in 1955, and Meg Wolitzer in 1979.)

By 1940, such gambits had turned *Mademoiselle* into America's bestselling fashion magazine. Perhaps it wasn't purveying haute couture, but its ascendance sent a definite message that the tastes, interests, and purchasing power of younger women could no longer be ignored.

The magazine had begun in 1935 as an experiment by Street & Smith, a venerable nineteenth-century publishing firm previously known for men's and boys' pulp fiction—authors such as Horatio Alger and Bret Harte and such magazines as *Detective Story*, *Western Story*, and the *Shadow*. At first the magazine had sputtered along sadly, steered by male executives who had no idea what they were doing. But then someone had the bright idea of hiring Betsy Talbot Blackwell, then about thirty, as fashion editor. In the fall of 1936, *Mademoiselle*'s fortunes were transformed overnight when Blackwell and her team made over a homely New York nurse in a week, publishing the before and after pictures under the headline "Cinderella."

Barbara Phillips, the nurse in question, had penned a letter to *Mademoiselle* about a new beauty campaign called "Make the Most of Yourself," in which a "miracle make-up man" for Paramount Studios worked magic on such stars as Joan Crawford and Katharine Hepburn. Nurse Barbara told the editors she was desperate to become an actress and begged them to transform her, too. "I am homely, too skinny and know none of the feminine wiles that my more attractive sisters seem to have been endowed by nature with," she wrote. "Don't you think it would be a feather in your cap if you could be the one who changed this very ugly duckling into even a pale pink swan? If you have any of Pygmalion in you, please be a sport and help me out."

Mademoiselle brought in the makeup man, a dress designer, a ladies' foundation expert, a dentist, and various other pros. Together they retooled Nurse Barbara's face, capped her teeth, lengthened her pathetic tresses with a wig, and turned her scrawny neckline enticing with a gown they later marketed as the Cinderella Dress. The stunt made national news, and *Mademoiselle* started a monthly makeover column, boosting its circulation from 30,000 to nearly 180,000 copies by 1939. Along the way, Blackwell was named editor in chief, and *Mademoiselle* adopted a new tagline, "The Magazine for Smart Young Women."

By this point Blackwell was also taking aim at careers, with an onslaught of stories and columns offering advice for what jobs to choose, how to find them, and how to keep them, written by some of the savviest female journalists of the day. (Its first career column was dubbed the "I Don't Want to Play the Harp Department," while its advice column was called "What to Do Before the Psychiatrist Comes.")

It used other gambits, too, to make clear that this was not your mother's magazine: in July 1939, the month before the first College Editors issue, *Mademoiselle* published a "Famous Offspring Number," filled with contributions by the children of Roaring Twenties luminaries. One essay, on the delights of Pullman train cars, was by the

writer and actress Erika Mann, daughter of the Nobel Prize–winning German novelist Thomas Mann, whose family had been forced into exile by the Nazis. A story by a young radio actress was illustrated with candid photos by James Abbe Jr., an up-and-coming lensman named after his father, James Abbe, a famous photographer known for making portraits of film stars and foreign strongmen such as Hitler, who had just annexed Austria and Czechoslovakia and was now making moves on Poland.

The magazine also published the first piece by Frances "Scottie" Scott Fitzgerald, daughter of Jazz Age literary heartthrobs Scott and Zelda. By then Fitzgerald's glittering works had fallen out of favor. His coffers had been drained by Zelda's struggles with schizophrenia and his own with drink, and he was trying to make a go of it as a scriptwriter in Hollywood. His daughter, in an essay called "A Short Retort," tartly summarized the fed-up mood of her peers.

"We're the offspring of a generation of the disillusioned '20's after the War," she wrote. "In the speak-easy era that followed, we were left pretty much to ourselves and allowed to do as we pleased. And so, we 'know the score.' . . . We've had to make our own decisions, invent our own standards, establish our own code of morals. The fact that we've turned out as well as we have is more to our credit than that of our parents."

By 1940, *Mademoiselle*'s circulation had soared to three hundred thousand, nearly a third beyond that of its older competitors *Vogue* and *Harper's Bazaar*. That's likely why Pratt's Paletteers, the school's girls' arts group, invited Blackwell, then about thirty-five, to give its annual February lecture in the twins' senior year, just as the magazine's "What's New" number, filled with young fiction discoveries, hit the stands. Franny, the Paletteers' president, was mistress of ceremonies. The talk was covered by the *Brooklyn Daily Eagle*, as well as the *Prattler*, whose reporter was clearly charmed.

"From the top of her demure off-the-face, mink-trimmed turban placed on her fine masses of brown hair to her tiny, tastefully clad feet,

she radiated a charm that easily captured the fancy of her listeners," the *Prattler* reported. (The subhead read, "McLaughlin Twin Presides.")

Blackwell spoke of her early artistic ambitions and her initial aspirations to go on the stage. She explained the confusion surrounding *Mademoiselle*'s launch, when quite a few men bought it because of the name, expecting to get "a hot French number." She mentioned her stepdaughter, currently a Pratt student, and her admiration for the school. (Like many sophisticated women in the 1930s and 1940s, the editrix was on her second marriage—divorce being a topic frequently addressed in her magazine.)

Then she delivered a list of "Do's and Don't's," the paper wrote, of the sort often doled out as fashion advice but here aimed at illustrators—a category that then included photographers.

"Don't feel discouraged if your work is turned down. Rather, ask for another appointment (perhaps the art editor isn't feeing well that day). . . . Don't rush your work, and above all, don't approach your work in a lackadaisical frame of mind. It ruins the excitement of your work. To sell, your work should be stimulating, exciting, different, and even alarming.

"Do make your work beautiful. People should see beautiful things in magazines to offset some of the ugliness they see around them."

As it happened, the twins probably didn't need Blackwell's advice as much as some of their peers. They had already been discovered by one of *Mademoiselle*'s many rivals, *College Bazaar*.

ALTHOUGH *MADEMOISELLE* HAD CORNERED the college market, it hadn't been the first magazine to recognize its importance; that honor went to *Harper's Bazaar*, America's oldest fashion magazine, founded in 1867 as a tabloid weekly. Now a monthly, it had introduced a back-to-school college issue in 1934; the decision was one of the first acts of its new editor in chief, Carmel Snow, a charming and glamorous Irishwoman who possessed a devastating sense of style

and a fondness for whiskey. William Randolph Hearst, *Bazaar*'s publisher, had poached her two years earlier from *Vogue*, the magazine's high-fashion rival, which was owned by his nemesis, the publisher Condé Montrose Nast. Under Snow's guidance, *Bazaar* had swiftly gone from moribund to cutting-edge.

Inspired by the results of "a soul-searching questionnaire" sent to coeds at twenty-seven colleges throughout the country, Snow's August 1934 issue "featured the first 'college fashions' to appear in a magazine," she wrote in her memoir, *The World of Carmel Snow*, "and started the trend that has resulted in today's highly successful magazines for young women and girls." The advertising department was so impressed with the response, she added, that she was persuaded "to turn over our August issue henceforth to fashions for the young." The picture assignment went to her new discovery, Martin Munkácsi, a Hungarian sports photographer whom she had met in New York while he was on assignment for Germany's *Berliner Illustrirte Zeitung*, or *BIZ*, Germany's highest-circulation photo-newsweekly, where he was a staff photographer. Snow had quickly arranged a sitting and taken him to Palm Beach, where, in 1933, he'd photographed the model Lucile Brokaw running in a cape alongside the surf. "The resulting picture, of a typical American girl *in action*, with her cape billowing out behind her, made photographic history," Snow wrote.

So *Bazaar* signed the amusing Hungarian, who became known as Munky around the office, to a contract and used him to capture the essence of the American college girl—and by extension, American femininity, too. "With Munkácsi to photograph girls on actual campuses," Snow wrote, "poised on roofs or leaping into space, we were able to promote the College Shops that [we] inaugurated to feature our fashions." (The timing was also fortuitous for Munkácsi, a Jew, who had just covered a terrifying Nazi rally for *BIZ* and wasn't eager to stick around.)

In 1938, the *Bazaar*, as it was known among the staff, launched a stand-alone junior offshoot called *College Bazaar*. The project seems

to have begun as an annual issue in August 1938, mailed to college girls around the country and distributed for free in the college shops, where fashionable and discerning coeds could find clothes selected by *Bazaar*'s editors.

At first the magazine looked oddly adult, filled with pictures of youthful-looking models wearing serious fashion, shot by the great photographers *Bazaar* was starting to discover, such as the transplanted Californian Louise Dahl-Wolfe, who had started out photographing her friends near San Francisco with a Brownie, naked at the beach; now she was known for luscious, somewhat enigmatic color photographs of models outdoors in natural light. But the 1940 edition of *College Bazaar*, where the twins' photographs were first published, was something quite different. Although many of the pictures were still taken by *Bazaar* staffers, it was primarily written and photographed by college girls, whose work was nonetheless expected to rise to the stylistic level of their elders.

Harper's Bazaar had attempted to find student photographers once before, when it ran a college snapshot fashion competition in 1937. Now *College Bazaar*'s thirty-five-year-old editor, Margaret Hockaday, set to work finding more campus contributors at the dawn of the new decade, with a strong focus on identifying girls who could take good pictures.

"During the darkest weeks of midterm exams, before Dartmouth had its Carnival or Michigan its J-Hop, we announced our spring issues of *College Bazaar*," Hockaday proclaimed in the March issue of the magazine. "We asked for college news, for fashion trends, for snapshots. Then we waited anxiously as if for a Clipper bringing fashion pages from Paris." The contests she ran have not survived, but Hockaday was soon grooming her new discoveries.

"Dear J'Anne," she wrote to a young Vassar recruit later that month—likely around the time Franny noticed one of Hockaday's contests and applied—"It was marvelous to talk with you and your friend on Saturday. I do hope you will be able to find that photographer on

campus." She then inquired tactfully whether it made sense to contact the editor of Vassar's student magazine: "Perhaps they would know the names of the best prospects?"

After requesting that J'Anne's friend send her a list of beauty questions that other students might wish to see covered, Hockaday doubled back to pictures: "Also we want snaps of our contributing editors for our first issue, so be sure that you both include photos of yourselves."

The mix of material Hockaday arrived at in the first March issue was reminiscent of *Mademoiselle*, but far more stylish. The college correspondents—from such places as Wellesley, Stanford, and Bryn Mawr—were all pictured on the magazine's opening pages. They filed their own reports on the latest college fashions (spaniel-dog earmuffs, Pan-Cake makeup, knee-high vinyl boots, milkman coveralls) and stories about the ideal clothes for exam cramming (quilted robes and pigtails, or horn-rimmed glasses and faded blue jeans).

There were notable stories by the correspondents, too: in August, *College Bazaar* beat *Mademoiselle* at its own literary game, running Vassar coed Scottie Fitzgerald's first short story, "The End of Everything," a thinly veiled account of her expulsion from the posh Connecticut boarding school Ethel Walker, her dislike of her mother, and her discovery that her family was broke. (Her father, Scott, who would be dead by the end of the year, wrote to her, "You've put in some excellent new touches, and its only fault is the jerkiness that goes with a story that has often been revised.")

But the primary emphasis of *College Bazaar* seems to have been on rounding up good-looking students who could model, and finding smart student photographers who could take good pictures. The effort made sense because, by that time, *Bazaar* had become the primary fashion magazine for great photography. Snow had discovered an exciting new art director, Alexey Brodovitch, who was making photographs the center of his spreads—allowing them to float against white space, running them at an angle along with blocks of sans serif text, or letting a single picture bleed across two pages. Snow had a wealth

of photographic talent, such as Munkácsi and Dahl-Wolfe, who was becoming known for her color work, and great luminaries such as the fashion photographer George Hoyningen-Huene, who had left *Vogue* for *Bazaar* years before.

Staff photographers such as these contributed to *College Bazaar*, but the coeds did the rest—and as the year went on, their photos grew larger and they got more space. Then Hockaday began making discoveries: her first was a student from California, Caroline Wickett, who had started taking photos in high school in her hometown of Palo Alto. She had continued at Bennington College, a progressive girls' school that had been open for only four years when she took the long train ride to Vermont for her freshman year. She studied art there, concentrating on photography. Like the twins, she used a Voigtländer camera.

In January 1940, Caroline visited the offices of *Bazaar* to show the editors her work; two months later, she appeared on *College Bazaar*'s first 1940 masthead as a contributing editor, smiling in gingham in a tiny thumbnail photo as she lounged against a rustic wooden wall. She began contributing right away, starting with a tiny semi-action shot of a girl poised beside a bicycle, clad in student chic: a hooded lambskin jacket, a short flared skirt, and cable-knit knee socks. For June, she worked on location, turning in artsier pictures from California, shot at oblique angles, of Stanford girls sunning themselves at Lake Lagunita and kicking up their saddle shoes in the Main Quad. The following month, she made it into big *Bazaar*, as it was known around the office, with a portfolio of fashion shots of girls in cotton dresses, also taken on campus.

By August, after graduation, *Bazaar* had brought Caroline on staff, as assistant to the great Brodovitch—a plum appointment, which the magazine announced by running a biographical sketch that said they'd given her the job because they "were so impressed by her get-up-and-go." Her next *College Bazaar* photo was also published in *Bazaar* itself: it featured a model in a raccoon-collared coat standing next to an American Airlines plane.

For the same issue of *Bazaar*, she was also given a real New York City assignment, to go down to the docks to photograph a boatload of refugee children. They had "arrived on a muggy July 4, when all our photographers were out of town," the biographical sketch read. "Miss Wickett rushed down to the *Scythia*, and got us the pictures." Her shots of the kids waving to the Statue of Liberty were a hit, and she landed the magazine's accessory beat, with an actual byline—not an easy get.

Then Caroline became engaged to the well-connected James G. Dern, the youngest son of George Dern, the former secretary of war, and her brief, shining career was over. Photography "was something she enjoyed during high school and college, and a little after," explained her youngest son, George H. Dern, who inherited her Voigtländer and became a photographer himself. "But she got married in 1941; 1942, she was pregnant."

Hockaday's next success stories seem to have been Franny and Fuffy. By the time the twins came her way, they were deeply embedded in the college shop world. They were among four coeds representing Pratt in the Twix-Teen shop at Manhattan's Abraham & Straus department store on Pratt Day, where they modeled and helped customers pick out clothing. It was then that Franny had entered the *College Bazaar* editing competition. "After the editors saw us," Fuffy said, "they said, 'We think we could use you in our next issue.'"

Hockaday never made them full-fledged editors or put their names and thumbnail photographs in the magazine, maybe because they weren't truly on-brand for *Bazaar*: after all, they attended a Brooklyn art school, rather than a full-fledged college, so they had no real college cachet. But she and the rest of the staff were clearly taken by their charm and twinly exoticism. Hockaday did publish their first professional photographs, most likely of makeup and accessories, for which they received $3.50 each, without a byline. Someone else at *Bazaar* arranged for them to sell a pattern they'd brought in to show the magazine—this one for a pair of crocheted suede mittens—to a major New York City glove manufacturer, Wimelbacher & Rice.

More memorably, the twins were hired to model evening dresses for the back-to-school August 1940 issue, shot by James Abbe Jr., the famous photographer's son, who by now was quite well-known and a *Bazaar* staff photographer himself. As well as being the primary photographer for *College Bazaar,* he covered fashion for the main magazine and for *Ladies' Home Journal* (newly restyled as "The Magazine Women Believe In"), which had been the leader before the Great War and was on an intensive new modernization campaign to regain its former stature, with covers shot by famous photographers from other publications. Jimmy would soon break through there as a celebrity photographer himself, specializing in glamour shots of Hollywood stars such as Vivien Leigh.

The twins had likely read about Jimmy in *Mademoiselle* the previous summer. Here's how *Bazaar* breezily described him in an editor's note at around the same time: "He is twenty-six, looks like Hansel of 'Hansel and Gretel,' loves big cars and Class B pictures, is married, and just now, engaged in moving a charming old farmhouse to a new site for his country week-ending."

The copywriter didn't mention that Jimmy was fabulously good-looking, with bedroom eyes and a shock of blond hair that kept falling into them, but who needed to? The thumbnail photo did the job. And the twins undoubtedly noticed all that and more when they entered his Madison Avenue studio for the shoot.

It took place on July 5, 1940, in the same building as the magazine. Fuffy got to wear an off-the-shoulder "sweeping black moiré taffeta which rustles when you dance," *College Bazaar*'s copywriter enthused, while Franny was garbed in purplish blue velveteen that "will melt your date and be the envy of the girl stag line." The twins posed standing next to each other, holding the same dance program and gazing down coolly into its pages as their skirts pooled together. Captured by Jimmy's large-format camera, they appear quite collected: their eyebrows are fetchingly arched, and their powdered faces and décolletages glow perfectly and demurely in the hot studio lights.

But by Fuffy's account, their hearts were likely pounding. They didn't come away talking about the makeup or the clothes, or the impressive studio equipment, or their $5 modeling fees; their main takeaway was the photographer and his matinee idol good looks.

"We just thought he was gorgeous," Fuffy said. "And famous. Like Gary Cooper!"

What the *Bazaar* bio didn't say was that Jimmy's marriage, soon to produce a baby boy, was heading for the rocks. He must also have been knee-deep in models, Hollywood starlets, and—courtesy of *College Bazaar*—teenage girls. He may have noticed the twins. But he wasn't ready to focus on them, yet.

"They were sort of sandwiched between others," Jimmy said later. "I wasn't so sure that I was up to it at that point." But the world of photographers in New York was small. It wouldn't take long until their paths crossed again.

Before that could happen, though, the twins had an even bigger and more important magazine competition to conquer.

Prix de Paris

The Prix de Paris was launched in 1935, when one of Condé Nast's admen came up with a clever plan before a marketing lunch to create a competition for college seniors that would unearth talent throughout the country and channel it into the offices of *Vogue*, the grande doyenne of fashion magazines.

That October, *Vogue* published a letter introducing the idea; it was signed by Edna Woolman Chase, editor in chief since 1914. While the arts had their Prix de Rome, "Fashion now has its Prix de Paris," Mrs. Chase proclaimed. "A year's employment with *Vogue* in New York and Paris for the college senior who comes most triumphantly through a fashion contest that will appear in coming issues of *Vogue*." After delivering a brief disquisition on the enduring aesthetic importance of fashion, Mrs. Chase explained its economic power as an industry.

"To you who are interested more in facts than in philosophy, the national ledgers have shown that except for food, women's clothes form the biggest retail business in the United States. And fashion dominates every sale—not only of dresses or hats, but of cars and radios and refrigerators. Good taste is no longer a polite formula: it is a vast economic force in the world of to-day."

She followed that up with an even more compelling argument: "Outside of rare movie opportunities and even rarer stage chances,

fashion work offers to women more pay and more future than almost any other single business occupation. It is ideal work for women."

Chase knew whereof she spoke: the middle-class granddaughter of Quakers and a child of divorce, she had started at *Vogue* in 1895, when the magazine was three and she was eighteen, addressing envelopes in the circulation department. After Condé Nast purchased *Vogue* in 1909, using it to launch a publishing empire that spanned half the globe, she had risen to become editor in chief of the Three *Vogues*, headquartered in New York, London, and Paris. Finding her first husband an inadequate breadwinner, she had been able to divorce him. And merely two months before her Prix letter was published, the French government had awarded her their own *prix*, the coveted Légion d'Honneur. (Because the traditional knight's cross was designed to be worn on a man's uniform, the staff of French *Vogue*, referred to in the office as *Frog*, had given Mrs. Chase a small jeweled reproduction better suited to an evening dress.)

The Prix differed from most competitions, an accompanying ad explained, "in that it offers a definite job with salary attached, as well as an opportunity for the best kind of training—actual experience." First prize was a year's employment, at least six months of which would be spent in the Paris office, where the winner "will learn at the very source how fashions are created."

The runner-up would work for at least six months at *Vogue* New York, where she would study the more prosaic business of reporting, distribution, and merchandising—in other words, how the sausage was made when it came to reaching the American consumer.

The Prix was a tough competition. Over the next six months, the magazine rolled out a rigorous gauntlet of six quizzes comprising thirty-three questions. Contestants were required to invent new layouts, to suggest article and column ideas, and to come up with improved captions for previously published pictures. They were asked to rewrite and improve stories; to create new trade names for a range of shoes; to dream up clothing for specific social occasions and ages;

and to canvas their fellow students for ideas about beauty and fashion and report back their findings.

Then came the final fifteen-hundred-word thesis—a feature story, an essay about how you'd beautify yourself with a spare $1,000, a critique of the magazine, or an analysis of American advertising trends. The only entrance requirement was to "study *Vogue*, just as you would study a text book for facts on any subject."

In 1935, that grim Depression year, there were plenty of takers: five hundred girls from 192 colleges and 46 states applied. *Vogue* ended up making four hires instead of two, and naming ten honorable mentions. Many of the winners later acquired jobs through their new contacts, not only at Condé Nast but at *Mademoiselle* and the *Saturday Review of Books*, as well as at department stores, museums, and businesses such as Eastman Kodak. Only a handful of the jobs they landed were secretarial.

By late 1938, *Vogue*'s management realized that they had created something far more useful and wide-ranging than a talent contest: the Prix was an ideal way to boost circulation, win the loyalty of the next generation of *Vogue* readers, and conduct market research into what they were thinking. That's when Mary Campbell, private secretary to Condé Nast, *Vogue*'s publisher, typed out a series of memos outlining her ideas for the Prix's reinvention.

In her first, dated December 7, 1938, she suggested building it into a course of study "paralleling the college curriculum throughout the 4 years . . . with the culminating senior contest [being] the Grand Prix."

It should also be broadened beyond writing to encompass layout, art, and photography, Campbell suggested. On January 26, in a two-part memo titled "What Is Wrong with the Prix de Paris?" and "What can be done immediately to help the Prix de Paris?" she advised creating a separate Prix division at the company, appointing a full-time editor and assistant, and providing training for the winners, instead of just letting them sink or swim. Better yet, she suggested, why not open an in-house job-placement bureau for all who applied.

"It is exciting to think of the army of VOGUE-conscious young career women who could slowly be spread throughout this country—all eager to sing VOGUE'S praises and spread her prestige," she wrote.

The four-year college program never came to pass, but *Vogue* did promote the contest more assiduously, featuring the Prix in its first back-to-school college issue in August 1939. It was the peg for the lead fashion spread, "Clothes for the Class of '43," shot by the magazine's star woman staff photographer, Toni Frissell. Like the editors of *Mademoiselle* and *Harper's Bazaar* before them, *Vogue*'s editors wrote that they had put it together with the help of "Prix de Paris seniors in two hundred and fifty-one colleges," who divulged "this-minute news on what was actually being worn on (and off) their campuses."

The following June, the Nazis marched into Paris, French couture houses shut down, and Paris *Vogue* closed with them, as designers, editors, and photographers fled for their lives. New York suddenly became the world's fashion center. Two months later, the Condé Nast company set up a special Prix department, and marketing representatives fanned out to college campuses throughout the land. Mary Campbell's ideas had been rolled into action, just in time for the twins to apply.

FUFFY REMEMBERED SPENDING HOURS on the Prix. "In our senior year, along with everything else we did, like attending Kuniyoshi's art class at night, we worked very, very hard on the *Vogue* Prix de Paris contest," she said. Photos show them sitting on the Brooklyn apartment floor in matching sweaters and skirts, heads bowed as they diligently pasted up layouts and pored through copies of *Vogue*. "You had to write quite a bit. For example, what would you choose if you're a college girl and you're going away for the weekend—how would you handle that? Then we had to pretend we were writing an article for *Vogue*."

The effort was worth it: among the 1,121 who applied, from the nation's forty-eight states, as well as Hawaii and Puerto Rico, the

twins were among the select few summoned to meet the editors at
Vogue's offices in the Graybar Building on Lexington Avenue, a mas-
sive art deco tower embedded in the city-like complex that soared
above Grand Central. It was all part of an experience "seldom for-
gotten by a contestant," as the magazine put it later that year, in their
first major story about the prize. "She steps off the elevator on the
nineteenth floor. . . . Beneath her feet, a black floor, studded with
brass stars. Ahead of her, around a sign-posted corner, the Chippen-
dale reception room, full of flowers and would-be fashion models.
For the next few hours, an agenda of telescoped conversations with
memorable-hatted editors, all up to their jabots in dead-lines."

The twins did indeed recall being greeted by Jessica Daves, *Vogue*'s
managing editor, and Albert Kornfeld, then the publicity director.
"They had paid everyone's fare from Bennington or upstate New
York," Fuffy said. But the twins were the only contestants to have
taken the subway in from Brooklyn, and "just for fun," Miss Daves
and Mr. Kornfeld made a great show of giving them a nickel each
to cover the fare.

Franny and Fuffy might not have been collegiate enough for *Col-
lege Bazaar*, but their stylishness, art school unconventionality, and
no doubt their twinny-ness were just the ticket for *Vogue*. Although
they didn't win, they were accepted into the sorority, joining the
twenty girls who received honorable mentions.

They were also among the few chosen to be photographed for a big
display ad in the October 15 issue of the magazine. "Seniors! Enroll
today in *Vogue*'s 7th Prix de Paris," it proclaimed. "BE an Honourable
Mention winner, like the nine girls shown above, and you will have
the chance to be interviewed for a job by leading organizations all
over the country." The other seven girls were featured individually,
but the twins were pictured together in a single shot and identified,
memorably, as "The McLaughlin Twins."

Yet while the world still perceived Franny and Fuffy to be two
identical peas in a single pod, their Prix entries reveal how very

different they were. Witness how they both answered Quiz Three, Question Two: "Suggest a theme for an 'Under Twenty' feature and write the copy you would include in its presentation."

On the surface, their answers seemed similar. They both turned in layouts that used a lot of photos. ("Since we were at Pratt," Franny said, "we would sidestep the writing.") Fuffy had photographed Franny on the porch of Wallingford's St. George's Inn, wearing one of the Joan of Arc snoods that were the rage that year—they had crocheted theirs, in yellow, from a pattern in *Bazaar*. Franny had photographed Fuffy in a gallery, poised behind a contemporary string sculpture that spanned ceiling to floor.

Yet beyond that they veered apart. The art world was then concerned with defining the meaning of "modern," and the twins, art students to the core, took the question as an invitation to do the same thing.

Fuffy concentrated on folk art, which was collected by artists and designers they knew and admired, such as Kuniyoshi and Walter Teague, and shown regularly at the Museum of Modern Art. Fuffy filled her layout with photos of knitted socks, mittens, and caps that the twins had made themselves. Her writing spoke of "the awakened interest in American Folk Art. Of wool, string, or synthetic fiber . . . hand-knits are prized by the young."

Franny, meanwhile, waxed eloquent about plastic fabric, which had entranced the twins when they'd seen it in the World's Fair in Eastman Kodak's pavilion, where fashion models had showed off clothing confected from the same material as their cameras. "A faintly fantastic aura surrounds these fashions; the magic sum of coal + air + water = a lovely nylon fabric," Franny wrote. "After two thousand years of shearing wool from sheep we have a newly created material chemically produced. It presages things to come, finer things for you at under twenty prices."

Their final fifteen-hundred-word essays reprised those themes: Franny wrote again about plastics and the future, while Fuffy wrote about the eccentric late eighteenth-century folk art collector Lord

Timothy Dexter of Newburyport, Massachusetts, who filled his garden with hand-carved wooden statues of the American presidents.

The remainder of that spring, as school barreled toward the climax of graduation in June, must have been exhilarating. The twins participated in their first two museum shows, both at the Brooklyn Museum. They helped install the show *Printed Art*, about the illustrators and designers who were changing everyday life with anything that could be made with a printing press, from a movie poster and a newspaper to a liquor bottle label or a length of printed fabric. For its preview, the *New York Sun* ran a photo of Fuffy, smiling as broadly as a calendar pinup girl as she arranged a group of boxes. Even more exciting, just before they graduated, the museum included the twins' "Under Twenty" Prix de Paris photographs in its first invitational exhibition of amateur photography, resulting in a buoyant finish for their college career. Fuffy was represented by her photo of Franny, smiling in the Joan of Arc snood outside the quaint Wallingford Inn, and Franny by her photo of Fuffy, reveling in the wonder of the future as she posed in a dress purportedly made of plastic.

By the time the show came down and graduation rolled around, the twins knew that they had taken honorable mentions in the Prix; Franny even won a prize for her essay on plastics. And by October, when the *Vogue* ad with their twin photo came out, they were both working in Manhattan.

Although Fuffy often said later that hard work had made their careers, she was also developing a habit of casting everything that happened to them in terms of luck. She would soon land the first of their *lucky breaks*, a phrase she loved to use. "Everybody seemed to welcome us," she said later, "and for a short time we were known as the fair-haired girls of New York." But though they had been inseparable until then, "we wanted to blaze our own trails and express individual visions. Our paths quickly diverged."

THE WORLD
OF WORK

Making the Right Call

While job hunting in Manhattan that summer, the twins stopped by *Bazaar* together to pick up the mitten sketches the editors had helped them sell to Wimelbacher & Rice and learned that Margaret Hockaday had left and that *College Bazaar* as it had once been was no more. The moneymen had killed it; or, rather, boosted up its size and price and watered down its contents so the magazine was but a pastiche of its former self. Junior clothes remained in, but the older, more sophisticated models, staff photographers, and staff-written advice were back, and the college editors and photographers were out. In Franny's opinion, the magazine had fallen victim to the plague of being owned by "one of these big corporations where they have boards of trustees," and the board "was still frowning on the young stuff. Margaret Hockaday had lost her job when they folded it up."

But Margaret had moved on to an even bigger corporation, the Chicago-based catalog pioneer Montgomery Ward, one of the largest retailers in the country, second only to Sears, Roebuck and Co. Ward's had just moved one of its most valued executives out to its New York City headquarters to oversee the company's Bureau of Style, and Margaret had been hired there to introduce fashion into the catalog. When Franny visited her former editor in her new offices at One

Holland Plaza, a big industrial building opposite the Holland Tunnel, at the southern tip of Greenwich Village, she emerged with a job in the Bureau of Style, too.

Ward's had junior clothes, and Franny, together with another woman her age, was given the job of shepherding them through production and overseeing the catalog's junior pages. Margaret also found a job for Fuffy, at Stone-Wright, a huge photo studio just north of Union Square that churned out the pictures for many of the Chicago mail order houses—not only Ward's but also Spiegel and the Chicago Mail Order Company—an industry so colossal that it made the ready-to-wear manufacturers of Seventh Avenue look like boutique operations. Not only was Fuffy the girl Friday for the woman who put the pictures together for Stone-Wright, but "my sister actually photographed those junior clothes," Franny said. And it all happened because Margaret made the right call. "She was just big on discovering all kinds of people."

Franny compared their situation to the way the twins' friends from Choate treaded water in internships and suddenly found themselves with real jobs overnight. All the small projects and contests the twins had been involved with up till then, Franny said, "was as if you worked as a runner in the stock market, and then after you'd done that for a couple of years in the summer, then all of a sudden, somebody told you that there was a big opening, and then you went and got hired." Once you had that job, "you started visiting and palling around with your boss." At Montgomery Ward, "we all went skiing," Franny said. "We didn't have any money, but we used to go on the overnight train." Sometimes higher-ups came along. Opportunities blossomed from there.

The twins continued to hone their photography after hours and on weekends, taking pictures of each other with their new Rolleiflex cameras, which they had obtained upon graduating from Pratt, professional-level cameras that were an upgrade from the Voigtländer. They shot anything that came to hand—interesting

vistas, the Ward's gang as they laughed and lounged in tweeds and hand-knit sweaters in a snow lodge, or the other twin, as they explored the sidewalk art and bookstalls of Greenwich Village—and developed the film wherever they could find a studio.

Yet the jobs themselves were challenging. "We worked like dogs," Franny said. At Ward's, where she punched a time clock at 8:00 a.m. and started at $15 a week (just under $300 today), she and another girl "put the fittings together, got the buyers to okay the dresses and the model." Although Polaroid cameras wouldn't go on the market for another seven years, "we had some kind of quick pictures we did on the spot," Franny said. Then they'd parade the models past the buyers, who'd quibble about details, complaining, "The skirt's too long" or "No, the button has to be over here." Because the company's volume was so big, there was no margin for error.

Franny also had to attend meetings with Sewell Avery, the company's president. Margaret, Franny's boss, revered him. The more time Margaret spent in the mail order business, the more she believed it might be America's greatest sales invention, delivering a pitch so potent it had to convince the reader through the printed page, leaving the imagination to do the work. "The miracle is that the customer accepts the whole thing on the word and picture," Margaret once said. "She isn't even buying a known brand as in a supermarket—and no salesman is present as in the retail store. She is all alone with what you've told her." And it was Avery, she recalled, who taught her to respect the sophistication of the American consumer, whether that consumer lived in a big city or a small town.

Avery, an autocratic director, would go on to be one of the most notorious union busters of the era. In 1944, after he refused to cooperate with collective labor bargaining agreements, Montgomery Ward was temporarily taken over by the government; he was carried out on his chair by two national guardsmen when he refused to leave his office. But to Franny, the company chairman, then in his late sixties, was simply "real old. F-A-R-T is what he was."

Another girl Franny's age was in the office, a Skidmore grad-
uate, and at least one other 1940 *College Bazaar* alumna worked
there, too, briefly: Scottie Fitzgerald, who had contributed the short
story to the quarterly's second issue. Her father had died only a
few months earlier, leaving her and her mother destitute. She had
tried—unsuccessfully—to pawn her fur coat to pay for Vassar. Then
her father's agent, editor, and best friend had stepped in with a loan,
and she returned to school. Perhaps that's why Franny remembered
Scottie quitting "almost right away. . . . I think she was a drinker,
too, like her parents."

The female bosses, however, seem to have been spectacularly
entertaining and madcap, starting with the head of the New York
Bureau of Style, Harriet Higginson, who had previously been Mr.
Avery's right-hand assistant in Chicago. A Boston banking heiress and
"one of the early feminist spirits," she had moved to Chicago during
the Depression, trying to strike out on her own as a broker. She had
swiftly thrown in her lot with the avant-garde and in 1935, at twenty-
one, had built the city's first Bauhausler-designed home—a simple
canvas-wrapped structure created by a former Bauhaus student,
Bertrand Goldberg, which featured Montgomery Ward windows and
could be washed down with a garden hose. (It was also the first com-
mission for Goldberg, a Chicago native best known for designing the
Marina City complex in the 1960s, who had been at the Bauhaus when
the Nazis shut down the school and life suddenly grew dangerous
for Jews.) Even as a high-ranking retail executive, Higginson danced
to her own drum: when Henry Field, a curator of anthropology at
Chicago's Field Museum, threw a party to celebrate animals in 1938,
she had turned up sporting a crown of cellophane, which held two
living, chirping chicks, dyed brilliant purple and bright green. Now
she supervised Franny's entire department in New York.

Franny's immediate boss, Margaret, had from the start demon-
strated a quicksilver independence that first gave Franny the idea
that a woman could run a business and be a leader. Raised in a

suburb of Chicago, Margaret had graduated from Vassar in 1930 and had gone to work as a copywriter at Marshall Field, just before that store launched its Young American Fashion contest. She had then moved on to New York and a copywriting job in the fashion division of the advertising behemoth J. Walter Thompson, the first agency to have an all-female creative team. Known as the Women's Editorial Department and formed in the teens, before women won the vote, it revolutionized the sale of cosmetics—and made the company America's most successful advertising agency—by targeting women with ads that appealed to the emotions. (The woman who founded the department, Helen Lansdowne Resor, is renowned for having created the first ad that used sex appeal as a sales tactic—in this case Woodbury facial soap, whose ads featured ingenues smiling demurely as they were embraced by slightly older gentlemen, with the tagline "A Skin You Love to Touch.")

Margaret herself was charming and charismatic, a Peter Pan–ish figure whose "manner and speech are quick, but never abrupt," who "consistently thinks from a young viewpoint, then polishes that viewpoint with a mature practicality"—at least, that's how she was described by the reporter who had followed her around for a day for Canada's *Edmonton Journal* just before the launch of *College Bazaar.* Although she was thirty-three at the time, "that whole combination defies you to guess her age," the reporter wrote. That day, she was "stunning in a taupe . . . suit of light-weight wool" with a chartreuse blouse that gave "the casual effect of a jerkin," while wedge shoes struck an "up-to-the-minute note, besides being comfortable for her active day. Someone is always waiting to see her about something—at noon it was a luncheon date, so I only glimpsed a taupe turban, spiked with feathers, and a matching ruff tweed reefer, as she shot around the corner." She had arrived at work "firmly convinced that Americans are fast loosing their sense of humor," the story continues. She knew that because she had spent the previous evening throwing snowballs at the back windows of a Park Avenue apartment, a

transgression that had, to her great dismay, elicited little response. "Some people won't even look up until they finally remember they should have gotten mad," Margaret had said.

Meanwhile, at Stone-Wright, the catalog mill, the atmosphere was far more earnest and sober. Fuffy's immediate boss in the fashion department was likely a woman, but the company was dominated by men, and its want ads usually ran in the "Help Wanted—Male" section of the papers. It was the sort of place where young men who wanted to get into the business worked for a while, trying to learn the trade before going on to better things. (The photographer Sy Kattelson, who later joined the leftist Photo League, also worked at Stone-Wright on catalogs early in his career.)

The company also became the first stop for the newly arrived refugee Hans Namuth, a twenty-six-year-old German who had just escaped from Europe and started working there at about the same time as Fuffy. (Today, Namuth is best known for his 1950 photographs of Jackson Pollock making an action painting.)

Namuth had fled his native Essen after he'd been caught distributing anti-Nazi leaflets. He had picked up the photography trade as a refugee in Paris. Together with a German partner, he'd supported himself making portraits and selling pictures to newsmagazines and had gone to Spain to cover the Civil War. But when France and Great Britain declared war on Germany, they became enemy aliens subject to internment. He and his friend were separated, and the friend, rather than returning to Germany, committed suicide. Namuth, who had sold his camera equipment hoping to buy the other man's freedom, escaped to America and eventually landed at Stone-Wright. He later described his position as the first photography job he could obtain that didn't require papers or cameras: he started there as a darkroom assistant for $15 a week—what Franny was making at Ward's—which he could boost to $30 with overtime.

So far the war hadn't really touched America. As combat intensified overseas, men had been required to register for the country's

first peacetime draft the previous October, but the country remained officially neutral as it continued to struggle free from the Depression. Fuffy, whose salary was similar to Namuth's, experienced her job at Stone-Wright quite differently. Although she described the company as "tacky," she seems to have had more opportunities and freedom. For her it was a stepping stone, and it soon became the golden ticket to a career.

In the fall, the firm sent her on a trip to Charleston, to assist a famous photographer who was shooting a special promotion for Montgomery Ward. It would be "the first time I was ever in an airplane," she said. "I said, 'Fine, I'll go. I'd love a trip like that!'"

The famous photographer was Toni Frissell, *Vogue*'s lone star female talent. The purpose of their trip down South was to capture junior models in junior clothing, posed against a variety of picturesque backgrounds, such as Corinthian columns and quaint store signs, to give the pictures drama and flair. Toni ended up photographing Fuffy, too—or at least using her to check light levels and skin tones.

Fuffy was quite a hit with the famous photographer. In the plane on the way back to New York, Toni asked, "Would you like to come and work for me?"

A week later, Fuffy had skipped free of Stone-Wright's clutches and was working uptown in Toni's office, in the Grand Central Palace. This massive beaux arts exhibition hall was two blocks north of the art deco Graybar Building, where she and Franny had interviewed for the Prix de Paris only a few months before. Toni was on contract with *Vogue*, and her office was just down the hall from the glass door of the famed Condé Nast Photo Studios.

As Fuffy said, "It was like a dream come true!"

Fuffy's Lucky Break

Fuffy's new boss wasn't the only woman taking fashion photographs at the time. Louise Dahl-Wolfe's beautifully posed and lit color photographs appeared regularly in *Bazaar*, and Lee Miller, a *Vogue* model turned photographer, had become the magazine's most prolific London contributor. But Toni was certainly one of the best known. The twins would have grown up poring over her pictures in Kitty's issues of *Vogue*. They were likely even familiar with elements of her life story, for she had been a staple of the society pages since the twins had been toddlers. But only when Fuffy stepped into her office did the twins come to understand what she was really like.

The daughter of a Park Avenue doctor, descended from bankers and railway magnates, Toni had learned to make pictures by traipsing around with her older brothers, each of them armed with a Brownie, like many American children during the teens. "I started photography while still a child," she explained to another writer and photographer, Margaretta Mitchell, many years later. "My brothers and I carried our box Brownies at home and when we went on trips to Europe." As the youngest of three and the only girl, she added, "I was not exactly a boy but I was the water-pistol carrier for my brothers' war games."

Toni had especially idolized her eldest brother, Varick, who grew up to become an explorer and documentary filmmaker. In 1931, when

he was twenty-eight and she was twenty-four, Varick and much of his crew disappeared at sea in an explosion while making a film in Newfoundland. (This was the worst disaster suffered on a Hollywood production, and the horror of it was used in its promotion when it was released a few months later as *The Viking*.) In the grief-stricken months that had followed, Toni, an artistically inclined debutante who was employed writing captions at *Vogue*, was jilted by her Russian aristocrat fiancé and fired from her job because of her inability to spell. At the same time, she learned her beloved mother, who had fainted after *The Viking*'s premiere, was dying. Over the summer, as she and her mother sat together on a hotel balcony at Newport, watching the sun play over the grass, she experienced a Thoreau-like vision that redirected her life. She wrote about this moment in an unpublished memoir. "'Get out your Rolleiflex and get to work and experiment,' she heard an inner voice say. 'Look at that field of waving grass. Take pictures on location.' Why, yes, I thought, why not take pictures out of doors. How pretty some girl would look running in that field with her hair flying as we did as children. Why do all fashions have to be photographed in a studio. Why not make nature and the world my picture studio."

Toni soon repaired to the Newport Country Club, where she sought out a friend who "was a great lover of pretty girls" and photographed his latest conquest, who had "the face of an innocent child," running through grass as she'd envisioned. The pictures worked, and more followed: a friend in a riding habit, accompanied by her horse; a pair of debs on the crabbing bridge at Newport, "their figures reflected in the still waters"; another friend sitting in the window of her parents' apartment in town, luminous against the background of the Queensboro Bridge and the sky. She had them blown up and began flogging them to editors. (Toni was basically shy, but often compensated for that by being aggressive, as Fuffy later observed.) *Town & Country* published a few. *Vogue*, its competitive blood stoked, hired her back, this time as a photographer.

Although Toni was largely self-taught and was promoted early on as a dilettantish amateur, she had actually learned a lot by observing other photographers at work. As a girl at Newport, she had heard about the way the "fearless" Margaret Bourke-White had talked her way onto Harold Vanderbilt's yacht and persuaded him to let her take pictures, remaining undaunted and coming away with "a remarkable series of yachting pictures" even after being washed overboard. While writing captions for *Vogue*, Toni had watched Horst P. Horst, a German photographer later famed for his sensual neoclassical tableaux, when, early in his career, he started out "with a large camera doing color for *Vanity Fair* on current Broadway shows." She had also briefly assisted Cecil Beaton, the British society photographer who had famously been taught to take photographs by his nanny and early on had still sometimes relied on the same box camera he had used growing up; his genius was to situate his elegant subjects within elaborate and fantastical sets.

Although the duties Toni assumed for Beaton were nominally similar to some of those Fuffy assumed for her, Beaton's style made the job quite different in practice. Toni's second week at the magazine, an editor had sent her out to collect props for photographing "a number of the most beautiful women in New York." She was instructed to procure "a crystal chandelier, a lace window curtain, a pair of gold flying cherubs, a baroque mirror, a large glass ball, the kind that fortune tellers use. Buy at Bloomingdale's a quilted mattress pad and as it is near Christmas, go to a Christmas trimming place and buy some angel's hair, the kind you use to finish decorating the branches of a Christmas tree." Toni was concerned. Did Beaton not realize the angel's hair was made of a dangerous material, spun glass? She fretted, fearing the consequences "if one of the beauties got it in their eyes." She calmed down when she realized that "he usually put these things far in the background, out of focus."

Beaton made most of his pictures in his suite in the Hotel Ambassador, a grand neoclassical pile that stood at Fifty-First Street and Park Avenue. Once, Toni recalled him photographing a cousin of the

last Russian czar, Princess Natalia Paley, who was now a model. She was posed as if she were about to be ravished by a dancer, perhaps inspired by the rape scene in Diaghilev's *Le Spectre de la rose*. Margaret Case, *Vogue*'s society editor, walked into the room, took one look at what was taking place in the elaborately canopied bed, and backed out, saying, as she tactfully shut the door behind her, "Oh my goodness, how chic!"

Toni bucked this trend by making her pictures outdoors in nature—and in this she had always been supported by Edward Steichen, Condé Nast's chief photographer. By then Steichen had led many different creative lives, having started as a fine art photographer, then breaking new ground in aerial intelligence during the Great War, and subsequently daring to pioneer fashion photography as an art form. He was then perhaps the most influential and powerful figure in the field—"the best individual expression of photography today," as Tom Maloney, the publisher of *U.S. Camera*, put it later in his introduction to the 1939 *Annual*, which Steichen edited. When Toni first encountered him in the 1930s, Steichen was revered for his striking black-and-white celebrity portraits for *Vogue* and *Vanity Fair*—one of the best known depicts the film star Gloria Swanson gazing out from behind black lace. He had also created *Vogue*'s first color cover, which appeared in July 1932, a shot of a woman in a swimsuit holding a beach ball over her head. Nast had lured him on staff in 1923, for a generous amount—"more than they'd ever paid any other photographer," Steichen exulted in his autobiography—and a generous agreement that allowed him to work elsewhere; in 1929 *Time* called him "the highest-paid photographer in the country . . . who often receives $1,000 a print" (about $17,500 today).

By the time Toni met him, Steichen's studio was indoors, in a converted stable on East Sixty-Ninth Street—one so capacious that he could drive his car inside and park far beyond the reception area— and he made many of his pictures in Condé Nast's apartment, a thirty-room penthouse overlooking Park Avenue. But Steichen was

also expert at outdoor and location work—"his favorite subject-matter is anything at all . . . from a tooth brush to Greta Garbo or the Rocky Mountains," another photographer once wrote—and where Toni was concerned, "he was always very kind and helpful, encouraging me to go on working in natural backgrounds," she recalled.

Many rolls of film and experimental photographs later, Toni Frissell developed the signature style that Franny and Fuffy would have known from *Vogue* and copied in their high school drawings: snapshot-like pictures of young society ladies lounging on beach-club decks with their scarves flying in the breeze, or leaning against fences in jodhpurs, or otherwise disporting themselves in nature, taken with the small roll-film minicameras that were widely prized by amateurs yet still not widely used by fashion magazines. Munky Munkácsi—Mrs. Snow's exciting action photography discovery at *Bazaar*—had become famous for photographing models leaping in the sand at Palm Beach. But Toni was doing something similar at around the same time, using real people instead of models, if one considers nubile debs and stunning young upper-crust matrons to be "real." Along the way, after a whirlwind courtship involving plenty of dancing, Greenwich Village speakeasies, and illegal liquor, she had acquired a husband—Mac Bacon (Francis McNeil Bacon III), a young blue-blooded stockbroker she met on a blind date. She did not let it cramp her style.

By the time the twins had discovered photography at Pratt, Toni's photographs of girls running around on land and sea had become a staple of *Vogue*, and her full-color pictures of women skiing, swimming, surfing, and piloting planes were regularly featured on its cover. She often shot the women from below so that they seemed to loom heroically, like Amazons, or Soviet socialist heroines. Toni was so fond of shooting from this angle that she even did it while heavily pregnant with her first child. Once, after she had lumbered down onto the floor of the Graybar Building to get a particularly great shot, "I saw next to me a beautifully creased pair of pants and perfectly

polished shoes," she said. "I looked up and there was Condé Nast himself looking down at me. He said, 'What are you doing down there?,' and I answered, 'Well, I'm interested in the way it looks from down here. I see things in my own way.'" A couple of weeks later the baby—a boy, named for her brother Varick—emerged, "none the worse for photography," as she put it.

Although *Vogue* initially made use of Toni's connections, running ads that positioned her as a society "snapshooter," she was a daredevil when it came to sports, and technically adventurous, making "what we believe are the first underwater fashion photographs," the magazine wrote, for its January 1, 1939 issue, published that first year the twins were working in Civardi's lab. To create the photos, Toni took two models to Florida's Marineland, which had just opened the world's first oceanarium and underwater movie studio, and captured them two fathoms deep as they modeled fashion swimsuits in the greenish depths amid porpoises and angelfish. A year or so later, around the time the twins were finishing their degrees, Toni one-upped herself by photographing another model at Marineland, this one dancing her way up to the light in a white evening gown, as a deep-sea diver lurked in the dark below her.

Fuffy's new boss was also powerfully popular—a figure whose "corn yellow hair and China blue eyes," as *Popular Photography* wrote in October 1939, in a profile called "Outdoor Specialist," as well as her flair for adventure and her habit of chewing gum while she breathed "the breath of naturalness on her film," made her great story fodder for the new photo magazines. *U.S. Camera*, not to be outdone, profiled her two months later in its "American Aces" column as someone who "has created a novel, vastly diverting and distinctly personal type of fashion photography." That feature was written by Frank Crowninshield, the fine arts editor of *Vogue*, who had known Toni since she was a girl and lived in the same Park Avenue building as her parents.

The month the twins graduated from Pratt, one of Toni's photographs—of a woman using a camera like theirs to photograph

a toddler in a sunbonnet—appeared on the cover of *Vogue*'s June 15 Camera Issue. Its pages covered the history of American photography in that publication, starting in the teens with the stylized celebrity portraits of Baron Adolf de Meyer, *Vogue*'s first contract photographer, following through into the 1920s with Steichen, and on into the 1930s, exemplified by Cecil Beaton, the surrealist Man Ray, the color experimentalist Anton Bruehl, and many more. Toni was tipped as an experimentalist, too, one whose "beautifully animated shots" had come to embody "the art of photographing young women outdoors."

Also in that issue was a contest, "Studio versus Outdoor Snapshot," in which readers were asked to vote for a studio photo by Horst, of two models in evening gowns reclining against a circular Bourne settee, or a photo by Toni, of the same two models positioned somewhat incongruously on a beach, smiling in bright daylight. Horst's photo won, to Nast's surprise, but Toni's was there to represent his growing conviction, based on his discussions with Henry Luce, the publisher of *Life*, that more photo reportage should be incorporated in his company's magazines. "The studio photograph . . . is a work of photographic art completely under the photographer's control," the copy read. But "the outdoor photographer is a discoverer, on the lookout for something lovely to happen—and when he sees it, he snaps his camera."

The twins were clearly advocates of outdoor photography themselves—if not exactly in nature, then in the urban canyons of New York. They still photographed each other constantly throughout the city, on subway platforms, perusing sidewalk bookstalls, and wandering among the paintings at the biannual Washington Square Outdoor Art Exhibit in Greenwich Village. To work for a photographer known for making pictures outdoors, and a woman on top of it, made Fuffy's new job even more of a thrill.

"It was a lucky break for me," she said, "because there were not too many women photographers that you could find, let alone work with." On top of that, her new office was steps away from that of the

stable of legendary photographers that *Vogue* had featured in its photo issue. "The renowned 'Vogue Studio' was on the same floor and I walked down the hall carrying a tray of wet prints to dry them on the *Vogue* drum dryer." As she went about these duties, she couldn't help feeling awestruck whenever she ran into some of the other lauded fashion photographers of the moment—men such as Horst, who had left Paris as the Germans, his former countrymen, marched in; or John Rawlings, a new young American who had recently arrived from the London office. (By that time, Beaton had been forced to resign from *Vogue* after he inserted two jokes that included the word *kike* in tiny letters into a drawing that accompanied a story about New York café society, neglecting to delete them even after an editor spotted them before they went to press; although Beaton claimed he had done it without understanding what the word meant, 130,000 copies of the magazine had to be withdrawn from newsstands and reprinted, at great expense.)

The office was busy, too, as Toni was much in demand for work outside *Vogue* and Condé Nast. As *Popular Photography* had put it, "the phone was ringing constantly. Publishers wanted her to do a book. Department stores wanted to exhibit her work. Dowagers wanted sittings for portraits. Anxious mammas wanted her to go straight down to Southampton and photograph their little dears on the beach." Although by now Toni had two children, a girl called Sidney in addition to Varick, she traveled constantly on assignment—to Jamaica, Hawaii, Canada's Mont Tremblant.

Fuffy had been working for Toni for less than a month, still amazed at her good fortune, when her new boss flew off again, this time to Bermuda, a British colonial outpost that had also become a U.S. military base when Britain had declared war on Germany the year before. It was December, and *Vogue* wanted their resort clothes photographed in a tropical climate, so they packed Toni off "with two wonderful models," as Fuffy put it, in her starry-eyed way. It was to be a short trip.

Despite the island's being occupied by two armies, life was still relatively languid there, and the plan was for the wonderful models—"two rather dumb beautys [sic]," from Toni's more experienced perspective—to show off some of its pleasures. They were to be photographed in evening dresses with a popular guitar troupe and a group of traditional dancers wearing their peacock-feathered cloaks. The models were "a spontaneous hit" with the British and American forces, and the blonde immediately began an affair with a British captain who'd been a huge hero during the Blitz. "I can see why—she was a bombshell," Toni recounted, with her characteristically amused, appraising air.

So it wasn't entirely surprising that one day the blonde turned up quite hungover at sunset for a shoot. Toni was trying to make the best of it when, from some distance away, she noticed another British officer running toward them.

"I say, have you heard the news?" he cried as he drew close. "Rather good from our point of view. America is at war!"

By the time Fuffy heard what had happened weeks later upon Toni's very delayed return to the office, life in New York had completely changed.

The Women's War

War announced itself in New York City at 2:26 on the chilly afternoon of December 7, as a radio announcer hurriedly broke into the transmission of the Giants–Dodgers game at the Polo Grounds in Upper Manhattan. "We interrupt this broadcast to bring you this important bulletin from the United Press," the voice crackled urgently across the airwaves, as if horrified by itself. "Flash, Washington. The White House announces Japanese attack on Pearl Harbor."

To most New Yorkers, the South Pacific military base was a dreamy Technicolor arcadia, a place it probably didn't occur to them to think about unless they had a son, husband, brother, or sweetheart stationed there. But now, families gathered around radios, twisting the dial as they hunted for scraps of information that broke through regular programming. Broadway matinees stopped midact so that announcements could be made. People stood silent in Times Square, staring at the ticker. The gossip-mongering *New York Enquirer*, the only local paper with an afternoon edition, was first in the nation with the news: "Japs Attack U.S." Three U.S. warships were under fire. Three hundred and fifty men had been killed by a direct bomb hit. Aerial dogfights and plumes of smoke rose into the sky as black bombers flew in formation above Honolulu and Pearl

Harbor, the wings of each plane bearing the rising sun insignia of Japan. Men kissed children good-bye and ran downtown to try to enlist.

Toward evening, Fiorello La Guardia, the mayor of New York City, and also the country's head of Civilian Defense, delivered a speech that made the tension worse, not better: he warned his people that they were in "an extreme crisis" and that the Nazi "thugs and gangsters" to the east had masterminded the Japanese carnage in the west. "We must not and cannot feel secure or assured because we are on the Atlantic coast and the activities this afternoon have taken place in the Pacific," La Guardia proclaimed in his familiar squeaky voice. "We must be prepared for any thing at any time."

By the time President Franklin Roosevelt addressed Congress the next day, and Congress delivered its formal declaration, war was a foregone conclusion. Men had already been lining up at recruiting offices for hours, waiting for the doors to open. Soon they would be able to enlist twenty-four hours a day.

The women of New York City leapt into the fray alongside them, eager to volunteer—as nurse's aides, air raid wardens, drivers—so thronging the offices of the Red Cross and the Office of Civilian Defense that their officers termed it a "madhouse." Two days after war was declared, six thousand women swarmed the Red Cross headquarters on Lexington Avenue, far superseding the response the organization had received during the previous war. Volunteer numbers for the knitting unit were so great that it had to be moved to new headquarters. Women even lined up for the chance to help make bandages, a sight officials claimed never to have seen before.

But the jobs women really wanted, it seemed, were those that went beyond their previous experience. They were also inquiring about aviation lessons and clamoring to join the Motor Corps, to such an extent that Mrs. Fred C. Bael, a first lieutenant with the unit, complained to the *New York Times* that the military had been forced to tighten regulations and administer driving tests. Advisories

went out, with the head of the Manhattan Civilian Defense Office begging women to volunteer for "work which they are suited to," such as receptionist and clerical positions, while the dean of Barnard College, Virginia Gildersleeve, begged her students to stay in school. "Keep on with your courses," she urged them. "Train yourself for the higher types of service your country so greatly needs."

Meanwhile, for women who were already embarked on professional careers, such as Fuffy, doors suddenly sprang wide in a way that could never have been predicted. "We knew everybody, and a lot of the poor boys had gone off to the war," she said. "So there were opportunities for women, let's face it."

AFTER PEARL HARBOR WAS BOMBED, private planes and non-essential flights were grounded for a few days, leaving Toni and the models stuck in Bermuda. When Toni finally returned—she seems to have taken a little more time than was strictly necessary—her film didn't make it back to the office with her, having been waylaid by customs. But right off the bat, "Toni trusted me with responsible tasks," Fuffy recalled. One of the first was sending her down to the Custom House at Bowling Green to try to get the film released before a customs official destroyed it—or, worse yet, ruined it by developing it badly.

The building, constructed just after the turn of the century at the southernmost tip of Manhattan, must have been a glorious sight. Only a few years before, Franny's old painting teacher, Reginald Marsh, had covered its soaring domed ceiling with frescoes, each of which depicted a different aspect of the bustling port life of New York City, the busiest dockland in the world. In the space of eight panels, he had charted the passage of ocean liners into the city: the giant vessels were shown passing a lightship, being boarded by customs officials, steaming past the Statue of Liberty toward the bristling skyscrapers, and being towed into berth.

Outside the Custom House, the streets of this "virile neighborhood" dominated by the sea, as it had recently been described in the Works Progress Administration's *New York City Guide* of 1939, were still thronged with "clerks, maritime employees, Custom House officials, stenographers, sailors on shore leave, Army and Navy men, South Street lodging house indigents, commuters to Staten Island and Brooklyn." But now, only a block away, a new crowd gathered: the hundreds of young men who lined up around the clock at the army recruiting office on Whitehall Street and slept in corridors, eager for their chance to clamber onto warships going in the opposite direction. Across the street, the Red Cross had set up an emergency canteen staffed by freshly minted volunteers, who kept the new recruits supplied with cups of coffee from a giant urn. Twice a day, the volunteers handed out doughnuts and sandwiches, as a bugle blew to call mess.

Although Fuffy tried her best to persuade the men in the Custom House to give her the film, she wasn't successful; someone higher up at Condé Nast had to get them released. Back at work, life had been upended, just as it had been in the world outside, as *Vogue* hurriedly rejiggered the content of their annual February 1 Americana issue—or "number," as they called it—which would soon go to press with an eagle and a shield emblazoned with LIFE IN WARTIME on the cover, rather than a photo of the all-American fashions inside. "The atmosphere in the *Vogue* office changed overnight," Bettina Wilson, one of the fashion editors, recalled later. (Today Wilson is better known by her married name, Bettina Ballard.) "We talked war instead of fashion. Edna Chase was outraged at the Japanese. Our pages in *Vogue* reflected a new austerity. . . . All the smart women whose faces were familiar to *Vogue* readers were now photographed at their favourite war work."

Two weeks later, for the February 15 issue—even during the war, *Vogue* continued to publish two issues a month—the magazine ran a story about Margaret Bourke-White's hair-raising experiences in

the summer 1941 Moscow Blitz, and another explaining how the war was changing life for major players on the world stage. Naval strategists had begun to practice the piano to cope with stress, while doctors were reading poetry. A lady tennis champ working in the office of Civilian Defense kept calm by taking more walks and jumping rope, while the beautician Elizabeth Arden spent every spare minute designing health exercises for the American Women's Voluntary Services. Those in government, such as Admiral Stark, the chief of naval operations, arrived at work earlier and left later than ever before. And Mayor La Guardia took no time off at all: if his children wished to see him, they had to visit him at the office.

In between these stories ran Toni's lighthearted Bermuda pictures, which showed the two beauties in white rayon evening dresses surrounded by adoring guitarists and dancers. They already looked behind the times and Nast wasn't pleased. "They failed both as journalistic and as fashion reports," he complained in a memo to Dr. Agha, *Vogue*'s art director. Although "the pictures of the Bermudian players are interesting and the grouping of the figures is quite good," Nast wrote, "it is too bad the models could not have been made to look more a part of the real scene."

Toni herself was fed up with what she was doing. She had shot her first Red Cross poster some months before the Bermuda trip: it depicted a volunteer wearing the Red Cross's new uniform, which had just been revamped by the American fashion designer Elizabeth Hawes in partnership with Sears, using gray-blue gabardine with a snazzy zip-out red felt lining for the matching coat. As was her tendency, Toni had photographed the model from below, standing like a Soviet patriot before the sky and two fluttering Red Cross flags. When she returned, she was greeted by a letter from one of her society friends, who was volunteering for the organization, saying that the chairman had pronounced it "wonderful" and approved the money to print it. "Your name is on it," the letter said, and "the slogan is 'Volunteer for Victory.'"

Fired up by her success, Toni began wheedling *Vogue* to release her from her contract so she could photograph the Norwegian Air Force ski team for *Life* magazine. After Nast freed her to do so, she sent him an effusive thank-you note, in which she enthused, "I'm most terribly anxious to get into reporting photography as much as possible." Nast had had a soft spot for her since she was a child, when she'd played with his daughter during summers at Newport. "I think it will also help my fashion work and give me a new eye," she wrote. Next she asked to be released to work for the USO, or the United Service Organizations, which ran clubs and canteens and sent performers to entertain the troops. Nast was agreeable and began making approving noises about the new work she was sending in.

Toni, hungry for more, set her sights on getting to Europe with the Red Cross. "She was dying to get into the war zone," said Fuffy. But it didn't happen right away, and in the meantime, the phone kept ringing and Fuffy kept accompanying her to shoots. And because a lot of Toni's assignments were for Montgomery Ward, Franny was often on hand, too, to deal with the models and the clothes.

Many of Toni's shoots took place at Sherrewogue, her sprawling estate in the tiny town of St. James on Long Island's North Shore. She and her husband had bought the property not long after they married, just before Sidney, their daughter, was born. They had driven out from Manhattan, looking for something rough and rustic, and had instead happened onto a big white Colonial farmhouse on a cove. Over the years it had accumulated many additions, most recently a long grand wing added in the late nineteenth century by the beaux arts architect Stanford White. (He had built it for his sister and her husband, a golf course designer, and they sold it to Toni and Mac.) The estate had a vast boxwood garden and an arboretum, and in summer the air was pungent with the fragrance of lilies and honeysuckle.

Beyond the house were a barn and stables and several brick outbuildings where Toni often had her models pose. Here, the illusion of

rainfall could be created by a servant spraying water from a hose. Or Toni might situate the models on a small set in one of the meadows.

Franny photographed Toni there one sunny spring day in 1942, while Fuffy and another assistant prepared the set for a skiwear shoot, with help from Mac and the children. In a series of action shots, likely made with one of Toni's spare minicameras, the set is transformed into a winter environment, covered with mounds of soap flakes or some other material used to simulate snow. Soon, Toni and Fuffy have buried Sidney up to her neck in the stuff; then Toni crouches down to her daughter's level and snaps pictures up close.

Toni's tips on how to photograph children had been the cover story for *Vogue*'s 1941 Camera Issue. It was heavily promoted, with ads that blared, "Toni Frissell, topflight photographer of Young America, shows you how to take successful snapshots of your own small fry," and illustrated with charming pictures, primarily of Sidney, who was shown raking piles of smoky leaves, running naked across a beach, and kicking her legs as she swung gloriously free against the sky. Toni's suggestions—use a speed camera, "be quick," "get away from the frozen attitudes," "avoid static poses," and go for a "series of action shots—one bound to be good"—would soon become leading trends in fashion photography, too. The twins must already have absorbed this approach, for Franny used precisely these techniques to photograph Toni that day.

Franny came away with some of the few candid shots of Toni at work. In them, Toni is seen crouching on the grass, behind a Speed Graphic mounted on a tripod, as she stares intently at three models showing off Montgomery Ward snowsuits. The rest of the scene is chaotic: a male assistant crouches tensely near Toni, while Sidney sits on top of Mac, tickling him, in the foreground, and Fuffy looks around anxiously for props. (Making sure her boss stayed organized was always an ordeal, but working outdoors was better than indoors, where she had to be careful that Toni didn't set off the flash when Fuffy was taking the bulb out.)

The twins also did some modeling for Toni. In many ways, they may have been her ideal mannequins: she once wrote that she liked to photograph "uninhibited, slightly crazy people," especially "long-legged, coltish-looking girls . . . who don't pull a mirror and lipstick out every other minute, but whose hair is arranged in such a way that it keeps neat; whose eyes are candid and have the ability to smile and can take discomfort and laugh about it." She added that "for visual impact prefer dark hair." (Later, in an interview, she said she'd enjoyed photographing Fuffy simply because "she was awfully pretty.")

Toni seems to have asked them to pose when Ward's or a magazine needed to recycle a twin cliché. In Ward's spring-and-summer 1942 catalog, which came out soon after Fuffy began working for her, the twins hold hands, smiling in front of Sherrewogue's Stanford White porticos, as they show off a junior coat-and-dress duo that Ward's promoted in the copy as "Your Double Life." Elsewhere, as "Junior Twins," they stand on a rocky outcropping, holding matching golden retriever puppies on leashes, as they pose in identical suits in different fabrics, "styled after your man's army military gussets and gleaming metal buttons." Although they both smile toward Toni's camera, Franny's face glows a little less enthusiastically than Fuffy's, and the matching puppies strain at their leashes in opposite directions, tugging the twins apart.

THE MORE TONI AGITATED to get to Europe, the more distracted she became, and the more responsibilities fell into Fuffy's lap. Apart from two darkroom assistants—"two marvelous darkroom boys," Fuffy called them—she basically did everything. "Here I was, just out of art school. I held the cameras, the flash. I watched all the technique and went with her for sittings and lunched with people when she couldn't lunch with them." When Toni left the office at the end of the day, Fuffy stayed on to develop her own negatives and make her own prints.

By September 1942, Toni had finally persuaded the Red Cross to let her work for them in Britain. By then, Fuffy was very much Toni's second-in-command. Since Toni would be gone for nearly three months, she gave Fuffy a lot of her assignments in exchange for a percentage. And with that, Fuffy was on her own in the office, with Condé Nast's cameras and her own projects. "I really started working right then," she said. "Probably the war and the lack of manpower helped put me in demand."

Judging from her portfolio, Fuffy seems to have taken on a lot of catalog, junior fashion, and wedding work. She may have freelanced, without a byline, for *Glamour*. Lacking access to Sherrewogue as a setting, she often photographed her models around the city, posing them in parks and at the zoo, and on the streets of the Lower East Side.

Fuffy had learned a lot from her few months observing Toni. "My ways of handling people," she often said, "came closest to her philosophy of working," describing it as "casual and carefree," wanting to know the people she photographed and "to find out what makes them tick." She believed that "a woman photographer brings a certain emotion and a certain warmth to a photograph" and that she had picked that up, too.

But her interest in posters and graphic design, and perhaps the growing tension of the war, made her aesthetic interests strikingly different. One of her fondest memories from that period was a photo shoot she carried out with the young model and actress Betsy Drake, who married the film star Cary Grant a few years later. The shoot, with a couple of assistants on the Lower East Side, on Chrystie Street, used a minicamera mounted on a tripod. As a crowd of men gather to watch, a model dressed in what appears to be a budget-conscious tweed suit stands in the sun between a run-down jewelry store and a parking garage. Behind her on the sidewalk looms an enormous pile of junk, composed of bedsprings, oil cans, tires, and an upside-down Coca-Cola sign. Someone has suspended a rope from the fire

escape above the junk pile, and at its end hangs an effigy of a Japanese soldier, as if from a hangman's noose. In the shot Fuffy selected to print, Betsy smiles and vamps, striking a glamour pose, with her head tilted at the same angle as the soldier's broken neck.

Fuffy always said that was her favorite kind of work. "I never lost my interest in photographing what was on the streets."

CHAPTER 10

Civil Service

L ike everyone else, Franny's boss, Margaret, plunged into the war effort, joining the drive to organize women's uniforms, an undertaking that occupied many in the fashion business. Margaret became so engaged in the cause that she was usually out of the office during the daytime, leaving Franny in charge. Although this led to more responsibilities being dumped in Franny's lap, they weren't exciting projects, like the ones that had come Fuffy's way. Instead, Franny simply found herself working around the clock while making frantic excuses to the many people who were desperate for Margaret's attention. But the situation did help usher in some significant changes in the world of fashion.

A week to the day after the attack on Pearl Harbor, the *New York Times*'s fashion writer, Virginia Pope, announced the launch of a line of stylish uniforms for female Civilian Defense workers, just as the clothes were released for sale in department stores in New York and Newark and "some thirty other cities of the United States." Created by some of America's exciting young sportswear designers, including Claire McCardell, Bonnie Cashin, and Vera Maxwell, the styles were "snappy, serviceable and adapted to all types of women." Their palette was "defense blue," similar to air force blue, "selected for its general appeal and becomingness as well as for its practical value."

For office workers, there was a blue rayon frock with a cinched waist and shoulder tabs—"a good-looking dress of the kind American girls like," Miss Pope enthused. Hospital aides got a striped cotton costume with a "starched, breezy air that brings good cheer"; canteen workers were offered a belted blue denim shirtwaist; and outdoor workers had a suit with showy buttons and epaulets, with plenty of space for ribbons and insignia.

Perhaps the most remarkable aspect of the project was that it was the brainchild of Mayor La Guardia, who'd conceived it right after he'd been appointed Civilian Defense director, with Mrs. Eleanor Roosevelt as his deputy. The two had convened a group of powerful women in the fashion industry to help, including the renowned stylist Tobé; Julia Coburn, the head of the Tobé-Coburn School for Fashion Careers, which she and Tobé ran together; Dorothy Shaver, a vice president of Lord & Taylor who was staunchly promoting American fashion; and Pope herself.

That the launch happened just after war was declared was merely fortuitous. By the time the tiny, personality-packed, cigar-chomping mayor had dreamed up the idea of fashion-conscious uniforms, he had already taken the New York fashion world under his wing as a pet project, perhaps because of his previous life as a lawyer, when he'd worked with the garment industry. More than a year before Pearl Harbor, in March 1940, he had given a talk to the Fashion Group, a professional organization whose membership included some of the industry's most powerful women.

With conditions in Europe increasingly "unfortunate," as La Guardia put it, New York had already become the world capital of art and music; now it was time for it to be tops in fashion, too. "I don't see why we have to take our fashion from any other country," the "little Mayor," as *Women's Wear Daily* called him, had squeakily declaimed to the group, which had gathered for light lunch and serious conversation in the top-floor ballroom of the Biltmore Hotel, a fixture across from Grand Central where society had met and mingled since the

last war. "When it comes to the design of clothes, we have everything that you need right here."

To hammer home the industry's economic importance to the city, he was introduced by Anna Rosenberg, director of the regional Social Security Board, who later became Truman's assistant secretary of defense, the first woman to serve in that position. Rosenberg thanked the assembled women for "helping us harassed, tired so-called administrators and businesswomen to keep the thing that we realize is so very important to keep in our life, and that is that we still look like women." She also gave the mayor a good ribbing, to the amusement of all present, over his well-known dislike of contemporary ladies' fashion hats. La Guardia, who had arrived flamboyantly late, as usual, and knew a great photo op when he could create one, got up and tussled with her hat—a white straw covered with lilies of the valley, which he deemed "top heavy in the front"—causing camera bulbs to flash and pop as he attempted to wrest it from her head. "You think this one is bad, too? I think it is good," Rosenberg chided him. "I don't have to tell you what a great sense of confidence it gives us when we go out in a man's world. Sometimes our spirits are very low, and it helps us when we can get a new dress or a new hat."

Then La Guardia got down to business. The gist of his argument was that in Europe fashion had begun as the province of "the nobility, owners of land, and the ladies of leisure" and had never truly trickled down to the middle and working classes. But America, a great democracy full of giant department stores, savvy consumers, and an avid interest in all things new, was chock-full of women who were ready to dress as smartly as any New York fashion maven. "This is the designer's paradise," he said. "There isn't anything like it." One day, he predicted, not only all of America but the entire world would copy New York.

La Guardia also urged those present to think about designing clothes for the American masses with New Yorkers in mind. "In designing for New York City you must take the traveling condition

into consideration," he said. "They travel in buses and subways and they must walk, and they can't walk with dainty little steps. They have to stride out."

Although some felt he spoke sense, the idea of New York taking the crown from Paris must have seemed nuts—the wishful thinking of an oafish naïf who didn't understand hats or couture.

But a few months later, all the mayor had predicted came to pass.

Until that moment, the lunchtime talks often focused on the dire circumstances pressing in upon the Fashion Group's peers in London and Paris, as they confronted bombing raids, dwindling supplies, occupations, and hordes of desperate refugees. These women knew change was coming: Would Paris be forced to create under German command? Then, on June 14, 1940, the Germans marched into the city, and French couture shut down.

At the next Biltmore lunch, held barely a month later, the group agonized over how to carry on the torch without access to the luscious fabrics and refined hand detailing that distinguished Parisian style— and which had also defined American fashion until that moment, as stores and designers generally relied on copying and interpreting the latest French mode. As the New Yorker put it, the occasion "gave American dressmakers the opportunity of a lifetime and also a screaming sense of insecurity." From a more prosaic perspective, something had to be done, and soon, otherwise the garment industry would grind to a halt.

The twins were probably unaware of this huge sea change, and the agonies it had prompted in their bosses. But at this particular lunch the fashion mavens had suddenly been rallied by someone they had reason to admire: the advertising consultant Mary Lewis, who had organized the array of fashion shows that had wowed them at the World's Fair. "Are we mice or designers?" Lewis demanded. "We shall do without, and in many cases we shall invent something better, for resourcefulness, and inventiveness, are bred in the American soul." For ideas, she suggested that they draw upon the same sources of

inspiration as their Parisian peers, which paralleled those the twins had been taught to revere at Pratt: museum exhibitions and collections, the culture of other countries, theater and "the beloved American movies." She pointed to a show of Persian art that had just closed and demanded, "Will its influence be felt in the silhouette of next season?" She reminded them of the Italian expat Elsa Schiaparelli, who had recently popularized shocking pink—an idea she'd borrowed from the Incas in Peru—and suggested that they, too, look to Latin American textiles and colors. Lewis urged them to visit Rockefeller Center's new and richly stocked Museum of Costume Art (now the Costume Institute of the Metropolitan Museum of Art) and create new designs based on its collection.

Lewis advised her audience that they should also promote American designers, who typically worked in the shadows with only manufacturers' names on the labels. "Let us highlight our designing personalities more," she said. "Let us tell our customers the story of the new fashions, let us sell them by being sold ourselves."

EFFORTS TO THAT END were already underway. Since the early 1930s Dorothy Shaver, who oversaw style at Lord & Taylor, had been promoting American designers and a new type of clothing they were making, known as sportswear—a category that in the 1930s encompassed everything from swimwear and skiwear to the glamorous, trench-coated look popularized by 1930s movie stars such as Greta Garbo and Katharine Hepburn, whose roles the twins had playacted while they were growing up, to the off-the-rack clothes that American designers were starting to conceive for modern women who led fast-paced contemporary lifestyles, as they worked, traveled, and dressed themselves without maids. This included separates that could be combined into different outfits, backless halter dresses, softly tailored suits that came with pants as well as a skirt; dresses and blouses that fastened with wraps and ties rather than buttons

and laces; dressy culottes and pajamas, sweaters for the evening; and, always, plenty of pockets. One designer, Claire McCardell, had a surprise hit in 1938 with the Monastic, a robe-like, bias-cut dress that looked like nothing on the hanger but fit anyone and could be belted wherever the wearer chose.

For years Shaver had predicted that this uniquely American style and these designers—many of whom were women—would one day cause New York to eclipse Paris. She had helped them along by launching the American Design Awards in 1938, with first prizes going to Clare Potter, an avid sportswoman who relied on color for ornamentation, and Nettie Rosenstein, the creator of the perfectly sized, cut, and tailored little black dress. (The twins were beginning to adopt this style themselves: they had entered Pratt looking "strictly Peck & Peck," as they wrote later, wearing matching "cloth coats, pork-pie hats and ankle socks," but had graduated wearing body-hugging rompers, playsuits, and black jersey separates.)

The summer Paris fell to Germany, after Lewis's rousing talk, Lord & Taylor banded together with Saks Fifth Avenue and four of the other big stores—Bergdorf Goodman, Bonwit Teller, Hattie Carnegie, and Jay Thorpe—to put on two days of American fashion shows. Many were working with a publicist—Eleanor Lambert, who had previously cut her teeth on promoting artists and art institutions, including Dalí and the Whitney Museum. Bonwit Teller, which had anticipated the change in Paris, had already started marketing something called the New York Look. In the heady days that followed, the *New York Times* proclaimed the shows "the beginning of an American couture," and *Vogue* and *Harper's Bazaar* had published their first all-American fashion issues.

"For the first time, the fashion centre of the world is here—in America," Mrs. Chase averred in *Vogue*, while the *Bazaar* romanced Seventh Avenue, "that long, noisy nondescript street which strikes through the very heart of Manhattan, 'twixt the docks and the theatres, shaded by skyscrapers, cluttered with hand trucks heavily

laden with ocelot collars." If you were to enter this "world unknown to lay shoppers, a tough, hard-working, fast-thinking market," the writer continued, you'd discover "a world of merchants who feel goods with knowledge in their fingers. A world of designers who go to the Yale Bowl, Indian reservations, Jones Beach, for their inspiration. . . . You'd be astonished at the quality, fascinated by the ingenuity. And you'd take off your bonnets to these manufacturers and designers who have made it possible for every woman in America to dress with style."

Even if the fashion world didn't fully believe they had what it took to overturn Paris, La Guardia kept reminding them they did. At one press conference he announced that he now considered himself the industry's patron. He made headlines at the Saks runway show by turning up fashionably late in black tie, and refusing to pose for pictures unless he was with a model in New York designer clothes. He appointed a former mayor, the flamboyant, fashionable Jimmy Walker, known as Beau James during the Roaring Twenties, to oversee the cloak-and-suit industry, giving it a direct line to City Hall.

The following spring, around the time Franny and Fuffy were finishing up at Pratt, La Guardia was appointed head of Roosevelt's new Civilian Defense department, and as every state and municipality in the country began to organize volunteer air raid, blackout, and fire squad units, all of which required uniforms, the mayor again remembered his fashion friends and tapped them for the job.

The September before Pearl Harbor, a monthlong Civilian and National Defense Exposition opened in the Grand Central Palace, and many of the exhibitions included uniforms, causing *Women's Wear Daily* to predict huge opportunities for their industry "in the event that the country goes to war." Although the mayor's new uniforms weren't quite ready, he spoke at a Fashion Group lunch a few days later. After congratulating the millinery trade on "the great improvement in design since last year," he thanked everyone else for their help with the uniforms. "They're smart, they're practical,

they're attractive, they're pretty, and inexpensive." And they would soon bring designer fashion into American homes.

Meanwhile, he urged all assembled to figure out how they might best contribute to the war effort against an enemy he characterized as "the most cruel, the most ruthless, the most greedy, the most calloused group of men that ever had control of government."

So it probably wasn't surprising that when war was declared, stores already had sales plans ready to roll into action for civilian uniforms. New York designers soon began working with the War Office, and by the spring of 1942, Dorothy Shaver had been appointed a merchandise consultant to the army. Before long, uniforms came in all varieties, from budget to custom-made. And Franny's boss, Margaret, and her sidekick, Elizabeth Sisson, who had worked with her in Chicago at Marshall Field, were suddenly gone most of the day, "out being do-gooders about women's war uniforms," as Franny put it. "They never even came back until five o'clock at night." Which left Franny, who still had to punch her time clock at eight every morning, holding down the fort.

She spent her days trying to keep everyone happy—or as happy as possible. "We worked with about six different tough buyers," Franny said. "They were all very nice. But they'd run in and they'd be screaming, 'Where is she? Where is she?'" Margaret and Elizabeth would finally arrive at five, at which point Franny's second workday would start. "I'd have to give her all the information and get everything ready to tell the buyers the next day. So I'd hang around until the evening waiting for her to come." Margaret and Elizabeth would stay at work till nearly midnight. Franny was run ragged: "I never worked so hard in my life!"

But while the work was hard, and rules flew out the window, the remarkable thing was that nobody laid down the law or tried to do much about it. For when the war began, the sense was that a genie had been let out of the bottle, and the normal order of things no longer applied.

Perhaps it was madness to think that directors could suddenly take off from their jobs and work on a second project, leaving twenty-one-year-old assistants in charge. But who on earth would have imagined two years before that the boutiques and couture workshops of the Rue de la Paix would be supplanted by the handcarts and honking yellow cabs and ready-to-wear manufacturers of Seventh Avenue, or that the patron of international fashion would be a cigar-chomping politician who despised ladies' hats?

"That was the peculiar thing about the war years," Franny said. "Everybody was using whatever excuse they had to do what they wanted to do."

The twins found their excuse when Franny ran into Jimmy Abbe, the sexy lensman who had photographed them two years earlier in not-quite-matching evening gowns for *College Bazaar*.

PART IV

NEW HORIZONS

CHAPTER 11

Jimmy

Toni wasn't the only high-fashion talent who was working for mail order catalogs. Alexey Brodovitch, the Russian émigré art director whose genius had revolutionized the look of *Harper's Bazaar*, had also taken on a project for Ward's great competitor, Sears, Roebuck. In 1939 they hired him to modernize its women's fashion pages. He gave the section a toned-down version of the look he had created for the magazine, introducing a lot of white space, sans serif type, and diagonally slanted pictures. According to the London design magazine *Art and Industry*, the retailer—which sold everything by mail, from tractors to ladies' lingerie—had decided to hire Brodovitch "following a research among farm women as well as urban and suburban customers who all demonstrated preference for the *Harper* presentation," which was his handiwork. Brodovitch then went from Sears to Saks Fifth Avenue, where he oversaw advertising. He wasn't at all snobby about his clients: he had done many different types of projects in the past and, like most European avant-garde designers, likely believed good design could improve everyday life and appreciated the mass audience to be reached through a catalog. (In addition, few said no to high-paying work, especially at the end of the Depression.)

By 1942, mail order catalogs had become such big business that Harry Conover, a top model agent who is credited with having

invented the term *cover girl*, had phone lines directly wired to the catalog houses, including Sears, Ward's, and Stone-Wright. That year, his agency made a quarter of its $750,000 annual take from catalog work (about $14.3 million today). Now that the war economy was starting to boom, and middle-class consumers had more disposable income, catalog companies were striving mightily to, as Conover put it, get "out of the outhouse and into the living room."

Margaret Hockaday was now farming out work to other successful photographers, not just Toni. So it was only a matter of time before Franny ran into Jimmy on a shoot. His star was rising fast. His *Ladies' Home Journal* cover of Vivien Leigh costumed for her role as Scarlett O'Hara in *Gone with the Wind* had led to more covers for that magazine, including a patriotic series that would feature a uniformed nurse, a WAVE, and a WAAC. (These were the acronyms for Women Accepted for Volunteer Emergency Service in the navy and the Women's Army Auxiliary Corps, both established during the war to allow women to serve in noncombat positions.) They were made up like glamour girls, a gambit—American girl next-door turned siren—that was becoming Jimmy's specialty. He often flew out to the West Coast for sittings with movie stars. Jimmy's true ambition, he'd once told *Mademoiselle*, was "to photograph everything and everyone . . . to revolutionize the movies."

Now Ward's had hired Jimmy to sprinkle his Hollywood stardust on their latest Crimplene housecoats—"terrible-looking" garments, Franny observed, "that were, like, so stiff they could stand up by themselves." (Just because catalogs did a lot of business and had the art directors and photographers needed to make the clothes look good didn't mean they actually were.) Franny arrived at his studio in the afternoon with Mary Lou Malany, the senior assistant in Ward's fashion department. They had two Conover models in tow: one forgettable, the other Dusty Anderson, a corn-fed Ohio brunette who had recently married a marine and was becoming popular among the troops. (Conover, who specialized in well-scrubbed, all-American

beauties with memorably crafted new monikers such as Jinx, Choo Choo, and Frosty, had recently renamed her Dusty and jettisoned her old name, Ruth. When the businessman's daughter from Toledo first walked into his office, Conover had told the *New York Herald Tribune*, "she looked like a young colt left loose on the prairie with her black mane flying in the breeze.") Two years later, Dusty would star in the 1944 film *Cover Girl* with Rita Hayworth, decamp for Hollywood, ditch her husband, and marry a director. But right now she, like everyone else in the room, had no choice but to sit back, cool her heels, and wait for the celebrity photographer.

Franny remembered the clock ticking slowly by, to one o'clock, then two. When Jimmy finally turned up, he took one look at the housecoats and made a beeline for the back of the studio, where his cot was waiting. They waited some more. They discovered he was taking a nap. "Poor guy," Franny said. "He was always so nervous." Jimmy finally came out, pulled himself together, and managed to carry off the shoot. Then the group went around the corner for drinks, to the bar at the Madison Hotel.

The evening was a success, and as with everything else in their lives then, Fuffy and Franny began visiting Jimmy's studio together. It was in a very central spot, in the Hearst building, just above the Henry Halper drugstore, at the corner of Madison and Fifty-Sixth Street; *Bazaar* and *Town & Country* were upstairs, and *Mademoiselle* was just across the street. Models often stopped at the drugstore between assignments to buy perfume and false eyelashes, and young editors dropped in to the soda fountain for a quick lunch.

Soon Jimmy was going skiing with the twins and the gang from Ward's, a group of about nine traveling up to New Hampshire on weekends. Judging from the pictures the twins took of people laughing in ski sweaters in ski lodges, the group included Margaret—or Hocky, as the twins had taken to calling her—her sidekick, Elizabeth, and Mary Lou, the fashion assistant. Sometimes Harriet Higginson, the head of style, went too.

On one of those trips, one twin photographed Jimmy smiling over breakfast on the porch of a ski hut, making it the first in a long line of Jimmy photos—and one of the first that seems to crystallize everything the twins had learned by then about composing a picture on the fly. At first glance, it seems quite casual, as though whichever twin took it had risen from the table, snapped it quickly, then sat down again. But it is in fact carefully composed, striking a balance between the building's geometry and the lounging figure that would soon become characteristic of both their work. Jimmy sits squarely at the center of the composition, and the sun lights up his handsome face as he assesses the competence of whichever twin is lining up the shot.

Before long, the twins and Jimmy had become a trio. Jimmy couldn't decide which one he wanted—or so the story goes—so as he tried to figure it out, he squired them both around town, one on each arm, both twins at five feet, four and a half inches skimming conveniently lower than his five-foot, six-inch height, and all of them dressed to the nines.

To hear Jimmy tell it, he wasn't especially eager to choose. "I was delighted with this chance of being involved with twins," he once said. "It seemed novel and interesting and crossing my own interests in human psychology. It was considered the ideal thing to be able to have twins." He didn't specify whether he meant by other men, himself, or his psychoanalyst. But by now, Jimmy's marriage was disappearing in the rearview mirror, and he, like many others in his world, was embarking on a voyage of self-discovery, aided by a growing popular interest in the "science of the soul."

JIMMY'S DECISION TO BECOME A PHOTOGRAPHER—and perhaps his need for psychoanalysis, too—might as well have been preordained. His father, James Abbe Sr., known as Papa within the family, had been one of the most renowned entertainment photographers of the early twentieth century. A successful small-town photographer in Lynchburg,

Virginia, Papa had come to New York in 1917 to seek his fortune and found fame making unusual portraits of great Broadway actors such as John and Lionel Barrymore and Helen Hayes—close-ups made onstage in costume under theatrical lights, or chatting backstage with the crew. In 1920, drawn by the fledgling movie business, he went out to Hollywood and began snapping such stars as Charlie Chaplin, Rudolph Valentino, and Mary Pickford, becoming the first professional photographer to conquer both coasts. (The *Saturday Evening Post*, famed for illustration, had already run one of his photos on the cover, of the stage and movie star Jeanne Eagels—a first for the magazine.)

In 1922, the movie star Lillian Gish—"the First Lady of the Cinema" as *Vanity Fair* dubbed her, "and the only actress in motion pictures worth the powder to blow them up with"—persuaded him to come with her to Italy to consult on a film. Papa Abbe was waved off from the pier in New York by a huge group filled with more stars, including Lillian's sister, Dorothy, and Mary Pickford, of the long braids and soulful eyes. Also on the pier stood his wife and three children, whom he'd brought up from Lynchburg, Virginia, a few years before, among them ten-year-old Jimmy, his youngest and his only son. "Little did they know," Papa Abbe recalled later, "nor did I for that matter, that they would never again be able to count me one of their family circle."

While abroad, Papa Abbe left this family to start another with an actress working on the film, a former Ziegfeld Follies showgirl. Having relocated with her and their new baby to the Parisian artists' neighborhood of Montparnasse, he began to photograph Europe's great artistes and entertainers, including Mistinguett, the star of the Moulin Rouge; Josephine Baker, the great expatriate Harlem dancer who was performing in *La Revue Nègre*; and the fabulous Hungarian Dolly Sisters, whose elaborately staged cabaret acts were the talk of London and Paris. His pictures were eagerly received by the newspapers and magazines of London and New York, including the *Tatler* and *Vanity Fair*.

After small, fast minicameras came on the market in the late 1920s, and photo-newsweeklies began flourishing in Europe, Papa Abbe reinvented himself yet again as a "tramp" photographer and started traveling the world, from Moscow to Havana to California, contributing documentary stories to such picture publications as *Berliner Illustrirte Zeitung*, or *BIZ*, which had been around since 1892; *VU* in Paris, a newer entry founded in 1928; and the *London Magazine*, a pocket-size monthly where he had a column. He reported on avant-garde Russian theater and film, Chicago gangsters, life in Cuba, and the cultural revolution in Hollywood as silent pictures gave way to talkies. Returning to the Soviet Union, he talked his way into the Kremlin and captured the first photograph of Stalin, in 1932, seated at a table beneath a portrait of Karl Marx, which ran worldwide. Then he carefully cozied up to the Nazis and chronicled their rise, photographing Hitler at party headquarters just before he became chancellor, and wiring photos of Goebbels, Göring, the entire cabinet, and the 1933 Nazi Party rally at Nuremberg back to *Vanity Fair*.

Jimmy had joined the family profession in 1931, after high school, when he went to Paris, reconnected with his father, met his three half-siblings, and became his father's assistant—a job that gave him immediate entrée with the city's photographers and artists. "I became a photographer sort of *faute de mieux*, as the French say," he would later explain to a reporter. "Simply because I'd been exposed to it, and it was one of those fields you could get into without too much formal training." Back in New York, he was hired by *Bazaar*, where for a time he assisted new arrivals such as George Hoyningen-Huene, who is said to have requested him because of his blond good looks, and Louise Dahl-Wolfe.

Jimmy also worked for Man Ray, whom he had known in Paris, most likely when the surrealist spent three months in New York at the time of MoMA's big Dada-surrealism survey. The artist, who'd been at the heart of both movements, was known for pioneering many experimental photographic techniques, such as the rayograph,

his variant of the photogram. But he'd grown up in Williamsburg, Brooklyn, as Emmanuel Radnitzky, helping with his father's tailoring business. When he returned to New York, his first wife, an anarchist poet and artist whom he'd never bothered to divorce, turned up to demand a settlement for the sixteen years they'd lived apart, which he had spent among artists and aristocrats in Paris. Perhaps that's why, around the *Bazaar* offices, the expat eminence "was considered to be rather glum," Jimmy recalled, noting that people used to quip that Man Ray had the air of a man "who was looking for a place to vomit."

Dry wit notwithstanding, Jimmy had a healthy dose of neurosis, too. Early in his *Bazaar* career, an unfortunate incident had taken place after he stepped out of a studio for twenty minutes, entrusting the roomful of camera equipment to a handyman, who then skipped, leaving the door unlocked. Jimmy's transgression had been reported to management by Leslie Gill, an older, more established photographer, and it almost got him fired. Just as he was pleading his case with one of *Bazaar*'s vice presidents ("I sincerely regret that you have had cause to form so unfavorable an impression regarding my attitude toward the studio," he wrote. "I regret also that Mr. Gill did not see fit to speak with me before going so vigorously on record"), Papa Abbe came to the rescue, sort of.

"Dear Jim," his letter read. "Worried that your mother said you were not certain *Harper's* would keep you on. Let me know the dope, so I can stir about elsewhere for you if necessary." Then Papa twisted the knife by telling Jimmy about a bestseller his Paris brood had published about their European adventures, and how fantastically well sales were going. "Going to press with an edition of 5,000 which makes total to date of 14,000 one week after publication date. Looks pretty swell." (The 1936 book, *Around the World in Eleven Years*, was written by the eldest Paris child, Patience, with her two younger brothers, Richard and John, as dictated to their mother, the former Ziegfeld Follies showgirl. It became a multinational bestseller, making

the children household names and leading Hollywood to summon them for screen tests.)

Jimmy won himself back into favor at *Bazaar* and Hearst, patched things up with Gill, and established himself as an up-and-coming magazine photographer. Perhaps to differentiate himself from Papa, he added an accent to his name, and started signing his photos *Abbé*. While he began to succeed professionally, his love life was rocky. He fell for screenwriter Ben Hecht's actress daughter, who refused his proposal. He married someone else on the rebound three weeks later. His bride, Frankie Adelman, was the assistant to *Bazaar*'s brilliant literary editor, George Davis, just as the magazine was also becoming known for publishing exciting new writing by such authors as W. H. Auden and Christopher Isherwood—an oddly bookish choice for a man whose life was dedicated to sizing up the world with his eyes. By the time their son, Jamie—officially, James Abbe III—was born, on August 5, 1939, their marriage was fizzling out.

"Well sir, it sure does me good to see you billed as a practicing photographer, the son of a photographer, and on your way to fame and fortune," Papa wrote to Jimmy several weeks before little Jamie's birth, from Colorado, where he was living with his second family on a dude ranch purchased with the proceeds of the children's bestselling book. But the week before Jamie arrived, Papa wrote to Jimmy's older sister, informing the first family that he was leaving the second family to start a third, with an ingenue who far outshone any woman he'd had before. They were moving to California, where she would soon give birth. Although he was writing to one of his daughters, he didn't stint on the cringe-inducing details. "SHE wants babies, and by me," he said of his new bride, adding, "She was a virgin, until I made other arrangements."

No surprise that Jimmy, who had already started seeing a psychoanalyst at the Payne Whitney Psychiatric Clinic in New York, was soon on his way back to Hollywood, too, shooting stars and presumably chasing starlets at his home away from home at the Garden of Allah

Hotel, a notorious complex of Spanish villas tucked behind a pink neon sign on Sunset Boulevard, which had for years been frequented by everyone from Ernest Hemingway and Cole Porter to Greta Garbo on their trips to Tinseltown and was renowned for the titillating activities said to take place in and around its rooms and pool. "JAMIES CONDITION SPLENDID," Frankie telegrammed him across the continent from the charming little schoolhouse he had purchased on Long Island as a country retreat. "HAPPY VALENTINES DAY."

But when the twins started swanning around New York with Jimmy about two years later, they probably had no knowledge about these details of his life, at least not at first. More likely, their attention was focused on his wife's being out of the picture and they being in it. The boys they'd kept company with in high school and art school had suddenly gone to war—"They were off in the service, just whisked off!" Franny said—and the twins suddenly had the attention of a real man. A real Bohemian. And a real photographer.

CHAPTER 12

Living the Photographer's Life

At Pratt and at work, the twins had learned the basics of how cameras functioned—how to load film, how to use a light meter to determine the correct camera exposure settings, how to line up a shot, how to mix the correct ratio of chemicals in the darkroom. But through Jimmy they were introduced into New York's small, close-knit circle of photographers, in many cases socializing with people whose work they already knew from magazines. Only then did they begin to understand how photographers looked at the world and to get a sense of how they lived. "It was really opening a whole new door," Fuffy said, "because Jimmy had so many photographic friends."

When the twins met Jimmy, he was extremely close to another photographer, Fernand Fonssagrives, and his wife, Lisa, a model. Both were refugees from Paris who had been on their way to visit New York when the war began. A mutual photographer friend in Paris—Franny thought it might have been Jean Moral, also known for outdoor fashion photography—had given them Jimmy's contact information; the couple had looked him up when they arrived, and they had all hit it off. By then, both twins said Jimmy and Frankie had separated. For a while Jimmy had bunked with the furniture designer

Hans Knoll, but now he moved in with Fernand and Lisa Fonssagrives on Long Island, where he had been spending his country weekends. Franny also recalled that Jimmy had paid for Lisa's teeth to be fixed and let Fernand share his studio until the new arrival was able to get his own. Fernand's talents quickly found a home at another Hearst publication, *Town & Country*, while Lisa soon established herself as a cover model for *Vogue*. They had a young baby, too, a girl called Mia. Then the twins entered the picture. "That's how we all became friends," Franny said. When they went skiing, the Fonssagriveses would go, too, and Fuffy marveled at the way Lisa's skiwear clung smoothly to her body—an effect achieved, she eventually came to realize, because no undergarments came between it and her skin.

Up till now, the twins had pursued their careers quite doggedly—"hard work" remained their eternal catchphrase—but the Fonssagriveses offered a demonstration of the value of chance and spontaneity, not only in creating an artwork but also in shaping a career. Everything in Lisa's and Fernand's lives seemed to have unfolded by instinct, from their choices of profession to the way they pursued them. They had met and married in Paris, where they had started out as dancers. Then Swedish-born Lisa, with her flexible, athletic body, elegant features, and blond hair, was discovered in an elevator by the fashion photographer Willy Maywald, who asked her to model some hats. Fernand shared Maywald's photos with the head of the studio at French *Vogue*, and Lisa was booked for a sitting with Horst. Suddenly she had a career as a fashion model—something she began figuring out how to do by visiting the Louvre and making a careful study of how the portrait subjects held their hands. She tried to create the character who might wear the gown she was modeling and even learned photography to better understand the problems and perspective of the person on the other side of the lens. (Lisa later became a photographer herself, for *Ladies' Home Journal*.)

At around the time Lisa started modeling, Fernand was injured in a diving accident and forced to stop dancing, so she bought him

a Rolleiflex and suggested he try photography, too. The idea bore miraculous fruit. When Lisa wasn't modeling for the collections, Fernand's new profession enabled the couple to travel around Europe, skiing or camping on the beach. He would photograph her as she swam in the sea or sat on the edge of a rock overlooking a ravine or pole-vaulted across an icy river, clad in little more than a sunhat or snow boots. His photos found a home among the growing market of European youth and naturalist magazines. The money the couple earned let them keep traveling until it was time to return to Paris once again so that Lisa could model for the collections.

The twins thought the Fonssagriveses were amazing. Fernand was a wild man, spontaneous and free, but he was also technically adroit, expert at developing his film in hotel rooms with little equipment. Lisa was exceptionally creative, and practical—she could weave a pigeon's nest, Fuffy once recalled—and fearless as a model. Just before leaving Paris, she had collaborated on a remarkable group of photographs, one of the last made in the city before war was declared in Europe. The photographer had been Blumenfeld, the louche experimentalist whose artistic nudes Franny and Fuffy had so admired in *Coronet* when they were at Pratt. He had taken several women up to the top of the Eiffel Tower to photograph them in couture, but Lisa was the one who'd had the nerve to lean out from the tower, untethered, clinging to an iron strut with one hand so that she appeared to soar above the city's rooftops and the Seine—a daredevil high-wire act that seemed to defy both gravity and the advancing Germans. The first photograph, in which she held out the fluttering skirt of a plaid Lelong gown, appeared in French *Vogue*, as part of a spread celebrating the tower's fiftieth anniversary, and a different set, in which she wore pink taffeta by Molyneux and pale gray silk by Mainbocher, appeared a few months later in American *Bazaar*. Lisa hadn't been afraid. "I was too young and too strong," she said later.

Blumenfeld, also a friend of Jimmy's, had recently arrived in New York himself, having survived a variety of surreal escapades and

nightmarish French internment camps. His cynical, acerbic sense of humor must have been strikingly different to the worshipful reverence the twins had come to expect from everything surrounding *Bazaar*. A German-born Jew who became a stateless alien in Paris when war was declared, he had taught himself photography—and his ability to make pictures under any circumstance had saved his life. He had distracted the policeman who came to his studio to arrest him by offering to take the man's portrait, in a ridiculous bathing costume and cap, payable up front. From this improbable venture, he earned enough to strike a few bargains in Le Vernet, the foul, stinking concentration camp at the base of the Pyrenees, where he ended up interned anyway. There he curried favor with a ring of German gamblers by helping them forge passports—Blumenfeld made the photos. When he finally reached the relative safety of Nice, having been reunited with his wife and children, and visited the American consulate to try to procure them all visas, he was saved once again when the vice-consul turned out to be a passionate photography buff. Or at least that's what Blumenfeld was told when he entered the man's office and discovered him sitting on a couch under an American flag with a woman bent over his lap.

"At this point the whole affair took on a surrealist tinge—I recognized her," Blumenfeld wrote in his bitter, fantastical memoir, *Eye to I*. "In the weeks before the outbreak of the war I had found myself in precisely the same position with her in Paris." The woman, a quick-thinking Viennese demimondaine called Sissy, stood up, kissed Blumenfeld on the lips, and announced that she and the vice-consul had just been discussing Blumenfeld's work. He "greatly admires your nude under wet silk," she said, then promised that his visas would be forthcoming. Blumenfeld received them the next day.

After another detour, to Casablanca, the photographer and his family sailed into Brooklyn Harbor on a Portuguese cargo ship, docking on August 8, 1941. A relative picked them up, drove them to Great Neck, and fed them an all-American meal of fried chicken and apple pie.

The next morning, Blumenfeld borrowed some money, bought a cheap summer suit, and took the subway up to *Bazaar*'s offices, where Mrs. Snow, the editor, "surrounded by arse-licking editors and her arsehole of an art director Brodovitch," he recounted, "delightedly gave me her orders as if we had never been separated by two years of world war."

Mrs. Snow told Blumenfeld that Hoyningen-Huene's photographs had not worked out, and he had gone on holiday again. "We have to have the September issue finalized by tomorrow," she said. "Run up to the studio right away and do some fabulous retakes." Promising lunch one day, she shooed him into a broiling-hot studio, where he shot eight pages. Then she presented him with a bill for the use of the studio and the equipment, which wiped out more than half his profit, and signed it, "Love Carmel."

"'Love' at $800 for the first night—that's America for you!" Blumenfeld wrote. Luckily his old friend Munkácsi offered him studio space, and his career in the New World was off and running.

JIMMY WAS A PHOTOGRAPHER of a different sort: the kind of supersuccessful studio specialist who was replacing the illustrators who were starting to be edged out of magazines. As well as working for *Bazaar*, where the fashion photography had to be cutting-edge, much of his bread and butter came from *Ladies' Home Journal* and other such publications that liked their fashion straightforward and appealing. Top-notch illustrators such as Jimmy's acquaintance Ray Prohaska, a *Saturday Evening Post* contributor, were well aware that "there really were these beautiful movie star looking girls in small towns all over the nation," as Prohaska's son, Tony, explained later in a memoir. Jimmy had reason to know that, too.

Although he was a Bohemian in his soul and had grown up surrounded by the same kind, Jimmy had the lucrative ability to make actresses and models look like everyday Americans, and ordinary

women look like movie stars. He was also a perfectionist in the darkroom, where he understood all the tricks that could make a picture come to life. "He was pristine in his approach," said Fuffy, who became expert herself. "I could never do a print good enough."

When he needed to be, Jimmy was also a perfectionist at handling people; although his Virginia accent had worn off, he could easily switch it back on when charm was required, transforming himself into a vivacious Southern gentleman. He could clearly turn it on with editors, too. "I can't tell you how pleased we all are with the photographs you have been doing lately," Wilhela Cushman, the fashion editor of *Ladies' Home Journal*, had gushed to him in a letter earlier in his career, around the time she selected him to go out to Hollywood and photograph Vivien Leigh in costume on the set of *Gone with the Wind*. (Cushman and Jimmy had likely met at *Harper's Bazaar*, where she had been assistant to the editor, Mrs. Snow.) "Really, Abbe, you are God's gift to us working editors!"

On that trip, he'd been required to photograph Leigh, who had a cold, with a one-shot camera, the awkward, cumbersome studio beast that was the standard for commercial color photography—it made three separate color negatives simultaneously that would be printed together to create a full-color picture. (The finished product, known as a carbro print, required hours of skillful, laborious darkroom work.) As Jimmy fussed with the camera, which had been rented from a local photographer, who was also on set because of union rules, Leigh's lover, Laurence Olivier, glowered nearby, insisting that Jimmy finish up in only three takes while also stepping on his shots. By the end of the shoot, Jimmy had mollified Olivier so effectively that the star agreed to sit for a quick black-and-white portrait with Leigh, whom he would soon marry.

All these qualities made Jimmy the ideal person to take on the fashion photos in *Ladies' Home Journal*'s "How America Lives" column, which profiled families throughout the country, depicting them as "the last stronghold of democracy" and "the validity of our simple

but profound American way of life." The stories were handled by separate teams, with one photographer documenting the family going about its daily routine, another documenting the inside of the house, another the outside, and so on, with a glamour squad swooping in to dress the family in the latest styles—within the limits of the family budget, of course—and make them over to look spectacular. Then Jimmy would arrive to take the beauty shots.

In June 1942, a few months after the twins had started spending time with Jimmy, he traveled to Eugene, Oregon, to give a family the Abbé glamour treatment. He also stopped in Portland to visit his father, who had reinvented himself yet again in the Pacific Northwest as a radio newscaster. After another quick trip to Hollywood, to photograph Ingrid Bergman for the *Journal* as she was finishing *Casablanca*, Jimmy returned to New York with his editor, Wilhela Cushman, crossing paths in the air with Judy Garland and Alfred Hitchcock, a trip that was noted in *Variety*'s "N.Y. to L.A. / L.A. to N.Y." column, which chronicled the comings and goings of film folk between the coasts.

After he'd captured Bergman, as well as "our simple but profound American way of life," on film, Jimmy went to see the twins in Wallingford, where they were staying with their mother at the St. George's Inn. Somehow he persuaded Kitty to let them return with him to Montauk, a remote village at the farthest reach of Long Island's South Fork. Freed from her watchful eye, they took the ferry with Jimmy across the Long Island Sound.

For once, there was no far-off glow of civilization in the sky. To prevent ships offshore from being easy targets for German submarines—a frequent occurrence when America entered the war—lights had been dimmed along the coast. Even New York City's ever-present radiance was subdued. Traffic signals, streetlights, and store signs were all lit low. Night baseball had been canceled. Times Square's neon signs were out, and the lights of the upper floors of high-rises were veiled. The ferry docked in a swirling fog, against a shoreline

where every light that faced the ocean had vanished. "It was a magical moment," Fuffy said. "It was very mysterious."

As the three of them walked along Napeague Road, she recalled, small houses and windmills grew clear in the darkness. Finally they arrived at a shingled cottage called Second House. Built in 1746, it was the village's oldest dwelling, put up to house the man who herded sheep and cattle in its pastures when nothing much else was nearby. Early on, it had been one of the few lodging places for visitors to Montauk, and since its beginnings, Fuffy said, it had always been known for giving a warm welcome and serving wonderful food. That night, in the blackout, surrounded by mist, they arrived just in time for supper. There were freshly caught fish, vegetables, and lettuce picked straight from the garden behind the house, and some sort of delectable dessert—coconut cake or floating island. Jimmy had already been telling them about "the magic of Montauk," Fuffy said, "and it certainly came true on that occasion."

JIMMY HAD STARTED GOING OUT to visit Second House when his sister Phyllis had married into the Kennedy family, a wealthy New York clan who had built an empire, Kentile Floors, out of a small cork-flooring company founded in the late nineteenth century. The family had bought the house several decades before and now lived there half the year. For Jimmy, going out to visit in the summers had become an escape from the madness of urban life. The neighboring villages of East Hampton and Amagansett had drawn artists since the late nineteenth century, but Montauk, a remote agricultural hamlet whose denizens had subsisted on fishing and farming, had mostly escaped all that. During the Jazz Age, Carl Fisher, the same man who had developed Miami Beach into a playground for the rich, had attempted to do the same thing with Montauk, hiring the Olmsted Brothers, sons of the landscape architect Frederick Law Olmsted,

to carve it into land parcels, and putting up a few grand mansions, but the Depression had put an end to his plans.

The war was, however, subtly transforming the area's fortunes once again, as European refugees such as the painter Fernand Léger and the poet André Breton, the founder of surrealism, began coming out to stay with patrons and friends in nearby towns (they shocked the locals by swimming and sunbathing nude), and a few New York creative people who were too broke to afford Provincetown or Rhode Island either settled or began summering nearby. Carolyn Kennedy Tyson, Jimmy's sister-in-law, would eventually become a patron of the arts: after the war, she and her husband, also called Jim, would assemble a compound of historical cottages in East Hampton, building them into an arts colony that buzzed with activity at all times of day and night, and she would become known as something of a local arts doyenne. But for now, weekends in Montauk remained somewhat sleepy, although Second House was always full of interesting visitors from the city and beyond, and there was always a game of croquet to be played on the grassy lawn that rolled from the back door of the house toward the sea.

It must have been a far cry from the beaches where the twins had vacationed as children in Connecticut, surrounded by family, or the tar beaches where they'd sunned themselves more recently in Brooklyn since they'd started school. Fuffy was "dazzled by the array of wild flowers and wild fruit that I saw during that summer," she marveled later. "There were blueberries, cherries, blackberries—wild grapes and beach plums at the end of summer and into the fall."

The twins and Jimmy also took photographs, many of which show them exploring the lighthouse at Montauk Point, the easternmost tip of Long Island, which was just a short drive down the road from the house. The point was considered one of the places in the country most vulnerable to German attack, and about a month before the twins first visited Montauk, four German spies had crept ashore

from a submarine at the neighboring village, Amagansett, armed with explosives and grand plans for sabotage. They had been intercepted by an alert coastguardsman, an FBI manhunt had ensued, the plans had been derailed, and now the entire point was on high alert. By the next year, the point would be a military base, but in the summer of 1942, the lighthouse, a 110½-foot sandstone tower with a revolving Fresnel lens, which dated back almost as far as Second House, could still be visited. Judging from Jimmy's photos, the twins spent plenty of time there, posing for pictures in matching white sweaters, checked Bermuda shorts, and sparkling knit snoods.

Jimmy's photos of Franny and Fuffy that first summer explore many different visual metaphors about femininity and twins. In most, they look like proverbial college girls, smiling happily as they stroll down the path from the lighthouse or clamber around the railings outside. In one, however, their bodies appear fused together, like Siamese twins, while their heads turn in opposite directions, as if they're trying to pull apart. Another shows them standing at opposite ends of a driveway, like chess pieces placed on a board.

The twins took their own photographs, too. By then each had her own Rolleiflex camera, but when they traveled with Jimmy, all three often seem to have traded a single camera back and forth, because their pictures are often intermingled with his on the same contact sheets. On one, following Jimmy's pictures of the twins at the lighthouse, is a photograph by Franny of Jimmy and Fuffy together, sitting on a railing, gazing into each other's eyes as though nobody else were there. But this paired-off moment seems to have been short-lived. In the next picture, Jimmy is seen helping Fuffy down. Then Fuffy is alone, smiling gaily, her eyes shielded by harlequin sunglasses, as she sits before an expanse of dry grass.

Back in New York, Jimmy continued squiring both twins around town. They were still dressing alike, and he got shirts and jackets for himself made to match their clothes. "I wanted to be in on the act," he said.

He also introduced them both to his mother, Phyllis, who lived an hour or so out of the city, in the elite enclave of Locust Valley, where she bred cocker spaniels. A picture of them, trying to control a litter of six puppies, soon appeared in *Town & Country*'s "Kennel Annals" column. This nice gesture didn't quite go as planned, because by then Papa Abbe had so many litters himself that even a society publication like *Town & Country* couldn't keep them straight: they misidentified Phyllis as "the mother of those noted eleven-year-circumnavigation children," rather than the first jilted wife and the mother of the magazine's own photographer.

CHAPTER 13

Love in Wartime

Perhaps the most surprising aspect of the twins' relationship with Jimmy is that it began, and apparently flourished, while they were still living with Kitty, their mother, in her Brooklyn apartment. They were giving her a hefty percentage of their take-home pay—Franny was turning over more than a third of her $130-a-month salary, and Fuffy, who earned considerably more working for Toni, did the same—and Kitty was still making a strenuous attempt to keep the twins under her thumb. In February 1943, when the twins had known Jimmy for about a year, he went back out West for a fashion shoot (editors liked to send photographers West in winter, he said, because "we could depend on the weather for shooting outdoors"), and Fuffy wrote to him to say that the family had heard from her cousin Charles Downey, who had been something of a big-brother figure since the day he'd taken them to their first day of school in Wallingford. The family agreed that Kitty was overly strict, and Charles, now in the army, had sent Kitty a letter filled with "good advice," as Fuffy relayed to Jimmy, "about letting us have a good time."

For outside Kitty's apartment, the world was changing. Birth control, while not always easy to obtain, had become legal throughout the country during the twins' freshman year at Pratt. Young women were still generally quite well protected, but the more adventurous ones

sometimes "overstepped the conventions," as magazines put it. Morals had loosened during the Roaring Twenties, and the Depression had made it harder for couples to marry and set up households in a timely fashion. In a *Ladies' Home Journal* survey that same spring—part of a series that had already canvased American women for their thoughts on marriage and divorce, birth control, and money—the magazine discovered that while "a moral collapse is not imminent," petting was commonplace, and 22 percent of those under thirty were open to premarital sex, at least when the couple intended to wed. "Young people can't afford to get married," a twenty-three-year-old stenographer in Detroit had told the magazine's researchers, "but that doesn't stop them from having the 'urge.'" (Her date, who had come to pick her up while she was talking with the researcher on the phone, had chorused with her, "Everyone does!," when the subject of petting arose.)

While the twins were in school, *Mademoiselle*'s advice columnist, Dorothy Dayton, addressed the same topic, albeit in a wittier, more urbane fashion. "There isn't the slightest doubt in my mind that virtue still pays," Dayton wrote in March 1938—although, she added, "some moderns would say it pays only the psychiatrist."

Dayton noted that "the ideal of monogamy, as well the urge toward variety, is common to both sexes." Furthermore, "the kicking over of convention, in serious trial marriages"—by which she meant couples living together—"is not uncommon among young people in the large cities. . . . I know of many such couples among well brought up, well educated young people. And I've never heard any of the young women concerned complain that they've been wronged." (Various plans for young people living together, without children but with birth control, had been advanced by progressive thinkers in the 1920s.)

Some "radicals" even experimented with open relationships, Dayton wrote. Yet ultimately, she concluded, marriage and monogamy was preferable: "There is no law which forces us to get married. We can remain single and be as free and uninhibited as we please. The only trouble is that we don't, as a rule, like it."

But now, four years later, with the country at war, even such worldly counsel seemed quaint. Some couples married hastily to help the husband avoid the draft, often coming to realize later it had been a terrible mistake. Other couples sped up weddings that had already been planned, only to be separated from each other for months and years. More than a few dispensed with the formality of marriage entirely.

As women and girls crowded into stations and docks all over the country, desperate to kiss departing soldiers goodbye, and women began leaving their homes to work in factories and offices, the FBI reported that even teenage girls were running off to chase servicemen. Magazines waded into a slew of urgent new topics. How did one know if it was really love or just a case of "uniformitis" (i.e., "the sentimental tendency of all women to glorify a man merely because he is in one of the services")? How should a USO hostess handle a drunken soldier who was soon to ship out? Was it appropriate for married couples, when parted, to socialize with the opposite sex? Should single girls succumb to temptation when boys their age had been "whisked off," as Franny had put it, and only older, more experienced married men remained?

When the twins had been seeing Jimmy for a year, the British philosopher and mathematician Bertrand Russell took on this subject in a story for *Glamour* called "If You Fall in Love with a Married Man." (Asked later why he had written it, the lofty intellectual responded, "I did it for fifty dollars.") Russell, who had been teaching in American universities since 1938, was a popular, titillating, endlessly controversial figure—one who'd produced a stream of books, essays, and lectures in which he frequently advocated infidelity and what he called "temporary childless marriages" for students. "War more than anything else hastens this destruction of social barriers," he wrote in *Glamour*, predicting that men and women would soon find themselves doing a lot of unchaperoned intermingling. "If you are an unmarried girl, you will probably find that most of your former

companions who are both fit and intelligent, and therefore attractive, are in the services, and the men with whom you work in factory or office are often married." Although Russell had been divorced by two previous wives for infidelity, he suggested young women think twice, for, among other things, a relationship with a married man could lead to stepchildren. "If you marry a man with children," he wrote, "either he must sacrifice their custody to the mother, or you must marry them too."

Jimmy's child, young Jamie, then about three and a half, was living with his mother, Frankie, and had even at that tender age probably seen many more conventions kicked over than the twins. While still a toddler, he and Frankie had lived next door to New York's most notorious artistic salon, run by George Davis, her former boss at *Bazaar*, in a brownstone at 7 Middagh Street, at the northernmost tip of Brooklyn Heights. There, refugees such as Dalí, the novelist Thomas Mann, the German composer Kurt Weill and his wife, and the singer Lotte Lenya—whom Jimmy had already photographed— met and mingled with a glittering New York creative crowd, includ- ing Louise Dahl-Wolfe, the choreographer George Balanchine, the composer Aaron Copeland, and the burlesque dancer Gypsy Rose Lee, who lived upstairs and sometimes sublet her apartment to a circus troupe.

Frankie helped draw up the guest lists, often more than a hundred strong, organized the events, and acted as an editorial assistant for the building's residents. They included Carson McCullers, a brilliant young novelist from Georgia whom George had discovered and pub- lished in *Bazaar*. (Frankie Addams, the protagonist of McCullers's 1946 novel, *The Member of the Wedding*, which she began soon after moving in at 7 Middagh, may have been named for Jimmy's ex.) W. H. Auden lived there for a time with his friend and sometime lover, Christopher Isherwood. So did the writers Jane and Paul Bowles, who had an open marriage. As for George, his amorous interests ran to sailors. He met them in the seamy Sands Street red-light district by

the port, known as Hell's Half Acre, and brought them back to join in the festivities. Jamie recalled his father, Jimmy, telling him that the brownstone's spacious ground-floor kitchen was "the only male brothel in New York—there was stags as far as the eye could see."

But little Jamie wasn't yet a pressing concern for Franny and Fuffy. They were still trying to extricate themselves from Kitty's clutches, and vying with each other for Jimmy's attention. That February 1943, he was out in California for a month, staying at the Garden of Allah Hotel, and they were both peppering him with amusing, cleverly written and designed letters, postcards, and booklets that were as assiduously conceived and crafted as the projects they had once spent months creating for the Prix de Paris. They worked on all the booklets together, but wrote and sent some of the letters separately, as though each was trying to get the jump on the other without her sibling finding out.

In some of these missives, they called Jimmy "Daddy." Fuffy addressed him as "Dear Daddy-poo," adding, "I think about you daily," while Franny wrote, "I still want my Daddy more than anything else in the whole world."

Among Jimmy's assignments in California, he was to photograph the model Mary Lee Abbott for *Mademoiselle*; he had also photographed her for the long-running Woodbury soap campaign, which now featured not just any "skin you love to touch," but the touchable skin of debutantes, whose names were printed in the ads. Mary Lee, a socially prominent New Yorker, was more interesting than the usual Woodbury soap debutante, at least to the twins. Before coming out at the Colony Club, she had studied painting at the Art Students League. While there, she had horrified her family by falling for a nouveau riche arriviste—Lewis Teague, Fuffy's erstwhile fiancé from Pratt, who had left school after his junior year to devote himself to painting full-time, after which his relationship with Fuffy apparently died off without rancor. He was now in the Army Air Force, stationed on the West Coast. Mary Lee "is in California visiting none-other

than Lewis," Fuffy wrote to Jimmy. "If you work with the young lady I expect excellent behavior & hope you'll return her to my ex-fiancé in good shape!"

For Valentine's Day the twins collaborated on an elaborate handmade card, shaped like a heart and decorated with doilies and butterfly and flower stickers. On one side was a picture of Jimmy photographing a radiant starlet who looked a lot like Mary Lee. On the other was a snapshot of a chubby infant in a bassinet, as if to remind Jimmy of the trouble he might get into if he didn't behave.

The next day, they sent a joint letter, with Fuffy writing one page and Franny the next. That's when Fuffy reminded him to take care of Mary Lee, who was now engaged to her ex. (In fact Lewis and Mary Lee were about to embark upon one of those precipitous doomed-to-fail wartime marriages.) "How is mother's little angel?" Franny inquired tartly. "Is he doing his best by all the friendly little starlets and helping them interpret their art?" She then listed all the underwear and shaving gear she had discovered in Jimmy's studio and offered to send them on by courier, adding that she hoped "for my darling blonde lensman to be back sooner than ever with a big wonderful hug for me."

In another joint letter, they pretend to be Jimmy's students. "Dear Sir, We are twins and we like photography very much. We have been studying very hard at the Abbe Correspondence Course in Making pictures. . . . We also usually fall in love with some of our instructors and have a cruch [sic]. Would you be able to sned [sic] a small snapshot of yourself in the enclosed, self-addressed envelop [sic]. We feel sure it would serve as an inspiration for us and a real goal."

They also put their art school skills into crafting an elaborate manual called "M.Y.M.T.," or "A Manual for a Young Man Traveling." It opened with a snippet of advice, cut and pasted from a magazine: "Send him your picture, often. Pose in a natural, friendly manner, against a background with which he's familiar." Above this was a photo of Fuffy waiting at a train station with her skis, standing with Jimmy and another man who looked at Franny as she took the picture.

The other pages were covered with more exhortations sliced out of ads and magazines, among them: "What a fine full chest tells about growth" / "How to Have a Glamorous Bedroom" / "I'm sick of JUST READING about Love" / "Your satin-smooth Face is a magnet for kisses" / "Wanted—a wife."

Their separate letters make it clear that the twins, in addition to their regular jobs, were acting as Jimmy's de facto assistants as well as his girlfriends, relaying information about assignments, retouching his prints, supervising his newly acquired East Fifty-Seventh Street bachelor pad, and handling scheduling, sheet changes, and laundry for visitors—primarily his mother and Carolyn Tyson, the future East Hampton arts doyenne, who stayed there while he was away.

The twins sent Jimmy office gossip, mostly about Condé Nast: Bettina Wilson, a *Vogue* fashion editor, had quit her job to join the Red Cross. Dr. Agha, the company's longtime art director, who had been born in Turkey, had left the company "to do special government work," Fuffy wrote. "Turkey I guess gets him." And they sent endearments. "I guess there's not much use in trying to behave any longer—I miss you very much," wrote Franny. "Except for pining away I am fine and good . . . healthy as ever—except I may be drafted for essential industry by the time you return." Meanwhile, Fuffy wrote, "We are making beautiful Abbé prints for beautiful you—are you coming back before *we* get drafted? . . . In your *next* letter ask Franny who weighs 5 lbs more than her sister. I guess you can see whose appetite is not affected by your departure."

By the following summer, although the twins and Jimmy all appeared in each other's photos wearing matching plaid shirts, Fuffy and Jimmy had started to pair off. When Franny photographed them, more often than not they were gazing into each other's eyes.

One might expect Franny to have been disturbed by this turn of events, but perhaps she didn't much mind. Although from Fuffy's perspective—at least as she later described it looking back—she and Jimmy were definitely a couple, he hadn't fully decided which

twin suited him best. And Franny had other interests. While Fuffy's letters during the correspondence spree had been sent from Toni's office, Franny's came from a new address: the East Sixty-Second Street studio of Leslie Gill, the photographer who had some years ago reported Jimmy's irresponsible behavior to the management of *Bazaar*.

By now, Jimmy and Leslie had patched up their relationship. And Franny, after spending a year at Ward's, had left to work for Leslie as his girl Friday. Leslie had even started to go skiing with the twins, and they had incorporated pictures of him into some of the projects they had sent to Jimmy. For instance, they had put a photograph of him in the travel instruction manual: in the snapshot of Fuffy and Jimmy at the train station, he was the other man who fixed his eyes on Franny as she took the picture.

Yet in contrast to the other members of the ski group, Leslie wasn't always free to get away. As the twins had explained to Jimmy in one of their joint postcards, "At this writing Gill may or may not go skiing (wife—difficulties)."

CHAPTER 14

Leslie

Later Franny often dropped the year she spent in Leslie's employ from her biography, explaining once that she'd done so because he'd been married at the time. "Nothing transpired that was anything exciting," she said. "But, you know, we got along very well."

Even without that admission, it was clear that Franny must have thought about him frequently, for she continually dropped his name in the flirtatious letters she sent to Jimmy. When Fuffy wrote to Jimmy, she didn't have much to say about her boss, Toni. But Franny always found plenty to say about Leslie.

One time, she wrote Jimmy a letter outlining Leslie's worries about the draft. Although married men had so far been spared, the boss was growing increasingly concerned that he might be called up. "S.L. Gill is fretting mighty plenty about the new ruling on family men which lists photography as a non-essential occupation after Apr. 1. He thinks it may be 75% reality—25% chance of nothing happening immediately—but even so." It was too bad that Jimmy, "his guide and mentor," was away "at such times of heroic decision as these." She urged Jimmy to return in time for "the Gill studios"—that may have meant her, too—to take a ski trip to Canada.

When Jimmy didn't return in time to go skiing, Franny informed him that Leslie had gone by himself: "L. Gill is away now. —so I

spend all my time enlarging pictures of you." Again, a few days later, when Leslie returned: "Your uncle Leslie I'm afraid got his head 'frozen up' in Canada. . . . He really got his cheek frostbitten. It was 50° below at Tremblant."

She also sent Jimmy a poem "found by L. Gill" and confessed that it was his baby picture the twins had purloined and pasted into the valentine. "I guess you know pretty much who the baby Valentine was," she confessed. "Fuffy and I never go around painting red hair on photographs."

In person, in Leslie's presence, Franny seemed as awestruck as the twins had been when they'd first visited Jimmy's studio in college for the *College Bazaar* photo shoot. For her new boss was not only tall, blue-eyed, handsome, and redheaded, but he was truly renowned as a photographer. One of the most respected talents working at *Bazaar*, he had helped create the look that made the magazine's pages seem so archly modern.

Leslie had begun contributing to the magazine just before Brodovitch arrived and was swiftly "discovered" by the famous art director, who told Leslie he should stop art directing and concentrate on photography. "His great eye for the beautiful elements of Americana and his creative genius for putting those elements in relationship," Brodovitch wrote of him later, "made each of his photographs a work of art."

Leslie had created *Bazaar*'s first cover photograph, for the December 1935 issue—a photogram of a bow, tied in such a way that it suggested the magazine was a gift-wrapped package. He had already been creating photograms for the inside pages—negative images made with objects, photosensitive paper, and light—including a spread for the beauty column, "The Cosmetic Urge," which featured lipsticks, perfume bottles, and eyelash curlers floating against black space. Leslie swiftly abandoned the photogram idea because he felt that was Man Ray's territory. Instead he began to invent his own techniques, weaving cosmetics and accessories into increasingly surrealistic still lifes.

Perfume bottles would sprout from a bank of sand against a cloudy sky, surrounded by pine cones, sheaves of wheat, and ripe fruit, like a cross between a nineteenth-century American trompe l'oeil painting and a composition by Dalí. Or a perfectly manicured hand wrapped in gold and jewel-studded bracelets might caress a pair of feet strapped into silk jersey sandals by the jewelry designer Jean Schlumberger, the whole sensual composition luminescent against white fur.

Leslie was said to have come up with the concept of a "designed" photographic page—a photo made with a large-format eight-by-ten view camera with the same proportions as a double-page magazine spread, which might incorporate type, hand-lettering, drawings, and objects such as jewels, butterflies, locks of hair, torn photographs, a playing card, or a smear of lipstick. The text of the story would run over this photograph.

Using this technique, Leslie also began to illustrate *Bazaar*'s increasingly dazzling fiction offerings in a very up-to-the-minute way: as Carmel Snow put it, "He was the first photographer of taste and imagination to glimpse the possibilities of illustrating fiction with symbolic photographs." Ten pearls and a jeweler's loupe spilled across the opening spread of Virginia Woolf's "The Duchess and the Jeweler," a tale of moral corruption. A black cat with one blinded eye spat at the start of Elizabeth Bowen's "Joining Charles," the story of a bride who confronts a future of being trapped in a loveless marriage. A girl lying on a psychiatrist's couch as if she were laid out upon a bier hovered over Mary McCarthy's "Ghostly Father, I Confess," a saga of yet another failed union.

Born in 1908, in Cumberland, Rhode Island, Leslie was eleven years older than the twins. But like them, and like many other photographers of his generation, he had set out intending to paint. He had studied at the Rhode Island School of Design (RISD) and was close friends with two older Brown alumni, S. J. Perelman, the comic writer, and Nathanael West, the satiric novelist. After graduating with honors from RISD in 1929, Leslie had traipsed around the

world with his artist girlfriend, moving from one Bohemian locale to the next—Provincetown, Woodstock, Greenwich Village, Paris, Nice—stopping in New York long enough to make money in advertising before taking off again. Back in New York in the Depression, he found work as the art director of *House Beautiful* just as photography was starting to make inroads on illustration. When he couldn't get anyone to create the pictures he had in mind, he bought a camera, learned how to use it, and made them himself.

Leslie's work as a photographer soon became known, and by 1935 he had opened his own studio—which he shared with the early colorist Paul Outerbridge—and worked for Hearst publications such as *Town & Country*, as well as *Harper's Bazaar*, and took on advertising accounts. He made his own art photographs, too—deftly lit, precisely rendered arrangements of the early American sculptures and folk art paintings he had begun to collect.

Franny might not have been aware of this background when she came to work for Leslie. But she and Fuffy would likely have read about him in 1940, when he and his girlfriend, Dilys Wall, who had gone the fashion illustration route, were married and enough of an it couple to be featured in the "Young Marrieds" issue of *Glamour of Hollywood*, as Bohemians who couldn't figure out how to stop making money. By now the magazine had a new tagline, "Fashion and Beauty for Young American Moderns," and the Gills had a rented townhouse on East Sixty-Second Street—the place where Franny was working for Leslie now—with his-and-her studios on the ground and second floors, two little girls, Carol and Eliza, a nursery, a garden, a live-in nanny and cleaning woman, a butler, and a rented vacation home in Bridgehampton. Dilys—the *Glamour* story's real subject—made up to $150 a week (about $167,000 a year).

What the story didn't say was that, while Dilys was a fashionable illustrator, Leslie was a photographer's photographer, an exacting perfectionist whose work had been featured in the *U.S. Camera*'s annual from the first issue, starting with a composition of wagon

A rare picture of Toni at work. Here she photographs three models in snowsuits for Montgomery Ward, on a set at Sherrewogue, aided by Fuffy and another assistant. Mac and Sidney are in the foreground. (Frances McLaughlin-Gill, 1942)

The snowsuit picture they were taking, above, ran in Montgomery Ward's fall-and-winter 1942–43 catalog.

One of Toni's photos of the twins, for the junior section of Montgomery Ward's spring-and-summer 1942 catalog.

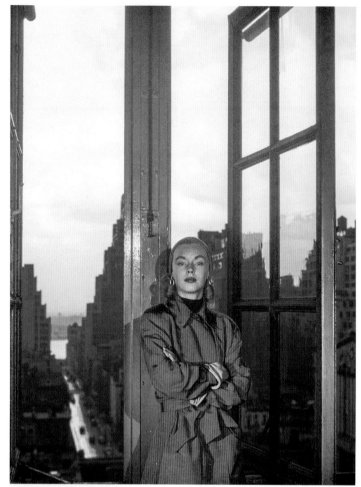

The moment that Franny came to commandeer *Vogue*'s junior fashion section.
(Frances McLaughlin-Gill, *Manhattan, Vogue,* © Condé Nast, November 15, 1944)

Blasé junior chic in 1946, posed in Franny's apartment.
(Frances McLaughlin-Gill, *Vogue,* © Condé Nast, November 1, 1946)

The bride with a career sails away in a suit for her honeymoon. (Frances McLaughlin-Gill, *Pat Donovan and Henry Clarke in a Boat, Glamour,* © Condé Nast, April 1947)

Fuffy's career took off when she met Jane Troxell, the new fashion editor at *Charm*. This photograph was made on location at Rancho Santa Fe in California. (Kathryn Abbe, *Charm*, May 1946)

One of the many swimsuit shots Fuffy did for *Charm*.
(Kathryn Abbe, *Charm*, June 1946)

A picture that seems to anticipate Fuffy and Jimmy's extended stay at the Boulderado dude ranch outside Las Vegas.
(Kathryn Abbe, *Charm*, May 1946)

Jimmy's hard-won shot of Vivien Leigh, taken for the cover of *Ladies' Home Journal.*
(James Abbe Jr., *Vivien Leigh in the Role of Scarlett O'Hara,* 1939)

One of several portraits of Vivien Leigh and Laurence Olivier that Jimmy persuaded them to sit for on the same day.
(James Abbe Jr., *Portrait of Vivien Leigh and Laurence Olivier,* ca. 1939)

12

An example of one of Leslie's "designed" photographic pages, as well as the sort of innovative still-life accessory shot for which he was known. A version of this picture appeared in *Harper's Bazaar* with text running across it as part of a lipstick story. (Leslie Gill, *Still Life with Lipstick Pots*, 1945)

13

One of the Roman aristocrats Leslie photographed on his postwar trip for *Harper's Bazaar*. (Leslie Gill, *Portrait of Donna Milagros del Drago*, 1947)

The painting by the anonymous "limner" that Leslie saw and bought on the street. It is now the signature work in the collection of the American Folk Art Museum in New York. (Ammi Phillips [1788–1865], *Girl in Red Dress with Cat and Dog*, vicinity of Amenia, New York, 1830–35, photo by John Parnell)

The last issue of *Coronet*, October 1961, featuring Fuffy's photograph of Eli biting an apple.

Dilys Wall and friend, in her apartment in New York, seated beneath the Ammi Phillips painting.

wheels casting shadows against a corrugated-metal wall. He was becoming known as an experimentalist, too, "one of the restless spirits tirelessly jousting with lights and chemicals in pursuit of new ways in photography," *Popular Photography* once wrote, classing him with Blumenfeld and the radical Swiss photographer Herbert Matter, among others. Leslie was also one of a small group whom Eastman Kodak contacted to test new products. In the late 1930s, when the awkward, cumbersome one-shot camera was still the standard for commercial color photography, Leslie had been one of the first asked to test eight-by-ten Kodachrome color transparency film, which made it possible to make color pictures with a standard large-format camera. (The other experimentalists were said to have been Steichen and Bruehl, Condé Nast's early 1930s color specialist, who together with the technician Fernand Bourges developed the Bruehl-Bourges color process, which the publishing empire licensed and used to dominate color magazine photography until Kodak's Kodachrome supplanted it in the late 1930s.) Later Leslie became an early adopter and popularizer of strobe lighting, using it not only to capture motion, but to photograph fragile objects such as flowers and ice before they wilted or melted under the intensity of hot studio spotlights.

Yet despite Leslie's accomplishments, he'd had professional heartaches. He and Brodovitch worked together closely throughout the 1930s. But things changed in 1937, when Brodovitch decided to use Leslie's work as an example for his students. The great designer was teaching a course on European design principles at the Pennsylvania Museum and School of Industrial Art in Philadelphia; this was the first version of his famous Design Laboratory, a workshop soon to become legendary among aspiring photographers in New York.

The events that followed were remembered well by Mary Faulconer, Brodovitch's assistant at *Bazaar*, who helped teach the class. Brodovitch had "arranged for an exhibition of a photographer, Leslie Gill, who he had discovered in his new position at *Bazaar*," she wrote later, in a brief reminiscence about those early Design Laboratory

days. "Gill was an original photographer who had developed his own high key photography and beautiful still-lifes." His elegant, pristine photographs made a big impact on the class. "At least three of the students were inspired and influenced by his work," she wrote, naming the young men who were so moved: Ben Rose, Sol Mednick, and Irving Penn. Evidently, their attempts at making still-life photographs impressed Brodovitch, because he began hiring them for *Bazaar* assignments instead of Leslie.

"Brodovitch had difficulty communicating with people his own age, so he preferred to work with students in most cases so that he could control what he needed for the *Bazaar*," explained Faulconer, who had herself started out as Brodovitch's student. (She had worked with him on the redesign of *Bazaar*, and he'd brought her with him to the magazine when he was hired.) "Because Brodovitch could direct and control the students, money, etc."—that is, because they were also easier on the art department's budget—"he started to use them, mostly Penn instead of Leslie Gill."

For the next two summers, Brodovitch hired Penn to work with him as his assistant at *Bazaar*—an unpaid position—and Penn began contributing work to the magazine. Although Leslie maintained a vibrant career—and Brodovitch continued to use the photographer's work in his presentations—having younger talents at *Bazaar* usurp the still-life vein he had pioneered there made it "a very sad time for Gill," observed Faulconer, who remained friends with all involved.

One thing that had not recovered from success and its attendant stresses, however, was Leslie's marriage. It had begun with the shared goal of a life spent in pursuit of what *Glamour* termed "pure art" but had grown more stylishly brittle the more successful the couple became. They had spent their art school years "chasing one another around the plaster statuary," Dilys had told the *Glamour* reporter. Early family photos show them kissing passionately and mugging, vamping and building human pyramids with other students at beachside artists' colonies, their paintings drying outside shingled

studios in the open air. Soon they're in the city, skating on snowy rooftops, smiling on fire escapes, walking in the park. Towheaded toddlers arrive. Dilys stands at the helm of a new car, flinging her arms wide in glee.

By 1940, however, when the *Glamour* story came out, their relationship was marked by froideur. "Communication between Dilys and her husband during the day is reduced to a civil minimum," the copy read. "When the telephone rings for Leslie and Dilys answers she presses a buzzer which prompts him to pick up the downstairs extension. The buzzer works the other way too. Visiting is firmly and sometimes loudly discouraged by both. Once in a very great while they confer for criticism. But since they usually disagree violently on what is good drawing or good photography, they prefer to skip these conferences and remain on speaking terms. Lunch is a quick business taken separately. . . . At four or five in the afternoon, both knock off work. Friends drop in for cocktails which are mixed and served in the living room back of Leslie's studio."

As to the violent disagreements: one argument, at the Cotton Club in Harlem, became so heated that Dilys left on her own "long after midnight," as she wrote in her diary, walked until she found the nearest subway, and took the train home by herself.

Nobody else ever had a bad word to say about Leslie. "To know him was to love him," said Dorry Rowedder, who worked as his secretary in the 1940s. "Along with his enormous talent, he was continually kind, thoughtful, funny and wise." (She would later become a model and is now best known by her married name, Dorry Adkins.) Having matured into a modish, mustachioed sophisticate, Leslie was often quiet and reserved, preferring to draw pictures of what he'd seen that day rather than talking about it. Yet he could also be a prankster, convincing a fashion editor friend that she had to, simply had to, purchase a deer head trophy for her apartment because it was the latest thing, or teasing a child by picking up a magazine, choosing a sentence at random, and reading it backward with a completely

straight face. Despite his "quiet smile," as his high school yearbook had said, he was "always ready for fun."

And while Leslie could be a driven, focused, and fastidious task-master in the studio, he was open to suggestions, even from those with less experience, and willing to share credit.

Dilys, on the other hand, was intense almost all the time, by anyone's measure. Despite her free-spiritedness, she led a fairly reg-imented life, working with a model until noon, then breaking for lunch and an old-fashioned, followed by a nap and a brisk game of tennis, whether the family was in the city or at the beach. She kept long lists of things that interested her, or that she wanted to do: reading, puzzles, bridge, Scrabble, anagrams, golf, dancing, movies, conversation, *italiano*, astrology, stock market, study psychology.

Dilys also "had a terrible rep for being a terror!" said Leslie's assistant, Dorry. On one occasion, when Leslie was working for one of his frequent clients, Cartier, which brought jewels to the house with accompanying security, she went down to his ground-floor studio to inquire what he wanted for dinner—not that it really mattered, she mostly cooked chicken—and found an armed guard outside the door. "You cannot go in there," the man said. Dilys, ignoring his gun, gave him hell. She eventually got her way and entered the room. On her way out, she told the guard, "I really don't want your goddamn diamonds," as she strode past and made her way up the stairs.

When Franny came to work for Leslie partway through 1942, this was the atmosphere she stepped into—one turbulent with sudden outbursts and slamming doors. For Leslie, her arrival must have seemed like a gust of fresh air.

FROM THE START, Franny and Leslie got along extremely well. They shared a passion for photography, and Franny was intently focused on studying his approach. "Leslie seemed to know what was coming next before it arrived," she wrote about him later, "a sure instinct or

prescience for the trends in fashion, sculpture, drama, music." She was interested in capturing what she saw on the street. ("*Always, always* carry the camera around with you," she advised young photographers later. "Keep it as handy as a pack of cigarettes.") But she was fascinated by Leslie's studio-based experimentalism and exactitude.

"He worked very quickly when he had his idea," she wrote. "When someone else might still be sitting talking about how a thing could be done, he would be up and out looking for a filter material, a diffuser for a light, an arm for the tripod, or the objects he had seen somewhere with which to make the photograph." Many of his most famous pictures began as tests. He was "a master of LIGHTING. A genius, no doubt." When he was stumped about how to solve a problem, he would visit his favorite carpenters or repairmen, or antique dealers, and talk over ideas until a solution emerged. "I cannot recall that he ever gave up on a job," Franny wrote. "Leslie Gill had a roving and restless mind."

While working with Leslie, Franny also learned to hone her eye in another way for, like Kuniyoshi and some of the twins' other teachers, Leslie was also an avid collector of Americana—the paintings, furniture, and folk art, such as wildfowl decoys, signs, and mechanical toys—which was only just starting to be accepted by critics. By now Leslie had moved his family uptown, into a fancy new apartment on East Eighty-Third Street, with six bedrooms and two maids, and had relocated his studio to the same building as Julien Levy's Fifty-Seventh Street gallery, near the heart of Manhattan's antique district. So Franny had a front-row seat for much of Leslie's buying. He rarely returned home, she recalled later, without a new object, such as a print, a feather, a group of old stamps or coins, an antique book, an unusual box, or a painting.

Franny seemed to have an effect on Leslie, too: during the period she worked for him, one of his friends, the art director Jan Balet, who also collected folk art, joined *Mademoiselle*'s staff and hired Leslie to photograph young women for the beauty column, who applied

makeup, performed calisthenics, and lathered themselves with soap in the shower. Many of the models looked strikingly like Franny, with cool demeanors, radiant complexions, and neatly arranged dark hair.

LATER, MANY IN THE GILL FAMILY assumed the relationship began that year, as Franny followed Leslie around, infatuated, bedazzled by his eye and his prowess in the studio, trying to understand how he approached a photograph. "I heard that's how it happened," said Eliza, his youngest daughter, four at the time, who doesn't even remember meeting Franny then, "but I didn't *know* it." Carol, Leslie's elder daughter, who would have been seven, claimed that the only thing she could recall was that Fuffy sometimes worked for her father, too. "If one didn't show up, the other one did, and I don't think he ever knew which one it was," Carol said. "They truly looked very much alike."

But what must have given Dilys pause, at least in retrospect, was that while Franny was working as Leslie's assistant, and they were spending so much time together, she somehow became involved with her boss's acquisition of a cherished painting. They had apparently been out together, some in the family believed, when he spotted a well-known antiques dealer, Charles W. Lyon, hurrying past on the street with a portrait under his arm. Leslie stopped him and asked for a closer look. Made by an unknown "limner," or itinerant portraitist, it was a luminous likeness of a small girl in a red dress; she held a white cat in her arms, and an alert brown dog sat guard at her feet. Lyon relinquished it for some amount that now seems negligible—$35 (about $600 today), one family member recalls. Later "there was some talk," Carol says, "that Franny paid, wrote the check," maybe because the enraptured assistant wanted to give her boss a gift, or simply because he didn't have cash or a checkbook on him that day. Leslie took the portrait uptown and hung it in his new living room, where Dilys and the children were frequently photographed sitting

beneath it on the couch. Eliza said later that she, too, thought Franny might have been involved in some way. But at the time, her opinion was merely that "I always liked the animals in it."

Other than that, however, there was never any real proof that "anything exciting" happened, as Franny put it, except that they got on so especially well. If something did take place, it must have been so well concealed and tactfully carried off that nobody knew anything for sure. And Leslie, who was devoted to his daughters, certainly showed no signs of leaving his wife.

So it continued, until a surprising event put a definitive end to Franny's idyll in Leslie's studio.

Franny's Lucky Break

During this period when the twins had been distracted by Jimmy and Leslie, Toni Frissell had also been preoccupied, as she tried to get permission to travel to Europe as a war photographer. "I became so frustrated with fashions that I wanted to prove to myself that I could do a real reporting job," she said. While she was doing this, two things happened that upended her relationship with *Vogue*.

First, half a year after America entered the war, Toni's two-year contract with Condé Nast neared its expiration date. Dr. Agha had tried to renew it, figuring that as she was the company's lone female contract photographer, they might need her as male photographers disappeared into the war machine. "If all the young men in the studio are drafted, Toni Frissell is the only first class photographer we have left," he had written in a memo to Nast in May 1942, the month before Toni's contract was up. Most of the company's photographers worked on staff in the studio. But Toni, following Steichen's example, had maintained her own establishment and employees—the office down the hall from the Condé Nast studio where she employed Fuffy and the "two marvelous darkroom boys"—and was paid via a complex formula that guaranteed her a minimum number of pages a year, some in color and others in black and white. Over the last year, she had earned $14,400 (about $264,300), with 117 pages and

one cover—about $1,000 more than the previous year, when she'd had fewer pages but four covers.

Agha briefly considered asking Toni to join the studio to keep costs down, but decided she "would be a disrupting influence" by wanting "all the lights and all the assistants and all the cameras, at once," and the studio staff agreed. He recommended to Nast that they renew on the same terms and "start the renegotiations right away."

But Toni, still eager to move beyond fashion photography, surprised them by responding that she'd take less money in exchange for the freedom to work for other publications. Agha's response was to box her in, forcing her to request approval for all her other projects, and making the terms increasingly restrictive. He also told Nast privately that he considered her attempts at photojournalism unlikely to succeed—"There is little chance that *Life* would want Frissell's services in the straight reporting field," he wrote—and wagered they would only be interested in her "covering some fashion show, producing a society feature, etc." She called Agha's bluff by refusing to sign.

The second unexpected event was Nast's death from a heart attack.

"For a year and a half he had been a desperately ill man," Mrs. Chase, the editor of *Vogue*, wrote in her autobiography. "I think he had a horror of anyone finding out, because he had a horror of being pitied." Nast succumbed to his carefully hidden heart condition on September 19, the same day Toni's Red Cross passport for Britain came through.

Toni left for London with no contract. She spent ten weeks photographing the sights she encountered—vast seas of rubble, bombing stations, doctors tending the wounded, the massive social clubs that had been set up for American soldiers and sailors, run by the Red Cross volunteers known as recreation girls.

When she returned, the Red Cross mounted a show of two hundred of her photographs. "They are marvelous. Never saw better!" wrote one of Toni's friends, the socialite, big-game hunter, and Red

Cross volunteer Gertrude Sanford Legendre, to her husband. "Her photos showed women in England everywhere doing something, helping the soldiers, feeding them, amusing them etc etc. . . . Gee what I would give to be somewhere doing anything a little more active instead of behind this desk." (Legendre had her wish: two years later she joined the Office of Strategic Services, the American spy agency, in Paris and became the first American woman in uniform to be captured by the Nazis.)

Vogue published Toni's story about the experience in its annual Americana number, illustrated with a handful of the pictures. But many of her most stunning Red Cross photographs appeared elsewhere. One, of white-robed choirboys singing for American soldiers and nurses in a church whose roof had been sheared off by Nazi bombs, was used by the charity for the Christmas cards it sent to the U.S. troops serving in England. Another version of the same scene became *Life*'s "Picture of the Week." *Bazaar* published a picture of a young Red Cross volunteer reading to an air force sergeant with a broken arm.

Toni had called Agha's bluff again, but it didn't really matter: not long after these pictures appeared, Agha was gone—not because he was doing special government work, as Fuffy had naively suggested to Jimmy in one of her letters, but because he'd been fired—and Toni was working with a new art director. She continued contributing to *Vogue* as a freelancer, while also trying to get herself onto the Continent and into the European theater of combat. In the meantime, Toni became the official photographer for the WAACs, or the Women's Army Auxiliary Corps. Her photographs of these troops appeared in *Vogue*'s "Calling All Women" issue of July 1943, which featured military professions for women, in a story called "The WAACs Take Over." It showed them doing calisthenics, crowded into the back of a truck, riding motorcycles, playing in a band, hauling duffel bags, and sitting in rows under hair dryers in a military beauty salon—and the truck picture was even used for the cover of the unit's recruiting

brochure. (The government was trying to soften up the American public to the idea of women in uniform, and magazines had become its willing collaborators.)

The following month, in August 1943, Toni came into the office one morning and told Fuffy, who was still employed as her assistant, that *Vogue*'s new art director was looking for a new staff photographer for the Condé Nast studio, down the hall.

"Do you mind if I don't send you?" Toni asked. "Because I don't want to lose you."

Fuffy took it in stride, and instead, Toni called up Franny, who was still working as Leslie Gill's assistant, and suggested that she go for the Condé Nast interview.

Whichever twin Toni chose to recommend, it must have seemed a long shot to them both. The Condé Nast studio was still full of famous men, such as Horst and Rawlings, and the twins had only been out of school for two years. So even though Franny dutifully made the appointment and hastily finished up her portfolio—she had already been working on it—she didn't have high expectations when she arrived a few days later for the interview.

It took place in the art deco Graybar Building, which she and Fuffy had last visited two and a half years earlier, together, as Prix de Paris finalists. Once again, Franny took the elevator up to the nineteenth story and stepped out, onto the splendid black stone floors inlaid with golden stars, but this time she was on her own. The conspiratorial receptionist directed her to a huge corner office, where the new art director, a debonair man with slicked-back hair and a trim pencil mustache, sat behind an imposing mahogany desk with very little on it.

"I tiptoed in," Franny said. "I put down my portfolio." She waited, tensely, as he paged through it.

Opposite the door where she'd come in, a second door led into "the actual production room side," Franny recalled. As he went through her work, people kept opening the door, asking him to come and look at things, and otherwise clamoring for his attention. Later, she

couldn't recall if he had spent two minutes with her, or six or twenty. She did remember him liking a picture she had made of Fuffy, smiling on a beach in Wallingford.

Eventually he looked up and said, in perfect English, tinged with a posh continental accent that made him sound like a film star, "Please, don't be upset that I'm not taking much time. I'm very impressed and I'll call you tomorrow."

Then it was over and she went back out the same door she'd come in. "I never even told anyone I was there," Franny said. "I thought, 'Well, that's the end of that.'"

The next morning the new art director called and offered her a job and full-time salary of $100 a week (nearly $1,700 today) on the staff of the Condé Nast studio, working for *Vogue* and *Glamour*, which the following month would update its tagline yet again, to "For the girl with a job."

"I certainly snapped it up, I'll say that," Franny said. "I think he must have wanted a woman photographer."

She had worked for Leslie for about a year. But he was out of town, so she had no chance to give him notice in person. "I think he was a little bit hurt, like somehow I just walked out the door overnight and didn't say anything."

The following week, the Tuesday after Labor Day 1943, Franny entered the Grand Central Palace and walked down the hall past the office where her twin was still employed as Toni's assistant. Then she crossed over the threshold of the Condé Nast Photo Studios, where at twenty-three, she had been hired straight out of the gate as a full-fledged staff photographer, the only woman in a firmament of male stars. One new hire had joined the studio just before she did—Irving Penn, Brodovitch's former student and onetime assistant, who until that time had been working for Liberman in a small cubicle alongside the office where she had just been interviewed. She already knew Irving a little through Jimmy, from the days when he'd worked for Brodovitch at *Bazaar*.

Later, Fuffy liked to tell the story as though Franny's joining the Condé Nast studio was just another lucky break, commensurate with the one she'd had eighteen months earlier, when Toni discovered her on the trip to Charleston. Franny's sudden elevation as a *Vogue* and *Glamour* photographer "was big break number two," Fuffy often said. "That's why we say that twins are lucky!"

But at the time, she was devastated.

PART V

THE SEPARATION

The Inner Sanctum

When Franny arrived in the studio, it was one of the most essential cogs in the machine that was Condé Nast—"a very down-to-earth Paradise of cameras and flash-bulbs," as *Smart Girl*, an in-house magazine published for Prix de Paris winners, described it in their first issue. (It was the one place all the Prix contestants had wanted to visit when they got to New York City for their interviews.) By 1943, photography had been firmly established as the primary mode of illustration for the company's portfolio of magazines, and the studio, overseen by the stylish, elegant Claire Mallison, its longtime manager, produced photographs for every last one—*Glamour, House & Garden, Vogue Pattern Book*, and of course *Vogue*, which despite paper and ink shortages continued to put out two issues a month and to print in color throughout the war.

Spread out over much of the eighth floor of the Grand Central Palace, a squat, block-size skyscraper spanning Forty-Sixth and Forty-Seventh Streets, the studio employed dozens of people in addition to the photographers and their apprentices and assistants, and more who arrived to help when required. There were set builders, electricians, and prop and darkroom crews, as well as dressers, an alterations lady, and a model supervisor, both of whom ran traffic control and shepherded the models in and out—models being anything from

a professional mannequin, such as Mary Lee, to the socialite Mrs. Vincent Astor, head of the women's division of the War Fund Drive, to an entire ballet troupe. There might also be a hairdresser, a makeup man, a guard if jewelry was involved, messengers who could run out for sandwiches, Scotch, soda, aspirin, and cigarettes on demand, and sometimes a pianist, in case music was needed to enhance a dance scene. Each photographer had a separate studio, and all the magazines had their own stages so that many different shoots could take place at once, with *Vogue* on one side of the hall, and *Glamour* and *House & Garden* on the other. The atmosphere was chaotic when sets were being sawed and hammered together, but tense and focused when photographers were at work. Mallison, the studio manager, speaking to *Glamour*, had once likened it to a circus, and herself to the ringmaster, called upon to keep peace between "temperamental photographers, editors and models, pinch-hitting in the dark room for a technician who has just gone into the navy, driving a hard bargain to get some new photographic equipment, and even building a set worthy of a Hollywood production."

More photographers were beyond the doors of the studio, too, for the Grand Central Palace was the center of photography for all of New York, if not the entire country. The building held one of the city's two commercial camera suppliers, and on the ground floor was the city's premier lighting shop, run by Ben Saltzman, one of America's major manufacturers of custom stage and studio lighting and photography equipment. The Lexington Avenue side was filled with smaller private photography studios. The color specialists Anton Bruehl and Nickolas Muray were based there; so was Jerry Plucer, the fashion photographer who had hired Hans Namuth away from Stone-Wright at around the same time Fuffy had gone to work for Toni. (Namuth had become a U.S. citizen, joined the army, and returned to Europe, working for military intelligence.) The building had enormous elevators that could ferry up equipment to the different rooms, and a rooftop that could be used as an open-air studio for scenes and portraits that required

daylight. The Palace's central atrium also hosted the city's largest photography display—the International Photographic Exposition, the show that had drawn over a hundred and ten thousand visitors when it launched in 1938.

But now that show, together with all the city's other great annual expositions and trade fairs that had been held in the building for decades—the International Flower Show, the Westminster Kennel Club show, the beauty, aviation, and sporting equipment shows— was temporarily on hold, displaced by the U.S. Army, which had transformed the Grand Central Palace into the country's largest induction center. It teemed with teenage boys, who began arriving each day at 6:30 a.m. to volunteer, armed with signed permission slips from their parents.

On the eighth floor, however, where Franny was assigned a secretary and an assistant, the Condé Nast studio still remained an ivory tower where it was possible to focus on making pictures. For the most part, the stable of photographers "was really like an international congregation," Franny said. It included Horst ("a wonderful person," in Franny's estimation), who had joined the army as a photographer just before she was hired, and Rawlings, who had started out as Beaton's props assistant and worked for a time at British *Vogue* (or *Brogue*, as it was known in the office). There was Luis Lemus, originally from Mexico, who had previously quit to work for *Mademoiselle*, but had just been lured back. There were also two Russians, Constantin Joffé and Serge Balkin, who had arrived in Europe as children during the Russian revolution and were now in New York, refugees for a second time.

Then there were the Americans—the group of new, fresh, talented photographers the art director was hiring and training. Two more arrived the year after Franny and Irving Penn: the Chicago-born, acid-tongued Clifford Coffin, a former hotel manager who was "not young in years but in experience," Franny sharply observed, and his opposite number, Richard Rutledge, who had just finished school at the Art

Center School in Los Angeles, where he had studied photography—it was one of the few places in America with a photography program—and had already published a couple of pictures in French *Vogue*.

"We were considered a powerhouse of new talent," Franny said of her newly discovered American cohort. "Everybody moved fast. No one was there unless they really knew how to use a camera, and to order." Although she later realized she had been hired for what she called her "filmic look"—her ability to convey a sense of movement and action in a still shot—she was now expected to handle whatever was thrown at her, day after day, in a studio setting, whether it was photographing handbags, shoes, hats, or the people who'd designed them—"you had to take on this particular series," she said, one after the next, just as she and Fuffy had been trained to do at Pratt.

They all served at the pleasure of the new art director—another refugee who had fled Europe and was now remaking the studio and the look of the magazines to his liking.

AFTER FRANNY HAD BEEN at Condé Nast for a time, she and Fuffy must have realized that they had been naive to believe the story that Dr. Agha, the company's longtime art director, had volunteered to step down from his lofty position so that he could go to war, as Fuffy had told Jimmy several months earlier in a letter she'd sent to him in California. The truth was that Dr. Agha had been deposed in a corporate coup.

It had begun taking shape about eighteen months before Nast's death, when the new art director, a Russian-born Jew called Alexander Semeonovitch Liberman, arrived in New York, after a harrowing journey filled with narrow escapes that had taken him from his home in Paris to Provence, then farther south through Spain and Portugal, saved only by luck and his wits. When his ship docked in Brooklyn's harbor on January 8, 1941, he was accompanied by his lover, Tatiana du Plessix, another Russian émigré, whose husband, a French *vicomte*,

had died in combat, and her only child, Francine. Three days after their arrival, the *vicomtesse* had gone to work designing hats for Henri Bendel. Liberman, who'd entertained dreams of painting full-time, cast aside that fantasy and began looking for work.

Liberman had previously been managing editor of *VU*, the Paris picture newsweekly that had been the inspiration for *Life*, so it made sense for him to seek work at another magazine, especially as his contacts were the many French and Russian magazine people who'd arrived in New York before him. Liberman's first stop was *Bazaar*, where his fellow countryman Brodovitch tried him out on a graphic design job, at which the newcomer failed miserably. Tasked with drawing a page of women's hats, Liberman arranged them rather too obviously in the shape of a woman's head. Brodovitch showed him the door.

Liberman then visited his old boss, Lucien Vogel, the creator of *VU*, who was consulting for Nast in New York. (Vogel, a committed leftist, had worked for Nast in Paris, after selling him two fashion magazines, *Gazette du Bon Ton* and *Le Jardin des Modes*, and Nast had taken pains to get him out before it was too late.) Vogel commended Liberman to Nast in the highest possible terms, writing that the young man "was one of the best of my former collaborators . . . with me for many years as art director and lay-out man for *VU*." Vogel reconnected him with another Russian, Iva Sergei Voidato-Patcévitch, who had managed the Condé Nast publications in Paris. Newly arrived in New York, Pat, as he was known, had become Nast's second-in-command and designated heir. He introduced Liberman to yet another Russian, Dr. Agha, who examined the younger man through his monocle and agreed to try him out.

But once again things did not go well. Liberman started on a Monday and was given a week's worth of layouts. On Friday, Agha reviewed what Liberman had done and fired him, saying, "I'm terribly sorry, you're really not good enough for *Vogue*." Later that afternoon, however, Mary Campbell—Nast's clever secretary, who had years

before rescued the Prix from extinction—rang to say that Mr. Nast would see him on Monday. Liberman, keeping quiet about the recent debacle, went to the meeting, taking along a gold medal he'd won at the 1937 Universal Paris Exposition. (The medal was for a photomontage presentation on how magazines are created; Liberman later claimed not to remember much about it, but had brought the prize to America anyway.) Nast, unaware of all that had just transpired, peered at Liberman through his pince-nez and decided that he liked the young man and his gold medal. As Pat stood by, translating their conversation between English and French, Nast declared, "Well, a man like you must be on *Vogue*." Then he summoned Agha and suggested he add Liberman to the art department. Agha could not refuse.

So Alexander Liberman joined Condé Nast a second time, and a wary, triangulated dance began—with Liberman suavely ingratiating himself with Nast, who was eager to make his fashion magazines look more like *Life* and *VU*; and Agha, who had once been the golden boy, boxed into a corner, helplessly watching his power erode.

A dozen years earlier, Agha had been the prodigy who had held the key to modernizing the company's growing portfolio of magazines. Born in Russian Ukraine to Turkish parents, he was working for an ad agency in Paris when he was hired in 1928 to design the brand-new Berlin edition of *Vogue*. It quickly flopped, but Nast, besotted by Agha's talents, brought his new young whiz kid to New York in 1929, where he was soon art directing not only *Vogue*, but also *House & Garden* and *Vanity Fair*. Agha swiftly set about modernizing the look of all of the books, vanquishing the italic typefaces, the hand-drawn script, the borders around the photos and the columns, and introducing a look influenced by Russian constructivism—sans serif type, diagonally tilted photographs and text, and lots of white space. He tried eliminating capital letters, an experiment that failed. But he also pressed for photographic innovations, designing the first double-page spreads, full-bleed images—pictures that had no border and filled the entire page—and color photographs. In fact, he introduced many of

the ideas that Brodovitch and *Bazaar* would build upon a few years later. Although Agha had started out in a single room, soon Nast had to take over an extra floor in the Graybar Building to accommodate all the different projects his polymath had undertaken.

Agha and Nast adored each other—although Agha's attitude could be so cutting and cynical that many of the company's employees regarded him with fear as well as admiration, referring to him as the Terrible Turk behind his back, and "Doctor" to his face (his doctorate was in political science, and his full title was Dr. Mehemed Fehmy Agha). He was fluent in five languages, and many degrees, medals, and diplomas lined the walls of his office.

Yet Liberman, during his first month on the job, suddenly—and seemingly effortlessly—became the new "genius in the art department." That's the title Frank Crowninshield, *Vogue*'s fine arts editor, bestowed upon him when Crowninshield became captivated by a new *Vogue* cover design on the young designer's desk. Liberman maintained that it had been nothing, a trifle: he'd merely been playing around with a Horst photo of a model in a swimsuit. She lay on her back, legs crossed in the air, balancing a red balloon on her toes: all he'd done was to swap the balloon for the *o* in *Vogue*. Crowninshield was smitten. So was Nast.

The suave, charming Liberman, with his dapper mustache, and his upper-crust accent, continued to blithely ingratiate himself to Nast, Crowninshield, and the rest of the staff, and bided his time. His life until then had made him finely attuned to the moment, starting with his family's careful departure from postrevolutionary Russia—his father, a government timber expert and economist, secured permission to have him educated in England, visited frequently, then left—up to Liberman's own chaotic escape from the Nazis.

So while Agha hoped that the upstart would be drafted and sent back to Europe, Liberman, who had ulcers and was classified 4-F—unfit for military service—stayed on and smilingly waited Agha out. Then Nast died. A few weeks later, Agha was foolish enough to give

Patcévitch, Nast's former deputy, now president of the company, an ultimatum: "Either Liberman goes or I go."

In February 1943, Patcévitch announced the Terrible Turk's resignation. A month later, Liberman was appointed art director of *Vogue*.

"I liked Alex very much," Patcévitch said later of his new hire. "He was very talented, and he was Russian." Liberman's $12,000 annual salary was also a bargain compared to Agha's $40,000 a year.

Just as Agha had done fourteen years before him, Liberman set about modernizing *Vogue*. He scrapped the remains of the hand-lettering on the fashion spreads, cut back on illustration to make way for even more photographs, and focused on "cinematic flow." He introduced a surprising new typeface—Franklin Gothic, a staple of tabloids such as the *Daily News*—to give the magazine a more street-wise, journalistic look. "I thought it would be provocative and exciting to use practically the same type as a tabloid newspaper in this very different context," Liberman said. "It brought vitality to the page." He also began to change the magazine's presentation of women. "I wanted to involve women in the life of the moment, and the war furthered this by destroying fantasy," he said. "Clothes had to be practical for women who worked. No more Ophelias dancing through the Plaza at dawn."

Liberman was also eager to make his influence felt at the company's other publications, starting with *Glamour*, the company's first mass-market venture, which Nast himself had created from scratch in 1939. When Nast died, the publisher had been trying to build his baby into a worthy competitor to *Mademoiselle*. He sometimes asked European newcomers, even aristocrats, for their suggestions on what to do with this quintessentially American publication, and Liberman had offered his ideas, working on a redesign that was ultimately rejected.

As with *Vogue*, the war had helped *Glamour* find its new footing quickly. Throughout the 1940s, it had expanded its purview beyond Hollywood stars to focus on the more fruitful territory of the New York career girl. In May 1941, *of Hollywood* was dropped from the title,

and in July, the covers began to feature real young women instead of Hollywood starlets. (Franny—or someone who looked very much like her—was the October cover girl that year, posing in a hat topped by a giant feather that was almost larger than her forearm.)

Liberman was excited by *Glamour*'s modernity, calling it "younger, more dynamic," and *Vogue* "too artificial," too tied to the concepts of class and exclusivity that had been the key to Nast's early success. "Early on, I believed in *Glamour*," he reflected later. "I thought *Glamour* was the future. I liked it better. . . . I thought the fashion was more available and more popular. I loved the reality of *Glamour*, as opposed to the illusion of a sort of limited class society."

So it's easy to understand why, when Franny had arrived in Liberman's office in late summer 1943 with her portfolio, Liberman might have felt it was a great idea to bring her into the studio. The women who had preceded her as staff photographers had had impressive social credentials, even titles. In 1930, *Vogue* had added the German society photographer Antonie "Toni" von Horn, a baroness, to its all-male roster of stars. (She had stayed for a couple of years before going to *Bazaar*, then left photography to marry a philanthropist.) *Vogue*'s second regular female contributor, Toni Frissell, raised on Park Avenue, was just as well-connected as her editors: she could easily ring up the latest Mrs. Cornelius Vanderbilt Whitney and make photo shoot arrangements herself.

But Franny, born in Brooklyn, the granddaughter of an Irish policeman, was only a generation removed from the working class. Rather than strolling over from her parents' Upper East Side flat or from some demurely chaperoned women-only residential hotel, she took the el train to work from Brooklyn every day. She was also the same age, size, and outlook as the company's growing coterie of junior models—not to mention the younger readers it wanted and needed to attract. And by the summer of 1943, she really knew her way around a camera.

Franny's New World

Franny's first *Vogue* story ran in November 1943, a two-page spread on Pat Arno, the fifteen-year-old daughter of the *New Yorker* cartoonist Peter Arno and the magazine's fashion editor, Lois Long. Like Scott and Zelda Fitzgerald, Pat's parents had been an it couple during the Jazz Age. But unlike Scottie, she still had a foot in childhood—two years earlier, *Vogue* had run a story on what she'd purchased with her first clothes allowance—and her presence seemed the harbinger of a more optimistic new era, even though her parents were divorced and she was growing up in a country at war. Franny captured little Pat in a variety of attitudes that adroitly suggested her transition to womanhood: in one photo she wore a grown-up dress while dandling a marionette; in another she sported a pinafore as she molded a teddy bear from clay. The copy read as if it had been lifted from the coed-penned banter in *College Bazaar*: "Like any fifteen-year-old, she loves visiting overnight with her young girl friends. . . . She draws caricatures, models in clay, writes with a punching insight, reads and reads. Knows exactly what she wants in clothes." The photographs were unusual because Pat was so young, and she didn't seem to have been posed; she was simply going about her business in smart-looking clothes.

Franny's work was introduced in *Glamour* the following month, with six stories. One big fashion spread was on furs, shot on the

grounds of a simple New England church—the models strolled along beside it, apparently chatting to one another—and a spread on sportswear featured a model blowing on a cup of coffee to cool it down, which looked like a polished version of one of the snapshots that Franny and Fuffy were still taking of each other on their ski trips. There were also stories on face powder, dresses, evening harem pants, and charity gifts for children in hospitals.

The magazine introduced their new photographer on its "Behind the Issue" page, just above André Kertész, who had arrived from Paris a few years before. "His pictures have been in all the best magazines," the writer enthused about the great Hungarian photographer, while Franny "does the young and gay in fashion." Her bio also mentioned that she was "the twin of another photographer, Fuffy." After summing up the twins' joint art school and Prix de Paris history, the writer added, "Models find it very confusing to be photographed in two different places by what looks like the same girl, even to the clothes." Identical photographers were bad enough, but identical bylines might drive the production department crazy. It seemed to spell the end of any hopes the other McLaughlin twin might still have harbored for a career at Condé Nast.

Much of Franny's work for both magazines was in the studio, where she learned to wield a large-format eight-by-ten—"quite a challenge," she said, since so far her expertise lay with more portable models, such as her own Rolleiflex and the Graflex, which she and Fuffy had learned to use at Pratt. For *Vogue*, her beat soon expanded to diplomats' daughters, young dancers, actresses and film stars, such as Shirley Temple and Judy Garland, and other junior members of society. For *Glamour*, Franny worked in color from the start—usually straightforward shots of models in pretty dresses, suits, and sportswear, sometimes accompanied by a soldier, or sitting next to a dog and holding a fishing pole, to enhance the mood.

But where she really shone was in location work. *Vogue* had inaugurated its first "Junior Fashions" section the month she was hired,

with a six-page spread of junior dresses and suits shot by Toni in Washington, DC, focused on "the young who live in the nation's capital," and now the magazine was following it up with regular junior coverage featuring diminutive, girlish-looking models wearing clothes created expressly for this type. Photographers and editors were free to choose their own locations and to run with their own ideas. "It was fun because we didn't have anyone leaning over our shoulders," Franny said. "Anything you thought of, you did." For one 1944 *Vogue* story, she followed a group of suited juniors through the sort of galleries she and Fuffy had visited as students; they're seen mulling over folk art at Edith Halpert's Downtown Gallery, one of the first places one could buy it, and a show of traditional Latin American clothing at the Brooklyn Museum. Soon after, she photographed Tee Matthews, a high school bathing beauty who'd recently been discovered in Florida by *Life* and had come to New York City to make her fortune. Franny captured her hugging a poodle in midtown, looking lost and naive in the big city. *Vogue* had posed models in art galleries and on street corners before, but perhaps because Franny and Fuffy had spent so much time photographing each other all over New York, Franny's photos of young women moving around town had an ease that was more typical in pictures of models running and leaping on the beach.

The same thing happened in the pictures she made for *Glamour*, where the models were more grown-up, and the locations were grittier and more streetwise. Here her subjects never seemed to pose; instead she seems to happen upon them in passing, as they walk around City Hall or Chinatown or stare down the subway tracks for a train. For a March career issue, she got a group of *Glamour* Career Girl Councillors—the work-related equivalent of the college board—to lean out over the balcony of the Museum of Modern Art and look at the street below, as if posing for a photo taken by a friend who just happens to be a great photographer. The next month, for a summer suit feature, she took her models to train stations. The lead shot features a girl smartly attired in black and white who walks

purposefully up the subway steps into the grimy vaulted glory of Penn Station's vast waiting room.

A year after Franny started at the company, this streetwise, journalistic look she had been cultivating for *Glamour* finally made it into the "Junior Fashion" pages of *Vogue*. That month, she was given almost every picture in the section, which opened with a glowing color shot of a girl in a fuchsia trench coat standing like a goddess before a window overlooking a foggy midtown street. The rest of the page is filled with tiny, blurry thumbnail snapshots that illustrate the many ways New Yorkers protect themselves from the rain: there are racks of coats being rolled through the Garment District; navy men striding along the street in dress blues; a chic new raincoat boutique; and a surly woman swathed in plastic sheeting, a photo Franny had snapped with the Voigtländer four years earlier at Pratt. The same formula was used throughout the section, with studio shots of dance frocks offset by blurry snaps of couples samba dancing in a frenzy, and a picture of a Broadway dancer lounging in an alley surrounded by tiny pictures of young women showing off a wartime fashion trend born of rationing—wearing Capezio ballet flats instead of shoes.

"That's why Alex Liberman hired me on that first bounce, I guess," Franny said. "He saw something in my pictures that was this action that other people weren't doing." He would always use the pictures when the girl was in motion, or where the handbag or the background was blurred. "He encouraged that." And Liberman was only too happy when she had her models pose in alleys or under the Third Avenue el. "Could you imagine any other place using that?" she said. "Alex loved that! The minute you did something he liked, he let you know."

If Liberman didn't like something, he also made that clear, but obliquely, with comments like "Don't use that model again" or "I don't know what you were thinking of—what was in that corner?" He might give the assignment to someone else and say it hadn't worked out. But otherwise, he offered no instruction, other than "Just do

one of your marvelous pictures." Franny was astonished to hear him say the same thing to much more experienced photographers, too, such as the Swiss emigré Herbert Matter, known for his surrealistic work, whom she and Fuffy had considered "our dream" photographer when they were in art school. Back then, Matter had been working for *Bazaar*, where one of his best-known covers superimposed a brilliant-green butterfly over a model's face so she appeared to be wearing the insect like a fascinator with a veil. He moved over to *Vogue* and *Glamour* just as Franny arrived, and sometimes when she'd pick up her assignments for the week, Matter would be getting his as well, and Liberman would tell him, "Herbert, just do one of your marvelous pictures." Then Liberman would turn around and tell Franny the same thing.

DESPITE LIBERMAN'S LOW-KEY COACHING, and the stimulation of working in the studio, it was a tough time to start out there. Film was rationed because of the silver it contained, so there wasn't much room for mistakes. To make it go further, Franny learned to warm up her sitters by pretending to take photographs. When the moment was right, she'd quietly signal her assistant, who'd load the camera; only then would she start shooting in earnest. "You'd have maybe three sheets of film to work with," she said.

Rationing also created tension about things that in better times might have been minor crises. "You couldn't get new lenses, or new anything. Break or lose a light meter—you were dead." That meant location shoots were even more vulnerable than usual to theft. Once on a trip to Connecticut, her camera case was stolen, along with the camera and a roll of exposed film. Even though the local radio station broadcast an appeal and a reward for the exposed film, there were still no takers. Because so many people from the studio had joined up and "there wasn't anyone there to really do a good job" of processing pictures, she stayed there till late at night developing them herself.

All throughout the magazine world, men were going off to war. Leslie Gill, her former boss, had volunteered for an Office of War Information job soon after Franny left; he was now nearly six thousand miles away in Cairo. Don Honeyman, who'd been put on staff after winning *Vogue*'s first student photography competition, held the same year as Franny and Fuffy's Prix, had joined the army just before Franny arrived. After working there for a little over a year, Irving Penn, Liberman's first young American hire, volunteered for the American Field Service as an ambulance driver. Young women were disappearing, too, such as Bettina Wilson, the fashion editor, who joined the Red Cross to run rest camps in Cannes and Nice, packing a black Norell gown and an opossum fur cape along with her bedroll and uniforms because she couldn't bear to give them up. Cecil Beaton, forgiven his anti-Semitic episode, had rejoined the London studio; but now even he, too, had left to become an official war photographer for the British Ministry of Information.

Refugees arrived to replace those who'd gone, and many filling in for the assistants were young women. Although they never complained about what they'd lived through before reaching New York, some were quite hostile toward their American counterparts. One of Franny's assistants, a young émigré called Liesl, frequently found fault with American women and their lingerie. "European women don't wear petticoats, they're so *dirty*," she'd complain. Another smoked heavily, and whenever she and Franny took a cab together, she'd exhale straight in Franny's face, even though Franny couldn't stand cigarettes.

Among the photographers who remained, there were no overt rivalries—"Alex knew how to juggle people," Franny said—but one of the refugees, Joffé, always got upset with her when she used one of the Graflex cameras, which she often took with her on location. It had a pop-up viewfinder with a velvety collar, and when she bent to look down into it, she often left the edge marked with lipstick. "He was a very good photographer," Franny said, "but he used to get mad about that."

Joffé was under pressure himself: before the war he had been a top photographer in Paris, but then he had joined the French Army, been captured by the Germans, and ended up in a POW camp, a horrifying experience he had written about for *Glamour*. Somehow he had escaped and made his way to New York and Condé Nast. The company had been testing him out, hoping to break his "very French fault of too much retouching," as Vogel, a consultant for Condé Nast, had written to Nast in a memo. The results of his first assignment, a year or so before Franny arrived, had been "terrifying," Mrs. Chase had confided to Nast. Joffé was over the worst of that now, but maybe it wasn't only the lipstick that got his goat; perhaps it also pained him to be around someone who came by the more casual American style so easily.

CHAPTER 18

Woman Power

Franny had not been the first young woman recruited to the studio. A year earlier, Nast, Agha, and Vogel had considered asking Lisa Rothschild, a teenage refugee from Berlin, to join the staff. Lisa had arrived in New York in 1939 accompanied only by her widowed mother; although she was only seventeen, she listed "photographer" as her profession on the ship's manifest. In 1941, already two years out of college, she won an honorable mention and $3.95 (nearly $85) in *Popular Photography*'s annual Picture Contest, whose prizewinners were shown at "leading museums, public libraries, and department stores all over the country," with a photo called *College Girls*, of two young women standing with their horses in a field, which showed off both her compositional skills and her savvy about the market. The following year, the Condé Nast studio hired her as an apprentice photographer, but only on a freelance trial basis.

"Lisa Rothschild is something of an infant prodigy," *Glamour* wrote of the company's discovery in its May 1942 contributors page. "She's a full-fledged professional photographer, and still only nineteen years old." She had three features in the magazine that month: a summer suit story, a four-page pictorial on Red Cross nurse's aides, and the monthly "Rising Star" fashion promotion of junior clothes selected by the editors for the magazine's proverbial "Rising Star"

reader. This wunderkind's work also appeared throughout Condé Nast's other magazines, including *House & Garden* and *Vogue*, sometimes under the simpler byline "Lisa." The company quickly decided against bringing her on staff, however, concluding that while she was certainly "very gifted," as Vogel had told Nast in a memo noting the pros and cons of their photographers, her work wasn't any more innovative—or cost-effective—than that of the other freelancers. Worse, she didn't get on particularly well with her colleagues in the studio. (The company executives never sounded completely satisfied with what they had and tended to analyze the photographers in cold, harsh, and calculating terms, weighing their cost against their inventiveness and rate of return; during this period they even considered axing the much-lauded Horst, who wasn't satisfying their investment as handsomely as Rawlings.)

Next there was some discussion of trying to develop Nada—the daughter of Patcévitch, then Nast's second-in-command, who in Vogel's view was "sensitive, intelligent, and cultured"—from an amateur into a professional photographer. "Mr. Nast and I," wrote Mrs. Chase to Jessica Daves, *Vogue*'s managing editor, "are most anxious to have her have a good chance at a real sitting." But between Nada's vacation schedule, poor health, and lack of interest and confidence, the idea never panned out.

Agha had missed his chance to hire Louise Dahl-Wolfe, *Bazaar*'s star photographer, back in the early 1930s, when she was starting out in New York. She had sent him her portfolio, and he had returned it with a note meant for Nast, which dismissed her as being too old. "She has taste but on account of her advanced age . . . perhaps a little too late." (She wasn't quite forty.) Once Dahl-Wolfe became successful, the company had tried to poach her, without success, after which management frequently discussed how to "influence our various photographers in order to help them to acquire her special qualities," Vogel had once written to Nast. Although company management never quite defined those qualities, they considered her

the "only one conspicuous photographer of portraits and fashions" to have "appeared in the periodicals outside of the *Vogue* orbit," as Crowninshield had allowed in the 1941 camera issue.

However, after Liberman was hired and began exerting his influence on *Vogue* and the other magazines, more female bylines began to appear, especially at *Glamour*, where their proliferation was likely aided and abetted by Cipe Pineles, a Viennese expat in her thirties who had been named the magazine's art director in 1942, becoming the first woman in America to win that title at a mass market magazine. While Pineles was art director, Kay Bell, who had been a fashion editor at the magazine for some time—*Glamour* had three—borrowed a Rolleiflex and took a few photographs on a dare, suddenly stumbling into a new career. (Apparently Kay had quite a personality, too: an early *Glamour* bio notes that she had a passion for black-and-white animals, crazy hats, and the color red and could bark like a dog, which she had once done live on the George Burns and Gracie Allen radio show.) By the time Franny was hired, Kay had opened her own studio and was well established as a photographer for *Vogue* and *Glamour*. The following year, Halley Erskine, another member of the *Glamour* fashion editing triumvirate, also began taking photographs for the magazine, although she remained on staff. The third *Glamour* fashion editor, Jane Troxell, had started as a photographer for the department store B. Altman.

Generally Liberman liked the idea of having women photograph the models because he believed that they were better at capturing their kind au naturel, unawares and in the wild, as though they weren't being observed. He felt it gave some insight into the interior life of the woman in the photo. "I had a theory that perhaps women photographers would bring a certain understanding to their images of fashion," he said. However, his views on female photographers weren't entirely flattering: "They have a certain quality, women. They lack the aggression that the great men photographers have, but there is a sort of suave, in some of them."

Perhaps that is why female photographers were usually relegated to the junior section of *Vogue* and kept off the cover of *Glamour*, except for Toni, who was a star and had produced plenty of *Vogue* covers in the past. Kay Bell, who had likely been in the fashion world for at least as long as Toni, did make *Glamour*'s cover once, in 1944, with a photo of a girl waving a red flag over a war bond for the patriotic month of July. But how far Franny's "suave" sensibility would propel her career had yet to be determined.

INCREASINGLY, YOUNG WOMEN ran and leapt through the pages of magazines, partly because it was the fashion of the times, and also because it dovetailed with good patriotic propaganda. Throughout the war there was an understanding between magazines and the Magazine Bureau, a branch of the Office of War Information overseen by Dorothy Ducas, a journalist and *House Beautiful* contributor who had been appointed to the job because of her close friendship with Mrs. Roosevelt. Under her direction, magazines were encouraged—or, as Franny saw it, "not asked, but really ordered"—to do at least one monthly story on the war effort. The bureau produced a bimonthly publication, the *Magazine War Guide*, which by the end of 1943 was sent to more than nine hundred magazine staffers and a thousand freelancers.

It was filled with story ideas and picture suggestions, such as focusing on Red Cross workers or victory gardens or the experiences of women in Europe. That's why, for July 1943, *Glamour* ran Horst's photo of a girl in a candy striper's uniform embroidering a cushion with an American flag, while *Bazaar* used Blumenfeld's picture of a WAAC surrounded by waving flags, *Life* ran a photo of a U.S. fighter squadron carrying a flag-draped coffin through a field in Tunisia, and *Town & Country* boasted a photo of flags flying from the mast of a navy patrol ship taken by Lieutenant Commander Steichen, who was now running a special unit of navy photographers. (Apparently

he had offered Toni a spot in the unit, but she refused, pleading her domestic responsibilities.)

"It was just part of the game," said Franny. "One month it would be about nurses, another it would be Marine Corps girls." She was sent to photograph the female marines at their boot camp at Parris Island in South Carolina, but the story never ran. "It didn't hurt but it didn't help that much. It was all for morale."

Fuffy was less cynical—after all, Toni, her boss, was the official photographer for the WAACs. "The war was going on, but the government in general made you feel by working at a magazine you were helping the country to move ahead," she said. Although Jimmy had registered for the draft, his psychiatrist had got him classified 4-F, or unfit to serve; but his career had also taken a patriotic turn. Early on, he had photographed women working in factories, and his *Ladies' Home Journal* covers of glamorous nurses, WAACs, and WAVES were eventually used as posters to encourage more women to serve. When magazines presented upbeat images of working women, Fuffy said, "It was thought that we were contributing to the economy."

One of the big problems confronting the Magazine Bureau was the need to persuade more women to go to work. When Paul V. McNutt, the former governor of Indiana, was appointed head of the War Manpower Commission, or "manpower czar," Washington wags joked that his title should be "womanpower czar," because his real task was to convince several million women to work in factories, "most of them housewives who do not have to work," wrote *Fortune* magazine, "and are not sure they want to."

For magazines geared toward working women, however, the Magazine Bureau was preaching to the converted. *Mademoiselle*, still the magazine to beat, happily turned over its career pages to wartime jobs, running monthly segments about young women who had joined the WAACs, the WAVES, or other military units, or who had volunteered as block leaders or nurse's aides. In place of the usual makeovers and design competitions, the magazine instituted

a Practical Patriotism award, consisting of a certificate and a Cartier sapphire merit badge, given to young women who contributed to the war effort. Some of the jobs they profiled became fodder for fantastic pictures. To illustrate a story about "deglamorized cowgirls," young women milked cows, branded colts, and reined in steeds; another story, about women who assumed civilian pilots' duties during the war, freeing men to go into combat, featured a photograph of two women smiling from the cockpit of a plane. *Mademoiselle* even published a piece by McNutt, "This Is a Workingwoman's War," in which he promised, "The woman in overalls with a riveting gun in her hand will become as much a symbol of this war as the parachute trooper with his submachine gun."

Condé Nast also leapt into the fray. Just as Franny was hired, in response to a call from the Magazine Bureau to use covers featuring "a woman or women in any kind of work which contributes to the war program," *Vogue* ran a photo by Rawlings, one of their more established photographers, of a smartly dressed woman perusing a job application from behind a veil. The cover line read, "Take a Job! Release a Man to Fight!" Inside features demanded, "Why aren't you working?," and suggested the new and varied jobs that might suit a modern society woman—not only factory jobs, but also selling war bonds, working as a nurse's aide, volunteering for the Urban League, or training student pilots. The cover won honorable mention in a magazine cover-design competition at the Museum of Modern Art, "on the theme of Women in Necessary Civilian Employment," the press release read, which was cosponsored by the Office of War Information and McNutt's War Manpower Commission. *Vogue* was the only fashion magazine to place, ranking alongside *Collier's*, *Pennsylvania Farmer*, and *Modern Screen*.

Glamour, as its competition entry, had put Uncle Sam on the cover, pointing his finger past a girl in a sensible black-and-red-checked dress and aiming it at the reader. Once rebranded as "For the girl with a job," the magazine had backed up its tagline by creating a Job

Department, soon to be fully staffed, which canvased readers, read and answered letters, interviewed personnel directors, and analyzed job trends. "You're Doing the Work of a Man . . . Think like One," read one early column headline. "Accept criticism in the spirit it's offered," the story suggested. "Don't wear your emotions on your sleeve. . . . Resist the temptation to gossip. . . . Try not to show what an individualist you are." The editor advised trying to figure out how to turn a hobby into a wartime job—and noted that she herself, after hours, was studying for a pilot's license.

For one *Glamour* career story, Franny went up to Hartford, Connecticut—"a working girl's town with 58,000 career girls, one of U.S.'s largest concentrations of girl workers," the story read, and "the perfect place to track down the girl-with-a-job." She photographed the women "in humming, whirring factories; in huge, famous insurance companies . . . swarming through the city like so many industrious, buzzing bees." They are seen driving trucks, leaning over test tubes, and inspecting engines and parachutes. One girl worker in a jumpsuit stands before a biplane as the wind on the tarmac blows her hair. "Hartford girls are air-minded," the caption reads. "Some want to become commercial pilots; all would like to buy planes."

Yet there were limits to what *Glamour* would let Franny cover. While on the trip, she and her editor visited some servicemen recuperating at Avon Old Farms, a boys' school that had been turned into a convalescent home for blind soldiers, where she was horrified to discover that many of the men, survivors of the brutal North African campaign, had been burned "almost irreplaceably," she said. "That was quite a shocker, because the papers and the news didn't feature what was really going on in the world, and I didn't know." Nonetheless, she continued taking pictures. While photographing a black soldier, her flash went off directly in front of him and he cried, "I see a light! I think I see a light!," when it was obvious he couldn't see at all.

By now, three years into the war, photographs of dead and wounded Americans overseas had begun to appear in magazines.

A few months before Franny's trip, Lee Miller, *Vogue*'s European correspondent, had returned a dispatch from an American field hospital in Normandy that opened with a surreal picture of a burn victim whose face, torso, and hands were completely swaddled in white bandages—an image that had put the lie to Liberman's belief that women weren't aggressive as photographers. The *Magazine War Guide* had recently advised that huge numbers of wounded were being cared for stateside and welcomed journalists to visit, but the emphasis was on the "highly specialized medical and surgical treatment"expended upon their care, rather than the horrors they might have to live with. Franny's pictures of girls working in Hartford got a seven-page spread in the magazine, but the only trace of her visit to Avon Old Farms was a tiny thumbnail snapshot of a young woman teaching a smiling blind man to dance.

CHAPTER 19

Fuffy's New World

Meanwhile, things in Fuffy's work life were uneasy. "I couldn't stand having Franny a full-time photographer and I was an assistant!" she said. "That was just not manageable for me as a twin. You compare yourself to your twin. You don't really compete with her, but one can't be the assistant and the other one the star."

So sometime in 1944, the year after her twin became a Condé Nast photographer, Fuffy quit her job as Toni's girl Friday. One of Toni's previous assistants, Anne Simpkins, now had her own studio and a viable career shooting fashion spreads for *Junior Bazaar*, which was the reinvention of *College Bazaar* and had run as a regular section within the magazine since March 1943. It was also produced as an annual stand-alone fall issue. It didn't seem unreasonable that Fuffy might have a similar success. "We knew people," she said. "It was easy in those days. Cinderella-like, I guess."

She found a friend to take her place—Virginia Thoren, who had been a year behind the twins at Pratt. Ginny was now an assistant in *Vogue*'s art department, where she was a great favorite of Crown-inshield's. The editor, known as "Crownie," had a habit of becoming familiar with the young women in the office; he had noticed and befriended her while she was waiting for her interview and peri-odically took her out to lunch to regale her with war stories about

his hunting trips with Nast. But the idea of getting to know all the famous photographers in the Condé Nast studio was enough to entice Ginny away, and Fuffy, having secured her replacement, was finally able to give notice, although "I left with some regrets," she said. "It had been a very interesting experience." (Ginny eventually became a well-known photographer, but not until much later; she lost the job with Toni after a year when, her unpublished oral history says, she "miscalculated the train time to Oyster Bay, and arrived with the equipment too late for the session.")

Jimmy rushed to help Fuffy, offering her his studio in the *Bazaar* building as a base, just as he had done with Fernand and many others. "He took pity on me," Fuffy said. Later she explained that because they had been going out "for a year and a half or so," as she recalled it, "I just sort of moved into his studio and used his facilities and helped him and I was just in business."

But Jimmy's studio came with strings attached. She had already learned a lot from him about darkroom technique: how to mix the acrid-smelling developer to his liking, and how to sense how hot or cold the water should be for the negatives to come out as she chose. "He was a beautiful technician with very high standards of quality," Fuffy said, and she had risen to meet them. Yet now, although daily proximity had brought them closer than ever, she frequently found herself roped into mixing developer for him and helping out with his assignments—acting as something of a glorified girl Friday. Jimmy claimed he would have done that with anyone, even the models. "Everybody was all-purpose," he said. "We would let anybody do work who crossed our path."

He also proved a distraction in other ways. With Franny sidelined at Condé Nast, Fuffy spent more time with Jimmy in Manhattan, and also during the summers in Montauk. Now he was building a house at the seaside, and Fuffy was drawn into that, too.

She had been in Montauk with him when he suddenly hatched the plan. When Second House, where his sister's husband's family lived, was too crowded, Jimmy and his guests had to find lodgings elsewhere.

That day, he and Fuffy were staying just up the road, with a woman who ran an inn and also sold real estate. The landlady greeted them at breakfast one morning with the news that she had a visitor in her kitchen: a widow, who was in tears over a small plot of land she was desperate to unload. Jimmy, who "always loved old houses and antiques and land," said Fuffy, immediately agreed to take a look. Fernand Fonssagrives, who was out visiting at the same time, went along, too.

The plot, a 150-foot-long stretch of ocean frontage along the Old Montauk Highway, was so thick with vines and brambles that they had to hack their way through from the road with a machete before they could even see it. Once there, they stood at the edge of a forty-two-foot-high bluff overlooking the Atlantic, awed and intoxicated by the salt spray, and the constant, crashing waves. One hundred dollars later, Jimmy owned the land, part of a parcel that had been carved out by the Olmsted Brothers for Carl Fisher, the developer who had tried to transform Montauk into a Miami Beach–like playground for the rich before the Depression had hit. Straightaway, Jimmy resolved to put up a house, even though he'd been told, over and over, that wartime restrictions severely limited new construction. Fuffy recalled the size allowed being no larger than a two-car garage, with no more than $700 to be spent.

But Jimmy was determined. He spent the fall and the winter dreaming and making drawings of a shingled cottage near the edge of the cliff, a one-room cabin that would be as snug and neatly made as the hold of a ship. It would have built-in bunks modeled after those in the *Charles W. Morgan*, the nineteenth-century wooden whaler that had recently gone on display at Connecticut's Mystic Seaport Museum. Kerosene lamps would provide the lighting, food would be stored in an icebox, and water would come from a freshwater well sunk into the beach. Fuffy helped him figure out the dimensions and the design with pegs and string on the lawn of Second House.

The following spring Edward Pospisil, the local master builder, went to work, with lumber salvaged from other buildings. "Eddie was

really a cabinetmaker of great skill, almost like a shipbuilder," Fuffy said. "Jimmy would make a sketch and he'd make everything in his shop. Then he'd bring it back and set it in." The final price was $402.80 (about $6,900 today) for materials and labor. Other than for a small coast guard tower to the east, Jimmy now possessed the only building on that stretch of the beach. He drove a signpost with his name into the ground beside it, added a weathervane to the roof, and a hitching post in the shape of a horse's head, and he was done—at least for a while.

Montauk was an active military base again by this time, and even though the beaches remained open throughout the war, what tourism there had been dried up, with most of the action centering around the military and migrating to the base, which held dances and showed movies. Fuffy spent time photographing the old whaling village of Sag Harbor and its crumbling buildings.

Although Fuffy now seemed to be Jimmy's favored twin, and to all intents and purposes they were a couple, Franny continued visiting, and Jimmy still enjoyed the company of them both. While the twins had mostly stopped dressing alike, unless they were doing a publicity shot or wanted to create an effect for a special occasion, they seem to have carried on doing so with Jimmy in Montauk. He photographed them, and they photographed each other, in matching McCardell sundresses, and also in a pair of white halter dresses that he designed and they ran up. Once, a navy weather kite washed up on the beach, and Fuffy and Jimmy spent the day wrestling it ashore and trying to set it aloft again, while Franny photographed them doing it. They both wore matching swimsuits Fuffy had made from Indian-print fabric, copied from suits Toni had brought back from Hawaii. Another time, a friend photographed Franny, Fuffy, and Jimmy in a trio of matching swimsuits, made by the twins from Hawaiian fabric, as all three of them stood in the sand together at the Montauk Surf Club.

Perhaps the matching outfits and their closeness reinforced the idea—at least in the eyes of others—that Jimmy still had a harem.

"It was always a joint venture," said Mia, the daughter of Lisa and Fernand Fonssagrives, who encountered the twins as they entered Jimmy's life when she was just a baby. As she recalled it, her family would go out to visit, they would have parties on the beach, Jimmy and her parents would sunbathe in the nude, her father would cook (he "was very good in the kitchen, he was always cooking *moules marinières* and the pie his mother taught him called *dartois aux pommes*"), and in the beginning "they were always together. It was like Jimmy's little sister wives for a while. Jimmy, Fuffy, and Franny."

Mary Lou Malany, the Montgomery Ward assistant who had been at the shoot where Franny first ran into Jimmy, also considered them a trio. "Dearest Jimmie," she wrote from Taunton, Massachusetts, in 1944, where she had moved with her new husband two years after that encounter, "you & the twins should come & visit us."

The same assumption held at Second House, Jimmy's home away from home until he built his Montauk cottage. David Tyson, the son of Carolyn Tyson, the East Hampton arts doyenne-to-be, whose family owned the eighteenth-century dwelling, recalled that it was Jimmy's psychiatrist—the one who got him classified 4-F—who eventually forced Jimmy to decide between Fuffy and Franny, and that the decision-making had continued for quite a while. David's father, also named Jim, had been in analysis with the same psychiatrist, and Jim and Jimmy had frequently discussed their therapeutic progress. "Jimmy was going out with both twins, and she told him he had to choose," David said. "That's the way my father put it."

Jimmy's first son, Jamie, didn't recall meeting Fuffy by herself; but he remembered staying with both twins out at Montauk after the cottage was built. At night, he was put to bed in a small built-in bunk at one side of the room, while Fuffy and Franny and his father climbed into the larger bed under the front windows. Jamie didn't go into further detail about what happened. But "I don't think he got into a bed with two voluptuous women and they played charades," Jamie said. "The sleeping arrangement" was "indisputable."

Indeed, decades later, Jimmy's daughter, Lucinda, recollected her father telling her after his mother's funeral that he hadn't known which twin to propose to. Even in his late sixties, the decision still resonated in his mind as having been a burning quandary.

Would Franny have said yes if he'd asked? She never voiced a public opinion on the matter. But whenever Fuffy spoke of her relationship with Jimmy, at least in retrospect, she made it sound as though it had all been settled soon after they met.

SOMETHING ELSE THE TWINS were doing together was working out quite successfully. Once Fuffy went out on her own as a photographer, magazines started writing stories about the twins. As they both became fair-haired girls in the eyes of the world again, the scales that had been out of balance seemed to equalize.

At the end of 1944, *Women's Home Companion*, one of the country's bestselling women's magazines, ran an item in its "Look Who's Talking" column that suggested the pair were designers as well as top fashion photographers. "This isn't a double exposure but a portrait of the McLaughlin twins, Franny and Fuffy, who could pass as models for the photographs which they take for top fashion magazines," the story began. It was accompanied by a portrait of the twins in profile, identically dressed and smiling skyward in Condé Nast's open-air studio at the top of the Grand Central Palace, with Fuffy holding a Rolleiflex, as though they still shared a single camera. Growing up, the story continued, the twins "made everything from their own Christmas cards to tricky leather pocketbooks. They've knitted thirty-six sweaters, two dresses, several afghans and a drawerful of socks and mittens. Their favorite mitten pattern was sold to a glove manufacturer." The story concluded with Fuffy's advice for young shutterbugs: "First of all you have to be camera crazy. You take hundreds of pictures and train your eyes to get exciting backgrounds, composition and good lighting. The mechanics of

taking pictures is simple . . . capturing the split-second moment is what counts."

Another story the next month, in *Vogue Pattern Book*, for which Franny was also a staff photographer, was told from Franny's perspective. Here, the "small, sleek McLaughlin twins" posed in identical jersey suits they had purportedly made themselves (from *Vogue* pattern No. 5306), jazzed up with matching leather belts and black felt cloches, amid the massive cameras of the Condé Nast studio. This time they explained their philosophy of making and designing clothes, which they'd done since the age of fifteen. Conservative fabrics and colors were imperatives for twins, for "nothing is quite so hard on the eyes as an over-size print or a screaming colour twice," Franny was quoted as saying. "Because we feel fabric quality is a *must* for that made-to-order look, Fuffy and I keep a collector's eye open for one-of-a-kind remnants, buy them no matter what the season. . . . Twins have a wonderful advantage over the solitary sewer. We apply the assembly-line principle to dressmaking. . . . We fit each other super-critically, having found fittings to be the turning point between professional and amateurish results."

A third story, in the *Prattler*, the Pratt school newspaper, quotes them speaking jointly about their time as students. "'We learned how to experiment at Pratt,' said Fuffy, 'and they taught us to keep high standards for ourselves.' Fran added that an art background distinguishes many successful photographers from the rest." (The story claimed, perhaps erroneously, that Fuffy was doing "loads of work for *Glamour* magazine," while Franny was on the staff of *Vogue*.)

Magazines loved stories about young women's careers, with one growing area of opportunity being in photography. By 1945, so many young women had become active in the field, not only behind the lens, but also as darkroom assistants, salespeople, assignment editors, and more, that *Popular Photography* devoted a cover story to the phenomenon. Photography was welcoming to women, claimed the author, Etna M. Kelley, who frequently wrote for the magazine

about new directions, "partly because of the war and partly because of the general trend to widen woman's career horizon beyond the schoolroom and the office." The rarefied world of New York fashion was one of the "branches of photography in which women are inherently adapted to work," she added, making particular note of Toni, Louise Dahl-Wolfe, Kay Bell, and Lisa Larsen—the onetime Lisa Rothschild, who had changed her name to something less Jewish and more American sounding, presumably the better to assimilate.

Some believed Larsen had chosen her new surname—the same as that of *Life*'s publisher, the marketing genius Roy Larsen—in hopes of getting more assignments from the magazine. When asked if they were related, she is said to have responded, "I am not to comment on that question." Whether this was her motivation or not, she went on to have a glowing career as a *Life* photojournalist. But at this point she was working for the Black Star photo agency, founded by a group of German refugees, and had become a much-loved subject in *Popular Photography*, where stories about her assignments, whether in Hollywood or New York, frequently appeared in its "The Magazines" news column. On one occasion, the magazine gave her a very complimentary caption: "Lisa Larsen, herself a glamour girl, has been successful in making magazine photo-sequences, glamour pictures, and informal fashion photos."

Certainly, being a glamour girl didn't hurt if one wanted to make one's name as a photographer. It also didn't hurt that the market for young women's magazines was growing. Just as the success of *Mademoiselle* had spawned *Glamour*, so did the success of *Glamour* give rise to another publication created by *Mademoiselle*'s publisher, Street & Smith. Years before, when *Glamour* was easing away from its Hollywood focus and becoming even more like *Mademoiselle* by transforming itself into the magazine "For the girl with a job," Street & Smith turned the tables and made over its own movie publication, *Picture Play*, into a career-girl magazine with a Hollywood edge.

Mr. Nast, affronted, had penned an icy memo to several of his editors about the situation: "As you know, the Street & Smith Publication, formerly called 'Picture Play'—given wholly to the movies, with little attention paid to fashions—is about to change its name to Your Charm. The publication, under its new name, will follow quite closely, the GLAMOUR formula."

After that, a low-level recruitment war always seemed to be brewing, with Condé Nast sniffing out and hiring disgruntled Street & Smith employees, and Street & Smith doing the same in reverse. But not until *Charm* recruited one of *Glamour*'s three fashion editors was Fuffy discovered. Only after that did her career take off. By then, the war was over and the men were on their way home.

CHAPTER 20

Victory

The day Germany surrendered, hundreds of thousands of people swarmed into Times Square. Over a public address system, Mayor La Guardia ordered them to go home or return to work, to no avail. Unlike Europe, America was still at war, with "three beachheads left—China, Japan and San Francisco," as a sergeant in Manila told *Life* magazine, so its celebrations were somewhat muted. Throughout the country, "there was a little cheering, a little drinking and a few prayers" followed by "a great sense of relief and of a dedication to the job ahead." New York was the only city to erupt in "a real hullabaloo," the magazine said, with "snowstorms of paper cascading from buildings. . . . Ships on the rivers let go with their sirens. Workers in the garment center threw bales of rayons, silks and woolens into the streets to drape passing cars with bright-colored cloth" before they, too, ran out to join the melee. The celebrants' ardor was briefly dimmed by rain. But by evening, the lights of the Great White Way were blazing again, for the first time since 1941, and Lady Liberty's torch glowed in the harbor once more.

Condé Nast sent Franny out with a camera that day to meet a returning troopship, together with *Vogue*'s famous illustrator, Carl Erickson, who went by the name Eric. A fop who always sported a cane, a bowler, and a boutonniere, he was sometimes trailed by

a brown poodle and exhibited a great fondness for good red wine. Early on in her career, Franny was often sent out with Eric to give him backup, in case he forgot to show or made drawings that were unusable. "He might put horns on the woman's head or something, if he felt like it," Franny said. "He was very much a surreal kind of person." (Or, as someone later assigned Eric duty in Paris recalled, "My entire professional training was a hissed injunction . . . 'Keep Eric sober.'") Together with the editor who had been deputized to get Eric there, Franny made her way downtown to the piers and was astonished to see men crawling over one another and out of the portholes in their rush to get ashore.

The real celebrations would come months later, after the bombs had been unleashed over Hiroshima and Nagasaki. "We tried to imagine what it will mean to a soldier," mused E. B. White in the *New Yorker*, "having gone out to fight a war to preserve the world as he knew it, now to return to a world he never dreamt about, a world of atomic designs and portents." But the returning troops weren't spending too much time mulling things over. Now when troop transports came into dock from Europe, the *New York Times* reported, the returning servicemen "didn't march, but literally danced down the gangplanks, singing as they went." Many of these men had been scheduled for redeployment to the Pacific.

As they poured into the city, eager to "hit the big town for at least a brief spell once they got their furloughs," *Yank*, the army weekly, noted that the borough of Manhattan, which had always been "a nervous, high-strung, cluttered-up place," now seemed "more restless, jangling and garish than ever before." Because of rationing, bus routes had been cut, steak dinners were unavailable on a Tuesday or a Friday, cigarettes were hard to come by, and the battered taxis that ferried people around town in big gangs seemed to be sputtering on their last legs. But New York hadn't been decimated the way European cities had been, and everyone knew it. So nobody cared. The war was over. And the men, slowly but surely, were returning.

Charm had something to say about the situation. "This is real, this is now. From all the parts of the globe, men are coming home," the magazine proclaimed in a beauty story entitled, "You'll Be Together Again." It was illustrated with a picture of a blonde in a tight pink dress, smiling seductively into a mirror from behind a lace fan. (The photographer was Menyhert "Muky" Munkácsi, the younger brother of *Bazaar*'s famous Martin "Munky" Munkácsi.) "For him, everything must be ideal, especially you. . . . Find out how to change the any-girl of yesterday into a one-and-only by the time the harbor whistles blow."

Yet more than a few career girls must have wondered, What happens to us? *Charm* addressed that quandary, too, in a report on "reconversion," or the shift to a peacetime economy, which seemingly arrived overnight. The war had once required women to step forward and take over men's jobs in all sectors. Now that the situation had changed, wrote Raymond J. Blair, the *New York Times* journalist who contributed the story, those with office jobs stood "less chance of unemployment than do women in heavy industry." Still, he warned, the office workers among *Charm*'s readership weren't entirely safe. "If you're holding down a job which once belonged to a service man," Blair wrote, "there's a good chance you may have to give it up to him when he gets back."

Indeed, as another *Charm* story asserted, "It's Going to Be a Man's World Again." Instead of hanging around with only "the solid female brigade" for company, as had been the case for the last three-odd years, now it was going to be "a heavenly world with men in it." Yet dreamy as that prospect might be, the accompanying picture—a Lisa Larsen photo of two glum-looking women wearing pants—suggested that it might be hard to put women's newfound career ambitions back in the bottle.

Despite such disquieting portents and the precariousness of women's roles in factories and offices, change came more slowly at magazines. Opportunity continued to blossom for quite a while, especially for photographers who were good at making pictures of young women leading lives that seemed to offer boundless promise.

At the war's end, the market for young women's magazines was not only growing, it was also getting younger. Publishers had begun to expand into the teenage market, too, aiming for the little sisters of the career and college girls who were reading *Charm*, *Glamour*, and *Mademoiselle*. Previously, this group had been allotted an occasional teen or "sub deb" fashion spread, such as Franny's first shoot with Pat Arno posing in a ladylike dress with a teddy bear. But with so many mothers working during the war, and their daughters consequently taking on more responsibilities for shopping, decision-making, and the like—and gaining more freedom, too—there was clearly room for something more.

The first magazine to test this market was *Seventeen*, launched in 1944 by Triangle Publications, but the brainchild of Helen Valentine, who had previously run *Mademoiselle*'s promotions department. Valentine had been recommended to Walter Annenberg, Triangle's owner, by Dr. Agha, who was working as a magazine consultant. Annenberg had originally approached her about transforming his flagging movie magazine, *Stardom*, into a grown-up fashion magazine, as Condé Nast had done with *Glamour* and Street & Smith had done with *Charm*, in hopes of picking up some of their overflow ad business, but Valentine, a grandmother, had countered with the idea of creating a teen magazine instead, telling Annenberg that teenagers "are really thinking about very important things and we ought to be thinking about them in those terms." She promised a publication that would treat them like young adults, naming it *Seventeen* because that was the age, she said, "when a girl is no longer a child, yet isn't quite a woman."

In her inaugural editor's letter, in September 1944, she wrote, "Are you interested only in yourself and your closest family and friends, or do you care what happens to people you'll never see? You're going to have to run this show—so the sooner you start thinking about it, the better. In a world that is changing as quickly and profoundly as ours is, we hope to provide a clearing house for your ideas." The issue included features on high school girls in Hollywood and Britain, a

country where they were encouraged to start full-time defense jobs at sixteen; a photomontage dedicated to pictures of the twenty-eight-year-old actor, dancer, and crooner Frank Sinatra; and a story about wartime job ideas for teens. "Here are jobs that help victory today, may lead to a career tomorrow," the copy read. "When the war began, it looked for a while as though you were going to be by-passed. But you have since proved that the head-shakers who said you were too young and too inexperienced were all wrong."

Meanwhile, in advertisements to the trade, *Seventeen* was offering up its teens as brand-new, as-yet-untapped moneymakers. "6,000,000 girls from 13 to 18—a $600,000,000 annual market for apparel and cosmetics alone!" the publisher had proclaimed in a *Women's Wear Daily* ad the previous month. "Circulation estimated in excess of 250,000 copies." Just before the launch, *Business Week* covered the magazine and its potential annual market, by then estimated at $750,000,000. Two months afterward, in November, *Newsweek* reported that *Seventeen*, "an outsized, thick and slick magazine beamed at the bobby-sock brigade," had sold out its initial run of 400,000 copies and had received hundreds of letters from readers. The magazine had bumped up its print run to 550,000 copies. Annenberg, seeking to find more paper rations so he could expand it further, decided that by January he would shutter another flourishing Triangle publication, *Click!*, then the country's third most popular picture magazine, behind *Life* and its imitator, *Look*, which had been founded a year later, and turn over its paper stock to *Seventeen*.

After the war, with the ad market even healthier and paper and ink rations no longer an issue, Carmel Snow and the moneymen at *Harper's Bazaar*, buoyed by *Seventeen*'s success, decided the time was finally right to launch *Junior Bazaar*, the revamp of *College Bazaar*, as a monthly. This time, however, they overhauled the concept completely, aiming at "girls of thirteen to twenty-one," their first ad said, with an upbeat focus on postwar style and attitude and a fun new design that recalled Soviet propaganda—but all in the service of promoting

postwar taste and style. Three girls marched purposefully across the first issue's opening spread, heading toward the stenciled slogan "We want the best"; on the next, girls gazed dreamily into space beneath a translucent banner that stated, "I must have something black. . . ."

"Its appeal is to the younger set and its editorial routine borders on the fantastic," *Life* explained in a preview story, illustrated with photos of the young, socially connected staff, the magazine's open-plan office, and its well-stocked refrigerator where the hungry youngsters fed. "Most of the art directing seems to be done on the floor. The art director works in bare feet. . . . Average age of the staff is 21."

The barefoot art director was Lillian Bassman, who was actually twenty-eight. Brodovitch, the famous art director who had reinvented *Bazaar*'s look in the early 1930s, had discovered her some years before and had given her a scholarship to his Design Laboratory, which he'd moved to New York and was now teaching at the New School; she had become his first paid assistant at the magazine. Bassman, who was married to a photographer, Paul Himmel, didn't actually have the *Junior Bazaar* job completely to herself. After Mrs. Snow gave her the project, expecting her to make the magazine look very different to the more established big *Bazaar*, Brodovitch had gotten wind of it and threatened to leave if he didn't have creative control. Mrs. Snow, to make peace, had suggested they share the assignment.

But the cover photo, of a laughing girl in a striped dress laid against an intersecting *V* of pink-and-blue bars, was indeed taken by a very young photographer: a twenty-two-year-old Richard Avedon, who had recently been demobbed from the merchant marine and was another Brodovitch discovery. Brodovitch had only discovered Avedon because of his extreme persistence, for he had famously tried to get the venerable art director's attention for months: every week he'd make an appointment to show him photos of sailors and fashion models, one of whom was his wife, a Conover girl, and every week Brodovitch would cancel the appointment. (The photos had crossed Liberman's desk, too, because of the models, and Liberman, drawn

instead to the blurry action shots of sailors, had tried to recruit Avedon as one of his young Americans, but Avedon had held out for Brodovitch and *Bazaar.*) When Avedon did eventually get the audience with Brodovitch, the eminence dismissed the photos of the women and turned instead to a photo Avedon had made of twin merchant sailors, one facing forward in sharp detail, and the other out of focus in the background.

"What he saw—pictures of seamen in action—made Brodovitch ask the boy to try doing fashions for the young in the same manner," wrote Snow in her memoir. "And when I saw the results I knew that in Richard Avedon we had a new, contemporary Munkácsi."

Not everyone at *Junior Bazaar* was in his or her twenties. As well as Brodovitch, the initial team also included Margaret Hockaday, now married and well into her thirties, the charismatic and inspiring editor who had discovered Fuffy and Franny at *College Bazaar.* That's likely how Fuffy began working for *Junior Bazaar*, too. She shot a story about shoes and another feature on sweaters. She also took over the accessories column.

It must have been a big step up, for until that point, at least on the evidence of her portfolio, Fuffy, who was still working out of Jimmy's studio, hadn't produced anything remarkable—or at least not anything with a byline for a major magazine. Most of her fashion shots seem to have been made with the same chipper-looking models that she and Toni had worked with at Montgomery Ward, which suggests that she was still doing catalog fashion shoots, or ads for moderately priced fashion brands, such as the dress chain Jane Engel or the junior line Peggy Paige. She may also have been helping Jimmy with overflow projects, or working on unbylined photographs for *Bazaar.*

But at the same time as her *Junior Bazaar* breakthrough, something else happened that was even more significant, at least for Fuffy. In late 1945, *Charm* hired Jane Troxell, *Glamour*'s third fashion editor, whom Fuffy already knew from her years working just down the hall from the Condé Nast studio. By now, having ditched the movie idea

entirely, *Charm* had adopted the tagline "The magazine for the BG*," explaining right beneath it that the catchy acronym meant "business girl." Before Jane arrived, the magazine was still using mostly men as photographers. But Jane had started out as a photographer herself, and after she arrived, *Charm* began turning to women.

First it was Lisa Larsen. Then it was Betsy Zogbaum, another former assistant of Toni's, who had originally learned photography from her husband, the abstract-painter-turned-photographer Wilfrid Zogbaum, who was away in the service. (Betsy later left him for the abstract expressionist Franz Kline.) Then Jane started using Fuffy, trying her out with a separates assignment for the November 1945 issue. By the following May, Fuffy had traveled to Florida, California, Mexico, and Cuba on location and was covering a third of the stories in the book. Suddenly, Fuffy became a "name" photographer. "My life in fashion photography started when I met Jane Troxell," Fuffy said.

So did her life of adventure. Leisure travel had been severely curtailed during the war. After Pearl Harbor, gas had been rationed, planes were primarily reserved for those in the war effort, and buses and trains were crowded to bursting transporting troops. But by the spring of 1946, these pressures had eased and Americans began traveling for fun once more. That year saw the founding of a new travel magazine, *Holiday*, which covered subjects such as the futuristic plan to transform the nation's roads into superhighways, European tourist attractions that had not been too badly devastated by bullets or bombs, the heavenly fishing that might be had in the Gulf of California, and playground memorials to those who'd died during the war. The publication was "dedicated to the pursuit of happiness," said its first editor's letter in March 1946, and created "for all of those who see 'go' signs on the horizon, for all of those who seek to get more sheer living out of life itself . . . [who] have heard promises in the West Wind . . . restlessly listened to a train whistle at night, looked longingly at an airplane in flight, or dreamed of being cargoed to far lands on a passing ship." And in "this new postwar

world . . . , recreation will be more important to everyone than ever before—more important in this busier world of new stresses and strains because more and more doctors are prescribing escape, and travel, and fun."

This interest in travel also spilled over to career-girl magazines, which began shooting fashion spreads in increasingly far-flung places. At *Charm*, Fuffy was often the photographer. First she was given a huge story, called "Fashion, Coast to Coast," which had nineteen pages of photographs, one of which was a foldout. Not all the pictures were made on location, one other photographer contributed a couple of photographs, and someone else did the shoot in California. But Fuffy was sent to Miami, where she photographed models sunbathing on the beach, fishing on a dock, and lounging at the Quarterdeck Club, a notorious invitation-only fishermen's club that teetered on pylons over the waters of Biscayne Bay. The "social center of the colony," *Life* magazine had called the establishment when it opened in 1941, hovering "between sea and sky, a $100,000 play-place equipped with bar, lounge, bridge deck, dining room and dock slips for yachts."

Next Fuffy went to Southern California for a swimsuit shoot, where Jane discovered a high school student named Carol McCallson, a brunette with intriguingly adult looks. They photographed her there, and also down in Tijuana, where Fuffy captured her in striped denim on a cart pulled by a "zonkey"—one of the town's famous burros painted with zebra stripes.

Charm also had a travel column, "Two Weeks with Pay," described as "the Baedeker for BGs," which suggested what the magazine's readership might want to do with the novel concept of time off. "While the war was on," wrote the author, Faye Henle, a recent Barnard graduate, "perhaps you rode the train to visit your Aunt Hester, or commuted to the theater during an abbreviated respite from the typewriter. Or perhaps you didn't bother with time off at all. At any rate, you're ready now for the best vacation ever." Henle's story focused on visiting state parks on the East Coast. But for the same issue the magazine sent

Fuffy to Cuba, where she did a vast number of shoots. One featured swimsuits and playsuits by designers such as Carolyn Schnurer, whose New York sportswear line, inspired by folk traditions from around the world, became popular after the war. (Schnurer's first big hit, in 1945, created after visiting the Andes, was the "Cholo" coat, modeled after the garments worn by local shepherds.) Among other shoots, Fuffy also photographed a young model in a pretty dress examining real-looking fake blossoms in an artificial-flower market; a group of three women in one-shouldered tops looking like statuary in a marble quarry; and a mysterious figure in a chambray suit casting a dramatic shadow as she walked through an empty cobblestoned square—a picture that might have been made by one of the Eastern European avant-gardists Fuffy and Franny had seen in *Coronet* and so admired as students. Fuffy also took her own private photographs on the trip, of buildings covered with torn posters and graffiti, and herself, regarding her own reflection in a fly-specked mirror in her hotel.

By then, Fuffy's stylistic range was enormous: back in America, she was making contemporary-looking color pictures of women lounging next to pools and walking barefoot on the beach, and even one of a woman in dungarees straddling a fence in a corral, about to rope and saddle up a horse. She created more artful, surrealism-inspired fashion shots, too, including a black-and-white series on winter headdresses where the models, dramatically lit with pin spotlights, seemed to float against deep rich black backgrounds, a technique she likely observed in Blumenfeld's studio, which she visited often with Jimmy.

Blumenfeld worked in the Gainsborough Studios building, an artists' cooperative on Central Park South, and she and Jimmy often stopped by on their way home from work to see what he'd done that day and hear his stories. He was already becoming known as a great experimentalist. Photography "is at its very beginning," he had told *Popular Photography* in 1944, "and every photographer with imagination and love for his medium can blaze new trails in technique

and discover new beauties to show the world!" Or, as the magazine put it, "Blumenfeld will try anything." He posed his figures behind wavy glass or veils, lit them from different directions with different colors, or solarized the film, overexposing it until the dark and light areas reversed, a technique popularized by Lee Miller and Man Ray. Blumenfeld had also developed a portraiture technique that replicated the look of a Dutch-master painting, pin-spotting the face and shortening the exposure, so the model's features seemed to glow in a pool of darkness. (This was the method Fuffy sometimes used to photograph models in hats and hair accessories.)

Many of her other pictures had a lighthearted air that recalled some of the photographs she had worked on with Toni. Just after she left, Toni had published a children's book, a new edition of Robert Louis Stevenson's *Child's Garden of Verses* illustrated with photos of her own children and their friends, some made while Fuffy was her assistant. In one picture, Sidney, her daughter, leans into the wind, tugging on a huge umbrella; in another, the girl leads a group of boys on a march through a grassy meadow. Toni played with the children rather than posing them, and then, "when they struck the right attitude, I'd act quickly," she said later. Some of Fuffy's fashion shots—of a woman in a raincoat pulled by her umbrella, or a girl in a big straw hat and shorts, kicking her way through the sand—display the same carefree attitude.

Still more of Fuffy's pictures summon up thoughts of twins: she often used similar-looking pairs of models, posed in such a way that one seems to echo what the other is doing. On one spread, two young women with sleekly coiffed hair stand on an ornately carved balcony, wearing junior-size dark and light ball gowns, as they dance away from each other. On another, two identical-looking models stroll outside Havana's Presidential Palace, one in a dress covered with brightly colored Mayan symbols, the other in a plain shantung sheath, close enough that they can almost reach across the spread and hold each other's gloved hands. And for one color shot, two women face

each other on the same page, one turned forward and the other back, showing off identical dresses in black and white, as they stand on a rocky ledge. "Sunlight and shadow," reads the copy.

This trace of twins in Fuffy's pictures might have been because she was not spending as much time with her own, for her relationship with Jimmy had progressed. One day when Fuffy was posing for pictures for a magazine story—one about her this time, and her many different outfits, styles, and looks—Jimmy arrived at the set with a ring and proposed.

Getting to that point had not been easy. Frankie, Jimmy's wife, was not really a concern, for she and Jimmy had enjoyed what their son, Jamie, jokingly called "a whirlwind romance and a whirlwind marriage" and were on fairly amicable terms. But Jimmy's mother, who had brandished a gun at Papa Abbe when he left for Paris, was distraught about the idea of being abandoned by her only son. Kitty was also beside herself: the first of her adored twins was splitting up the party, and for a divorcing man, which also spelled the end of Fuffy's relationship with the Catholic Church. (It's not clear whether Kitty ever realized Fuffy and Jimmy were living together prior to the engagement: the twins never talked about how they had managed to extricate themselves from her clutches and move out of the Brooklyn apartment, they just somehow miraculously did it—although Franny once commented that moving in with a man would have been easier to keep secret from her mother than a marriage.)

As for the psychiatrist, once she had succeeded in getting Jimmy to choose between the twins, she had taken it upon herself to vet Fuffy in person, to make sure she passed muster as appropriate marriage material.

But now Fuffy had passed these tests, and she and Jimmy were engaged. All that remained was for Jimmy to actually procure the divorce.

AMERICA RISING

The American Look

Fuffy always looked back fondly upon the war years, a time when she had been young, in love, and still without the encumbrances of a family. "We were so carefree," she would say, presumably speaking for her twin as well as herself. "We didn't have to do any cooking."

But for Franny, the postwar years were filled with blissful optimism. After feeling such "restraint" during the war, "we left the ugliness, the despair, the bitterness behind . . . everything was possible," she said. "There was such a feeling of upness." As those who had survived returned and picked up the threads of their lives, it "seemed to be almost like a golden time." New cameras and equipment were available again, and as they arrived in the Condé Nast studio, which had expanded into an annex on West Thirty-Seventh Street, her life overflowed with new creative possibilities. Art directors made the assignments and briefed photographers on their needs, but after that, the creative team was free to follow its inspiration as they saw fit. "It was just like a cloud lifted," Franny said. "Once I went out and I ordered a whole wall full of Chinese silk. I didn't even have to ask. I was always authorized to spend at least fifty dollars a page. We were very treasured children at the *Vogue* studio."

The photographers typically worked with a single editor on multiple-page portfolios. At *Vogue*, Franny's first editor was Sally

Kirkland, who had started her career in the Lord & Taylor college shop and had strode around the offices in sleek Claire McCardell jersey sheaths since they'd come on the market, looking strikingly uncomplicated and modern. Later she worked with Connie Bradlee, a blue-blooded Bostonian ingenue whose older brother Ben would soon land a job as a cub reporter on the *Washington Post*. (Sally's daughter, also called Sally Kirkland, would become an actress, and Connie's brother Ben would become the *Post*'s executive editor in 1965.) Together, these teams were relatively free to dream up ideas, with little supervision from on high. "It was fun because we didn't have anyone leaning over our shoulders," Franny said.

When they traveled, they'd visit farms or historic homes throughout New England and pose the models in cottage doorways and windows or take them to a rustic port, the better to draw a contrast between the elegant clothes and the roughness of the docks and boardwalks. Sometimes they'd rope in young editors to model or stay over with another editor's family, as though they were all still in school. Franny kept track of location ideas in a notebook and became vigilant about doing reconnaissance before a trip; she had once planned to shoot a lighthouse in Boston's harbor only to arrive with the crew and discover it had been taken down. "I never made that mistake again!" she said.

In New York, when they weren't setting up on Third Avenue or under a bridge, they often used Franny's apartment for shoots. After Fuffy and Jimmy moved in together, Franny had taken over his bachelor pad, on the south side of East Fifty-Seventh Street, a small loft space with wide floorboards, northern exposure, a skylight, and deeply recessed windows with shutters. Installed with the sort of old American furniture and objects that she had seen Leslie collect and was now buying on her own, it made a distinctive background for shoots. Occasionally her growing interest in this sort of material jarred with Liberman's understanding of American aesthetics. Although he had a feel for graffiti and urban street culture, he doesn't

seem to have been especially conversant with what America looked like outside New York. (Once, while attending a baseball game with him and Tatiana, who now had her own extremely modish hat boutique at Saks Fifth Avenue, Franny had heard her whisper to him, "Tell me, why are they wearing these funny costumes?")

So Liberman didn't quite get it when, to suggest a countrified setting, Franny propped her apartment with early Americana that she'd rented from a dealer, including a miniature fire engine, a rooster weather vane, a miniature wagon wheel, and Shaker chairs, and used them to set off ankle-length, bias-cut plaid skirts and dresses in *Vogue* and *Glamour*. "Liberman just didn't understand what all this was that I had strewn around," she said. Luckily Steichen stopped by just as Liberman was puzzling over the photos and commented that they were "perfectly marvelous," Franny said. (The eminence, long retired from Condé Nast, had just become director of the photography department at the Museum of Modern Art.) "Liberman was pretty adaptable, and the pictures all got used. He was very quick to pick up on the tempo."

It was Franny's take on the American Look, the name that had been coined to describe American style, as well as American fashion, which had come into its own by the war's end, pushed to new creative heights by rationing and restrictions. McCardell's "Popover," a wraparound denim coverall with a cheery red pot holder attached, sold as a "utility garment" for $6.95, was a fun, cheap, fashionable way to deal with the wartime domestic labor shortage, while other designers came up with such ideas as silk apron dresses with matching silk aprons. McCardell also dreamed up the idea of wearing Capezio ballet flats when shoes were rationed and introduced jersey leotards and tights as daywear, worn under wrap jumpers, for coeds in unheated dorms and classrooms. As women began to wear slacks for war work—the designer Muriel King, among others, created figure-flattering designs for Boeing and other West Coast aircraft factories—they became more acceptable as casual wear. And the

New York designer Vera Maxwell's coverall for the women in Sperry Gyroscope's Brooklyn plant was so well publicized that it spurred a trend for elegant jumpsuits. (Together with a jumpsuit Helen Cookman designed for Montgomery Ward, Maxwell's jumpsuit would be immortalized in the "Rosie the Riveter" propaganda campaign.)

Dorothy Shaver, now president of Lord & Taylor, had defined the American Look in a press release in early 1945 and predicted at the press conference that it would soon "be copied all over the world." Along with streamlined, simple fashion, it was embodied in the quintessential American girl, who was healthy and milk-fed, raised on the diet of a newly wealthy nation—less Garbo, more the teenage Lauren Bacall, who had been discovered by Hollywood after she appeared on the cover of *Bazaar* in 1943, posing as a Red Cross blood donor, back when she was Betty from the Bronx. The American girl had "that certain kind of American figure—long-legged, broad-shouldered, slim-waisted, high-bosomed," Shaver asserted to *Life* magazine, for a story photographed by Serge Balkin's wife, Nina Leen (another Russian-born European refugee), that attempted to define the American Look. The American girl was also characterized by her "straight limbs and the glow of health," the story continued, "a friendly, luminous smile," and "the finest teeth in the world, an asset that derives from the balanced diet and good dental care that are the heritage of most American children."

Franny defined it more simply. The "new-look American girl," she wrote later, is "the girl on the move with her feet on the ground. The girl who is going places & knows where she is going."

But the truly chic American girl would of course rebel against such middlebrow wholesomeness. Franny was working with editors, assistants, and models who were very young—by this point often younger than she was—and also very fashionable, so the vision she shaped in the pages of *Vogue*'s junior section began to take on a uniquely teenager-ish look, with the models looking increasingly surly and self-absorbed, and somewhat indifferent to their modish attire.

For the August 1946 back-to-school section, Franny's girls are set loose upon Third Avenue, rather than a campus, and one looks up as warily as a deer, as if her thoughts have been interrupted, while she ascends the subway steps, dressed head to toe in Claire McCardell plaid, from hood to shoes. In the same story, a girl in a bonneted raincoat pauses by a shop window and gazes at her reflection, seemingly unaware of the store and the street. A few months later, Franny photographed another young model, in a glorious turquoise peasant blouse and gold sandals, slumped on the slatted-wood floor of the apartment she had inherited from Jimmy, leaning against a painted chest: she seems almost bored by the idea of Franny taking her picture, as well as by her beautiful clothes.

BACK IN THE OFFICE, people seized life with a vengeance. There were a lot of weddings and parties. Restaurants were flourishing again. The second issue of *Condé Nast Ink*, the company's new in-house magazine, published a spread on which editors scrawled their favorite restaurants, such as the Crillon, Voisin, or the "little omelette place on East 56th Street." Franny frequented Bruno's, which always held open a round table where "you'd always be able to find one or two other people you knew," she said. Practical jokes abounded. "All the important people at the magazines, they used to tease each other." Frank Crowninshield would sometimes hire "models, um, women who were prostitutes," and send them over to his friends at other magazines with a note saying something like, "Would you please give this girl a job at the *New Yorker*?"

To make life even more interesting, Irving Penn—the first young American Liberman had hired for the studio—was back from overseas. Like Leslie, who was also home again and working for *Bazaar*, Irving had started out as a painter and then become an art director, briefly working in that capacity for Saks Fifth Avenue, whose ad campaign he had reinvented with Brodovitch, his early mentor. After

a short while, disillusioned, he gave it all up to go and paint and take photographs in Mexico. Dissatisfied with his paintings, he'd returned to New York, where Liberman had hired him to dream up covers for *Vogue*'s art department. When none of the magazine's photographers was willing to create the still lifes he envisioned, Liberman had said, "Why don't you do it yourself? It's easy. I'll give you the camera and the assistant." Irving's first color photo, made in 1943, was also *Vogue*'s first still-life cover: it depicts a bag, a scarf, a belt, and a pair of gloves, in autumnal colors, and an unset, square-cut topaz, rendered at close to life-size. (Irving recalled later that Mrs. Chase, *Vogue*'s editor, hadn't understood why they would want to use his work. "Why don't we get a real giant—Steichen, Beaton, Man Ray . . . why should this assistant do it?" she'd asked.)

While Leslie and Irving did have some similarities, having both moved from painting and art direction to photography, in other ways Irving was Leslie's polar opposite. Leslie was something of a fashion plate, favoring dapper three-piece bespoke suits. Irving was "a plainspoken, plain-looking young American," recalled the fashion editor Rosamond Bernier, who arrived at *Vogue* soon after the war. "He wore sneakers, which at the time were anything but customary in the *Vogue* offices, and he rarely wore a tie. Quiet and reserved, he spoke little and he spoke softly." Quite a shocker in an environment where Babs Rawlings, the top fashion editor and John Rawlings's wife, went everywhere trailed by two black-and-white spaniels, and the company uniform—for the high-fashion lady editors and writers, at least—included "substantial rhinestone chokers" and swoop-brimmed Tatiana du Plessix hats. ("If you knew what was good for you at *Vogue*, you bought a Tatiana hat," Bernier made sure to note.)

Also in contrast to Leslie, Irving was available. Two years older than Franny, he had divorced soon after he joined the studio, and he and Franny started going out. Although Franny later told her daughter that he'd been her fiancé—a word the twins seemed to use interchangeably with *beau*—she usually mentioned but downplayed their relationship in

interviews. "I used to go out some with Penn during that stretch. Not seriously," she would say. Or "Penn and I got to be friends. We used to go out together, but we always knew that we had other interests."

Perhaps this was just Franny's natural discretion at work. But she did seem more drawn to Irving than the other men she was dating, perhaps because he was quicker than most, and up to her speed. "Penn is a very definite person," she told one reporter. "Have you ever interviewed him? He can be very witty, but also very sharp." Liberman had kept him working in the art department until he had reorganized the studio, she recalled; he had designed other photographer's covers during that period, but Franny later learned that "he didn't like a lot of those covers."

One summer evening, she said in the same interview, as she had just returned from work and was preparing to wash her hair, Irving called and asked her out. She had already turned down someone else she was dating, using the excuse that she was working late. But when Irving called, "I said, 'Of course!' I never said no." They went to Longchamps, the continental restaurant chain that had a branch around the corner from her apartment, and while they were seated next to each other at a banquette, the other man passed by their table—"very tall," Franny said, laughing—and, recognizing his defeat, tactfully bid them a good evening.

Franny's discretion may also have been due to the attitude from the bosses, who kept close tabs on what the underlings were doing. Once she and Irving attended a wedding together and stopped somewhere else afterward to top off the celebrations with champagne. Walking along Lexington Avenue later, they saw a store selling a huge stuffed Harvey rabbit, a novelty item inspired by Mary Chase's Pulitzer Prize–winning Broadway smash hit, *Harvey*, which opened near the end of the war, about a man whose constant companion is a six-foot-one-and-a-half-inch invisible white rabbit. The *New York Times* reviewer envisioned scholars of the future "muttering to themselves that here was a singular piece of goods . . . an entire play about

a rabbit which did not even appear on the cast of characters." When the producers sold reproduction rights to the invisible creature, the *New Yorker* opined that the transaction "involves one obvious difficulty," which had been circumvented "by commissioning an artist to draw Harvey" as "a pot-bellied, juicily grinning bunny wearing a collar with blue polka dots, a red bow tie, and a battered silk hat with holes cut for the ears." It was this very un-*Vogue*-like stuffed creature that Franny and Irving encountered on Lexington Avenue.

Irving bought it and had the store deliver it to Liberman's office, with a card signed by both him and Franny. Liberman, unamused, summoned Sally Kirkland and asked if his two young Americans were having an affair. "They were really looking into you," Franny said. "They were very paternalistic." Sally shrugged it off. By then, if she didn't like the bossiness or negativity of the staff's Russian overlords, she'd just say they were doing their gloomy "Uncle Vanya bit." (Chekov's tragicomedy *Uncle Vanya* had garnered bad reviews on Broadway that year.)

Yet from the Russians' perspective, the photographers were part of a valuable stable, thoroughbreds who had to be maintained in peak racing condition at all times. Liberman left the older talent, such as Horst and Rawlings, free to perfect their styles on their own; he let them take on advertising clients, too. But the young Americans were only allowed to do editorial photography. "He invested a lot of time, certainly in me and in Penn, probably a handful of others," Franny said, although that time largely consisted of "a lot of joking," time to experiment before they were reined in, and gentle reminders such as "Now, Franny, use your camera with the streak." (She had bought a smaller medium-format camera of her own during the war, a used German Primarflex that was capable of taking pictures more quickly using different types of film, but which also had a flaw—a light leak that produced streaks on her work—and Liberman adored the effect.) The photographers were encouraged to experiment, and occasionally those experiments were published, as happened with some color

abstractions that Dick Rutledge made for several months before he was redirected. "Liberman had impeccable instincts," Franny said, "and he also was a little ahead of everything."

He had a special and intense relationship with Irving, with whom his efforts were paying off. Although the young photographer had started out with the same polyglot assignments as everyone else—accessories, fashion, a few junior pages—his eye had matured during the war. He had driven an ambulance through Italy, Austria, and India, taking photographs along the way, and *Vogue* published a portfolio of these pictures when he returned. They included a group portrait of a Russian peasant family, pressed against a wooden fence in a British prisoner-of-war camp in Austria; a mysterious still life of junk awash in a Venetian canal that suggested a work by the abstractionist Paul Klee; and a portrait of the great metaphysical painter Giorgio de Chirico, whom Irving had encountered on the street and had spontaneously befriended soon after arriving in Rome. After he returned to New York, his work grew rich with artistic allusion, and he began to light objects and models and cultural figures—ballerinas, actors, comedians, even Santa Claus—as though they were sculptural forms.

"Penn immediately plunged into the vital question of inventing 'his' light, a key to a personal statement different from the accepted unreality of the fashion photography of the period . . . creating luminous tents in which objects and, later, models acquired a clear stillness," Liberman wrote later. "Penn is always graphic. The structure of the picture, the pose, has the excitement of lettering in a cubist composition. . . . What I call Penn's American instincts made him go for the essentials." As Bettina Wilson noted later, Penn was swiftly becoming the "spiritual child" of Liberman, who "realized through Penn all of the artist's dreams that he himself had had before Condé Nast had thrust success and responsibility on him."

* * *

FRANNY WOULD NEVER BECOME a surrogate for Liberman's thwarted ambitions, but her reputation was growing, too. In May 1946 she won plaudits for the deliberately blurry, casual style she was cultivating for *Glamour* when *U.S. Camera* ran a story in its "Women" section about that magazine's unconventional, trendsetting new photography. Called *"Glamour* versus 'Technique,'" the story used one of her pictures as the lead. Lifted from a fashion spread called "Men Scare Easily," it features a man sprinting away from a woman. He, fuzzy and foreshortened, takes up most of the foreground, while she, small and agonized, is in the back—and cleverly in focus so that her smart checked jacket is clearly visible. The shot "is kind of picture *Glamour* likes," the *U.S. Camera* caption reads, in the clipped jargon typical of magazine writing of the era, "despite fact other photogs might criticize technical quality. Blurred, distorted figure tells the story, adds wit to it."

The unbylined story discusses the willingness of *Glamour*'s art director, Pineles, to take chances on the "young, new talent" whose pictures filled the magazine's pages. In addition to Franny, they included Kay Bell ("the *Glamour* fashion editor who wanted to be a photographer"), Dick Rutledge ("came to New York fresh out of a west coast photography school"), and Clifford Coffin ("an out-and-out amateur photographer who had never taken pictures for publication before"). "You know all their names," the copy reads, before adding that Pineles also welcomed experimentation from "the great Condé Nast 'names'" such as Rawlings, Horst, Joffé, and Gjon Mili, among the first photographers to adapt strobe lighting to capture movement.

Pineles, somewhat surprisingly, isn't quoted. But Liberman is: "What a photograph has to say is more important than the perfection of its focusing or lighting." While superficial artistic effects were inadvisable, he believed, the accidental could play a great role. "In our age of super-perfect mechanical devices, of extraordinary technical developments in film, printing, cameras, etc.—the human element, call it the accidental or the mistake, has again a meaning. Perfection

in art can be cold, inhuman. It is through 'errors' that one suddenly discovers new forms of beauty."

In *Glamour* itself, Franny's photo had been part of a fashion package that sent up a new and somewhat insidious trend in smart career magazines: instead of seeing the world through the eyes of young women, the editors increasingly suggested that women regard themselves through the eyes of men. This particular picture was part of a double-page spread. Opposite the fleeing man are two women in suits (also clearly in focus), who appear to be gossiping about the sad spectacle. On the next spread, titled "Men Are Fickle," two women show off copies of the new full-skirted coats from Paris, whose couturiers were rising again: at its center a man's head appears to whiz around on its neck, as if gawking in two directions at once. The effect, achieved by printing negatives on top of each other, lies somewhere between a surrealist photomontage and a *New Yorker* cartoon.

A few months after the story came out, *Glamour* also launched a new youth-oriented column—perhaps to compete with *Junior Bazaar*—which showcased Franny's more casual brand of junior photography. Called "Young as You Are," it featured Pat Donovan, a teenager with long black hair and bangs and an exotic, otherworldly look. In the first spread, Pat drifts through a field in a white eyelet dress, while another girl gathers flowers behind her. On the next, Pat looks into the distance, playing a ukulele, while three girls sit behind her on a fence.

Franny had met and photographed Pat at the beach one summer, when the teenager was staying in Amagansett with her mother, a psychoanalyst, at the house of some friends. (By the early 1940s, Amagansett had become an illustrators' hangout, and Pat and her mother's hosts were Jim Perkins, a renowned illustrator's agent, and his wife, Kay, an interior designer and one of Pat's mother's patients.) Pat had still been in high school then, and Franny had taken her up to the house of the illustrator Jan Balet; now art director of *Seventeen*, he was friends with Jimmy, who had inspired him to buy a saltbox house

that stood on a lonely dune without much else around it. Franny's photographs capture Pat flitting through the sparsely furnished rooms in a white nightgown, looking like an otherworldly wraith.

Some months later, Franny rediscovered Pat at the Persian Shop, a Madison Avenue store that remains there today, where people from the fashion world often went to procure exotic fabrics, jewelry, and clothing, either for themselves or for shoots. Having finished high school, Pat was working behind the counter. Pat recalled Franny coming in, recognizing her, and asking, "I'm shooting for *Vogue* magazine. Would you like to work for me?" She immediately said yes. But by that time she was already modeling for Avedon, *Junior Bazaar*'s new young photographer; he had discovered her at the Persian Shop himself when he came in looking for earrings for his wife. From that moment Pat's career grew. It was partly to do with her unusual look and movements: "I was different looking," Pat said. "I was studying ballet, so I had certain moves and a way that I moved my body that was appealing to them. And I had a poignant appearance to my face. I had been through some very difficult childhood adolescence experiences with family. They just picked up on it."

One of Franny's other "Young as You Are" stars was even younger and had arrived at *Vogue* somewhat circuitously. Although she had originally been discovered by the wife of a *Bazaar* photographer who had spotted her on a crosstown bus on the way to her ballet class, her test shots with that magazine did not go well. But she and her mother were desperately poor, and the idea of modeling had piqued her interest, so her godfather introduced her to an acquaintance at *Vogue*, where she had a more successful test and was signed to an exclusive contract at $7.50 an hour. ("Better than taking the lids off Coca-Cola bottles," she told a reporter years later.) She and her mother lived near Franny's apartment, on Third Avenue in a tenement building without a phone, and when *Vogue* needed the raven-haired teenager, they would send a runner up to knock on the door and she'd roller-skate down to the studio. Her waifish,

enigmatic looks soon made her a distinctive presence in the company's magazines.

"She is Carmen Dell'Orefice, perhaps the youngest top fashion model today," read a *Seventeen* story in late 1946. "Carmen's first earnings from posing in sequinned black net paid for having her teeth straightened." The need to keep her lips closed to hide her braces gave her a mysterious smile, making her resemble an adolescent Mona Lisa.

During Carmen's first few months at Condé Nast, Franny worked on a portfolio of experimental photographs with the fourteen-year-old, in which the new young model seems to shape-shift from child to woman. One series shows Carmen wandering amid the trees of a scrubby tenement garden, wearing a long pale dress, in scenes reminiscent of the moody, romantic portraits of the nineteenth-century English photographer Julia Margaret Cameron, whose work was then on view at both the Metropolitan Museum and the Museum of Modern Art. In another group of photos Carmen runs alongside the el tracks in a velvet hooded cape, like a character in an urban fairy tale. Next she's in a baggy leotard and toe shoes on a rooftop, her banged-up tomboy shins very much in evidence as she practices pirouettes and arabesques. Then she's half-naked in Franny's apartment, seen from behind as she slips a tutu over her head.

Perhaps the most stirring pictures are those that show Carmen idling on the street, wearing a suit that's just a little too big for her skinny body as she clutches a woman's shoulder bag. As she descends into the subway, a much older man, having glimpsed her on his way up, turns back and gives her a piercing, disquieting stare. The entire group perfectly embodies the moment junior magazines and sections had been created to celebrate, "when a girl is no longer a child, yet isn't quite a woman."

The following year, at sixteen, Carmen would have her first *Vogue* cover—a Blumenfeld portrait with her lips painted to suggest Botticelli's Venus, and Van Cleef & Arpels jewels clipped into her hair,

which had grown blonder. Soon after, a company doctor would give her hormone shots to bring on puberty. By the time she was seventeen, Joe Kennedy, the great pal of the twins' famous cousin, Morton Downey, would offer her a Park Avenue apartment, and the fragile moment Franny had fixed on paper would have vanished. Yet unlike Irving's and Dick Rutledge's early experiments, which were given space in the pages of the company's magazines, only one or two of Franny's very early photos of Carmen were ever published, and not one ever seems to have appeared in *Vogue*. Instead, they remained in Franny's studio, in an envelope penciled with the words "4/23/46 Experiment—Portrait of Carmen."

The Elopement

At the time Jimmy proposed, Fuffy's freelance career was going fantastically. The May and June issues of *Charm* were her biggest ever: she had shot almost all the fashion pictures for May, and almost half of those for June. The latter issue, especially, was filled with Kodachrome shots, with more pictures from Cuba, of models in Schnurer playsuits prowling barefoot in straw hats around the fashionable Kawama Club, the priciest hotel along La Playa Azul in Varadero Beach, and a swimsuited beauty rising from the crystalline blue waters of the bay.

But the next two issues had nothing at all by Fuffy because Jimmy went out West to spend six weeks in Las Vegas so he could get a divorce, and she went along, too.

Divorce was already quite common in their circle, but because of New York State's arcane divorce laws, the process there tended to be lengthy and messy. Adultery was the only legitimate grounds for a split, which meant hiring detectives to catch the offender in flagrante, followed by a painful court trial. Many people got around this with what Ray Prohaska's son, Tony, called "the mock-adultery charade." His own mother, an illustrator's model, had ended her first marriage this way, paying a friend to stand in as the detective—she also paid him to take the pictures that were needed to prove the case

in court—and getting one of her husband's old girlfriends, a Broadway actress who was still sweet on him, to play the adulteress. The whole farce was carried out in her soon-to-be-ex-husband's apartment.

But those with money enough and time went to Nevada, America's divorce mecca, whose lenient rules had attracted European aristocrats and the idle rich since the nineteenth century—and, more recently, movie stars. In 1931, to raise cash during the Great Depression, the state legislature had shortened the divorce residency requirement from several months to six weeks. They also legalized gambling to provide amusement for divorcés-in-waiting. The move injected new life into the state's nineteenth-century dude ranch industry: well-heeled guests could spend their six weeks riding, swimming, fishing, and mingling with cowboys and other like-minded visitors—maybe even finding the next Mr. or Miss Right. The divorce itself took only six minutes of courthouse formalities and offered nine different grounds to choose from, including impotence, abandonment, mental cruelty, or simply having lived apart for three years.

The state's first divorce capital was Reno, where Mary Pickford, Papa Abbe's old friend, had a splashy split in 1920. Las Vegas took the title when Ria Langham, Clark Gable's second wife, divorced him there in 1939, buying her privacy with a huge story published as she departed. Jimmy and Fuffy chose Las Vegas a few years later, staying in its first dude ranch, the Boulderado, a quiet spot outside town that offered horseback riding, hayrides, fishing, and campfire suppers.

Fuffy arrived dressed casually but elegantly, in black pants and a sweater, with leopard-print-fur bootees from Henri Bendel and a real leopard-fur belt from Phelps, a fashionable belt and bag designer. She quickly resembled the cowgirl she had photographed for *Charm* a couple of months earlier, replacing the colorful dungarees with jeans and a cowboy shirt. Both she and Jimmy began wearing Stetsons and leather jackets, and drinking from what appear to be leather-covered canteens. Fuffy also played cards, surrounded by tablefuls of admiring men, and Jimmy bought an old car and fixed it up so they could

make photographic expeditions and visit people they knew nearby. They were gone for so many weeks that Jim Tyson, the husband of Carolyn, whose family owned Second House, had time to write him letters, telling Jimmy how his own therapy was going, what parties he'd been to, who was in love with whom, who was building where, that Franny was being somewhat elusive with a mutual actor friend who was eager to date her, and that he and Carolyn predicted "matrimonial ventures" for her within twelve months. He also asked, jokingly, when Jimmy expected the next "Abbé" baby to be born.

The proof-of-residency requirements for Nevada were fairly lax: as Jimmy used to recount later, all they needed to do was check in once a day, even if they did it just after midnight early Wednesday morning and checked back just before midnight late Thursday night. This flexibility gave them plenty of time to wander. They made at least one trip to Rhyolite, a picturesque ghost town on the edge of Death Valley that had once had an opera house, a hospital, and a stock exchange back in Gold Rush times. The town had lain empty and decrepit since 1916, until Paramount Pictures resurrected one of the buildings for a movie a few years later. Fuffy photographed Jimmy as he set up his camera and tripod and took pictures in the ruins.

Jimmy also used the six weeks' residency to perfect his flying; he'd been training for a pilot's license at East Hampton's tiny new airport. Fuffy had been learning, too, but she didn't intend to get her license: she just wanted to be able to take over the controls in case Jimmy got sick or fainted and someone needed to return them to earth. "It was a matter of self-preservation," she always said.

While they were in Las Vegas, Jimmy made his first solo long-distance flight, over the Grand Canyon. He also mastered his fear of tailspins, which were required for a license. "I was rather apprehensive about them," Jimmy said. "They were a little scary." He tended to see many things in psychological terms, including his fear of flying. One day on a practice run, as he was "trying to explore the situation with my instructor," as he put it, the instructor recommended that

he take the plane higher than the recommended altitude and try the tailspins up there, "spin after spin after spin," Jimmy said, until he had resolved whatever emotional blockage held him back. The instructor had been right: once Jimmy had done the spins to excess, he conquered his fear.

Then the six weeks were up. Fuffy and Jimmy went to the court-house and got Jimmy's divorce. Everything was going so smoothly that they did something neither of them had planned to do in Nevada: they got married. They didn't tell anyone, not even Franny.

Maybe they did it to avoid any fuss from Kitty or Jimmy's mother. Maybe Jimmy had finally overcome his fears. Maybe getting married was just exceptionally easy in Las Vegas, which promoted the act of bringing people together even more enthusiastically than that of rending those unions asunder. The state had no waiting period or health certificate for marriage, and Las Vegas in particular made it painless to take the plunge: a license bureau was in the train station, and the county clerk's office stayed open around the clock.

Or maybe after six weeks of adventures together, Jimmy and Fuffy were simply carried away by love.

After the wedding, they set up Jimmy's camera on a tripod with a self-timer and posed by a rough wooden fence, hands in their pockets, for their own wedding portrait. In the picture, they're wearing the same clothes they'd had on for the ceremony: jeans, fringed leather jackets, and bandannas, a denim shirt for him, and a plaid shirt for her. The morning sunlight slants across their heads and glints off Fuffy's wedding ring, while they both smile broadly.

"That was a pretty far-out wedding outfit for 1946," Fuffy said.

ON THE WAY BACK EAST, the newlyweds stopped in New Mex-ico to visit two of the twins' favorite teachers from Pratt, Dorothy Mulloy and Tom Benrimo, now married themselves and living in Taos, a thriving art colony. The scene there had taken off when the

Greenwich Village *saloniste* Mabel Dodge had moved out in 1917, fallen madly in love with Tony Lujan, a married man from the Taos pueblo, vanquished his wife, and sent her own husband packing back to New York. Happily remarried, she then took over the town's minuscule art scene and persuaded her creative circle to visit, including writers such as D. H. Lawrence and Thornton Wilder, painters such as Marsden Hartley and Georgia O'Keeffe, and photographers such as Ansel Adams. O'Keeffe moved there part-time, even though her husband, Alfred Stieglitz, considered the godfather of American modernist photography because of his many decades championing the medium as fine art, couldn't visit because of his heart condition. Several, including the Benrimos, moved there year-round.

O'Keeffe was in New York with Stieglitz, who was dying, at the time of Fuffy and Jimmy's visit, and their pictures don't record Mabel Dodge. But they took extensive photographs of the Benrimos, who lived in an adobe house they'd built in sagebrush country just outside town. It was small but spectacular, filled with Tom's surrealist-flavored paintings, which he was now able to work on full-time, and Dorothy's silver jewelry and the photographs she was making of the gravestones and crosses in local campo santos, or cemeteries. The couple had grown sun-weathered and wiry, taking to their new, more rural surroundings with ease, and their house recalled a Western version of Jimmy's Montauk cottage, with dishes ranged on open shelves and big picture windows looking out onto the mountains. When the Dallas art dealer Donald Vogel came out to see Tom's paintings a few years later, he described the house in some detail in his memoir, *Memories and Images*: "Their simple adobe had an oxblood polished floor shimmering with the color and surface of a rare Chinese porcelain vase with soft corners. Warm Indian rugs, fabrics, and pots, books for winter reading, and records for good listening graced their home. His paintings, which I found stunning, hung on the walls."

Because Fuffy and Jimmy had just gotten married, the trip became their honeymoon. But they were also visiting for work. Margaret

Hockaday had just become the fashion editor for *Holiday* magazine, and she had expressed an interest in seeing Jimmy photograph the Benrimos and their house, as well as a spread of Western fashions. Fuffy made some photographs, too, of the surrounding scenery, but mostly she acted as Jimmy's assistant, keeping track of all the details in his pictures, and typing up the notes later when they got home—the role she had been so eager to escape from when she worked for Toni.

WHEN THEY RETURNED TO NEW YORK, Fuffy bought Jimmy a wedding present—his very own plane. "I don't think he would have married me otherwise!" she joked. It cost about $3,000, but she had money saved up. "There was nothing to spend your money on during the war," she said, "and by 1946 I'd been photographing almost four years, and all my jobs were very lucrative." (The planes had gone on the market the previous year for $2,994, or nearly $49,500.)

They chose an Ercoupe, a two-seater that had revolutionized the design of light aircraft when it was introduced before the war: it was spinproof, stallproof, capable of flying cross-country, and handled like a car. After the war, civilian planes were allowed back into production again nine days after V-E Day, and the Ercoupe had been redesigned to be more powerful and consumer friendly. It was sold at department stores around the country and promoted as being essential to postwar American life.

"More business, more pleasure," promised the full-page Macy's ad in the *New York Times*, when it offered the Ercoupe for sale in its new "flight deck" department. "Would you like to live in Litchfield, commute to New York? . . . Do you want to close more out-of-town deals?" The Abbes weren't interested in closing deals, but they did want to get out to Montauk more easily. They stored the plane where they'd learned to fly, at the newly opened airport in East Hampton. Originally built as a Works Progress Administration project, its runways had been developed by two young women, former WASPs, or

Women Airforce Service Pilots, a civilian women's group that assisted the Army Air Forces by ferrying bombers across the Atlantic during the war. (Some in town had discussed whether women should be allowed to take over the airfield or whether the project should be saved for returning local servicemen; but the men weren't back yet and the runways were deteriorating, so the town had let them go ahead.) That summer saw the first commuter flights between East Hampton and New York. The Abbes and their illustrator friend Jan Balet were among the first to berth their planes there, together with Lammot Copeland, heir to the Du Pont company, whose booth had so thrilled Franny and Fuffy at the World's Fair.

The press was filled with stories about the entertainers and socialites who were buying Ercoupes, and before long a story appeared about the glamorous flying Abbes, too. *Mademoiselle* covered them in its October 1946 issue, with a piece headlined "Kathryn and James Abbe with Camera and 'Coupe." It ran with a picture by the celebrity photographer Peter Martin, which showed Jimmy sitting behind the wheel and Fuffy climbing into the passenger seat, both looking dashing in leather jackets and sunglasses as they prepared to soar off to parts unknown.

Even though Jimmy was the better-known *Mademoiselle* photographer, Fuffy, who was shooting the magazine's accessories column, was the story's focus. It was the centerpiece for a package on photography careers, in which women were warned not to expect too much at first, and Fuffy's attainments were ranked roaringly successful. "Loaded down with photography gear, cameras, tripod, flash bulbs and aerial chart, the Abbes get ready to take off on another assignment," the story read. "In their snub-nosed Ercoupe they jaunt around the country to snap pictures for national magazines. When they work as a team Kathryn concentrates on black and white shots; Jimmy specializes in color. . . . Now she and Jimmy have a New York studio of their own in a converted carriage house on 53 Street, where they employ two assistants."

Jimmy had rented the carriage house before they went to Nevada. It was glorious—a nineteenth-century building with arched windows, a two-room apartment at the top, two studios and a darkroom downstairs, and a large garden, which could be used for daylight shots or converted to look like a restaurant or a tented nightclub for a party scene. The house itself was great for throwing parties. Passersby sometimes took it for an antique shop—there was no signage other than the words JAMES ABBE JR. in brass letters just below the eaves and painted on the front door.

"We paid four hundred and twenty-five dollars a month to rent, for all that space," Fuffy said. "And we made perfectly good money from the work." Yet with the carriage house in New York, the house in Jericho, where Jimmy had built a saltbox in addition to the schoolhouse, and the cottage in Montauk, which Jimmy was still improving, she found herself with a lot more to manage than she'd ever had to handle in her single life. On Thursday afternoons she'd start packing to go to Montauk—or in the winters to the Long Island house—and Jimmy's Angora cat, Kissypoo, who had been in his life far longer than she had, went, too. (Sometimes she joked that her careful care of Kissypoo, whom she ran out to visit and feed every day after work before returning to the studio so she and Jimmy could go out to dinner, was "the other thing that persuaded Jimmy to finally marry me.")

But the assistants, at least, worked for them both. George Knoblach had been with them the longest; the Abbes had met him as a boy in Montauk when he was mostly interested in fishing and beach picnics and had hired him after he'd gotten out of the navy, where he'd been a military photographer. "When I got out," George said, "they asked me if I'd like to go with them, and then they taught me everything." Gus Clark had joined them at eighteen, also just as he was starting out; he would eventually take on his own assignments for *Ebony*, a *Life*-like publication billed as "the first national Negro picture magazine" when it was founded in 1945, and also for *Jet*, a smaller weekly newsmagazine that began publication in 1951.

Even though the name of only one Abbe was on the door, they sent out change-of-address cards that made it clear, for those in the know, that two photographers worked in the building. "NOW IN OUR NEW STUDIO / Fuffy & Jimmy Abbe," the cards said in hand lettering, above a Jan Balet line drawing of the two of them peering into the viewfinder of a giant camera mounted on a tripod, with a hood pulled over their heads, and their bodies emerging beneath, like nineteenth-century photographers. In the drawing, Fuffy was wearing a brief skirt and Jimmy had his legs crossed jauntily in plaid pants. It was all very jazzy and sophisticated, and quite far out for 1946.

Fuffy returned from Las Vegas with a new byline, Kathryn Abbe, creating some confusion at *Charm*, which ran her pictures in the September issue under two different names. But she was so delighted that she may not have been too bothered by it, or about her dwindling number of assignments at the magazine. Hal Reiff, a second-generation photographer from Philadelphia who'd been put on staff, was now getting the good travel stories.

By then, too, another major turn of events had erupted in the twins' lives: Leslie and Dilys split up, and Franny was suddenly in love. It seemed that the prediction the Tysons had made while the Abbes were out in Las Vegas waiting for Jimmy's divorce—that they expected "matrimonial ventures" for Franny within the year—might be about to come true.

CHAPTER 23

European Tour

L eslie had been away for about a year and a half. A few months after Franny quit to join Condé Nast, he had volunteered for the overseas branch of the Office of War Information. By the end of March 1944, he was in Cairo, then a British colonial outpost at the crossroads of Africa and Asia, where spies still did good business and camels, horses, and donkeys fought for space with expensive cars on the crowded streets. Rommel had been routed, and the Cairo Conference of 1943 had taken place, at which Churchill, Roosevelt, and Chiang Kai-shek met to discuss the war's progress and the future of Asia.

Leslie supposedly went out to Egypt as a photographer, but according to his and Dilys's elder daughter, Carol, the family had no idea of what he really did there. Judging from the pictures he took and posed for, he visited the Pyramids, the Great Sphinx, and other tourist sites. He even turned the tables and photographed another professional—a street photographer in a turban who used a special camera that could take the photo and develop it on the spot. After Leslie returned, he sometimes told his family about odd things that had happened to him personally, such as the time he watched in silent astonishment from his bed as a thief crept into his room at night and stole his wristwatch from the dresser.

He also sent constant letters to Dilys. "I have had 5 letters from Gill since last Friday," she wrote to her mother in 1944, after complaining that, as usual, he had charged her with buying a birthday present for her mother-in-law. "It's very hot there (one day around 120°) & dirty, & has lots of ants & flies in the apartment—but he says it is very interesting & beautiful." The city was still full of literary expats, and Leslie had discovered several acquaintances there, Dilys added, among them a couple who lived in a houseboat on the Nile.

Otherwise, silence, according to Carol. "I never saw one picture that he ever took," she said, at least not of his official work.

Cairo, however, was one of the centers where the OWI had a PWB, or Psychological Warfare Branch. Due to its location, it had been a major distribution point for OWI news and propaganda since America's entry into the war. By the time Leslie arrived, the unit was collaborating with its British equivalent on a propaganda campaign in the Balkans, air-dropping encouraging news briefs for civilians, and disinformation leaflets for German troops. Leslie was attached to the PWB not as a photographer, but as an art director, and one of his first projects was to create a group of publications with a design that could be printed in eight different languages. "We included Les Gill," the section director wrote later, "because we knew that a top-notch art man would be needed to set up the operation."

By September 1944, soon after the Allies took control of Rome, Leslie was redeployed to the Eternal City, joining a unit that produced cultural publications that promoted America and democratic ideals. Although the German occupation was over, conflict still cleaved the country, with people fighting on both sides.

A few months after the Americans arrived, *Town & Country* published a letter by Peter Lindamood, a young arts critic also attached to the PWB, in which he discussed the cultural renascence underway in the liberated city, less devastated by bombing than some. Lindamood found its relative "intactness" a relief in contrast to "the wreckage

we drove through to get there. . . . I realized as I bumped along how facile had been my comprehension of Picasso's 'Guernica' back in the security of Paris and Manhattan art galleries." The Psychological Warfare team spent the first few weeks churning out material to rebut fascist propaganda and admiring the "first-rate culture weeklies" already published there. Then, Lindamood wrote, they "settled down to work a lot and play when we could."

Leslie's work there was to be the founding art director of *Nuovo Mondo*, or "new world," a picture newsmagazine modeled after *Life*, which was soon printing nearly a quarter million copies. The great European picture newsweeklies that had once inspired *Life* were gone: *BIZ*, having been "aryanized"—devalued and sold off cheap to Aryans—in 1934, now published Nazi propaganda; and *VU* had been shuttered before the Nazis reached Paris.

There were plenty of people to play with. Lindamood had written in his letter that the Eternal City, "like practically all war centers, was jammed to the cornices with 'personalities,'" some from the world Peter and Leslie had left behind. The head of their unit was James Linen, formerly of *Life*, who became *Time*'s publisher after the war. The *New Yorker* cartoonist Saul Steinberg was detailed to the Office of Strategic Services (the precursor to the CIA), creating disinformation to be air-dropped over Germany. The American ambassador to Italy, Alexander Comstock Kirk, who oversaw all they did, and who'd been transferred with them from Egypt, his previous post, was the heir to a Chicago soap fortune and entertained constantly in his palazzo.

Rome was also throbbing with European artists and writers, most of whom gathered around La Margherita, an antiquarian bookshop and gallery that showed the famous de Chirico; his younger brother, the "fantastic" painter Alberto Savinio; the surrealist Leonor Fini; and many more—including a young painter with whom Leslie became especially close, Renzo Vespignani, who'd grown up in one of the city's poorest quarters and had begun making art during the occupation. The gallery was also a locus for writers—the poet and philosopher

George Santayana, and Alberto Moravia, then working on his 1947 novel about the occupation, *The Woman of Rome*.

But despite the charms of the Eternal City, Leslie's OWI file notes that he was "completely fed up, tired of the whole operation," and so anxious about something going on with his family that he was desperate to get back to New York, even temporarily, to straighten it out.

He finally returned on a troopship at the end of May 1945, ten pounds underweight, with a raging sinus infection. Free of the chaos of Rome and the war, he arrived at the grand apartment building at East Eighty-Third Street and Madison Avenue, where the elevators that opened onto each floor revealed two doors leading to two separate homes, one promising the calm, splendor, and familiarity of his own apartment. Dilys was out, but the children were in. He rang the bell, and Carol, then nearly ten years old, opened the door to see a strange man in uniform.

"He was gone for so long that I didn't really recognize him at first," Carol said, recalling her bewilderment after the absence of more than a year. "When I finally realized, I jumped up in the air and I sort of wrapped my legs around his waist." Both children were screaming, "Daddy!"

"Then we heard the elevator coming up again from downstairs," said Eliza, who was six, "and we hid him in the coat closet, which was just to the right of the door."

They all waited tensely in the dark of the closet as they heard the elevator door open and close. "It was going to be a great surprise," Eliza said. "You know, 'He's here!'"

Then they all burst out—and saw Dilys in the foyer, kissing another man.

The marriage was over.

"I don't think he ever stayed there again," Eliza said, "although we begged him sometimes."

* * *

THE GILLS' MARRIAGE WASN'T the only casualty of the times. The divorce rate was rising across the country, with one out of three unions failing, as couples who had married in the romantic haze of war suddenly realized what they'd signed up for, and couples separated for years were forced to acknowledge they'd grown apart.

"Divorce is on its way to becoming our leading industry," the magazine writer Don Romero announced in *Charm*. The postwar boom was nothing, Romero claimed: within twenty years, "most experts agree that at least one out of every two marriages will end in the divorce court." Broadway was full of divorce-themed productions, from *Park Avenue*, a brittle musical about "the divorce racket," as *Bazaar* put it, to Moss Hart's play *Christopher Blake*, based on the musings of a twelve-year-old boy forced by a judge to decide under oath between his parents. *Mademoiselle* characterized the children of the half million divorces secured each year after the war as "displaced persons right here in our own country."

Yet for Franny, who had been so sweet on Leslie when she worked as his girl Friday, his split would have been the only one that mattered. Her daughter thinks it may have been Irving Penn who reintroduced them. By then Leslie had been separated from Dilys for quite some time and was living in the space that had been his first studio—the one he had shared with the color expert Paul Outerbridge. Leslie was off his feet with work, taking pictures for *Good Housekeeping* and *Ladies' Home Journal* and appearing frequently in *Junior Bazaar*. Even though *Life* had claimed *Junior Bazaar* was put out by a staff of the youngest of the young, careworn old Leslie had been doing many of its fashion and beauty stories, as well as its covers, since the second issue, which announced his return with a cover shot featuring a young woman with dark hair smiling sidelong at a tantalizing red apple.

In Leslie's other *Junior Bazaar* photographs, girls posed demurely in gray felt caps and capelets before all-American Shaker furniture. Or they danced wildly in ball gowns between colorful lights, as the

copy burbled, "It looks like spring." Before long, whatever had or hadn't happened when he and Franny had worked together three years earlier in his town house, or in his studio in Julien Levy's building, or the magical day in the street when Leslie had seen the painting of the girl with the cat and dog and Franny had been beside him and may have helped him obtain it—none of that mattered. The war was over, he had survived and returned to take up the threads of his life, it was a golden time, and they were finally at leave to fall madly in love.

"FRANCES DEAREST, ST. VALENTINE arrived at Rue Jean Goujon today with some rather similar sentiments to my own! At least from this distance it seems very safe to tell you how much I miss you! Really Franny I do. Even though you probably think not."

It was February 1947, and Leslie was now writing from *Bazaar*'s offices in Paris, where he had been chosen to go with Carmel Snow to cover the first real couture collections since the war.

"Most of the last few days have been hectic. Trust my 'boss'!," he wrote. "All day long driving around frantically looking for back-grounds (when everything looks good enough to me), or going to the 'openings' which are rather electric and I guess would be more so if only I were a bit more queer!" He and Mrs. Snow had been to Balenciaga, Alix Grès, all the others. But it was the final show, by a newcomer called Christian Dior, that had really drawn the editors across the Atlantic, and that had been accompanied by a tide of applause that continued and intensified as the show progressed. Mrs. Snow reported later that she had said, "Dior saved Paris as Paris was saved in the Battle of the Marne."

Paris couture had stayed alive during the occupation, barely. The Germans had briefly considered transporting the entire fash-ion industry—designers, ateliers, workers, textile manufacturers, everything—to Berlin. But the designer Lucien Lelong, head of the

1

Toni Frisell's mysterious underwater shot of a model in an evening dress. It ran in the May 15, 1941, issue of *Vogue*.

2

One of Toni's many photos of the Tuskegee Airmen's 332nd Fighter Group, the elite black-fighter-pilot unit, taken at their base in Ramitelli, Italy, in March 1945. Here, they are briefed before a mission.

3

Like her twin, Fuffy loved working on the street. This shot was made on Chrystie Street, in front of a pile of junk, which her crew rearranged to make a better setting. The model is an actress who married Cary Grant after the war. Above her head, dangling from a noose tied to the fire escape, hangs an effigy of a Japanese soldier.
(Kathryn Abbe,
Betsy Drake, Lower East Side, 1943–44)

Fuffy used the same pin-spotlight technique as Blumenfeld for this early accessory shot for *Charm*, which gives her model the look of a Dutch old master portrait. (Kathryn Abbe, *Charm*, December 1945)

Shot in Cuba, this picture of a mysterious figure in a chambray suit walking through an empty square recalls the work of Eastern European avant-garde photographers that the twins had admired in *Coronet* as students. (Kathryn Abbe, *Charm*, May 1946)

Fuffy photographed Leonor Fini, notorious for her extreme costumes and her surrealistic work, when she and Jimmy visited her in Paris after the war. (Kathryn Abbe, *Portrait of Leonor Fini in Her Studio*, 1947–48)

Franny made
these photos
(*left, below,
and opposite,
top left*) when
Carmen was
fourteen.
(Frances
McLaughlin-Gill,
Carmen
Dell'Orefice in
Cape, Test Shot,
1946)

(Frances
McLaughlin-Gill,
Carmen
Dell'Orefice in
David Costume,
Test Shot, 1946)

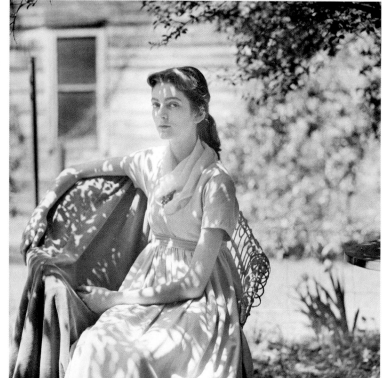

Franny at work in 1946, at the time she made the pictures on these pages. The image of her face was run at thumbnail size for a publishing careers package that ran in the September 1946 issue of *Glamour*.

(Frances McLaughlin-Gill, *Carmen Dell'Orefice in Ballet Costume, Test Shot*, 1946)

(Luis Lemus, *Frances McLaughlin-Gill, Glamour*, © Condé Nast)

An outtake from *Vogue*'s 1946 back-to-school junior fashion shoot; the model is wearing Claire McCardell, head to toe. (Frances McLaughlin-Gill, *Mary Tice on Third Avenue*, 1946)

This photo of Pat Donovan, taken by Franny in her apartment, was part of the group
she entered in the 1948 Women's Invitation Exhibition at the Camera Club of New York.
(Frances McLaughlin-Gill, *Vogue*, © Condé Nast, April 1, 1947)

Carmen posing in a hat by Mr. John. This picture appeared in the show *A History of Women Photographers*, which opened at the New York Public Library and toured America for two years. Fuffy's work also appeared in the 1994 book by Dr. Naomi Rosenblum that inspired the show. (Kathryn Abbe, *Carmen Dell'Orefice, 53rd Street Studio Garden, 1949*)

One of the photographs Franny made for *Vogue* in the Château of Versailles—the first time, she was told, that a magazine photographer had received the French government's permission to carry out a shoot there. Variants of this picture also appeared in French and British *Vogue*, as well as Rosenblum's book and the related show. (Frances McLaughlin-Gill, *Fiona Campbell, the Palace at Versailles, Paris [Jacques Fath Gown], Vogue,* © Condé Nast, September 1, 1952)

supervisory government agency La Chambre Syndicale de la Haute Couture, which he had miraculously managed to retain in French control during the occupation, had persuaded the Germans to keep couture in Paris, using the argument that it must remain rooted in its native terroir. So the industry had limped along until the Allies had arrived, carried out by the handful of designers who had stayed. They had really gone over-the-top with it: hats had become flagrantly huge and extravagant, partly to poke fun at the gullible Germans, who readily fell for the idea that French fashion was always outrageous.

A handful of daring Americans had already been to see the first postwar collections in 1946. Mrs. Snow, who was among them, had later given a talk to the Fashion Group, urging more to venture forth next time. "Lelong has a new designer," she had told them, "whose collection was sensational—full of ideas. His name is Christian Dior."

Now, in 1947, a group of forty American journalists and buyers had made their way over on transatlantic flights, stopping in Newfoundland overnight and sleeping on cots in the airport while the plane refueled. In Paris, they were greeted by freezing weather, a general strike, and no heat or hot water in the hotels. But they were all on fire with talk of this amazing new talent, Dior, who by now had his own fashion house and collection and had just unveiled a show of fashions that embodied what Mrs. Show had christened the "New Look"—the diametrical opposite of American sportswear. All Paris was talking about it, even the taxi drivers. The basic silhouette included a jacket with a nipped-in hourglass waist, like the bodice worn by the world-weary barmaid in Édouard Manet's *Bar at the Folies-Bergère*, and a huge pleated skirt that recalled the skirts Marseilles fishwives wore to market. Long, extravagant, and intricately constructed, the skirt seemed to bloom from a woman's waist like a rose—while announcing to the world that rationing was over and France, fabric, fashion, and extreme femininity were back.

But Leslie, that lover of Shaker simplicity, who had already seen it all in Italy and Cairo, remained somewhat unmoved. "#1 as of this

week," he wrote. "His things are pretty exciting (I guess? At least that's the story) although I personally like the others better. They seem so much more mature and sure." He was now peppering Franny with letters, rather than Dilys, and as he explained late at night from his freezing hotel room, he was finding it almost impossible to make good pictures without much access to anything but evening wear and with models who had so little stamina that they couldn't possibly pose outdoors in the cold. With too little time and under pressure from Mrs. Snow to work at a hectic pace, he'd had to give up on doing street work or using a view camera and so was stuck doing "the usual lousy job," making fairly static images of women reclining against couches and chairs and passing through doorways "all over town" in the usual series of "odd apartments." Even indoors the cold was brutal: "It's most disconcerting to find their fingers have dropped off and the retoucher is so cold he can't put them back," Leslie wrote. "Dear Miss McLaughlin, if you ever come to Paris refuse any winter assignment—don't even listen to the idea; but on the other hand don't refuse one for summer—It's a great chance! For me unfortunately it is winter and I am certainly muffing it."

He allowed that the food was excellent ("never had any better food in my life—unless it was the other time I was here"), as was his passion, antiques ("every day I have to go by dozens of shops that make our efforts on Third Ave seem so futile. . . . I see so many things that would be so nice in our your apartment").

But for the most part, he was thinking, worrying about, and long-ing for Franny. Although he didn't say much about it in his letters, he and Dilys had officially separated the previous November, and Dilys was now taking steps to procure a divorce in Idaho, which, like Nevada, had loosened its residency requirements and was favored by well-to-do women who liked skiing. Yet while Dilys was the one who had set the wheels in motion, who had clearly moved on while Leslie was away at war, and had been caught in the act besides, she was not at all happy about ending their marriage. She was even less

happy that he was moving on himself—especially with this young upstart who had climbed to success on his coattails. The children had become bargaining chips, and sweet, kindly Leslie had grown "miserable" and "impossible." At least that's how he described himself.

Added to which, at this critical juncture in his personal life, when Franny might well run off and find someone more lighthearted and less encumbered, Mrs. Snow had marooned him in Europe for more than two months. After several weeks in Paris, he would continue to Italy, to photograph what *Bazaar* would later describe as "the pyrotechnical display of Roman talent" that was just starting to be recognized abroad—not only the artist friends he'd made during the war, but writers and film people, such as the actress Anna Magnani and the director Roberto Rossellini, whose movie about the German occupation, *Open City*, had created a splash the previous year. He would also travel up and down the country, from Capri to Milan, photographing the landscape, the fashion, the artisanal accessories, and the people, before returning to Rome, his "favorite city anywhere." To this end, when Leslie wasn't running around Paris making photographs, he was being wined and dined by the Italian nobles who were greasing the wheels for the second half of his trip—while worrying terribly that his antifascist artist friends in Rome would be appalled.

"My friends will probably never speak to me again when they see me hobnobbing with royalists," he wrote, meaning the locals he'd hung around with in Italy when working there with the OWI. Worse, he feared Franny might assume he was being seduced. "By the way, the Contessa is *not* beautiful—is about fifty or so (nearly my age). . . . Trust you will realize that this is only a social, business contact and nothing warmer."

Back in New York, too, lurked potential competitors, such as Irving Penn, who had included Rome in his *Vogue* dispatch the year before, with a portrait of de Chirico and the famous painter's appraisal of the local scene. "Since Saturday I've met every character in Rome," Leslie

wrote—although, he noted, he "wouldn't want to sound like Penn for the world. (By the by, is he the new boyfriend you mentioned?)"

By then, Franny likely knew that Leslie, the great god of photography, wasn't great at expressing himself clearly. While he was in the army they had had no contact, so far as anyone knew. But he had once sent her a mysterious gift from Cairo, a group of mounted butterflies, framed under glass. After he returned, she learned that the butterflies had borne a secret message: behind the mat he had pinned a $100 bill—her weekly starting salary at *Vogue* (and quite a big bite out of the severely reduced income he was receiving from the OWI). The message seemed to be something along the lines of "I worry about your well-being, even separated by the Atlantic, the Mediterranean, the Aegean, several landmasses, at least one desert, and a morass of personal complications." But the cipher was so subtle that she would probably never have thought to try to discover it, let alone crack it, unless they had met again.

So now, separated only by the Atlantic and Mrs. Snow, Franny was clearly reassuring him, urging him to have a few drinks late at night and pour out his New England soul in his letters, even though, as he wrote, "I am not free." At some point it clicked. "Miss McLaughlin you are the sweetest girl I know and I should like to settle something right now. I miss you. . . . I'd give the whole show up just to hold you tight for even a few minutes."

Between the letters, lit by Italy's glorious sun, and away from the clutches and demands of his editor, Leslie was finally taking gorgeous pictures: the bay of Salerno, filled with twinkling lights; younger and more beautiful contessas and principessas in their sixteenth-century palazzi; his artist friends in their studios and on the streets; earthy Anna Magnani, holding a cigarette as she leveled a knowing look across Rome. Perhaps he wasn't only good at still life; he might be good at real life, too.

Soon Leslie wrote to say he was bringing back some sandals and two folding leather camp chairs, the latter gift prompted by the "mad

idea that they are sufficiently severe and functional to combine with Shaker." But the real treat was a set of fishing tackle he'd purchased for her somewhere along the Riviera.

For Leslie, despite his bespoke suits and his passionate love of design, had turned out to be even more of a nature boy than Jimmy: when he was out of the city and in the wild, he was an avid fisherman—the sort who ties his own lures from quills, silk, and feathers and spends hours standing in rivers in his waders. "If I can find a car back in New York you will have to try it once," he wrote to Franny, before confessing that he had always dreamed of driving up to Nova Scotia. On the off chance that she didn't like fishing, he promised, they could amuse themselves all night instead. "If it doesn't take we will try a bottle of Cordon Rouge and see what that will do."

The following August, Mrs. Snow took Avedon and Louise Dahl-Wolfe to photograph the Paris collections and told Avedon he had to do what Leslie had dreamed of doing the winter before: take his models into the street. "I don't want pictures in the studio," she said. "I want to show Americans what Paris looks like." The weather cooperated, and Avedon returned with incredible photographs taken in daylight. Made in the new blurry American snapshot style, they showed models swirling umbrella-like skirts against the cobblestone streets, leaning against posters to reveal suit silhouettes, or lounging in fur and brocade before the windows of a clairvoyant's studio. They began to make his name beyond *Junior Bazaar*.

But Leslie may not have been all that concerned. That same month, with his Italian pictures out, he and Franny were up in Nova Scotia, and she was cutting a dashing figure of her own in waders. Dilys had also procured the divorce and he was free—or at least, no longer married.

LOVERS AND TYRANTS

Our Little Frances

Meanwhile, back at *Vogue*, Franny was holding her own in the studio. The company's in-house magazine, *Condé Nast Ink*, often covered the latest activities there, and in January 1947 they published a portfolio of five drawings of studio life sketched by Luis Lemus, the Mexican photographer who worked in the space next door to hers. The arrangement was not ideal. Years ago he had told *Glamour* that his goal was "to be a photographer on the wing, footloose, fancy-free, super-successful," but now with that goal at least partly achieved, he played loud music while he worked, and it drove Franny nuts. "I had to ask him not to do it," she said. "You could hear it over the transom."

In his caricature *The Czarina*, Lemus depicts Claire Mallison, the devastatingly glamorous and efficient studio manager—whom *Glamour* had once described as "a freshly scrubbed goddess" with "enormous style"—as a multi-armed Shiva wielding two phones, a cigarette in a holder, a pen, and a six-tailed whip. In *Penn Shooting*, he shows the tense scene outside Irving's studio, as the entire editorial team waits breathlessly before a sign that reads KEEP OUT—for by now he was known as a genius who made his subjects hold poses for hours and insisted on working in silence and total secrecy. But in *Our Little Frances*, Lemus presents Franny as a gawky young girl

in a gingham pinafore and a big hair bow, grinning as she aims her camera at a glamorous model nearly twice her size, and adult editors gather behind her looking anxious.

Franny was twenty-seven by then, and quite glamorous and devastatingly efficient herself. Although she sometimes wore a utility apron on shoots—another garment that had been popularized during the war—and in one contemporaneous picture, shot by Lemus, she wears her hair tied back with a large silken bow, she otherwise dressed in a very soigné style and sometimes surprised professional models by not looking at all Bohemian but being as elegantly turned out as they were, in contrast to other women photographers such as, say, the somewhat frumpy Louise Dahl-Wolfe, who wore glasses and was always swaddled in turbans and scarves. "She was just a gracious lady," said the model Dolores Hawkins, who worked with Franny a few years later. "Somebody would say she was a fashion photographer, and you'd say, 'Really?'"

Although Franny was polite and kind when dealing with models and subjects, she didn't suffer fools gladly in her private life and was no-nonsense and practical at work. Regarding Lemus's caricature, she likely rolled her eyes, brushed it off, and got on with her next assignment. By then she was the only woman out of at least ten photographers on the New York studio staff—and likely the youngest, apart from Rutledge—and the only woman contributing regularly to *Vogue*. Toni and Kay Bell had moved on to *Harper's Bazaar*, and Lisa Larsen (formerly Rothschild) was working for *Life*, where she would eventually win awards for her coverage of political leaders and world affairs. A new young photographer, Diane Arbus, had just started contributing to *Glamour*, but she came as part of a package deal: she did the styling and her husband, Allan, did the negotiations and took the pictures.

Franny later described working in the studio as a delicate balancing act, "propelled by quick wit and repartee, and the inclination never to acknowledge how much we loved each other. I walked a tightrope where <u>ONLY</u> my photographs mattered & where each

gracefully acknowledged the others." Some joshing went with the job. There was rivalry, but nothing overt, she often said, except from Clifford Coffin, who was "a little crazy," she once allowed, and took a big dislike to her, often cutting in front of her "like a little eel" when the photographers walked down the long hall to the lab to see how their photos had come out. But after the war Liberman transferred him to London, where "he was very successful" and "did beautiful pictures," and that problem went away.

Liberman himself would gain something of a snakelike reputation, someone who enjoyed pitting even good friends against each other, the better to make them work harder, while also somehow managing to make all the women in the company adore him. Irving, calling him "a tough man in a velvet suit," once observed that Liberman could "charm the wings off a wasp," yet was also "sometimes the executioner" when required. "If somebody is going to disappear," he said, "Alex lets them hang himself."

But with a magazine coming out every two weeks, there was no time for overt bickering, Franny always said, insisting in her cool, ladylike fashion that nothing truly troubling ever took place. "We got along very well. We never tread on each others' toes, no scratching, no biting," she steadfastly maintained. "When we left the studio, we used to shake hands with each other each night."

Even with Leslie back in the picture, she and Irving remained good friends. That spring she introduced him to the woman who would become the love of his life. Sally Kirkland had come up with the idea of doing photographs of many models together in a single presentation—no small technical feat for the photographer, because while the resulting picture created a stunning effect, it also required careful handling of the lighting, as well as deft management of the models—their positions, their expressions, and their egos. The picture they started out with, which ran in the magazine as "12 Beauties: The Most Photographed Models in America," was to represent "an Omnibus of Beauty, current replacement of Ziegfeld and Gibson

Girl legends," as the magazine would explain. Taken on a bare set propped with a ladder and a couple of scraps of raw carpet, as was becoming Irving's style, it offered plenty of challenges. The models included Dorian Leigh, a firebrand with whom he'd been conducting an affair, and the clothes, by American designers, included a mix of day wear and evening clothes, and couture and ready-to-wear, from familiar designers such as Claire McCardell, Nettie Rosenstein, and the American couturier Charles James to no-name, off-the-rack department store offerings—so plenty was in the mix to promote tension and rivalry.

Franny discovered Lisa Fonssagrives sitting in one of the stalls of the dressing room as Irving was setting up, looking miserable and forlorn. Her dress, a custom-made gunmetal silk ball gown by Hattie Carnegie, also a ready-to-wear pioneer, wasn't yet there, and she was worried that it wouldn't arrive in time. Franny recalled Lisa confessing how frightened of Irving she was—"Mr. Penn," she called him—which wasn't like her at all. "So I dragged him off the set while he was setting up," Franny said. "He came in and he was very soothing to her and just said hi and went out again." But then, she noticed, "When he put the picture together, he put her right in the middle." Most of the other models were clustered together, overlapping one another, but Lisa was on her own near the center, surrounded by plenty of space to show off her stunning and unusual profile.

Although Lisa remained with Fernand for a time, and Irving continued with his other interests, the meeting set in motion another shift within the group of friends—one that would lead Irving and Lisa to marry three years on.

Yet their friendships endured, as Franny pointed out to her daughter, Leslie, many years later, when she was having her own dating travails in high school. "These things seem like high drama," Franny told her, "but it all works out." And "as you know, we're all friends." As if to underscore the point, Irving gave Franny a copy of the photo he took of Lisa that day, inscribed with the words "for little Frances

from little Penn, with love." (Irving's use of the word *little* was also a studio in-joke—the assistants referred to one another as *les petits*, a French diminutive, Franny explained to a reporter later.)

Meanwhile, the Uncle Vanyas finally let "little Frances" age up and start shooting real fashion. She also began traveling farther afield for location work. (Perhaps it helped that *Vogue* was now helmed by a new editor: Mrs. Chase had retired, and her replacement was Jessica Daves, the managing editor who had been so amused by Franny and Fuffy when they had visited years before for their Prix interview.) In April 1947, *Vogue* sent Franny out to Texas to cover the Flying L Ranch; opened by a retired air force colonel, it was the first dude ranch with an airfield. It had launched with a glitzy fashion show put on by Neiman Marcus, the Dallas department store, featuring models surveyed by audience members on horseback as they showed off flying suits, horseback-riding suits, and a "rodeo bathing suit"—a jeweled two-piece decorated with horseshoe-shaped cutouts that *Life* magazine, one of many outlets to report on the show, pronounced "not seaworthy." *Life's* photographer was a young Cornell Capa, a Hungarian photojournalist who had served in the American air force.

Franny, who stayed friendly with Capa for years, was there to shoot real fashion, primarily all-white American sportswear by the likes of Clare Potter and Claire McCardell, and the ranch itself. Franny's models posed in and around the airfield, the corral, and the modernist guesthouses, which had been designed by William McPherson, an architect who had worked with Frank Lloyd Wright, to look like planes flying in formation. While there, she also covered a story on young Texas women who "like many of her generation"— including Franny's own twin—sped up their travel by flying their own planes to weekend getaways.

Another highlight came with *Vogue's* 1947 college issue, when Franny was charged with making the French New Look seem like something the savvy American girl—or *young lady*, as she was now termed—might want to wear. "When does a Smart Girl become a Young Lady?" the

copy asked. Apparently when wearing clothes that "ask for a walk instead of a stride; make you manage your hands and your feet and yourself with a new sort of grace. The effect is 'come hither'—not 'here-I-come.'" At this moment, as the girls who'd previously been "smart" were being reconceived as decorous, Franny got her first cover—a big change from previous issues when, no matter how much work she had inside the magazine, the cover had always gone to a man.

The clothes in the issue were by American designers, who were by now offering their own take on the postwar look. Over the last few months, as magazines had explained how women should prepare themselves to fit into the new, more structured and complicated French clothes, which had padding, boning, buckram reinforcements, and underlinings and required corselets, girdles, and even calisthenics to fit right, many had feared that the revival of Paris as a fashion center would be a huge reversal for American sportswear, with its modern, easy-breezy, uncomplicated style, and also for the American woman, who was used to freedom in dress, along with the other freedoms that had come with the war. Some American designers, however, such as Claire McCardell, had already "been thinking along the same lines," Sally Kirkland wrote later, "that women would like fuller and longer skirts as a change from the almost skimpy clothes dictated by war-time government fabrics restrictions." McCardell's solution used circle skirts and bias-cut bodices to achieve an effect "more like that of a Martha Graham dancer." Others were using pleats and designing mix-and-match separates. "America's love for separates grew even more in this time," Kirkland wrote, "as 'do-it-yourself' types eschewed French copies in favor of buying one or two longer skirts and playing around with different tops and accessories for their own New Look, easy to manage and vary with the occasion." All these solutions were on display in college-girl magazine sections that August, the month Franny had her first cover.

Bazaar kicked off its issue that same month with a scary spread of photographs by Richard—or Dick—Avedon, who had become the

great young hero of photography at the magazine. It featured the new long-line corsetry and talked brass tacks. "You Can't Be a Last-Year Girl," the headline admonished, over pictures of whalebones, padding, and laces. "This is more a mental revolution than a structural one. After all, this is a woman's *natural* shape."

Franny's photos for *Vogue*, by contrast, drew sustenance from one of her first loves, the theater. Her cover picture features a modern young woman, wearing a red velveteen jacket, a gray flannel skirt, and a beret; but she poses in what looks like an old-fashioned photographer's studio, and she pulls back a gauzy curtain to reveal a grisaille backdrop painted with a castle, as if to say, all the world's a stage. Many of the photographs that follow on the inside pages were made in similar stagelike studio settings, but several were taken in Franny's loft.

She was already expert at adapting her home to suggest different places and moods. One month, a model in a pink flowered dress and white gloves might sit looking out the window, white silk draped above her like curtains parted in a Broadway theater. The next month, a nineteenth-century grisaille screen would have transformed the space into a boudoir, and little Pat Donovan in a nylon peignoir would suddenly look like a woman, examining her appearance in a mirror while late-afternoon sun lights up her body and face. (The mirror turned up in a lot of Franny's pictures, reflecting the model or someone else in the room, who otherwise went unseen.) Franny had photographed Carmen Dell'Orefice prowling around there, too, leafing through a book, examining the paintings, gazing into the mirror, while showing off a big straw hat.

For this issue, she propped the loft with so many different types of paintings and mirrors and draped it with so many yards of China silk that it looked different in every shot, sometimes even resembling a street corner in Europe. Other pictures were taken outdoors in the woods near Fuffy and Jimmy's house in Jericho. Here Franny hung paper "to subordinate the busy background," she wrote later, in a

book about the early use of color photography in *Vogue*, of an image in which she employed a similar technique, "but kept the shadows of the plants to keep the 'feel' of a conservatory."

Franny's work that year would start to win her wider recognition outside the magazine. For the first time, one of her photos was chosen for the *U.S. Camera Annual*: a *Vogue* shot of a skier in a red coat bending to tighten her bindings before a triangular red barn. It ran next to one of Irving's still lifes, of opera accessories spilling out of an evening bag. She was also invited to participate in the second Women's Invitation Exhibition at the Camera Club of New York, a venerable organization formed in 1897 that, with Stieglitz's encouragement, had been early to champion photography as an art form. Among her other submissions, Franny contributed the picture of Pat Donovan gazing at herself in a mirror in the loft.

Yet to be included in a show of women's work was something of a double-edged sword. Although the first Invitation Exhibition had included photographs by an "impressive" group, as the *New York Times* critic Jacob Deschin put it, including Toni, Louise Dahl-Wolfe, and Margaret Bourke-White, the biggest compliment he paid the show was that the work was "not markedly feminine." By which he meant that "there are only a few pictures of babies, and these chiefly by photographers who specialize commercially in child photography."

THE FOLLOWING YEAR, Franny was moved up to fashion and personality pictures at *Vogue*, and the junior beat was effectively behind her. Despite her success, other signs indicated that she had not yet won full recognition at the magazine. Two weeks after her first cover came out, French *Vogue* published a group picture of the *Vogue* photographers, and Franny was not among them.

A black-and-white image that shows eight men standing in a clearing in a forest, the photo ran as part of a portfolio of Irving's work. The gathering includes Balkin, Beaton, Blumenfeld, Horst, Joffé,

Rawlings, George Platt Lyncs, the head of *Vogue*'s Hollywood studio, and Irving, crouched near the right of the group and holding the bulb to release the shutter, as well as the model Dorian Leigh, who looks decorative as she leans against an old bellows camera near the center of the frame. Most of the men wear jackets and ties, except for Beaton, who sports a flamboyant cape and beret, while Dorian wears a dress with a bustle and holds a parasol, as if to suggest the scene is taking place in the early nineteenth century at the dawn of the photographic medium. The magazine referred to the assembled group as "*les plus illustres photographes de* Vogue," or "*Vogue*'s most illustrious photographers."

Fuffy, who had also become good friends with Irving and retained her tendency to look on the bright side, always maintained that the photo had been a casual, last-minute thing, taken on the spur of the moment as the group visited Horst's new house nearby; or that Irving had told Franny it was going to happen and had urged her to come, too, but she had other plans and couldn't be bothered.

But Franny was very fond of Horst—she had given him an old coat to send to his mother in Germany after the war—and probably wouldn't have missed a visit to see his new house. And the presence of the bellows camera and Dorian's elaborate costume suggests that this was no blithe and spontaneous endeavor. Besides, Liberman was there, overseeing the shoot. An alternative version of the picture shows him crouching in Irving's place, his eyes fixed intently on the camera and his cherished star photographer, who stands behind it, taking the shot.

CHAPTER 25

Cautioneary Tales

F or women who managed to build successful careers in male-dominated professions, there were plenty of cautionary tales. Consider the case of Cipe Pineles, *Glamour*'s art director, who threw herself under a train at Times Square the month after *U.S. Camera* published its story on the excellent and unusual photography she had encouraged at the magazine. She survived, but the episode spelled the end of her time at Condé Nast.

Some months before, after a short leave to visit her husband, the fabulously handsome CBS art director William Golden, who was working for the OWI in Paris, she had returned to find that Liberman had usurped her position as art director on the *Glamour* masthead, and she had been demoted to art editor—a brutal comedown, considering she had once been free to run the magazine's look as she saw fit. She was the one who had created an intriguing visual mix for the company's first mass-market magazine, bringing in high-end photographers such as Toni, Herbert Matter, and André Kertész and fine artists such as Marc Chagall and Jacob Lawrence, the first black artist to show his work in a downtown Manhattan gallery, to illustrate stories. (Her July 1946 issue, published just after the founding of the United Nations, paired paintings, lithographs, and etchings by Lawrence and the Russian Jewish refugee artists Raphael

Soyer and Marc Chagall with features on racism, immigrants, and the history of anti-Semitism; it also included a beauty story on the wonders of different skin colors, accompanied by Horst's photos of black, white, and Asian women.) In 1943, the year Liberman became *Vogue*'s art director, Pineles had also broken barriers for her sex by finally becoming the first woman admitted to the Art Directors Club, after Dr. Agha, her former mentor, had repeatedly proposed her for membership, and she had repeatedly been rejected. Her bio in the magazine had once read, "*Glamour* is all hers." No longer.

Pineles was extricated from beneath the train—luckily, she fell between the rails—and, after a short hospitalization, returned to work. But the general opinion of the Uncle Vanyas and the other top editors was that she had become unstable. By year's end she was out, with her name misspelled *Pinelas* on the masthead in her final issue. Liberman replaced her as art editor with her much younger assistant, Tina Fredericks, a Berlin refugee and *Mademoiselle* College Board winner who had taken his fancy. (He also likely knew Fredericks's father, Kurt Safranski; before the war, Safranski had been Liberman's counterpart at Ullstein Verlag, the Condé Nast–like empire that had once published *BIZ*, and he was now a partner in the Black Star photo agency.)

Pineles was bitter. "I didn't leave. I was fired," she said later. But her career was resurrected within a few months when Helen Valentine asked her to bring her magical high-low art directing mix to *Seventeen*.

Later, Liberman barely seemed to recall Pineles's presence, observing that "art direction was very male" when he'd arrived at Condé Nast. "Brodovitch, perhaps myself," he said.

TONI WAS ALSO OUT AT CONDÉ NAST and had been since a year or so into the war. She had finally gotten herself back overseas, this time into the European theater of combat, where she had been fearless,

talking her way onto an artillery-spotting Piper Cub so she could photograph the site where the Battle of the Bulge had recently been waged; hitching rides on jeeps to make pictures of soldiers, corpses, refugees, and POWs along the Siegfried Line—the German line of defense—as the Allies advanced from Paris to the Rhine. Once, when she had just taken a picture of an American soldier looking like a corpse as he lay on a plank with his gun, her jeep was hit by hot shrapnel, and medics quickly arrived to administer morphine and a cigarette to the badly wounded driver.

She also spent time in Sicily with the Tuskegee Airmen's 332nd Fighter Group, the elite black fighter-pilot unit that escorted bombers into battle, clearing the path for their raids by shooting down the Luftwaffe's much-more-sophisticated fighter jets. She had photographed the men being briefed by their commander, Colonel Benjamin O. Davis Jr. ("a remarkable leader," she wrote in her memoir); playing cards in the officers' club before they flew into battle, each man equipped with cyanide in case he was forced down and tortured; and Davis himself, coolly examining a plane. (He later became the first African American general in the air force.)

Although these photographs are believed to be the only pictures taken of this important, extraordinary unit in Europe by a professional photographer, they never appeared in *Vogue*, for the magazine already had a correspondent at the front, Lee Miller. Both women were about the same age and came from similar New York social backgrounds, but Lee had learned photography in the Paris atelier of her onetime lover Man Ray and had become his model, collaborator, and muse, and Liberman regarded her desire to go to war as "a Surrealist gesture." Right after V-E Day, he insisted that *Vogue* publish Lee's photographs of the death camps—the ovens, the burned corpses, the newly freed prisoners in their striped rags looking like corpses themselves as they stood before piles of bones, and the oddly neat rows of ovens, as German children played happily in picturesque towns barely a breath away. The headline, "BELIEVE IT," was drawn from Lee's

cable. By contrast, Liberman saw Toni as a frustrated society matron and found her work passé.

But by then, Toni and *Vogue* had already cut ties, soon after *Vogue* had paid the Red Cross less than expected for her London dispatches. Toni had sent a long letter to Patcévitch outlining her discontents: not only the Red Cross being stiffed but also too many new photographers, she had said, listing them all by name (except Franny); and Rawlings, married to the chief fashion editor, got all the assignments, including some Toni had suggested.

In the past when Toni had complained, Mrs. Chase had taken pains to woo her back. But this time, because of Liberman's antipathy—and also perhaps because they now had Franny to cover the junior beat back home—Patcévitch called her bluff, just as he'd done with Agha.

"It is apparent that your grievances against Vogue are of long-standing," he wrote back. "I have to come to the sad conclusion that we should try if not a divorce—at any rate, a temporary separation. If in trying your wings . . . you decide to marry another magazine, I for one will not accuse you of bigamy."

Another suitor for Toni's war photographs arose straightaway— Mrs. Snow. But shortly thereafter that prospect was stymied by another photographer, the famously jealous and territorial Louise Dahl-Wolfe, who threatened to leave the magazine when Toni's first photograph, of an Army Air Force unit returning to base, ran in *Bazaar.* Louise, it seemed, was terrified of sharing any sort of turf with another woman.

Mrs. Snow, normally so sanguine, was flummoxed. Louise had refused to contribute anything further, "colour or otherwise," she wrote to Toni, "unless I assured her I would not use you." That the pictures were of war, not fashion, didn't matter. Louise would leave "if anything of yours appeared in the magazine."

Then Mrs. Snow hit upon a compromise: *Junior Bazaar.* Because she didn't intend to include Louise's work there, "I can use you for fashions as well as appropriate features," she wrote to Toni.

Toni became a regular contributor, along with Leslie, Dick Avedon, and Genevieve Naylor, a photographer about the twins' age who had apprenticed with the photojournalist Berenice Abbott. As a result, while some of Toni's war work went to magazines such as *Life* and *Collier's*, much of her best photojournalism went unpublished. But she was back working as a fashion photographer.

Curiously, Dahl-Wolfe must have relented, for Toni soon landed an astonishing assignment for big *Bazaar*: flying down to Jamaica's Montego Bay to shoot a model splayed out on a rock in a bikini, the skimpy two-piece named for the Bikini Atoll, the Pacific coral reef that had been the site for the first public test of an atom bomb. It was the first time a bikini had ever been photographed for an American fashion magazine.

The idea of one woman impeding the career of another might be nothing new, but it may have surprised the twins, who had received so much help from women such as Margaret Hockaday, and Toni herself. Besides, despite Toni's wealth, to them Louise had the more enviable life. The twins had compared the two photographers many times in the past and had always been perturbed by Toni's relationship with her husband, Mac. Although he oversaw the household while she was away, and the children were well cared for by Toni's childhood nanny, he "didn't like her to travel so much," Fuffy said. "He would say, 'If you don't stay home more, I'm going to sell the house.' That was the only way she tapered off her trips!" That partnership seemed strikingly different to the one enjoyed by Louise, whose slightly younger husband, the artist Meyer Wolfe, was devoted to her career. Because Jimmy's studio was in the same building as *Bazaar*, and Louise worked around the corner, "we used to see her all the time," Fuffy said. "I knew her quite well, and she didn't have Toni's problem at all. Her husband adored her working and did everything to make her life smooth." Louise's husband helped paint her sets, sorted out her business dealings, came to the rescue during difficult sittings, and referred to her, only partly in jest, as "Queen Louise."

Fuffy and Franny often weighed up the difference: "Can you imagine, Louise has all this, and Toni has to put up with that?"

Yet suddenly Louise, the fashion photographer who had every-thing, had inserted herself in Toni's path, to stop her from publishing photojournalism. It made no sense at all.

THANKFULLY, FUFFY DID NOT ENCOUNTER this problem in her own life. She was now working for the ever-generous Margaret, whose career was steaming ahead. During her brief tenure at *Holiday* as fashion editor, she had spread assignments far and wide among her friends. As well as hiring Jimmy to take pictures of Taos, Margaret had used him for a story about what to wear for a weekend on California's Mission Trail. She had hired Toni to photograph her ideal travel wardrobe, which included a sensible rain slicker, a black satin evening dress with a removable tulle overskirt, and a long mink stole. She'd also begun assigning Leslie fashion stories shot on location in contemporary buildings—for Margaret had been passionately interested in modernist architecture since her childhood just outside Chicago, in Oak Park, where she had grown up hoping to study with Frank Lloyd Wright.

When *Holiday* turned down Margaret's idea to do a travel clothing guide, she broke free and went into business for herself, combining her interest in fashion, design, publishing, merchandising, retailing, and salesmanship by opening her own advertising agency. It would soon become one of the few woman-run shops on Madison Avenue–and one of New York's most successful boutique agencies.

While waiting for clients, Margaret produced the travel guide herself—her first project—with Fuffy as the photographer. Although it purported to cover a vast area while explaining "the happy choice in clothes for the variable clime, the interesting place, the ideal time, couched with incidental data on regions, name-places and cities of note," it had only eight photos, all powerfully evocative, all shot within easy reach of the Abbes' three homes. The model was Barbara

Tullgren, a *Vogue* cover girl who'd made it in Manhattan after winning a beauty contest in Milwaukee, and all the scenes seemed to recapitulate moments from Fuffy's own life, which had suddenly begun to look as though it were being staged for the pages of a magazine.

For a chapter called "Weather," Barbara gazes out over the East River on a stormy day, wearing a raincoat and galoshes, her back to the camera, with the blithe attitude of a child in one of Toni's pictures. For "Country Wardrobe," she walks through tall grasses in a trench coat, ruminating over the landscape as Fuffy must have done on so many early trips to Montauk. For "Snow Wardrobe," she bends to adjust the bindings on her skis and grins up at the camera, recalling the pictures the twins had taken of each other on their long-ago ski trips with Jimmy; and for "Ranch Wardrobe," she faces a rough-hewn fence wearing a checked shirt and pants—which is reminiscent of Fuffy's own wedding outfit—about to grab a rope and saddle up a horse, just out of frame.

"It was just my cup of tea," Fuffy said, "because I imagined that somebody was in the West, and someone was in snow country, but I did them all within a range of a few miles. With no big-deal editors, just Margaret encouraging me."

Margaret sold the project, called *Fashion Guide to the U.S.A.: What to Wear Where in America*, directly to department stores. It was so successful that *Holiday*'s top brass was finally convinced. Rebranded as *What to Wear Where: Holiday Fashion Guide to the U.S.A., the Islands, and Mexico*, it was expanded with more pictures shot by Fuffy to cover Mexico and the "Islands," from the Caribbean to Hawaii. Like *College Bazaar*, it sold on newsstands as well as in department stores and eventually became a springboard for window displays, promotional campaigns, and store departments filled with *Holiday*-approved merchandise.

That year, too, although Fuffy wasn't doing quite as much work for *Charm*, the magazine made her the focus of a package on cameras and photography careers, for which she took most of the pictures.

The story's gist was that the United States now had about 20 million "shutterbugs," taking about 80 million pictures a year. "The nation's favorite hobby is also one of its biggest businesses: photography, in one way or another, is part of the day's work in 90 per cent of our commerce and industry." Fuffy, presented as a professional photographer who flew around the country with her photographer husband for work as well as recreation, was a perfect exemplar of the success that might be achieved.

For the package, Fuffy photographed a story on how to pose for photographs, as well as a fashion spread in which she gave her tips on how to take good fashion pictures: "I like to capture a mood and a fleeting expression to illustrate the feeling of a fashion. I may make as many as 36 exposures to get the one shot that looks just right." Her formula, she added, was "80% psychology, 15% sense of design, and 5% luck. It takes psychology to get the model to move in a way that expresses the mood of the fashion. It takes a sense of design to arrange the light and dark areas in such a simple and direct way that the photograph pleases the eye, and it takes a bit of luck to get the photographs back to your office intact in spite of sleet storms, customs collectors, delivery strikes."

Fuffy was traveling, too, just not for her own work. In December 1947, she and Jimmy went to Europe—for her it was the first time. The plan was that they would stay in London with the editor of *Everywoman*, a young women's magazine akin to *Charm*, which was publishing Jimmy's pictures, then move on to Paris for the holidays.

At the last minute, the plans went slightly awry, when the *Everywoman* editor, Anna Wibberley, having been carried away by the pictures she'd seen of Jimmy and Fuffy and their plane in *Mademoiselle*, suddenly decided to marry a New York show dog breeder in Las Vegas—a union that necessitated at least one divorce—and left London earlier than expected to set the wheels in motion. Jimmy and Fuffy forged ahead with the visit to London anyway, making a quick stop there before moving on to Paris.

"Although we shall certainly be disappointed not to see you in London," Jimmy wrote to Anna, who had visited the Abbes the previous summer in Montauk, "please know that we completely understand the urgency for action upon the important decisions which you have taken. We are happy to hear that you have chosen Las Vegas as it is our 'Alma Mater.'"

Jimmy also asked for more money for the fifteen Kodachromes and fifteen black-and-white pictures she was buying—which included one of Lisa Fonssagrives; one of Dorian Leigh's little sister Suzy Parker, new to modeling; and one of Mary Lee, who was trying to make her way as an abstract painter in Greenwich Village now that her marriage to Lewis Teague was on the rocks. (Mary Lee was soon to meet the abstract expressionist Willem de Kooning, who would become her lover and longtime friend.) Although *Everywoman* had paid quite generously, Jimmy wasn't satisfied and gently inquired if they were sure it was their top rate: he ended up getting nearly double the price, for a total of $2,792.51 (nearly $36,000), and being paid in dollars.

In Paris, Jimmy and Fuffy visited Studio Astorg, run by Jimmy's old friend the photographer Jean Chevalier, who was overseeing photography for *Elle*, a new fashion magazine founded there just after the war. There the Abbes posed for one shoot and watched another, conducted by Harry Meerson, one of the top fashion photographers in Paris. (Jimmy had briefly assisted Meerson early on, when he had started out at *Bazaar* in New York and the French photographer had been there on assignment.) Like many visiting Americans, the Abbes had brought supplies that still couldn't be easily obtained in Europe—in this case, color film, silk stockings, and cigarettes. Film was still so scarce in Paris that Meerson had to eke out his color shots almost as judiciously as Franny had done at Condé Nast during the war, with four and five frames per picture, while Fuffy seems to have had enough black-and-white film to photograph him in action quite freely.

They also visited the studio of one of Julien Levy's artists, Leonor Fini, who had returned to Paris after spending much of the war in

Rome, eventually setting up house with two male lovers and more than a dozen cats. Her dreamlike paintings, which often depicted long-limbed women dominating men, had first appeared in New York at the Museum of Modern Art's Dada and surrealism survey in 1936 and at Levy's gallery the following year. They typically involved fantastical costumes, sphinxlike women, catlike masks, and male nudes and seemed to draw inspiration from her own life, as Levy had learned when he first met her in Paris before the war.

Fini's reputation had preceded her, Levy wrote in his memoir: "She was 'ageless,' or 'twenty-two years old,' she was 'magnificent,' she was 'impossible.' Paul Éluard said, *'Quand c'est Fini, ça commence!'"* When Levy and Fini had finally met at a large reception, Fini was wearing a fur coat. "Pressed to take it off, for the evening was warm and the gathering indoors, she finally shrugged and threw it aside," Levy wrote, revealing that "she was nude." That was only the start. Asked by a painter to comment on his work, she had cut the canvas into small pieces and mailed it back, saying she regretted she had not been able to find a larger envelope. When a museum requested that she relinquish her umbrella before entering, she had urinated in a gallery in protest, saying, "I just want to show them . . . that it isn't only an umbrella that can wet." After Levy accompanied her to a "desolate" Walpurgisnacht orgy with Max Ernst—they costumed themselves out of her closet in spangles, horns, leather boots, feathers, and masks, while remaining nude from chest to thigh—Levy was so impressed that he had invited her to show with him in New York.

Fini's life in wartime Rome had been more sedate—she created a salon whose primary focus was conversation that included many young artists and writers, including Moravia—but her aura of dominance over men and her wilder beginnings among the surrealists no doubt appealed to Fuffy, who remained fascinated by the movement. Fini was now one of the most famous creative figures in postwar Paris and a magnet for photographers. Horst had immortalized her in her studio the previous year, wrapped in feathers, and now, for Fuffy, Fini posed

there wearing a dark cape and hat, staring sultrily through her easel and paintbrushes into the camera, for she was fond of women, too.

Fuffy also photographed everything else she and Jimmy visited in the city—the Eiffel Tower, a camera store, and the nightclubs, bookstores, cafés, and graffiti of Montmartre. Somewhere along the way, someone grabbed Fuffy and embraced her, thinking she was Franny. Then the Abbes motored down through France to Davos and spent a week skiing with some friends from Montauk.

Once home, they began supplying lights and camera equipment to Studio Astorg and making plans to return. "Thank you for the parcels—my life as a photographer has been transformed, it is now a real joy for me to take photos 'on location,'" wrote Chevalier, *Elle*'s director of photography, in French, before asking Jimmy for a tripod and more flashbulbs.

Anna, the editor at *Everywoman*, who fascinated everyone with her mellifluous accent ("*so* like Greer Garson's," *Charm* had raptly reported), had also become a fast friend to the Abbes. In her editor's letter for the January 1948 issue, she wrote about her fondness for the couple, with whom she'd stayed the previous summer "at their tiny little house on the wonderful beach of Long Island." She described the house as "cracking at the seams with happiness" and waxed enthusiastic about their exotic adventures in Jimmy's two-seater plane—how he'd thrilled and charmed her by taking her up on a foggy day and making "this Ed. feel she was flying herself."

Despite this buildup, though, the magazine somehow managed to run one of Fuffy's pictures—an outtake from the *Holiday* guidebook, of Barbara Tullgren in a raincoat looking out longingly over the East River—with Jimmy's byline. But not much could be done once it happened. At least the picture was out in the world and Fuffy had been paid. Besides, once the Abbes returned from the trip, she didn't have much time to look back. Their lives were about to change yet again: Fuffy was pregnant.

CHAPTER 26

The Big Change

As the postwar period settled in, young women who had been riding horses, piloting planes, and dancing through the pages of magazines suddenly began packing trousseaus, blushing in wedding dresses, and looking awkward but hopeful in maternity clothes. A year before, magazines had been carefully explaining the structure of government and urging their readers to participate. ("If Women Want a Better World They Must Get Out and Vote" was the title of one *Glamour* piece by Claude Pepper, a liberal senator from Florida.) But now, even the teen publication *Junior Bazaar* steered them toward weddings—not only what to wear and what food to serve, but how to recognize the type of man one might aspire to marry.

The focus had shifted, from smart young women to "These Bright Young Men," as the magazine headlined a January 1947 story. The consummate crop of five included the dashing fencing champion Dean Cetrulo, formerly a daredevil lieutenant in air force intelligence, today a Broadway actor; the brilliant young author Gore Vidal, who had written six novels since he turned fourteen; and the nuclear physicist Vernon Hughes, who had "helped perfect radar timing circuits during the war" and was currently acquiring his Columbia PhD. Back at *Glamour*, one could read a story called "Promising Young Career Men"—all of whom were "off to good starts in professional fields

with the kind of future that might interest your man"—including the radio journalist Eric Sevareid, director of CBS's Washington News Bureau, who had just written a bestseller about his wartime reporting adventures; or another called "Young Men Who Care," such as Arthur M. Schlesinger Jr., a twenty-nine-year-old associate professor of history at Harvard, who already had a Pulitzer Prize, and the twins' old Choate swain Jack, now known as Congressman John F. Kennedy, the "son of an influential father who didn't settle for a soft life" and a veteran who "believes good government begins at home."

Today's sparkling college girl was now expected to be great at entertaining, like Nancy Poor, a Bennington freshman who had been throwing parties since the age of thirteen, and who shared her recipes and hostessing tips with *Junior Bazaar.* Nancy—whose story was preceded by a portfolio of blurry pictures taken by Dick Avedon, of couples rushing past a church with armfuls of flowers—suggested a buffet supper for twenty, a dinner for six, and a postdance late-night supper, all for pairs. "Before they get really settled," she advised for the buffet, "pick out the tallest boys you can find and send them firmly into the dining room to dish out the food (the tallest boys because they can be spotted easily when the other guests come to be served)." Another *Junior Bazaar* story focused on a new finishing school near Stowe, Vermont, where today's young housewives could ski for two or three hours while being taught "household management precisely the same way their grandmothers learned it from their great-grandmothers—by practice and under expert direction."

As for the business girl, "You've a head on your shoulders—remember?" *Charm* reminded its readers, accompanied by a photo of a young woman in white gloves smirking up at a man who wasn't pictured. Yet the subject under discussion was beauty, not brains. "First maneuver: your hair!" the copy read. "It's under his nose when you're talking, walking, or dancing. Wear it cap-shaped. Brush it silky smooth. Spray it with a rememberable scent that stays with him till the next time." The face beneath the hair also mattered. "When you

make up for an extra-special date, allow ten extra minutes for your eyes and lips. Seen from above, they'll absorb his interest if your eye shadow is blended, if your lashes are carefully curled, if your lipstick pays tribute to your lips."

The picture had been taken by another bright young man, Horst's former assistant Francesco Scavullo, who had started his career at *Seventeen* and was rapidly ascending. He had also made the portrait for a second story in the same issue, "Pink Is for Girls," of a blonde smiling demurely as she cradled a big carnation. Fuffy, whose freelance business seemed to be slowing down a bit, contributed only two pictures to that month's big bridal package—honeymoon shots of shy young newlyweds departing on trains.

In the more mature career magazines, such as *Glamour*, where Franny worked, readers who had once been carefree girls with jobs were now married women who, like her twin, needed to juggle those jobs with husbands and, increasingly, families. Franny photographed such stories as "Mr. and Mrs. Inc."—"case histories of seven married couples," the copy read, "who are collaborating on joint careers in the arts, the sciences and business." (The piece opened with a photo of the young photographer couple Diane and Allan Arbus, who had just begun contributing to the magazine, and would separate about ten years later.) Another feature, "Careers and Children," started off with a picture of a housewife in the Bronx, whose new career was raising her toddlers. "I believe that if a mother bears in mind the important job she has as homemaker," she said, "many of the monotonous routines of housework will become less humdrum." The second woman in the story, pictured with two children who sat on a Shaker bench, had mostly stopped her art career and maintained, "The most important job any woman can have is running her home."

Franny photographed plenty of bridal packages, too. *Glamour* frequently dedicated its junior column, "Young as You Are," to casual wedding attire. Pat Donovan, the serious, dark-haired teenager Franny had discovered two years before in Amagansett and had

once photographed laughing and leaping with other girls in a field, now played a "bride with a career" who married in a suit and sailed away on her honeymoon. Pat shows off several suit variants while standing in a small wooden rowboat, holding a petite bouquet. For the final shot, in color, she poses against a painted backdrop that suggests Lake Como. Henry Clarke, a handsome new props assistant in the Condé Nast studio, sits at her feet, casually holding an oar as he plays her groom.

MARRIAGE, MOTHERHOOD, AND OVERSEEING a beautifully functioning household weren't the only things expected of young women. During the fall that led up to Fuffy's "big change," as career magazines referred to pregnancy, *Glamour* began running a seven-part series, penned by Marynia F. Farnham, MD, a woman psychiatrist, which explained the other big change coming for women now the war was over: the need for them to ready their psyches to mold the next generation of men who would rebuild the world. The series was called "Modern Woman," and as if immediately acknowledging that a radical reorientation would be required of last year's "girl with a job," it kicked off by explaining the societal role of women and how psychiatry could help them clarify their minds and desires to achieve it.

"Today's 'ordinary' problems are considerably more complicated than any that have confronted human beings in the past," the first column began. "Women have a very special responsibility to the world since they produce human beings and, more than any other influence, shape their lives." During the war, military records had revealed that almost half the men rejected for service had been disqualified for psychological reasons—one among several pieces of evidence that had recently led Thomas Parran, the surgeon general, to conclude, "One in ten Americans will sooner or later need the help of a psychiatrist."

Subsequent columns addressed such subjects as happiness ("the ability to live contentedly with yourself and the world"), premarital

sex (avoid "the sudden or vagrant wishes of the moment"), and finding a husband ("your inability to achieve marriage" may be "due to the fact that you do not want to be a wife").

Glamour's editors explained that they had been moved to select the overall topic because of their conviction "that women, being the mothers of men, fundamentally shape the course of civilization." And they had chosen the author because she had demonstrated that "a great part of the world's ills are profoundly traceable to the fact that modern woman is unconditioned to fulfill her destiny"—that destiny being to raise the men who would shape and better postwar civilization. Dr. Farnham had done it by coauthoring a book so attention-grabbing and popular that it had become a bestseller—although that qualification itself would seem to immediately disqualify her from advising women how to stand back and let men take the lead.

Called *Modern Woman: The Lost Sex*, the book argued that modern society was a disaster. Although it had been "committed to the idea of progress" since the Enlightenment, progress had brought only "modern large-scale war and economic boom and depression" and had birthed political movements such as socialism, communism, anarchism, nihilism, anarcho-syndicalism, anti-Semitism, racism, and feminism, each of which "has made a philosophy of violence and hatred." Readers should take no joy in having survived the Great Depression, won the most recent war, or raised America to new heights of power and prosperity. Instead, Dr. Farnham and her coauthor, Ferdinand Lundberg, a leftist journalist who'd made his name eviscerating conservative businessmen such as William Randolph Hearst, Condé Nast's archrival, took a longer view—that humankind had been sliding toward neurosis since the dawn of the machine age, and women were the root of the problem, "the pivot around which much of the unhappiness of our day revolves, like a captive planet."

Their argument invoked Freudian psychology, scientific analysis, and, as the anthropologist Margaret Mead wrote in a *New York Times*

review, "a long razzle-dazzle trip through European history, in which the Copernican revolution is cast as villain." Mead didn't seem to like the book at all: "Man, robbed of his cosmic significance, is psychologized in strokes which make up in boldness what they lack in detail or thought. There is a concerted attack in almost, but not quite the same, jumpy, headline type of style, on every modern ideology. . . . Perhaps the most puzzling of all are the sixty pages devoted to a savage attack on the feminist movement." Nonetheless, the book became a bestseller, perhaps because its thesis was so shocking and outrageous.

Its societal prescriptions were developed in extreme and somewhat freakish detail: the authors advocated extensive psychoanalysis, a tax on bachelors over thirty "so that they at least . . . might contribute to the social support of children," and government stipends for mothers. Public-school teaching jobs, the authors argued, should go to married women—preferably those with children—rather than "spinsters." Sexual pleasure was all very well, as long as it led to "the final goal of sexual life—impregnation."

Although Lundberg got top billing, the idea of a career woman with children telling other women to find fulfillment as housewives seemed so preposterous that Farnham attracted the attention. She did the talks and television interviews and appeared in her white lab coat in *The March of Time* newsreel shown in movie theaters countrywide, declaiming authoritatively about women and their problems. She was the one invited to contribute stories to journals and periodicals—not only *Glamour*, but also *Coronet*, which had been transformed from a "class magazine for arty intellectuals," as *Business Week* put it, into a more moneymaking *Reader's Digest*–like publication filled with general-interest stories, pictorial essays, and photographs.

"The Tragic Failure of America's Women: A Shocking Indictment by a Noted Woman Physician" was Dr. Farnham's story for this new, more wholesome publication, appearing the same month as her first *Glamour* column. It was promoted on the cover, against an illustration

of a blonde bobby-soxer in dungarees mooning up at a boy playing a harmonica. Farnham followed it up a few months later with "Who Wears the Pants in Your Family? A Two-Fisted Challenge Written by a Noted Woman Doctor." This time the line ran over an even more nostalgic picture, of two blond kids riding in a sleigh with a jolly old man.

The responses to Dr. Farnham's ideas were mixed, reflecting the wildly fluctuating ideas about women's roles. Some were incensed. "Dr. Marynia F. Farnham, practicing psychiatrist, evidently considers herself an exception to her theory that women should abandon their careers, or at least subordinate them to motherhood and housewifery," wrote the advice columnist for *Newsday*, a Long Island newspaper. "Can the good doctor—or any other thinking person—be so naive as to assert that women alone can go back a hundred years and lead the lives of their great-grandmothers while the rest of the world lives in the 20th century?" Farnham was slammed by the Hollywood gossip writer Hedda Hopper, whose column was syndicated in eighty-five newspapers. "Mariana Farnsworth" gave her a "big fat pain," Hopper wrote, misspelling the doctor's name, while noting that the career women she personally knew "make their homes the center of their lives" and "took up careers to keep their homes from falling apart and for the betterment of their children." They "are too busy taking care of their homes, families and jobs—yes, even husbands—to spend their time at . . . psychiatrists' offices."

Others professed amusement. Doris Lockerman, the powerful woman's news editor for the *Atlanta Constitution*—she would soon be named an editor of the paper, one of the few women in the South to hold that position—called her "the smartest cookie since Hetty Green," a mysterious, miserly financier who had secretly amassed a fortune to become the world's richest woman in the Gilded Age. As Lockerman astutely observed, Dr. Farnham had sold a lot of books by getting "every girl in America red-headed"—that is, flaming with anger.

In New York City—Dr. Farnham's home turf, where she knew all the right people and was so powerful that she could have a cop in her Park Avenue neighborhood transferred out to Coney Island if she made the right call—she was challenged by Harrison Smith, the dapper, urbane, and staunchly feminist publisher of the *Saturday Review of Literature*. Smith liked to boast that he had been "one of a sprinkling of self-conscious men" who'd joined the tens of thousands of suffragettes marching down Fifth Avenue in 1915, "prepared to dodge brickbats and catcalls," as they sought to encourage New York State to grant women the right to vote. (The referendum finally passed two years later, spurring Congress to pass the Nineteenth Amendment in 1919.) Now, in an editorial entitled "Woman, the Scapegoat," Smith pointed out that Dr. Farnham's book was only one in a growing chorus of women-baiting publications. In *Cosmopolitan*, in a story lamenting the rise of divorce, the writer Philip Wylie had blamed two phenomena he'd first identified in his 1943 bestseller, *Generation of Vipers*: the "Cinderella complex," which led women to expect romance from marriage, and "the cult of momism," which led to their sons having Oedipus complexes. ("Megaloid momworship has got completely out of hand" is how he'd explained it in the book. "Our land, subjectively mapped, would have more silver cords and apron strings crisscrossing it than railroads and telephone wires.")

Smith also pointed to a slew of recent stories in *Collier's*, the *Atlantic*, and the *Saturday Evening Post* that, one way or another, ascribed the ills of the modern world to women. "There is a full-fledged attack on women proceeding in books and magazines," he wrote, "that would have been almost inconceivable ten years ago."

In the summer of 1947, at a Fashion Group luncheon, he debated Dr. Farnham on the subject of women who wanted to continue working after marriage. She contended that industrialization had "made women idle, useless, and unimportant," leading them to seek work "at the expense of their emotional satisfaction"—a sorry turn of events that resulted in divorce, juvenile delinquency, and "emotional illness."

Smith countered that the rising rate of neurosis was related to the stress of the Atomic Age and the fear that the world might soon lurch into another depression or war. He also observed that women were always resented when they became too successful and that the label *career woman* had become a slur. During the war, women had encroached upon men's fields, he said, and the impulse now was to "send them back to where they came from."

The twins don't seem to have commented publicly on *Modern Woman*, or Dr. Farnham, even though her theories filled the pages of *Glamour* and ran cheek by jowl with Franny's photographs of modern career girls. Perhaps that was because the twins already knew her: she was Jimmy's psychiatrist.

NOBODY REMEMBERS WHEN JIMMY started visiting Dr. Farnham, whom they called Marynia, but she had played an integral part in his life, likely long before he met the twins. She was the woman who had saved Jimmy from going to war, documenting his neuroses and moral quandaries about the bloodshed so convincingly that she got him classified 4-F. She was the woman who had forced Jimmy to decide between the twins, and who had pushed him into wedlock again by vetting Fuffy as appropriate marriage material (although Fuffy might have helped her own cause by taking some lovely pictures of Marynia in the countryside, making the doctor, normally stiff and unphotogenic, look almost as good as a frumpy version of Kitty).

Jamie, Jimmy's son with Frankie, thinks his mother might have made the initial introduction. Marynia also treated children, and from some early age she had been called in to analyze his increasingly aggressive behavior. "My dad once referred to Marynia as the 'family physician,'" Jamie said. "He had a wry sense of humor."

Marynia had a broad range of clients, and not all enjoyed successful analyses. By the time Fuffy and Jimmy married, she was treating the television reporter Don Hollenbeck, as well as others in his circle,

when his marriage fell apart after he returned from covering the war, but she couldn't prevent his later suicide. One of his friends told Hollenbeck's biographer that Marynia was "a wild woman herself—a screwball," and a peer described her as "monstrously destructive." Later in life, Marynia analyzed and had a disastrous affair with the poet May Sarton, who saw her as a muse.

But Marynia's artist and photographer clients seem to have adored her. Jim Tyson, the husband of Carolyn Tyson, whose family owned Second House, used Marynia's services and, according to Jim's son David, so did Fernand Fonssagrives. Marynia was also close to the hard-drinking Rolf Tietgens, a German photographer with an interest in surrealism who rented part of Fuffy and Jimmy's studio. Rolf had been forced to flee to America not only because he was gay, but because a book of his photographs of Native Americans, made on a visit to the United States in the 1930s, had been banned by the Nazis. Now commercially successful, he had been embroiled for years in a tortuous romance with the lesbian novelist Patricia Highsmith. ("I shall leave it to his psychoanalyst to tell him that he is attracted to me for homosexual reasons," Highsmith wrote in her diary.)

At around the time of Fuffy's pregnancy, Papa Abbe also met Marynia on one of his trips back East. By then he was living in Northern California with his third family and his third, much younger wife, and working as a radio announcer and an entertainment columnist for the *Oakland Tribune*. He had been amused by the redoubtable medic, but not seduced. "I particularly enjoyed that dinner party the night before my departure when I joined the procession of Abbes, Kennedy's [sic] and Tysons who have fallen hard for that charming big hairy chested Doctor Farnham no less feminine for the masculinity of her approach to life," he wrote to Jimmy later, typing his letter somewhat eccentrically in all capital letters on a long unbroken scroll of paper, as if he were writing an extremely urgent, oversize telegram. Papa had brought home a copy of her book signed by the doctor and several of her analysands—likely Jimmy, Jim, Fernand, and Rolf were

among them—and added that his young wife and her friends had been extremely impressed and planned to discuss Farnham's ideas at the next meeting of their book club.

In person, Marynia must have set a completely different example to the one she preached: she had become a psychiatrist when fewer than twenty other women in the country were in the profession. She had divorced one husband and was widowed by the second at forty-five. She had raised children, and stepchildren, and at no point had she stopped working.

If Fuffy had paid attention to Marynia's actions, rather than her words, it wouldn't have been surprising if she, too, had assumed she would do the same, never mind the baby or Jimmy. Indeed, she herself would later tell her husband when he complained about her staying out too long or working too late, "Don't forget you knew what you married!"

But as Fuffy's belly swelled, her fashion work dropped off. And in May 1948, when she was about six months pregnant, Jimmy's first wife, Frankie, upended any plans Fuffy might have entertained about easing gently into motherhood. Frankie remarried, a union that required her to dump Jamie with the Abbes.

Frankie's new husband was the young novelist Robert Lowry, a protégé of George Davis's, her former boss at *Bazaar*, who was now at *Mademoiselle*. After serving in North Africa and Italy, Robert—or Bob, as he was known—had achieved renown with the publication of *Casualty*, an early, antiheroic novel about the war. It details two days in the life of a soldier who, after a series of misadventures, is court-martialed and dies ignominiously, flattened by a truck. Lowry himself was court-martialed for self-publishing an early version of the book on an army printing press in Italy. With its publication in New York, however, he suddenly became a brilliant young man.

Davis had discovered Bob a year or two earlier. Davis put him up, published him, and brought him into the salon, alongside Carson McCullers and Truman Capote. But when Bob turned out to be a

cadger and a sexual tease, Davis began fobbing him off on young women—first, Margarita Smith, his assistant and Carson's little sister; then, more successfully, on Frankie. When *Casualty* was published in Europe and Bob went over to promote it, he agreed to travel there with her as his wife, provided Jamie stayed behind.

"That's when I got parked with my father and Fuffy and Tom," Jamie said, referring to the new baby. Fuffy, now twenty-eight, had given birth to Tom in early August 1948, in Southampton Hospital, an experience so miserable she swore she would never have a baby there again. The new baby was born three days after Jamie's ninth birthday, and three weeks later, Jamie came to live with them, full of feelings he didn't completely understand. "Tom moved in, and I moved in," he said.

Fuffy described it as being like a punch in the gut. "I really had, like—slug! Children, suddenly."

AFTER THAT, HER CAREER as a photographer was the last thing on anyone's mind. But it remained at the forefront of hers.

She could easily have ended up like Caroline Wickett, the talented young photographer from Palo Alto whom Margaret Hockaday had discovered long before at *College Bazaar*—the girl who had gone to work for Brodovitch one year, married an officer the next, and seen her exciting career melt away when she became pregnant. Photography "was something she enjoyed during high school and college, and a little after," Caroline's son had said, before her life became too busy to think about making pictures.

But Fuffy had been working for six years by the time she suddenly found herself with a family—four before she and Jimmy married, two more by the time two children came along. Although a husband and the kids might slow her down temporarily, she was determined to keep going. She just had to figure out how.

CHAPTER 27

Twin Lives

As Fuffy hurtled into motherhood, Franny inched her way toward marriage. Now that she had taken over Jimmy's old loft on East Fifty-Seventh Street—just four blocks up Lexington Avenue from Fuffy and Jimmy's East Fifty-Third Street carriage house—the twins began to live their lives in parallel. They still did many things together: "After a long day at the studio," Fuffy wrote later, "when the last negative was developed, we usually dined at Longchamps," the glamorous continental restaurant chain that had a branch nearby, where they typically feasted on chicken and asparagus with hollandaise sauce and were often accompanied by Leslie, as well as Lisa and Fernand Fonssagrives. Dick Avedon, *Bazaar*'s famous new young photographer, sometimes joined them; so did Hoyningen-Huene, who would soon leave to work in Hollywood. "At the time, the photographic world seemed encapsulated within those few blocks around our studio," Fuffy recalled. Once a cabdriver recognized her as she was on her way to a job and said he had just driven Franny and her crew. "Would you tell her that the model left the shoes in my cab?" he said. "I dropped them at the local precinct."

Soon Leslie moved into Franny's loft and entered into the constant flow of parties and picture taking that occupied the twins' lives. One Christmas, Fuffy and Jimmy had thrown a party in the carriage house,

and both couples had taken matching pictures of each other, each of them seated in the semicircular window of the upstairs living room, before a punch bowl, surrounded by presents—the Abbes looking pleased with themselves and relaxed, as newlyweds often do, and Franny and Leslie looking somewhat more reserved. Another night the group had been joined by the Fonssagrives, and they all photographed one another in the studio downstairs, with five of them hamming it up against a roll of photo backdrop paper, using a short wooden ladder as a prop, while Lisa and Jimmy took turns behind the camera.

"Frances and Kathryn believe that it is important for twins to choose mates [who] get along with each other," the twins wrote many years later, in an early draft of their *Twins on Twins* book. "When this happens they and their mates can spend holidays and some leisure hours together."

Yet Leslie's real interest in Franny did not seem to be in her as part of a group or a pair, but as a singular creature. Soon after they fell in love, he made a portrait of two identical women that strongly resembled the pictures Jimmy had taken of the twins in Montauk over the years. As in those photographs, both women wore Claire McCardell sundresses and both wore their hair tightly pulled back. But both women were Franny, made to look like twins by combining two negatives to create a single picture. One version of her holds a pair of children's alphabet blocks, while the other holds a book of paintings by the Italian Renaissance master Botticelli—allegorical portraits symbolizing beauty, love, and desire.

The only person who was unhappy about their relationship was Leslie's ex-wife, Dilys. Franny and Leslie kept making plans to marry, but Leslie kept postponing the event, largely because Dilys kept threatening that if he actually went ahead, she would never let him see the children again. The first time the couple named a date, she objected to where the wedding was supposed to take place; the second time, to Franny's intention to wear white. The third time, Franny delivered her own ultimatum: "You either do it, or this is it."

They finally tied the knot on July 18, 1948—about a month before Fuffy gave birth—in East Hampton, at a small civil service attended by Leslie's editor at *Junior Bazaar*, Melanie Miller, and her husband; and Erwin Blumenfeld, the photographer whose pictures the twins had torn out of *Coronet* when they were in school—he had become a friend—as well as his wife and his eldest son. Also in attendance were some friends of the Abbes: Anna Wibberley, the English editor of *Everywoman*, and her new husband, a dog and mink breeder who lived in upstate New York. Franny wore a dress made from antique gray silk. Nobody documented the ceremony, but Jimmy and Fuffy photographed the bibulous lunch that preceded it at the house, over a table crowded with bottles of Cordon Rouge.

By now, Leslie and Franny had their own getaway fishing shack in Nova Scotia, a log cabin without heat, electricity, or running water. Drinking water came from a nearby brook, food was stored in a hole in the ground and cooled with ice, and Leslie shaved in the woods with his kit propped open on a tree stump. They had planned to drive up there after the wedding for a honeymoon, but when they got back to the city, they discovered that Carol and Eliza, Leslie's daughters, rather than having been removed from his orbit forever, were waiting for them on the doorstep. ("My mother rigged that one," said Eliza, who would have been nine then. "I'm sure it was some kind of plot.") So they took them along, too.

Franny was already a known quantity to both children; she had been in their lives, one way or another, since she had worked in their father's studio. After Leslie's return and the separation, they had been sent to board at the Tuxedo Park School in New York State, a place filled with girls who were "WASP-y," and "debutante-y" with "proper" futures, as Eliza described it. "The reason for it, supposedly, which never made sense," she said, "was that it was impossible to get help to take care of your children right after the war," but the real reason, she guessed, was probably that her mother wanted to date. "It's possible that she couldn't have a life and have children at home."

On weekends they went home to stay with Dilys, who continued working as an illustrator, but they also saw Leslie and he sometimes brought Franny out to visit. He and Franny had once come out to the school with cake for Eliza's birthday, and she had been proud to introduce Franny to her friends "because she was very pretty," she recalled. "I always liked her."

Although Dilys had no interest in fishing—"too busy," said Carol—the children had been on fishing trips with Leslie before and "hated all of them" because "there was nothing to do." Generally they found their father to be a "lot of fun" and "so cute," but they "were bored to death" by his passion, Eliza said—although she quite liked catching frogs. Once they had taken their tennis racquets and hit balls back and forth all day until every last one disappeared into the woods. Another time, stuck somewhere while Leslie got the car fixed, they had bored themselves silly watching Shirley Temple double bills, until Carol finally told her father, "We have to go back to New York." Although he never spanked them, that had made him irate. "Jesus Christ almighty," he had said, "I brought you children on this lovely vacation, and my car broke down, and all you want to do is get on the next plane out of here!"

But now after the wedding, driving up with Franny in the car, they mostly felt confused.

"I remember thinking they shouldn't be going on a trip if they're not married," said Carol, who had just turned thirteen. "I said something about it, and they said, 'Well, we *are* married.'"

Eliza recalled that after they were put to bed in Nova Scotia, and Franny and Leslie had gone to bed, too, Carol encouraged her to sneak into the grownups' room. She was mystified about why, and she doesn't remember what she did once she got there, or what their reaction was, although "of course I did it," Eliza said. But Franny and Leslie seem to have taken her nighttime visit in stride, and the trip went as well as it could, with the honeymoon somewhat set off-balance and two children who weren't especially partial to fishing.

Franny's relationship with Leslie's daughters continued to grow warmer, but her relationship with Dilys never improved. All communication went through Leslie, and the girls were strongly discouraged from mentioning their new stepmother's name at home. "We weren't allowed to say Franny," Eliza said. "'Franny's a good cook. Franny's this, Franny's that.'" So they called her the Unmentionable instead. "We'd say, 'You don't want to hear this, but the Unmentionable said . . .' That's how we referred to her for years to our mother."

Both Carol and Eliza remembered Franny as quite a tough customer herself. "No question about it," Eliza said. "She could be pretty snippy." She had a habit of calling up to say hello, then immediately saying she had to get off the phone because she had no time to talk. But the girls both found her foibles amusing. "We managed pretty well with Franny," Carol said. "She was a pretty good person."

FRANNY AND LESLIE SOON MOVED from the loft into a house of their own, a tiny brick building that had once been a metal-badge factory, tucked behind a row of apartments on East Eighty-Fourth Street. *Vogue* ran a story about it, together with several other "Career Houses," as the headline termed them—converted industrial buildings and barns where fashionable people lived and worked—calling it "one of the smallest houses in New York's upper east side." It had been turned into a home with the help of Calvert Coggeshall, an interior designer who showed his abstract paintings with the dealer Betty Parsons. The diminutive building lay in the heart of Yorkville, an old German neighborhood that had become a wartime locus for refugees, and it wasn't exactly spacious—two bedrooms in the basement, a loft-like area on the main floor, with just enough room for entertaining and a spare, modern decor. *Vogue*'s illustration, painted by Leslie's old friend Mary Faulconer, showed a Japanese abacus, a wooden soldier from the top of an old weather vane, an Early American apothecary chest where Leslie kept his trout and

salmon fly-making equipment, and one of the leather camp chairs he had shipped back from Italy.

By now Franny had become a real *Vogue* fashion photographer. Her second cover for the magazine had celebrated the launch of Dior–New York, the designer's American ready-to-wear line. This was a first for a French couturier, and also for *Vogue*, being the first Dior photograph the American magazine had run on its cover. (Its first Dior cover, in April 1947, was an illustration.) Louise Dahl-Wolfe had shot *Bazaar*'s Dior–New York cover. It pictures a woman peeking over the back of a couch, cozying up to a giant muff made of tawny jaguar fur. Franny's cover shows a woman in motion: she turns from a mirror to the camera, revealing that the underside of her sleek black hat is bursting with red carnations.

Capturing motion on film had become easier since the war, as cameras had grown smaller and better able to capture action. The Hasselblad camera, a huge breakthrough in this regard, was developed during this period. It was named for its inventor, Victor Hasselblad, a bird-watcher and nature photographer who ran a three-generation Swedish photography-equipment business. The company made its first camera during the war, an aerial surveillance model for the Royal Air Force. Hasselblad then set out to make a camera for himself. "I have used practically all types of cameras, none of which filled all my needs," he told *U.S. Camera* in 1949. "So I sat down and began to draw what I thought the ideal camera should look like." The result was small, compact, and light, with a neat modular design that made it easy to swap out different lenses, bulbs, and types of film, or to switch between color and black and white. It also had a 1/1600 second shutter speed, quick enough to capture the fluttering wings of a bird.

Both twins and their husbands were early adopters of this "dream camera," as *U.S. Camera* described it. Jimmy and Leslie had received early Hasselblads to test, and Jimmy's photos appeared in ads and brochures. Franny, who had taken up bird-watching in addition to

fishing, obtained two Hasselblads from the first shipment of ten that arrived in America in the summer of 1949, while Fuffy got one.

The Hasselblad finally allowed Franny get closer to the motion and intimacy she had sought since the beginning. She always started out with a "filmic concept, like a clip from real life," she wrote later. "I did not admire the dry-as-dust, tight as a corset looks that were some of the popular fashion looks of the time. When I planned my pages for the next issue I would ask myself: Who is she? Where is she? What is she doing there? What kind of woman is she? The result was often like a clip from a documentary film."

She began setting up storylines for her shoots, as in a 1949 *Glamour* beauty feature called "See Yourself in a Man's Appraising Eyes," for which she hired the Hollywood ingenue Nan Martin as a model and took her out to the beach to enact a twenty-two-page drama between a woman and a man where he believes he's in charge, but she clearly calls the shots. (The scenarios include "Men are still victims of a melting glance" as Nan stares at him from over her coffee cup and "Men . . . in favor of a feminine woman" as she regards him from the ground in a flouncy dress, proffering a hand so that he can help her up.)

Franny was earning more, too. Although Liberman's young Americans hadn't made much at first, "in no time the salary was just terrific for that time, like twenty, twenty-five thousand," she said. "It was really great but I needed that money. I was taking care of my mother. It was lucky." (Franny's pay stubs suggest that by 1952 she was making $761.54 a week, or nearly $450,000 a year.)

The magazine also began sending Franny abroad for shoots, ushering in a period when she was constantly on the road. Her first trip was a Caribbean cruise on the RMS *Mauretania*, a British liner that had been returned to leisure service after having been a troopship during the war. Her mission was to photograph swimwear and sportswear for several spring and fall stories, but she also made black-and-white portraits of the ship's crew and staff, posing each

able seaman, boatswain's mate, ship's carpenter, and bellboy on his own before a plain canvas backdrop. Liberman ran these portraits as tiny thumbnails along the edges of a fall feature about the cruise, the way he'd once run her blurry snapshots of dancers and people hurrying through rain when she'd started out years ago. Yet seen on their own at larger size, the individual photographs are fascinating. Franny had photographed men before, but she had usually been assigned what the magazine called "personality pictures," of composers and writers such as Benjamin Britten and George Orwell, who were used to working women. These are likenesses of tough, weather-beaten men who gaze at her intensely, as if they're trying to size up the beauty on the other side of the lens.

The men had challenged her, too, Franny told the photographer and writer Margaretta Mitchell, who interviewed her more than a quarter century later, when the world had once again become curious about a woman's point of view. Back then, she recalled, the men had wanted to know, "What does your husband think?" "How come he lets his wife travel?" One old guy in particular seemed especially flummoxed by her presence and wouldn't let the question drop.

Mitchell had pointed out that it was symptomatic of the era. She was traveling around the country interviewing great female photographers born near the turn of the century, such as Toni, Louise Dahl-Wolfe, Barbara Morgan, and Berenice Abbott, for a book and show called *Recollections: Ten Women of Photography.* The show would open at the International Center of Photography in September 1979 before traveling to seventeen more cities, and Franny would take Mitchell's author photo for the book. "Do you remember that psychological state?" Mitchell asked. "The skirt lengths were down, it was back into the home. The men were coming back. They wanted the jobs. There was a romanticism built up about it."

"I think you're absolutely right," Franny said. But, unlike many women during that period, she hadn't encountered resistance in her marriage. "Leslie was in the same business," she said. He knew how

much work it took to be a photographer, and he knew she would be unhappy if she couldn't keep on doing it. "He really understood."

FUFFY'S LIFE HAD TAKEN A DIFFERENT TRAJECTORY. She had stopped accepting assignments after the birth of her second child, a daughter called Lucinda, in March 1950—this time at the French Hospital, a small, private health center in Chelsea. Soon afterward, Jimmy decided to leave the East Fifty-Third Street carriage house and move out to Long Island, where there was no studio. She did insist they build an addition to the house, with real plumbing and electricity before they moved, but once that was accomplished, Jimmy and the assistants found a new studio near the United Nations building, then under construction on the East River, and she relocated the household to Jericho. For the first time since she'd finished Pratt, Fuffy had no studio.

Years later, near the end of Fuffy's life, Lucinda says, the family showed her mother a film of her and Jimmy outside the carriage house, shot by either Lisa or Fernand Fonssagrives, when Fuffy was heavily pregnant, probably with her first child. As it starts, Jimmy is seen buying a boutonniere and a bouquet of white flowers from the florist next door. He gives the bouquet to Fuffy, who is moving somewhat awkwardly in her royal-blue maternity suit. They sit down together, side by side, on the stoop. As Fuffy buries her nose in the bouquet, the camera zooms in toward her face and she looks up shyly at the camera; her eyes are incredibly blue. Lucinda said her mother said nothing when she saw the film—she was stoic that way—but later, as she got into bed, a tear rolled down her cheek. When Lucinda commented that Fuffy was crying, she said she wasn't. "That's basically my mother," Lucinda said.

Her mother, she felt, looked back on her years with Jimmy in New York, at the center of the city's photography world, as "the happiest times in her life. Not to say that the other times weren't happy. I don't

think she would have traded her life for something else. I think she really enjoyed her life. But I think that she would have loved that to go on forever—that feeling that she was just on top of the world, really successful and admired and popular and doing creative work. She never got that back again."

But moving out to the country didn't stop Fuffy from taking photographs. Not at all. "After I moved to the country and was no longer taking photographic assignments, without even thinking about what I was doing, I just kept photographing whatever happened," she said years later. If the kids started tearing up a packing box or slathering themselves with paint or Lucinda clambered up a ladder before she could walk, "I would just grab ye olde Hasselblad, my favorite camera, and rush outside and do it." Just before Tom was born, she had started working for *Parents* magazine, so she already had a foot in the door of children's photography. Gradually, her former art directors got wind of what she was up to and asked to see the new pictures.

That so many women were juggling motherhood and careers meant stories about kids were in high demand. Franny helped Fuffy take advantage of the trend. After the move to the country, Franny put Fuffy in one of *Glamour*'s "working mother" stories. Called "How Do They Do It?," it featured women who combined "good-sized jobs with good-sized families," among them a Bloomingdale's merchandise manager, a fashion coordinator for a fabric company, and a copywriter. Fuffy was the only woman who seemed at all offbeat. Her picture showed her sitting in the driver's seat of the windowless 1929 Model A Ford that she and Jimmy drove between Jericho and Montauk, surrounded by her incredibly photogenic family. Beautiful blond Tom, now two and a half, was in front, helping her steer; and handsome eleven-year-old Jamie—who by now spent most of his spare time torturing Tom—sat smirking in the back, looking cute but slightly dangerous as he held Lucinda, the new baby. (Franny had originally taken the photograph for the Abbes the previous August, for their 1950 Christmas card; the year before, Fuffy had

photographed Tom standing at the wheel of Jimmy's Studebaker convertible by himself.)

While the other mothers offered fairly obvious advice, such as the importance of hiring a good nanny, having a lot of children so they could help one another, or working part-time, "Kathryn Abbé . . . believes the answer to a career plus children is freelancing," the copy read, as if advertising her services. According to the story, she still went into the city three days a week to do some work in Jimmy's studio. "'That way I need only part-time help,' she explains, 'and our sitter also comes in evenings when we want to go out. Occasionally when I have an outdoor job in the country I take one of the kids with me.'" Although she had previously photographed fashion models, the story adds, she now photographed her children instead. "So many people admired these shots and asked for pictures like them of their own children that child photography has become Mrs. Abbé's current specialty."

It couldn't have hurt that the same years Tom and Lucinda were born, Fuffy's work finally made it into the *U.S. Camera Annual*, with photos she had taken some time prior. The 1950 annual ran her photograph of Carmen Dell'Orefice, her beautiful hands covering her face, while the 1951 issue used a picture of a blonde basking in the sun. It appeared in the same issue as one of Franny's shots of Nan Martin in *Glamour* looking delectable on a beach. Of the 182 photographers whose work was included that year, less than 10 percent were by women, a number that would continue to dwindle as the decade progressed.

Later that spring, in May 1951, when Fuffy was newly pregnant with Eli, her third child, Franny and Leslie finally sailed away on their honeymoon, a two-month trip through Spain, Italy, and France that began with a luxurious voyage on the SS *Independence*, the first large American cruise ship built after the war. They planned to do some work along the way. Leslie would photograph an unfinished cathedral in Barcelona by Antoni Gaudí ("of whom

outside Spain little is known," *Bazaar* wrote—for the first book on the "master-builder," who lived in his workshop, had not yet been published); an interesting new artist, Nino Caffè, a bearded, beret-wearing Bohemian whose paintings of priests had become the rage in Rome; and the Spanish countryside. Franny would stop in Florence to photograph a couple of contessas modeling coats at the Italian collections, and in Rome and Capri for accessory shoots. But for the most part, it was to be a grand holiday, with Leslie playing "cicerone to his wife . . . on her first European jaunt," as *Bazaar* put it in an editor's note.

The ocean liner they would travel on was the living embodiment of how far New York had risen since the twins had arrived there from a Connecticut factory town at the end of the Great Depression to study at Pratt. It had been created to "carry 1,000 passengers in air-conditioned luxury," wrote *Life* when the ship made its maiden voyage earlier that year—a fifty-three-day Mediterranean cruise that would stop at twenty-two ports in thirteen countries throughout Africa, Europe, and the Near East. Its corridors held "branches of Fifth Avenue shops, handsome public rooms and bars decorated with old tattoo designs, collections of ships in bottles and Early American silver." The observation lounge had vast picture windows, and the portholes were fitted with polarized glass. The cabins boasted modern decor, luxurious bathrooms, beds that slipped into the walls, and telephones that could make calls over a five-thousand-mile radius. It was the work of Henry Dreyfuss, the industrial designer who had created the Democracity for the 1939 World's Fair—the diorama that had demonstrated how Americans would live once the world had surmounted poverty and war. Now that amazing future was here—although the *Independence* could also be converted to a warship, if need be.

A big group of people had arrived at New York's harbor to bid Franny and Leslie farewell—Melanie Miller, Leslie's editor at *Bazaar*; his former secretary, Dorry, now married and a successful model, who

had gotten "glammed up" for the occasion; Jamie, Eliza, Jimmy, and Fuffy, who brought along her Hasselblad; and, also with his camera, the young art director Bob Cato, who had worked at *Bazaar* and would soon move on to *Glamour*. Crowds of people poured onto the ship. Messengers delivered flowers and liquor to the rooms. Everyone took pictures of the sights and of one another, as they waited in line to get on board and clowned around in the corridors, which were lined with an amazing new sort of modern deck chair made with snag-proof plastic webbing instead of wicker. Dorry fell back easily into the role of Leslie's assistant, bustling around the stateroom as she made sure everyone had a drink.

A few of the pictures show Fuffy and Franny standing next to each other. They, too, had come far. They were no longer the matching set of twins who had once walked arm in arm around the Pratt campus looking "strictly Peck & Peck" as they took turns using their single Voigtländer camera to photograph the world and each other. Fuffy had maintained her shoulder-length hair and still had a girlish, excited look. Franny, smartly dressed in a casual pinstripe suit, with the short curly haircut that was newly in fashion, looked more reserved, very much the modern American sophisticate. "There Goes an American" had been the name of a story in *Vogue* the previous year, written from the perspective of two Europeans watching passersby in a Paris café. "She is easy to spot. Her long nyloned legs carry her rather quickly up the avenue. She walks with purpose. . . . She looks at everything. If her glance were not so fleeting, it would be a stare. . . . She dresses well." The American girl had become a woman, one who projected an air of stylish efficiency.

Then it was time for the ship to embark, and everyone who wasn't going with it scrambled back to land. Yet Fuffy kept photographing everything—the last few stragglers hurrying off the gangplank, the flags and streamers fluttering from the hull, the tug maneuvering the ship out of port. Once Franny and Leslie had jostled their way to the stern, Fuffy photographed them, too, standing at the edge of

a crowd of excited people. In one image Leslie's arm is a blur; he is waving along with everyone else. But in the next, Franny, who appears to be holding a pair of binoculars, has moved them down from her face as the ship pulls out, as if anticipating what will make the best shot for her twin, who stands with her Hasselblad camera, taking pictures from the shore.

EPILOGUE

Love and Luck

B y the time Franny, the career bride, sailed away on her honey-moon, photography had fully infiltrated magazines, but America was no longer obsessed with college and career girls, and the swell of publications tied to the boundless opportunity symbolized by their youth, talent, and beauty was receding. Although *Seventeen* and *Mademoiselle* continued, *Junior Bazaar* had been killed as a stand-alone magazine in 1948 and folded back into big *Bazaar*. (Lillian Bassman, its designer, who had become increasingly frustrated by the new direction, became a photographer when it shut down.) Two years later, *Charm* was reconceived as a magazine for working women rather than business girls, and Helen Valentine and Cipe Pineles were hired away from *Seventeen* to steer its reinvention. By now, a new group of photographers was emerging—talents who were lauded as peerless stars in the world beyond the small circle that staffed magazines. Irving's gravitas had made him the reigning genius at *Vogue*, while Dick Avedon, his *Bazaar* counterpart, was acclaimed as a "Photographic Prodigy," as *U.S. Camera* termed him in the headline of a 1949 feature, marked by a flair for whimsy and spontaneity that made him, as Brodovitch said in the story, "the foremost photographer of today," famed for creating pictures of models who "are not beautiful dummies, but actual women."

In 1950 *Life* had run a picture of Franny, photographing the Parisian model Bettina Graziani outside Hunter College, for a story called "French Models Thrive in U.S." (It was shot by Gordon Parks, the magazine's first African American photographer, who was also working for *Glamour* and *Vogue*.) But nobody paid much attention in 1952 when *Vogue* sent Franny to Paris to cover the fall collections—the first woman to do so for the magazine. Black was big that year and the clothes had precisely rounded silhouettes. She shot everything on the street, but to ensure the lines of Dior's black dresses and coats were shown to full advantage—*Women's Wear Daily* had called them "as sleek and streamlined as jet planes"—Franny had a courtyard near the studio she was using in Paris painted white, "the whole thing," she said, "including the pavement, the rocks, and the tree." (She had been inspired by a trip she and Leslie had taken to Greece the previous Easter, when she had seen villages whitewash their streets and buildings for the occasion.)

Her photographs of evening wear were made outside the city, in the château of Versailles. Others had taken photographs in its gardens and grounds, but Franny was the first magazine photographer, she told an interviewer some years later, to receive the government's permission to carry out a shoot within the palace itself. Every day for almost a week, she and her team "commuted" from *Vogue*'s Paris studio to the château and photographed models in ball gowns by Jacques Fath, Dior, Balmain, Nina Ricci, Balenciaga, Grès, and others, as they moved through the palace and the Galerie des Glaces, its dazzling hall of mirrors, using mostly daylight—"although I did have some kick-in lights to use," she said later. "The gods smiled on me—every evening (*cinq à sept*—5:00 to 7:00 P.M.). I photographed the various gorgeous ballgowns by all the famous couture designers. The early evening light cast the shadow of the enormous windows on the mirrored door and walls." The pictures appeared in all of the Three *Vogue*s.

By then, although Franny had not been in Irving's photograph of the *Vogue* photographers—the one published in French *Vogue* in

1947—she had been included in something that may have seemed more important: Liberman's 1951 book, *The Art and Technique of Color Photography*. It gathered together the work of all but one of those "most illustrious photographers," as French *Vogue* had put it, and several more, including Kertész, Matter, Mili, Rutledge, and Coffin. Each was represented by several pages of pictures, a statement, and an appendix in which they discussed the technical challenges in making the work. Franny was the only woman in the book.

Her section opened with a photograph of Lisa Fonssagrives—who had recently left Fernand to marry Irving, and whom she now photographed frequently—shown in dim morning light in a black coat and a brilliant red scarf at the Wildenstein art gallery, turning away from an old master portrait. Also included was Franny's old "bride with a career" picture of Pat Donovan, sailing in a wooden boat across an old-fashioned photographer's backdrop of a painted Italian lake as she modeled wedding suits for *Glamour*; a girl cheering in a golden jacket at a Princeton football game ("The 8x10 camera *can* be used for snapshots!" Franny wrote); and the opening picture from her 1947 juniors portfolio, of a young woman sitting in the window of her old loft apartment on East Fifty-Seventh Street, which had presented another technique challenge because the light kept changing as she worked.

"Color photography, like ancient Gaul, is made up of three parts," Franny wrote in her essay. "The mechanical, or camera and lens; the chemical, obtaining an image on film; and lastly, the personal, the artistic. . . . I believe the physical effort of making a photograph, the virtuoso ability, should not be revealed in the result. As with a professional dancer, whose hours of intensive practice in perfection of technique should not be apparent to the audience, the photographer should present to *his* audience the beauty and feeling, motion and emotion—not the technique. . . . The theatre can be compared to photography in that it presents an illusion of reality by artful contrivance, producing for the viewer the image of true life. The photographer meets this same challenge."

By the time Liberman's book came out, a change had overtaken the Condé Nast studio. In the past, some of the older staffers had been allowed to pursue freelance advertising assignments, but now these were completely forbidden. Only a half dozen of its photographers remained, including Franny, Irving, and Horst. (Many of the rest, including Joffé, Balkin, and Matter, had formed their own company, Studio Enterprises, Inc., and were working out of the Thirty-Seventh Street studio building.) By 1954 Condé Nast had closed the studio, finding it too expensive and unwieldy to maintain, and Franny went freelance "with a nice contract under my arm," she said, which continued for another twenty years. She set up shop at 80 West Fortieth Street, just south of Bryant Park and the New York Public Library, an old artists' loft building now filled with photographers. Steichen had once been given a glorious studio there when he was first hired by Condé Nast, and Leslie worked there currently. He and Franny soon had adjoining studios on the fifth floor; Irving was two flights up, and in between was Bert Stern, another new, exciting young photographer who had swiftly built a reputation after finishing his service in the Korean War. (Stern was known for his Smirnoff vodka ads: the first had been a close-up of a martini in a coupe shimmering against a pyramid at dusk.) The photographers all shared equipment and ideas. "Bert for some reason used to dry all his pictures on my dryer," Franny said. "He and Leslie were crazy about each other."

After the war, Leslie had withdrawn somewhat from the fashion world. Liberman had once tried to recruit him for *Vogue*. "He was very pure, very graphic, really one of the very important photographers," Liberman said. "Perhaps I thought it was in the direction of the things that I envied in the *Bazaar* that we didn't have." But now Leslie turned increasingly to painting, and to advertising, using his "magic realist" abilities in color photography, as the *New York Times* art critic Aline B. Louchheim termed it, to create still-life photographs for clients such as Miller High Life and Kodak. He was also a photographer on one of Margaret Hockaday's first big

ad campaigns, for Dunbar Furniture, which put couches, beds, and chairs outdoors, on grassy hillsides, and in city crosswalks and tree houses—a concept that was wildly successful, imitated, and parodied. Work was so bountiful and the Gills were so well paid that they were able to take plenty of time off. They acquired two more fishing cabins. One was in the Catskills, which they shared with Charles Kerlee, a commercial photographer who had been one of the "original six" recruited by Steichen to his naval photographic unit (and "the same kind of fisherman-sports type" as Leslie, Franny said). The other cabin was in Canada on the Miramichi River, just across the border from Maine, where they spent long idyllic days salmon fishing with a local guide. Their ample pay, compressed New York schedule, and ability to work in Europe allowed them to spend weeks abroad. (On one trip to Paris, Franny brought back a Chanel suit for Kitty, who wore it constantly.) "We had a two or three months' trip to Europe several different times," Franny said. "We used to have about three months' vacation a year, and it was just absolutely glorious." When she traveled for work, Leslie sometimes drove up to one of the cabins and went fishing by himself.

Everything with the children was going well: after living with them on and off, Carol was married, and Eliza was off at school in Colorado. In late 1957, Franny and Leslie finally had their own child, a daughter they named Leslie, after him.

Before the baby was born, Franny had considered taking some time off, but Leslie had gently nixed the idea. "I want you to do what will make you happy," he had said. "But I frankly have to tell you, I don't see you staying at home."

Not long after the birth of his daughter, in early 1958, Leslie suffered a massive heart attack at home. He died some time later at Roosevelt Hospital, leaving their four-month-old daughter fatherless, like Frank McLaughlin before him.

* * *

"I HAVE A HARD TIME REMEMBERING THAT YEAR," Franny
said later. "It was such a horror show." Photography magazines were
turning out memorials to Leslie: "It is difficult to over-estimate his
influence on his own generation of photographers and upon those
who will follow him," Irving wrote in one. But with a new baby, two
studios, and their staffs to support, and Kitty and Aunt Anna to worry
about, Franny was soon back hard at work, with Leslie's Miller High
Life account added to her portfolio, and his surname appended to
hers, so that her byline became Frances McLaughlin-Gill.

Now, Fuffy said, "She really *had* to work."

"It took *all* the guilt feeling off leaving the baby," Franny said. "I
just knew there was no choice."

Fuffy cared for the baby on weekends and when Franny went out
of town on assignment. But Leslie's death spurred changes for the
Abbes, too. Jimmy, who had ulcers and was still as high-strung about
shoots as he had been the day he and Franny re-met, became increas-
ingly disenchanted with the pressures of the Manhattan rat race. In
1961, he closed his photography studio and became an antiques dealer,
specializing in Americana and primitive paintings. Like Leslie and
Franny, he and Fuffy had been collecting all along. Photography "was
becoming too much of a trend, and the city was simply becoming too
much," he told a reporter later. "I guess . . . you could say that I was
one of the early revolters against the asphalt jungle."

The *New York Herald Tribune* columnist Eugenia Sheppard, who
was fond of the twins and often covered them, launched Jimmy's
business in her "Inside Fashion" column, which was syndicated to
newspapers throughout the country. "Photographer James Abbe
opened a handsome little antique shop in Oyster Bay last weekend,
with mostly early American antiques," she wrote. "At the opening
Mrs. Abbe, one of the McLaughlin twins, was wearing a necklace of
Indian wampum beads. (How early American can you get?)"

Within a few years, Jimmy was established as a leading dealer of
American folk art. One of his most important sales was the luminous

painting of a child with her pets that Franny and Leslie had bought on the street in 1943. By the time Jimmy became a dealer, Dilys had returned it to Franny, and the anonymous itinerant portraitist who made it had been identified as Ammi Phillips, now recognized as one of America's greatest folk artists. Jimmy eventually sold the painting to a private collector, the collector then asked him to sell it again, and *Girl in Red Dress with Cat and Dog* became the first work of American folk art to change hands for over a million dollars. In 1984 the second collector donated it to New York's American Folk Art Museum, where it remains the signature work in the museum's collection.

By the time Jimmy started his new career, Fuffy had already returned to photography full-time—or as full-time as possible for someone with four children. She had used Franny's studio as a base of operations since her youngest son, Eli, had been a toddler, leaving the children with a part-time housekeeper and coming in to use the darkroom two days a week. While Jimmy still had his studio, she had tried using it but, as ever, found herself too easily drawn into his work. "Quite often he'd be in the midst of a big sitting with children or fashions and he'd need flags or he'd need flowers or he'd need someone to watch a puppy dog," she said. "And before I knew it I was part of that sitting and I wasn't doing my own prints. By being in Franny's studio, I was much more disciplined." Now, with her children more independent, she was able to start "a whole new cycle."

She had already gained a new foothold in fashion magazines, just from a different angle, by photographing her friends with their children. For *Cosmopolitan*, another Hearst publication, she had contributed a beauty spread on her friend Margie, the wife of Bob Cato, the art director who had worked with Leslie at *Bazaar*, playing with her children on the beach, which led to other beach-focused beauty shoots. For *Vogue*, she made pictures of fashion models and their babies, including Margie and her daughter Bettina, Jerry Plucer's wife and their youngest daughter, and Lisa and her new son with Irving, Tom Penn. "Lisa Fonssagrives, one of the most celebrated

fashion mannequins in the world, has appeared in *Vogue*'s pages since 1936," the story read. "Her husband is Irving Penn, the *Vogue* photographer, but he's also Irving Penn, the dairy farmer, now. The Penns have bought a farm in Vermont and work it seriously."

The postwar baby boom might have temporarily derailed Fuffy's career, but now it gave her a new one. Her growing cache of candid pictures of her family and the children of friends—people such as the Catos and the Penns—also went to magazines, defining the look of the perfect American family as Fuffy's Hasselblad captured them climbing trees, tussling with pumpkins in picturesque patches, and running along beaches. Many of her pictures ended up in *Coronet*, which by 1958 was putting photos on its cover instead of illustrations. One month, they'd run a photo of Mia Fonssagrives—a model now herself—bending to kiss Lucinda in the surf at Montauk, while Eli looked warily into the camera as he leaned against a golden retriever. Another time, they'd feature an old picture of Tom and Lucinda, seen from behind as they toddled hand in hand down a country lane. When *Coronet* finally folded in October 1961, the cover shot was a close-up of Eli about to bite an apple.

Throughout the 1960s and 1970s, Fuffy's photographs were also widely used in ads, for everything from insurance companies to pharmaceuticals. Two photographs of Eli won particular attention. One, which shows him cuddling a lamb on the Penns' farm, was sold to the pharmaceutical company Pfizer. In another, dwarfed by an old jacket of Jimmy's, Eli leans against the family's collie, Randy, as they both looked out over the fields in Montauk. It was used for the cover of the 1995 book *Animal Attractions* (which compiled work by William Wegman, Kertész, and others) and was exhibited in a show drawn from the book at Howard Greenberg Gallery in New York, which prompted a critic in the *Daily News* to call the image "as close to a real Timmy and Lassie as you can get." ("Nothing was posed," Fuffy wrote on the back of the contact prints she made of the children the day she took what she called her "famous" photo.)

Fuffy had developed a way of photographing children that was remarkably similar to the one Toni had used when she followed children around at Sherrewogue, her sprawling house in the tiny town of St. James: she let them do what came naturally and egged them on to take chances, even if what they were doing was sometimes a little dangerous, keeping the camera at the ready and going for action shots. In 1964, Fuffy shared some of her secrets with a writer for a "tips from a famous photographer" piece that was syndicated to several newspapers. Photograph them in all kinds of weather. Never let them face the light because they squint; instead, "photograph them with the sun behind them so that it lights up their soft hair." Also, put toddlers in the family car: "They almost never fail to grab the wheel like Daddy, and soon they're shouting with delight." Her favorite photograph, she said, had been of Lucinda at her first birthday party, getting cake all over everything in sight.

As the shoots became more complicated, turning into assignments, and Lucinda grew up, she often went along as her mother's assistant to help wrangle the subjects. The method was "as if you're having the children over for a playdate, and then you just take their pictures," Lucinda said. "More or less what children do anyway when they're visiting someone's house—explore or see what the toys are or look in the cupboard . . . kind of free rein for them to be themselves." They took along a bag of toys and allowed plenty of time, letting the children be "as comfortable as they wanted to be, which meant that someone had to keep collecting them and making them happy and bringing them back into the range of the camera." That's where Lucinda came in. Sometimes Fuffy would suggest where the children should sit, or that they might want to run, but the only real direction was to the mothers, and it was "Don't tell the child to smile."

Fuffy's easy way with large groups of children resulted in her "all-time favorite assignment," for *Good Housekeeping*, where she already had work in almost every issue, to photograph the Kienast quintuplets, the country's first surviving set of quintuplets born

through the use of fertility drugs. The project continued for ten years, as she documented them being fed and changed, crawling, walking, and then finally gathered around a Christmas tree. Every shoot was so complicated, requiring so many people to keep the quintuplets fed, happy, and occupied, that Franny worked on them, too. Their collaboration on this project led to them working together on the 1981 book *Twins on Twins*, and the interview with Dick Cavett.

Over the years, the twins also worked separately on many other sorts of projects. Franny had stopped shooting fashion for *Vogue* in the early 1960s after Diana Vreeland, the former fashion editor at *Bazaar*, joined the magazine as editor in chief. Vreeland's taste ran to "more fancy stuff," Franny said. "Ladies on Egyptian barges, all the sable furs, lying around on icebergs. It really wasn't my ball game." While she continued to do portraits and other sorts of stories for the magazine, she became more active in film, photographing actors on movie sets and making commercials and movies. Her first movie, a short called *Cover Girl: New Face in Focus*, was made as a half-hour short for Noxell, but it was artistically successful, winning a gold medal in New York's 1969 International Film and Television Festival and inclusion in the first New York Festival of Women's Films in 1972. She also taught, lecturing in a version of Brodovitch's Design Laboratory after his retirement, and teaching photography for years at the School of Visual Arts.

Both twins were active in the women's movement of the 1970s, joining the founding advisory board of an advocacy group called Professional Women Photographers and participating in several group shows by women photographers in New York, most notably *Women Photograph Men*, a 1976 slide and sound presentation at Rockefeller Center that was part of a women's arts festival and became so successful that the images were published as a book the following year.

As for Fuffy, she photographed adults as well as children: for several years she was the designated photographer for the *Good Housekeeping* advice columnist Dr. Joyce Brothers, an assignment that had

previously gone to Genevieve Naylor, a former *Bazaar* and *Junior Bazaar* contributor and Berenice Abbott's erstwhile apprentice. Fuffy was expected to take Brothers outside the office, to such locations as a bank and a post office, and to get her to smile spontaneously, something Fuffy achieved by telling the doctor she looked like the first woman president. Fuffy also photographed television stars and political protesters and shadowed the evangelist Billy Graham in Puerto Rico for a week for a book. After Papa Abbe died in 1973, Fuffy helped resurrect his career and build his market, which resulted in a string of shows at the Washburn Gallery in New York and culminated in a 1995–96 retrospective at London's National Portrait Gallery.

In 1996, interest in the twins resurged again when their work appeared in *A History of Women Photographers*, the first major museum survey of women's photography as fine art, which opened at the New York Public Library and toured the country for two years. It was based on an encyclopedic 1994 book by the photography historian Dr. Naomi Rosenblum, who, while working on an earlier treatise, *A World History of Photography*, kept noticing women's names in the back of photography magazines and began to realize that previous modern photographic compendiums had left most of them out. The 1994 book had included work by about 240 women, and the show exhibited photographs by most. Franny was represented by one of the black-and-white pictures she had taken at Versailles, of the British model Fiona Campbell in a pale satin Jacques Fath ball gown, passing through one of the doors of the Galerie des Glaces as the windows cast an arch of light around her. Fuffy's contribution to the book was an example of children's photography—a 1955 picture of Lisa Fonssagrives-Penn and her son, Tom. For the show, however, Fuffy was represented in the fashion section by a photograph she had taken in the back garden of the carriage house she and Jimmy had shared long ago in New York: it presents Carmen Dell'Orefice in a black strapless evening dress and a dramatic feathered hat by the milliner Mr. John, who had just moved his salon nearby. Carmen

perches on an old wooden ladder, smiling down beatifically, as if surveying a party from on high. The story Fuffy always told about the shot was that Mr. John asked her to do it in exchange for a hat (and "a hat for Franny, too!"), and Fuffy had persuaded Carmen, who also lived around the corner, to model.

In 2001, another photograph of Carmen from the same series appeared in *Vogue*, credited to Rawlings, who had died thirty years earlier, together with a story that discussed their relationship and how it had helped her flower, both creatively and as a model. He had supposedly spotted Carmen coming home from a party in the wee hours and watched her climbing up the fire escape, in this dress and hat, before calling up to suggest she come over straightaway to be photographed on a ladder in his studio. This image was the result.

This time, Fuffy, rather than letting the matter go, as she had done with the earlier misattribution to Jimmy, asked for—and received—a correction. But it must have rankled. Rawlings was the photographer Toni used to complain about, saying he was always assigned her best ideas. By this time, too, galleries and museums had started to regard photography as an art form, with attention finally spilling over toward fashion work.

By the early 2000s, when Franny gradually began struggling with dementia, Fuffy was already working to make sure they would not be forgotten. An autobiographical documentary, *Twin Lenses*, produced and directed by Naomi Rosenblum's daughter, Nina, had come out in 2000, the year after Jimmy's death. Another project, the joint autobiography *Twin Lives*, was published in 2011. "By today's standards, Abbe and Gill would be considered contemporary," the book proposal read. "Both married New York photographers and thrived on the big city excitement. They both had children, as well as successful photographic careers. Yet, they led these packed lives long before it was fashionable. . . . *Twin Lives* tells how they accomplished this matter-of-factly, despite personal tragedies and without attempting to 'make a point.'" When the proposal didn't

sell, Fuffy forged forward and published the book herself under both twins' names.

In 2014, three years after the book came out, both twins died, nine months apart—Fuffy in Jericho in January, at ninety-four, and Franny in New York City in October, at ninety-five.

How did the twins accomplish so much, even in a time when the deck was often stacked against women, while making it look so easy? In interviews over the years, Fuffy often waxed eloquent about the luck that came with having been born a twin, while Franny typically stayed silent or contradicted her. But in a conversation with the photographer Margaretta Mitchell in 1976—as frequently happened, they did the interview together—they seemed to trade positions.

"It seems to me, Fuffy, that our whole lives, apart from Leslie Gill's death, we never had any setbacks on anything," Franny said. "I mean, I don't think what we touch turns to gold," she added, searching for the right words. "It isn't gold I'm talking about."

"It's just hard work," Fuffy ventured.

Franny corrected her. "It's sort of magic," she said.

Cast of Characters

Anna O'Rourke—Kitty's maiden sister, the twins' aunt, and an avid Kodakfiend, or camera buff. She gives the twins their first camera and pays for their art school education.

Florence "Flossie" Downey—The twins' cousin and babysitter in Wallingford, Connecticut.

Morton Downey—Another Wallingford cousin, who becomes a famous singer in New York and Hollywood. It is likely that through his friendship with the Boston businessman Joe Kennedy, the twins get to know one of Joe's sons, Jack Kennedy, who is attending Choate, a prep school in Wallingford.

THE ABBES

James "Papa" Edward Abbe—Famous stage, screen, political, and "tramp" photographer, who starts out in Newport News, Virginia, becomes a smash hit in New York City, and travels the world for stories. By the 1940s, too old to serve as a foreign correspondent in the Second World War, he turns to other media, becoming a radio commentator and newspaper columnist in the San Francisco Bay Area.

James "Jimmy" Edward Abbe, Jr.—Famous New York magazine photographer, for *Harper's Bazaar*, *Ladies' Home Journal*, and others, who dates both twins and marries Fuffy. He learns the trade by working in his father's studio in Paris and knows a large circle of artists and photographers. In the 1960s, Jimmy becomes a renowned dealer of early American art and antiques.

Frances "Frankie" Abbe (née Adelman)—Editorial assistant in the fiction department at *Harper's Bazaar* and, briefly, Jimmy's first wife.

James "Jamie" Edward Abbe III—Jimmy's son with Frankie, a somewhat troubled boy.

Phyllis Abbe Trachman—Papa's wife, spurned for a former Ziegfeld Follies showgirl. Phyllis eventually remarries and relocates to Locust Valley, New York. (Actually, Papa had had a previous wife and two children in Newport News, all of whom died from natural causes before he married Phyllis.)

Polly Platt—Stage name of Mary Ann Shorrock, the showgirl who becomes Papa Abbe's next wife.

Patience, Richard, and John Abbe—Papa's French-born children, who become household names when their multinational bestseller, *Around the World in Eleven Years*, is published in 1936.

Irene Caby—Papa's final, much younger, wife, with whom he has two children.

Phyllis Abbe Kennedy—Jimmy's older sister, who marries into the Kennedy family, which owns Second House in Montauk. Papa Abbe notifies her by letter when he leaves Polly for Irene.

THE GILLS

Leslie Gill (given name is Samuel Leslie)—Artist turned art director and photographer, aka "the father of modern American still life photography," and Franny's true love. As a *Harper's Bazaar* staff photographer, he works closely with the pioneering art director Alexey Brodovitch.

Dilys Wall Gill—Leslie's art school girlfriend and first wife, an artist turned illustrator.

Carol—Leslie and Dilys's first child.

Eliza—Leslie and Dilys's second child.

FRIENDS AND ACQUAINTANCES

MANHATTAN

Jan Balet—German refugee illustrator and art director of *Mademoiselle* and *Seventeen*. Inspired by Jimmy's example in Montauk, Jan buys an old saltbox on a lonely dune in Amagansett and restores it with the help of master carpenter Ed Pospisil.

Lisa Fonssagrives (now known as Lisa Fonssagrives-Penn)—Swedish-born dancer who becomes a fashion model in Paris when her first husband, Fernand Fonssagrives, takes up photography. She escapes with him to New York during the war. Later she leaves him for Irving Penn. She is often referred to as the first supermodel.

Fernand Fonssagrives—Former dancer, technically and aesthetically adventurous photographer, bon vivant, first husband of Lisa Fonssagrives.

Mia Fonssagrives (now known as Mia Fonssagrives-Solow)—Lisa and Fernand's daughter.

Dorry Rowedder (now known by her married name, Adkins)—Leslie's assistant during the war, she later becomes a model and poses for one of Cecil Beaton's most famous pictures, of nine models in evening gowns by the American couturier Charles James.

MONTAUK (AND EAST END)

Carolyn Kennedy Tyson—Sister to Jimmy's brother-in-law, whose family owns Second House, the second-oldest dwelling in Montauk. She later builds her own arts compound in East Hampton and becomes something of a local arts doyenne.

Jim Tyson—Carolyn's husband, an eager analysand.

David Tyson—The Tysons' son.

Eddie Pospisil—Master carpenter in Montauk, who builds Jimmy's cottage and refurbishes Jan Balet's saltbox.

Ray Prohaska—One of a group of illustrators who, with his wife, Carolyn, an illustrator's model, moves to Amagansett in the early 1940s.

ART SCHOOL

Thomas Benrimo—A painter and illustrator who teaches art at Pratt. He introduces the twins to the European avant-garde, including surrealists such as Salvador Dalí and Max Ernst, and Germany's radically experimental Bauhaus, most of whose teachers and students are now refugees. Benrimo later moves to Taos, New Mexico, with Dorothy Mulloy, another of the twins' favorite teachers.

Walter Civardi—The twins' first photography teacher, and the third head of Pratt's fledgling photography department.

Yasuo Kuniyoshi—One of New York City's most popular painting teachers, with whom the twins study at the New School in Greenwich Village, who is renowned for his depictions of young urban women.

A Japanese émigré, Kuniyoshi is one of the few non-U.S. citizens whose work is regularly included in the annual exhibitions of a new institution, the Whitney Museum of American Art.

J. Gordon Lippincott—One of the twins' photography teachers. The second head of Pratt's photography department, he becomes an acclaimed design consultant, known for coining the term *corporate identity*. His first major project was modernizing the label of the Campbell's soup can.

Reginald Marsh—A famous American scene painter, celebrated for his paintings of New York City and its women, who teaches Franny one summer at the Art Students League. That same summer, she appears with him in *Art Discovers America*, a short film about the growing popularity of American painting.

László Moholy-Nagy—Experimental photographer and Bauhaus refugee who has established the New Bauhaus in Chicago. He gives a talk at Pratt but is uninterested in collaborating with the school.

Dorothy Mulloy (better known by her married name, Benrimo)—The twins' drawing teacher, a ceramicist and jewelry designer who marries Thomas Benrimo and moves with him to Taos.

Beverly Pepper (née Stoll)—Pratt student who works in the photo lab alongside the twins and grows up to be a famous sculptor.

Lewis Teague—An architecture student and Fuffy's boyfriend. He quits school to study painting at the Art Students League and marries a fellow student, the debutante, model, and painter Mary Lee Abbott, who becomes an abstract expressionist.

Walter Dorwin Teague—Lewis's father, the industrial designer who made Kodak cameras into hot commodities during the Depression.

Virginia "Ginny" Thoren—Pratt student and friend of the twins', who later becomes a successful photographer.

Alfredo Valente—Well-known theatrical photographer and director of the short film *Art Discovers America*, who photographs the twins under the Brooklyn Bridge.

THE MAGAZINES

CONDÉ NAST, THE COMPANY

Dr. Mehemed Fehmy "M. F." Agha—Sharp-tongued art director of *Vogue, House & Garden*, and *Vanity Fair* (until it is folded during the Depression), who promotes modernist design and encourages more photography throughout the company's magazines.

Mary Campbell—Condé Nast's executive secretary, who later takes charge of the Prix de Paris.

Alexander "Alex" Semeonovitch Liberman—Russian-born, European-educated Jew, and the managing editor of *VU*, he escapes from France when the Germans arrive and lands in the art department of American *Vogue*. (He is accompanied by his lover, the Russian-born Tatiana du Plessix, who swiftly becomes one of New York City's most fashionable milliners, and sometime thereafter, his wife.) In 1943, soon after Nast's death, Liberman replaces Agha as art director of *Vogue* and eventually comes to supervise the art and editorial direction of all the company's magazines.

Condé Montrose Nast—Publisher of *Vogue, Glamour, House & Garden*, and many more.

Iva Sergei Voidato "Pat" Patcévitch—Manager of the Condé Nast company's French publications, he becomes Nast's second-in-command in New York during the war, and president of the company after Nast's death.

Lucien Vogel—Creator of the French fashion magazines *Gazette du Bon Ton* and *Le Jardin des Modes*, both sold to Nast, and *VU*, the model for *Life*. Vogel, a leftist, flees Paris when war breaks out. He now consults for Nast in New York.

VOGUE

Edna Woolman Chase (known as Mrs. Chase)—Editor in chief of the Three *Vogues*—American, British, and French. Mrs. Chase starts at *Vogue* in the circulation department, addressing envelopes, before Nast buys the magazine in 1909, and rises to her current position.

Frank "Crownie" Crowninshield—Editor in chief of *Vanity Fair* until it is folded into *Vogue* during the Depression. He is now fine arts editor of *Vogue*.

Jessica Daves—Managing editor of American *Vogue* from 1932 until 1952, replacing Mrs. Chase as editor of the magazine upon her retirement.

Carl "Eric" Erickson—Foppish, bibulous illustrator, who makes surrealistic drawings and is hard to keep sober.

Sally Kirkland—Franny's first editor for junior fashion, and the originator of the multimodel sitting.

Babs Rawlings—Top fashion editor, married to the photographer John Rawlings.

Bettina Wilson (better known by her second husband's surname, Ballard)—American editor in the Paris office before the war, fashion editor in New York after the war. During the war she serves overseas with the Red Cross.

GLAMOUR

Cipe Pineles—The magazine's art director, the first woman in America to hold the title at a mass market magazine, and the first woman admitted to the Art Directors Club. A protégée of Nast's and Agha's, she is ousted from the company by Liberman, but goes on to be art director of *Seventeen*, art director of *Charm*, and the first woman inducted into the Art Directors Hall of Fame.

THE CONDÉ NAST STUDIO AND SOME OF ITS PHOTOGRAPHERS

Serge Balkin—Russian-born photographer and European refugee, married to the *Life* photographer Nina Leen.

Cecil Beaton—British society photographer whose nanny famously taught him to take photographs, known for posing his subjects within fantastical sets. Forced to resign after he scribbles anti-Semitic comments in tiny letters around a drawing and doesn't change them before the drawing goes to press; then quietly returned to work in the London studio.

Erwin Blumenfeld—Self-taught experimental photographer, deeply influenced by Dada and surrealism, and a German-born Jew who becomes a stateless alien in Paris when war breaks out. After surviving several internment camps, Blumenfeld bribes his and his family's way to freedom and arrives in America, where he works for *Harper's Bazaar* and then joins *Vogue*.

Clifford Coffin—One of Liberman's new American hires, a former hotel manager from Chicago. He dislikes Franny and is eventually transferred to London.

Toni Frissell—Society snapshooter known for out-of-doors action fashion photography, who discovers Fuffy on a Montgomery Ward catalog shoot and hires her immediately as a girl Friday. She becomes a photojournalist during the war, working for the WAACs (the Women's Army Auxiliary Corps), going to England for the Red Cross, and then into the European theater of combat, where she is the only professional to photograph the Tuskegee Airmen at their base in Italy.

Horst P. Horst—German photographer famed for his sensual neo-classical tableaux.

Constantin Joffé—Russian-born Paris photographer who survives a German prison camp before arriving in New York.

Luis Lemus—Mexican-born photographer who has previously quit to work for *Mademoiselle* but has just been lured back by Mrs. Chase.

Claire Mallison—Stylish, devastatingly efficient studio manager.

Lee Miller—Debutante turned model turned photographer, studies with Man Ray in Paris and becomes his muse, then becomes British *Vogue*'s most prolific contributor. She returns searing dispatches from the front, including some of the first pictures of the concentration camps.

Irving Penn—Starts just before Franny, the first of Liberman's hires for the studio, and becomes Liberman's adored protégé. He previously worked at *Bazaar* with Brodovitch. Irving dates Franny and marries Lisa Fonssagrives.

John Rawlings—American photographer who worked for a time at British *Vogue* and is now married to Babs Rawlings, the top fashion editor.

Lisa Rothschild (now known as Lisa Larsen)—Jewish refugee from Berlin, a photographic prodigy. As a studio apprentice, she is never put on staff. She becomes a famous *Life* photographer.

Richard Rutledge—One of Liberman's new American hires, who has just finished his photography studies at the Art Center School in Los Angeles.

Edward Steichen—The company's chief photographer from 1923 to 1938, an enormously influential and powerful figure who pioneers fashion photography as an art form, thereby becoming the world's highest-paid photographer. After retiring from commercial photography in 1938, he forms a wartime photographic unit for the U.S. Navy, then directs MoMA's photography department.

HARPER'S BAZAAR

Alexey Brodovitch—Russian émigré art director who revolutionizes the look of *Harper's Bazaar*. His Design Laboratory course, begun as a course on European design principles at a Philadelphia arts school, later becomes extremely influential among photographers in New York.

Louise Dahl-Wolfe—Photographer from San Francisco who becomes known for color and outdoor fashion work.

George Davis—Fiction editor, and Frankie's former boss at *Harper's Bazaar*, whose discoveries include W. H. Auden, Christopher Isherwood, and Carson McCullers. The host of the city's most notorious

artistic and literary salon at his home in Brooklyn Heights, he later moves to *Mademoiselle*.

Mary Faulconer—A student of Brodovitch's, she becomes his first assistant at *Bazaar* and helps teach his Philadelphia design course. She later becomes an illustrator and art director of *Mademoiselle* and *Harper's Bazaar*.

William Randolph Hearst—Nast's nemesis and competitor after Hearst acquires *Harper's Bazaar*, America's oldest fashion magazine, in 1913.

George Hoyningen-Huene—Formerly chief photographer of French *Vogue*, follows Mrs. Snow to *Harper's Bazaar*.

Martin "Munky" Munkácsi—A Hungarian Jew and a staff photographer for *Berliner Illustrirte Zeitung*, Germany's highest-circulation photo-newsweekly, who becomes Carmel Snow's first photographic discovery when he creates the first "action" fashion photograph, of a model running on the beach.

Man Ray—Dada and surrealist artist who has pioneered many experimental photographic techniques and occasionally takes fashion photographs for *Harper's Bazaar* in New York.

Carmel Snow (known as Mrs. Snow)—Editor of *Harper's Bazaar*, a charming, glamorous Irishwoman with a fondness for whiskey. Poached by Hearst from *Vogue* in 1932, she transforms *Harper's Bazaar* into America's most cutting-edge fashion publication. She creates the first back-to-school college section, the first college fashion spin-off, and names Christian Dior's "New Look."

COLLEGE BAZAAR

Margaret Hockaday—Editor of the first college-girl magazine, who discovers Franny and Fuffy. She moves to Montgomery Ward, then to *Junior Bazaar*, then becomes the first fashion editor of *Holiday*, then founds her own wildly successful advertising firm.

JUNIOR BAZAAR

Richard Avedon—Brodovitch's new protégé, and Mrs. Snow's most exciting discovery since Munkácsi. Avedon becomes the star of *Junior Bazaar*, then of *Bazaar*.

Lillian Bassman—Student in Brodovitch's Design Laboratory who becomes his first paid assistant. They art-direct *Junior Bazaar* together, until she leaves the magazine and becomes a photographer.

OTHERS

Betsy Talbot Blackwell—Editor who transforms the upstart *Mademoiselle* into the hot young magazine for young women that everyone else has to beat.

Wilhela Cushman—Mrs. Snow's former assistant, now fashion editor of *Ladies' Home Journal*, "The Magazine Women Believe In." One of Jimmy's biggest fans.

Jane Troxell—Fashion editor of *Charm*, who hires Fuffy as a photographer.

Helen Valentine—Founding editor in chief of *Seventeen*, the first teen magazine.

Acknowledgments

I am extremely grateful to have had such colorful and accomplished subjects as the McLaughlins, the Abbes, and the Gills. Their descendants have been wonderful, too: willing to give me relatively unfettered access to their archives, and patient about my questions and requests over several years. My thanks go especially to Leslie Gill, and Tom, Lucinda, and Eli Abbe, and also to their extended families, especially Lucinda O'Neill and Eliza Werner, as well as the late Jim (aka Jamie) Abbe, Jessica Arner, Tomie dePaola, and Carol O'Neill. (Special thanks to Lucinda Abbe for arranging and participating in my first interview with Jim.) Dan Abbe, Judie Bobbi, Cole Evelev, Yale Evelev, Fred Werner, and Oliver Werner offered many invaluable insights, too. And Chris Karitevlis, who was hired by Franny as Fuffy's photo assistant just as he graduated from art school and ended up working for both twins and Jimmy on and off for over thirty years, was an exceptionally helpful and generous resource, always ready to answer questions and expand my understanding of the many characters involved.

Leslie Gill advised me early on to find my story in the pictures, and that's what I did, searching through the twins' many boxes of photos, studying contact prints and notes scrawled on their backs (as well as newspaper clippings and assorted writings), as I pieced

together the stories of people who, although they'd once been well-known, had slipped out of the world without leaving much of a trace on art history.

Eli Abbe made another terrific suggestion, one befitting a grand-son of Papa Abbe: he urged me to focus on telling a great story, and to make it as entertaining as possible. It was incredibly freeing to be given license to do that by one of my subjects' descendants. To that end, one day, when Eli and I were in his parents' storage space together, he unearthed a box containing the twins' letters to Jimmy—apparently Jimmy had always kept them in his desk drawer—and the entertaining aspect of the tale was off and running.

I'm also grateful to the twins, who seem to have kept everything, and to Fuffy especially, who toward the end of her life maintained assiduous records, as if she was hoping someone like me would come along.

Many others helped as well: The photographer and critic Marga-retta Mitchell made an enormous early contribution by sending me her recordings of and notes on the twins, along with various other fascinating interviews, with Toni Frissell, Louise Dahl-Wolfe, and more. Nina Rosenblum, who made *Twin Lenses*, a 2000 documentary short on the twins, generously shared all her raw footage and recordings. She also took me to interview her mother, the photography historian Naomi Rosenblum, now deceased, who had included the twins in her landmark 1994 book, *A History of Women Photographers*. Jain Thomas, who compiled the biographies for that book, supplied me with further background information. Dodie Kazanjian and Calvin Tomkins gave me access to the research materials for their biography *Alex*, which are housed in the Smithsonian Institution's Archives of American Art, and allowed me to quote from their unpublished interviews. Brent Brookfield shared her memories of her grandmother Toni Frissell and, with the help of her niece Holly Brookfield, made it possible for me to see Toni's unpublished memoirs when the pandemic had shut down the world and I could not travel to them.

Although I have written many photography stories and I love taking pictures, I started this book knowing little about the details of early twentieth-century cameras or photography. Many people helped further my understanding of the medium, in particular Geoffrey Berliner and Sam Dole of the Penumbra Foundation, who identified many of the cameras in the photos; Erin Fisher and Todd Gustavson of Eastman House, who explained the cameras of the period to me in detail; Nate Francis, who let me try taking pictures with his vintage cameras; and Lisa Hostetler and James Welling, who gave me insight into the books and methods a student might have encountered studying photography in the 1940s. Erin, in particular, now special collections librarian at the University of Rochester Library, went above and beyond in helping me get the technical details right—and any mistakes are mine, not hers.

For insight into the wartime history of Montauk and environs, my thanks go to the area's historians and local librarians, especially Adrienne Collins and Aimee Lusty of the Montauk Library, Christopher Kohan of the D'Amico Institute of Art, Andrea Meyers of the East Hampton Library, Henry Osmers of the Montauk Historical Society, Richard Barons of the East Hampton Historical Society, Gina Piastuck of the Suffolk County Clerk's Office, and the oral historians Maura Feeney and Tony Prohaska, as well as several people who shared their recollections of the area in the early 1940s, including Daniel Vasti, Elena Prohaska Glinn, David Webb, and Richard F. White Jr. I'm also grateful to the many church and community leaders who helped me try to figure out where Franny and Leslie got married, especially the Reverend Rob Stuart, the pastor emeritus at the Amagansett Presbyterian Church.

For help with Wallingford's Depression-era history, I thank Jerry Farrell Jr. of the Wallingford Historic Preservation Trust, and the many people he reached out to on my behalf, including Maryanne Hall, Chris and Joseph McLaughlin (apparently no relation to the twins), and the Rossi sisters, Mildred Rossi and Julia D'Agostino.

For furthering my understanding of Pratt's early history, and aiding my attempts to figure out the development of its first photography department—a truly neglected subject—I'm indebted to the school's archivists, especially Johanna Baumann, Rebecca Pou, and Cristina Fontánez Rodríguez, and several generations of their design and arts leadership and photography faculty, especially Anita Cooney, Gerry Snyder, Jane South, Marvin Hoshino, Philip Perkis, and Robert Zakarian. For helping me piece together the story of how photography was taught in the twins' era, especially in New York, and how Walter Civardi learned his trade (something I never fully resolved), I must thank the scholars Anne McCauley, Mary Panzer, Sally Stein, Charles Traub, and especially Bonnie Yochelson, as well as several members of the Civardi family—Todd, Stephen, Susan, and James.

The help of librarians and archivists at many different institutions was essential. Those institutions I consulted include the American Folk Art Museum, the American Heritage Center at the University of Wyoming, Brooklyn Museum, Center for Creative Photography at the University of Arizona, Cooper Union, Fashion Institute of Technology, George Eastman Museum, Greenwich Historical Society, Hartman Center for Sales, Advertising & Marketing History in the David M. Rubenstein Rare Book and Manuscript Library at Duke University, International Center of Photography, Jericho Public Library, Library of Congress, Metropolitan Museum of Art, National Archives, New School, different branches of the Smithsonian Institution, and Stanford University, among others. Thanks especially to Steven K. Galbraith of the Cary Graphic Arts Collection at the Rochester Institute of Technology, Joe Tucker of the Bennington College Library, and Elizabeth Botten and Marisa Bourgoin at the Archives of American Art, who helped me make some surprising discoveries. The support of the Condé Nast Archive and its associated library, both of which hold many of the magazines I refer to in the book, was crucial. Ivan Shaw and Marianne Brown gave me extraordinary access, and Cynthia Cathcart and Isaac Lobel helped to the end with fact-checking and many other details.

The fabulous Stéphane Houy-Towner conducted some important investigations for me in Paris, at the Musée des Arts décoratifs, Christian Dior Haute Couture, and others. (He also dreamed up the book's title.) William Middleton aided my research in the archives of Versailles, Vince Aletti gave me access to the *Junior Bazaar* magazines in his incredible collection, and the OSS expert Nick Reynolds (a source years ago for a story I wrote about the Marine Corps combat art program) helped me decode Leslie Gill's OWI files once I'd located them in the National Archives.

I'm also grateful to my longtime transcriptionist Dee Pelletier, who can decipher any accent because she's an actress in her other life, and to my indefatigable interns, Daniela Durst, Anna Mitchell, Olivia Land, Olivia Nathan, and Maryam Zia Sheikholeslami, who transcribed scores of interviews and hunted down research. (Olivia Land also led me to her godmother, Pamela Thomas, who had written about Leslie's work, helped Franny organize his 1983 retrospective, and interviewed both twins for her 2009 book, *Fatherless Daughters*.) And my long-ago intern, Edward Hayes Jr., now a museum director, kindly returned to duty and spent two weekends scanning copies of a rare magazine that could only be found in the city where he lived—and was gracious enough to say he'd learned a lot from the experience.

Many others spent time sharing their knowledge of the twins, their circle, their times, and their magazines, and helping in many other ways, including Bernard Arfin, Beatrice and Floyd Asnes, Pam Barkentin, Deborah Bell, Elizabeth Billhardt, Victoria Bjorklund, Andrea Blanch, Patricia Bosworth, Phyllis Braff, Margaret Brucia, Candy Bull, Jim Campbell, George Chinsee, Maude Schuyler Clay, Deirdre Clemente, Becky Conekin, Natalie d'Arbeloff, Yvette Blumenfeld, Georges Deeton, Michel del Sol, George Dern, Victoria de Toledo, the leadership of the Dinizulu Cultural Arts Institute, Pat Donovan, Owen Edwards, Mary Engel, Helen Coleman Evarts, Mia Fonssagrives-Solow, Ken Fox, Robert Freson, Pam Glintenkamp,

Paula Goldstein, Christopher Gorman, Jorie Graham, Howard Greenberg, Andy Grundberg, Kevin Guyer, Nancy Hall-Duncan, Helen Harrison, Dannielle B. Hayes, Lizzie Himmel, Susan Hockaday, Michele Morgan Mazzola, Tom McCormick, Sean Moorman, Robin Muir, Robert Nedelkoff, John-Michael O'Sullivan, Saul Ostrow, Beverly Pepper, Terence Pepper, Pat Peterson, Dolores Hawkins Phelps, James Reidel, Penelope Rowlands, Charlie Scheips, Ilaria Schiaffini, Lois Wadler Schilling, Julia Scully, Nan Shapiro, Etheleen Staley, Mary Stubelek, Alison Teague, Micki Rosenzweig Tiffen, Sherill Tippins, Leslie Tonkonow, David Tyson, Tony Vaccaro, Charles van Horne, Shawn Waldron, Joan Washburn, D. J. White, and Vasilios Zatse. I thank them all—and if there's anyone I've left out, I fervently apologize.

This book could not have been written the way I wanted to write it without the support of the Dorothy and Lewis B. Cullman Center for Scholars and Writers at the New York Public Library, where I was lucky enough to be a Fellow in 2019–20. Salvatore Scibona, our director, and deputy directors Lauren Goldenberg and Paul Delaverdac extended a warm welcome, answered countless questions, and pointed me in the right direction for research. The librarians and archivists I met during my Cullman year continued helping me long beyond it, including Deirdre Donohue, a tireless supporter of my book from the start; Shannon Keller, who finally located the elusive *College Bazaar*, a "lost" magazine that I'd heard Franny mention in an interview but had been unable to find on my own; Thomas Lannon, who turned me on to the importance of the Fashion Group; and Rebecca Federman, Melanie Locay, and Tal Nadan, who helped with research and also kept me supplied with books and other material during the terrible period when libraries shut down during the pandemic. But above all, I benefited from the presence of my fellow fellows (especially Susan Bernofsky, Ken Chen, Bill Goldstein, lapsed photographer Gilbert King, Jo Quinn, and Eric Sanderson). It was huge good fortune to be surrounded by so many great writers, and to

be able to hear them all discuss their own approaches to writing and ideas—in the center's formal talks and casually around our common lunch table—as I was working out the early pages of my first book.

I feel lucky that my book found a home at Scribner, where my first editor, Valerie Steiker, suggested that I focus on the twins—an incredibly fruitful idea. Kathy Belden, my current editor, shepherded my manuscript through to completion with care and enthusiasm, gently shaping it into a much better book. She is known for being one of the best in the business, and rightfully so. My writing also benefited from the skillful touch of her assistant, Rebekah Jett, now an editor herself. My appreciation to Nan Graham for her support, too, along with everyone else at Scribner including Dan Cuddy, Kyle Kabel, Mia O'Neill, Lauren Dooley, and Madison Thân. And I'm extremely grateful to my agent, Peter Steinberg of United Talent Agency, and his entire team; Peter pushed me to write the book in the first place and helped me find the right idea. My thanks as well to his former colleague Eve MacSweeney, previously a longtime *Vogue* editor, who read an early version of the manuscript.

I also owe much gratitude to Julie Samuels of Peppercorn Partners, who helped me navigate the complex thicket of rights that arise when using photographs from a bygone era, and who did it with good grace and cheer.

Many others contributed, too. My longtime publicist friend Nicole Straus, with whom I've done many great photography stories, told me about the twins, and she and her partner, Margery Newman, went above and beyond to help with many different aspects of the book. Julie Coe, Lenora Jane Estes, and Tony Freund assigned me early stories about them; and Brooke Kamin Rapaport, deputy director and chief curator of the Madison Square Park Conservancy, and Tom de Kay, my former editor at the *New York Times*, wrote my Cullman references. I must thank particularly my dear friend Francesca Sterling, who did a lot of listening, Brooke Lynn MacGowan, who listened and checked my French translations, and Marion Asnes, my New York

friend who goes back the longest (we met in our first jobs—mine was at FSG, hers was at *Vogue*), who helped me reconstruct Liberman's accent and reminded me not to dismiss the twins' husbands' first wives, which led to some terrific lines of research. Many others discussed ideas or contributed in other ways, including Barbara Doshin Ende, Thomas Gebremedhin, Richard Gehr, Brent Foster Jones, Jason Kaufman, Laura Raicovich, Jan Rothschild, and Maria Smilios. Constance McCord, Maud Winchester, and my mother all read and commented on the manuscript, and one former editor, who doesn't wish to be named, offered wise advice from the outset and did an expert reading near the end. My beloved godmother, Joyce Ashley, was thrilled about the book when I started; I only wish she were still here to see it now that it's complete. My father never really knew about it, but he played a crucial role. As his health declined, I told him about an odd phenomenon I'd noticed and had wondered about, that there had been so many successful—and forgotten— women photographers in midcentury. He made an observation that stuck with me: "It was the war, of course."

Finally, I am so grateful to my mother. None of this could have happened without her unswerving love and support.

Selected Bibliography

Abbe, Kathryn, and Frances McLaughlin-Gill. *Twin Lives in Photography*. New York: self-pub., Abbe-Gill Press, 2011.

———. *Twins on Twins*. New York: Clarkson N. Potter, 1980.

Aletti, Vince. *Issues: A History of Photography in Fashion Magazines*. London and New York: Phaidon Press, 2019.

Appelbaum, Stanley, ed. *The New York World's Fair: 1939/1940 in 155 Photographs by Richard Wurts and Others*. New York: Dover, 1977. Kindle.

Applegate, Edd, ed. *The Ad Men and Women: A Biographical Dictionary of Advertising*. Westport, CT: Greenwood Press, 1994.

Arnold, Rebecca. *The American Look*. London: I.B. Tauris, 2009.

Ballard, Bettina. *In My Fashion*. London: Secker & Warburg, 1960. Reprint, London: V&A, 2017. Kindle.

Barry, John M. *The Great Influenza*. New York: Viking, 2004.

Bernier, Rosamond. *Some of My Lives: A Scrapbook Memoir*. New York: Farrar, Straus & Giroux, 2011.

Bishop, Robert Lee. "The Overseas Branch of the Office of War Information." PhD diss., University of Wisconsin, 1966.

Blumenfeld, Erwin. *Eye to I*. New York: Thames & Hudson, 1999.

Blumenfeld, Erwin, and Hendel Teicher. *Blumenfeld: My One Hundred Best Photos*. Translated by Philippe Garner with Luna Carne-Rosse. New York: Rizzoli, 1981.

Bogart, Michele H. *Artists, Advertising, and the Borders of Art*. Chicago: University of Chicago Press, 1997.

Bourke-White, Margaret. *Portrait of Myself*. New York: Simon & Schuster, 1963.

Braun, Sandra Lee. "Forgotten First Lady: The Life, Rise, and Success of Dorothy Shaver, President of Lord & Taylor Department Store, and America's 'First Lady of Retailing.'" PhD diss., University of Alabama, Tuscaloosa, 2009. https://ir.ua.edu/bitstream/handle/123456789/659/file__1.pdf?sequence=1&isAllowed=y.

Bussard, Katherine A., and Kristen Gresh. Life *Magazine and the Power of Photography*. New Haven, CT: Yale University Press, 2020.

Bussard, Katherine A., and Lisa Hostetler. *Color Rush: American Color Photography from Stieglitz to Sherman*. New York and Milwaukee: Aperture and Milwaukee Art Museum, 2013.

Caren, Eric C. *Pearl Harbor Extra: A Newspaper Account of the Unites States' Entry into World War II*. Edison, NJ: Castle, 2001.

Chase, Edna Woolman, and Ilka Chase. *Always in Vogue*. New York: Doubleday, 1954. Reprint, London: V&A, 2018. Kindle.

Clemente, Deirdre. *Dress Casual: How College Students Redefined American Style*. Chapel Hill: University of North Carolina Press, 2014.

Coe, Brian, and Paul Gates. *The Snapshot Photograph: The Rise of Popular Photography, 1888–1939*. London: Ash & Grant, 1977.

Conekin, Becky E. *Lee Miller in Fashion*. New York: The Monacelli Press, 2013.

Conover, Carole. *Cover Girls: The Story of Harry Conover*. Englewood Cliffs, NJ: Prentice-Hall, 1978.

Cotter, Bill. *The 1939–1940 New York World's Fair: The World of Tomorrow*. Charleston, SC: Arcadia, 2018.

Dahl-Wolfe, Louise. *Louise Dahl-Wolfe: A Photographer's Scrapbook*. New York: St. Martin's / Marek, 1984.

Devlin, Beth, Dawn Gottschalk, and Tarn Granucci. *Wallingford's Historic Legacy*. Charleston, SC: Arcadia, 2020.

Devlin, Polly. Vogue *Book of Fashion Photography, 1919–1979*. New York: Simon & Schuster, 1979.

Fashion Institute of Technology, ed. *All-American: A Sportswear Tradition*. New York: Fashion Institute of Technology, 1985.

Fass, Paula S. *The Damned and the Beautiful: American Youth in the 1920s*. Oxford: Oxford University Press, 1977. See esp. ch. 3, "The World of Youth: The Peer Society."

Freeman, Tina, and Frances McLaughlin-Gill, eds. *Leslie Gill: A Classical Approach to Photography, 1935–1958*. New Orleans: New Orleans Museum of Art, 1983.

Frissell, Toni. Memoir. Unpublished manuscript, hand-edited typescript. Courtesy of Brent Brookfield and Holly Brookfield.

Fulton, Marianne, ed., with text by Bonnie Yochelson, and Kathleen A. Erwin. *Pictorialism into Modernism: The Clarence H. White School of Photography*. New York: Rizzoli, 1996.

Gabriel, Mary. *Ninth Street Women*. New York: Little, Brown, 2018.

Gantz, Carroll. *Founders of American Industrial Design*. Jefferson, NC: McFarland, 2014.

Gefter, Philip. *What Becomes a Legend Most: A Biography of Richard Avedon*. New York: Harper Collins, 2020.

Gilbert, George. *The Illustrated Worldwide Who's Who of Jews in Photography*. Riverdale, NY: self-pub., 1996.

Goldstein, Richard. *Helluva Town: The Story of New York City During World War II*. New York: Free Press, 2010.

Gross, Michael. *Model: The Ugly Business of Beautiful Women*. New York: William Morrow, 1995. Kindle.

Grundberg, Andy. *Brodovitch*. New York: Harry N. Abrams, 1989.

Gustavson, Todd. *Camera: A History of Photography from Daguerreotype to Digital*. New York: Sterling, 2009.

Hall-Duncan, Nancy. *The History of Fashion Photography.* New York: Alpine, 1979.

Hambourg, Maria Morris, and Jeff L. Rosenheim, and contributors. *Irving Penn: Centennial.* New York: Metropolitan Museum of Art, 2017.

Hamburger, Estelle. *It's a Woman's Business.* New York: Vanguard, 1939.

Hannah, Gail Greet. *Elements of Design: Rowena Reed Kostellow and the Structure of Visual Relationships.* New York: Princeton Architectural, 2002.

Harrison, Helen A., and Constance Ayers Denne. *Hamptons Bohemia: Two Centuries of Artists and Writers on the Beach.* San Francisco: Chronicle, 2002.

Harrison, Martin. *Appearances: Fashion Photography Since 1945.* New York: Rizzoli, 1991.

———. *Beauty Photography in* Vogue. London: Octopus, 1987.

Harrison, Martin, and David Seidner, ed. *Lisa Fonssagrives: Three Decades of Classic Fashion Photography.* London: Thames & Hudson, 1996.

Hayes, Dannielle B., ed. *Women Photograph Men.* New York: William Morrow, 1977.

Heller, Steven, and Greg D'Onofrio. *The Moderns: Midcentury American Graphic Design.* New York: Abrams, 2017. Kindle.

Honey, Maureen. *Creating Rosie the Riveter: Class, Gender, and Propaganda During World War II.* Amherst: University of Massachusetts Press, 1984. See esp. section 1, "Creation of the Myth."

Janello, Amy, and Brennan Jones for the Magazine Publishers of America and the American Society of Magazine Editors. *The American Magazine.* New York: Harry N. Abrams, 1991.

Kazanjian, Dodie, and Calvin Tomkins. *Alex: The Life of Alexander Liberman.* New York: Alfred A. Knopf, 1993.

———. Research materials on Alexander Liberman, 1974–98. Archives of American Art, Smithsonian Institution.

Klein, Mason, with Maurice Berger, Leslie Camhi, and Marvin Heiferman. *Modern Look: Photography and the American Magazine.* New Haven, CT: Yale University Press, 2020.

Kleinberg, S. J. *Women in the United States, 1830–1945.* Houndmills, Basingstoke, Hampshire, and London: MacMillan, 1999. See esp. part 3, "From the Vote to World War II," and the epilogue, "The Feminine Mystique."

Köhn, Eckhardt. *Rolf Tietgens: Poet mit der Kamera: Fotografien, 1934–1964 / Poet with a Camera: Photographs.* Zug, Switzerland: Die Graue, 2011.

Lee, Sarah Tomerlin, ed., for the Fashion Institute of Technology. *American Fashion: The Life and Lines of Adrian, Mainbocher, McCardell, Norell, Trigère.* New York: Quadrangle / New York Times Books, 1975. See esp. ch. 3, Sally Kirkland, "McCardell."

Levin, Phyllis Lee. *The Wheels of Fashion.* New York: Doubleday, 1965.

Levy, Julien. *Memoir of an Art Gallery.* Boston: MFA Publications, 2003.

Liberman, Alex, ed. and designer. *The Art and Technique of Color Photography: A Treasury of Photographs by the Staff Photographers of* Vogue, House & Garden, Glamour. New York: Simon & Schuster, 1951.

Lowry, Robert, and James Reidel, ed. "Last Stand: Letters to My Psychiatrist, with an introduction by James Reidel." Unpublished manuscript.

Martin, Richard. *American Ingenuity: Sportswear, 1930s–1970s.* New York: Metropolitan Museum of Art, 1998.

Massoni, Kelley. *Fashioning Teenagers: A Cultural History of* Seventeen *Magazine.* Walnut Creek, CA: Left Coast Press, 2010.

McGee, William L., and Sandra V. McGee. *The Divorce Seekers: A Photo Memoir of a Nevada Dude Wrangler.* St. Helena, CA: BMC Publications, 2004.

Mitchell, Margaretta K. *Recollections: Ten Women of Photography.* New York: Viking, 1979.

Muir, Robin. *Fernand Fonssagrives: An Eye for Beauty.* London: Guiding Light, 2003.

Nourie, Alan, and Barbara Nourie, eds. *American Mass-Market Magazines.* Westport, CT: Greenwood, 1990.

Pepper, Terence. *Limelight: Photographs by James Abbe.* London: National Portrait Gallery, 1995.

Peril, Lynne. *College Girls: Bluestockings, Sex Kittens, and Coeds, Then and Now.* New York: W. W. Norton, 2006. Kindle.

Peterson, Theodore. *Magazines in the Twentieth Century.* Urbana: University of Illinois Press, 1956.

Pettit, Dorothy Ann. "A Cruel Wind: America Experiences Pandemic Influenza, 1918–1920, a Social History." PhD diss., University of New Hampshire, 1976. https://scholars.unh.edu/dissertation/1145.

Pettit, Dorothy Ann, and Janice Bailie. *A Cruel Wind: Pandemic Flu in America, 1918–1920.* Murfreesboro, TN: Timberlane Books, 2008.

Phillips, Christopher. "Edward Steichen and WWII Naval Photography." MFA diss., Rochester Institute of Technology, 1981.

———. *Steichen at War.* New York: Harry N. Abrams, 1981.

Plimpton, George, and Sidney Frissell Stafford. *Toni Frissell: Photographs, 1933–1967.* New York: Doubleday in association with the Library of Congress, 1994.

PM Magazine: Pratt Institute, December 1937.

Pollock, Lindsay. *The Girl with the Gallery: Edith Gregor Halpert and the Making of the Modern Art Market.* New York: Public Affairs, 2006.

Prohaska, Anton. *The White Fence: Icons and Legends in a Small Town—Recollections of Eastern Long Island Before It Became "The Hamptons."* Self-pub., Gratia Books, 2014.

Raeburn, John. *A Staggering Revolution: A Cultural History of Thirties Photography.* Urbana and Chicago: University of Illinois Press, 2006.

Rattray, Jeannette Edwards. *The Story of Second House, Montauk* (pamphlet). Self-pub., 1969.

Reidel, James. "Robert Lowry." *Review of Contemporary Fiction,* Summer 2005, 42–83.

Ronald, Susan. *Condé Nast: The Man and His Empire.* New York: St. Martin's Press, 2019.

Rosenblum, Naomi. *A History of Women Photographers.* New York: Abbeville Press, 1994.

Rosenblum, Nina, producer/dir., Dennis Watlington, co-producer/writer, and Dejan Georgevich, dir. of photography. *Twin Lenses* (film). New York: Daedalus Productions, 2000.

Ross, Ishbel. *Ladies of the Press: The Story of Women in Journalism by an Insider.* New York and London: Harper & Brothers, 1936.

Rowlands, Penelope. *A Dash of Daring: Carmel Snow and Her Life in Fashion, Art, and Letters.* New York: Simon & Schuster, 2005. Kindle.

Schaffner, Ingrid. *Salvador Dalí's Dream of Venus: The Surrealist Funhouse from the 1939 World's Fair.* New York: Princeton Architectural Press, 2002.

Schaffner, Ingrid, and Lisa Jacobs, eds. *Julien Levy: Portrait of an Art Gallery.* Cambridge, MA, and London: MIT Press, 1998.

Scotford, Martha. *Cipe Pineles: A Life of Design.* New York: W. W. Norton, 1999.

Seebohm, Caroline. *The Man Who Was* Vogue*: The Life and Times of Condé Nast.* New York: Viking, 1982.

Shields, David S. "Photography and the American Stage: The Visual Culture of American Theater, 1865–1965." Broadway Photographs (website), University of South Carolina. https://broadway.library.sc.edu/index.html.

Smärta, Hjärta, design, Ika Johannesson, ed., and Lillian Bassman. *Hall of Femmes: Lillian Bassman.* Stockholm: Oyster Press, 2010.

Smith, Rufus G. *Sailing Made Easy: Told in Pictures, with Special Photographs by Walter Civardi.* New York: Kennedy Bros., 1938.

Snow, Carmel, with Mary Louise Aswell. *The World of Carmel Snow.* New York: McGraw Hill, 1962. Reprint, London: V&A, 2017. Kindle.

Strassel, Annemarie Elizabeth. "Redressing Women: Feminism in Fashion and the Creation of American Style, 1930–1960." PhD diss., Yale University, 2008. ProQuest (UMI 3317280).

Sutton, Denise H. *Globalizing Ideal Beauty: How Female Copywriters of the J. Walter Thompson Advertising Agency Redefined Beauty for the Twentieth Century.* New York: Palgrave Macmillan, 2009.

Thomas, Pamela. *Fatherless Daughters: Turning the Pain of Loss into the Power of Forgiveness.* New York: Simon & Schuster, 2009.

Thomas, Stanley G. *The Ercoupe.* Blue Ridge Summit, PA: Aero, 1991.

Tippins, Sherill. *February House.* New York: Houghton Mifflin, 2005. Kindle.

Traub, Charles, ed. *The New Vision: Forty Years of Photography at the Institute of Design.* New York: Aperture, 1982.

Van Dort, Paul M. "1939 New York World's Fair: Building the World of Tomorrow, Preserving the World of Yesterday." https://www.1939nyworldsfair.com/index.htm.

Van Horne, Charles H. *Antonie von Horn Roothbert (1899–1970): Notes for a Biography.* New York: self-pub., Roothbert Fund, 2010.

Williams, Beryl. *Fashion Is Our Business.* New York, J.B. Lippincott, 1945.

Winkler, Allan M. *The Politics of Propaganda: The Office of War Information, 1942–45.* New Haven, CT: Yale University Press, 1978.

Zuckerman, Mary Ellen. *A History of Popular Women's Magazines in the United States, 1792–1995.* Westport, CT: Greenwood, 1998.

Endnotes

FREQUENTLY CITED MATERIAL, WITH ABBREVIATIONS

CA INTERVIEW

Casey Allen interviews with Frances McLaughlin-Gill, Casey Allen Collection, 1970–97. AG 148. Center for Creative Photography, University of Arizona, Tucson.

DICK CAVETT SHOW

Dick Cavett interview with Kathryn McLaughlin Abbe and Frances McLaughlin-Gill. *The Dick Cavett Show*, PBS, March 30 and 31, 1981. Privately recorded.

ICP LECTURE

Kathryn McLaughlin Abbe and Frances McLaughlin-Gill, "Twins on Twins." Lecture Series, International Center of Photography, September 30, 1981.

KAZANJIAN AND TOMKINS, AAA

Dodie Kazanjian and Calvin Tomkins research materials on Alexander Liberman, 1974–1998. Archives of American Art, Smithsonian Institution.

MITCHELL INTERVIEWS

Margaretta K. Mitchell interviews with FMG and KA, unpublished.

TWIN LENSES

Nina Rosenblum, producer/dir., et al. *Twin Lenses* (Daedalus Films, 2000). Raw soundtrack, sixteen recordings total, ca. 1999–2000.

TL

Kathryn Abbe and Frances McLaughlin-Gill, *Twin Lives in Photography* (New York: self-published, Abbe-Gill Press, 2011).

TOT

Kathryn Abbe and Frances McLaughlin-Gill, *Twins on Twins* (New York: Clarkson N. Potter, 1980).

TF MEMOIR

Toni Frissell, memoir, unpublished manuscript, hand-edited typescript. Courtesy of Brent Brookfield and Holly Brookfield.

NAME, PLACE, AND PUBLICATION ABBREVIATIONS

PEOPLE

CA: Casey Allen

FMG: Frances McLaughlin or Frances McLaughlin-Gill

JA: Jimmy Abbe

JA III: Jamie Abbe

KA: Kathryn McLaughlin or Kathryn Abbe

LG: Leslie Gill

TF: Toni Frissell

ARCHIVES

AAA: Archives of American Art, Smithsonian Institution, Washington, DC

CAC: Casey Allen Collection

CNA: Condé Nast Archive

FGI: Fashion Group International Records. Manuscripts and Archives Division, New York Public Library

NYPL: New York Public Library

PIA: Pratt Institute Archives, Brooklyn, New York

MAGAZINES AND NEWSPAPERS

CB: College Bazaar

HB: Harper's Bazaar

JB: Junior Bazaar

LHJ: Ladies' Home Journal

NYT: The New York Times

NYHT: New York Herald Tribune

PP: Popular Photography

WWD: Women's Wear Daily

Unless otherwise stated in the endnotes, letters and other material comes from private archives, and all references to *Vogue* and other publications are to the American versions. All interviews with Leslie Gill, dau., refer to Franny and Leslie's daughter.

PROLOGUE *Twins on Twins*

My main sources for this chapter were the ICP lecture and *The Dick Cavett Show*, except as otherwise noted.

xv *had been widely interviewed:* Nan Robertson, "Twins: A Special Identity," *NYT*, February 9, 1981, B4; Jill Gerston, "The Best Gift for Anyone . . . Is to Be a Twin," *Philadelphia Inquirer*, March 22, 1981, 1-I, 8-I; Kathryn McLaughlin Abbe and Frances McLaughlin Gill, "Twins," *Good Housekeeping*, March 1981, 150–53, 262–64, 266; *Today Show*, NBC, March 9, 1981.
xvi *"launched a thousand quips":* New Yorker, October 1, 1979, 93.
xviii *"social and biological oddities":* Hilton Kramer, "125 Photos by Arbus on Display," *NYT*, November 8, 1971, 52.

CHAPTER 1 World of Tomorrow

3 *"I knew instantly I was hooked":* Amy S. Rossoff, "Twins Tell Their Twin Tale to Dispel the Telling of Twin Tales Forever," *Pratt Reports*, Fall 1981, 6–9.

3 *"Right from the beginning"*: TL, 20.

3 *"enslaved by the* djinn*"*: Lee Miller, "Pioneering: I Worked with Man Ray," *Lilliput*, October 1941, 315–22.

4 *"magic of light and lens"*: TL, 20.

4 *"a Real American Native Art"*: Agha, "Preface," in T. J. Maloney, *U.S. Camera, 1935* (New York: William Morrow, 1935), 3–4.

4 *Even then, in one of the worst years:* Raeburn, *Staggering Revolution*, 94; "Our Book Shelves," *Camera Craft*, October 1935, 570–71; "Success Story," *Minicam: The Miniature Camera Review*, September 1937, 20–23.

5 *The display and its tour:* Raeburn, *Staggering Revolution*, ch. 1, "A Calendar of Thirties Photography" and "The Rebirth of Photography in the Thirties."

5 *In 1937, the eight-year-old Museum: Photography*, March 17–April 18, 1937, MoMA.

5 *An even larger show:* Raeburn, *Staggering Revolution*, 187, "Exhibiting FSA Photography."

5 *Soon a new sort of magazine:* Ibid., ch. 7, "Camera Periodicals and the Popular Audience."

5 *The first of these,* Life: Henry R. Luce, "A Prospectus for a New Magazine," box 431, folder 23, p. 3, August 1936, Time Inc. Subject Files, MS 3009-RG 3, New-York Historical Society.

5 *Its opening cover pictorial: Life*, November 23, 1936.

6 *sold out its first quarter-million run:* Raeburn, *Staggering Revolution*, 196.

6 *By 1938, the year the twins decided:* My own analysis of the covers of these magazines. *Glamour of Hollywood*, which launched the following year, only ever had photographs on the cover.

6 *amid displays of futuristic new products:* TL, 21; Van Dort, "1939 New York World's Fair." For the Eastman Kodak Building specifically, see Ariane Pollet, "The Cavalcade of Color: Kodak and the 1939 World's Fair," trans. James Gussen, *Études photographiques* 30 (December 20, 2012), https://journals .openedition.org/etudesphotographiques/3486.

7 *Photography also permeated:* "Taking Pictures at Fair Gates," *NYT*, May 7, 1939, sec. T, 11.

7 *U.S. Camera, in addition to its annual: U.S. Camera Magazine*, August 1939.

7 *Cameras had sold well throughout the Depression:* Gilbert, *Illustrated Worldwide Who's Who*, 292; "The U.S. Minicam Boom," *Fortune*, October 1936, 124–29, 160, 164, 167–68; Coe and Gates, *Snapshot Photograph*, ch. 6, "Smaller Cameras and Faster Films."

7 *"Amateurs Swarm over Grounds"*: "Most Fair Shooting Done with Camera," *NYT*, July 5, 1939, 13.

8 *each trip costing them a nickel:* William B. Bloeth, "Things You Should Know about the World's Fair," *Woman's Day*, June 1939, 6–7, 46; Van Dort, "1939 New York World's Fair."

8 *One of their friends: TL*, 21.

8 *Behind a pale pink plaster facade:* Schaffner, *Salvador Dalí's Dream*; Carol Kino, "Venus on Red Satin: Salvador Dalí's House in Queens," *NYT*, June 22, 2003, sec. 2, 25.

8 *"You can imagine that we felt"*: TL, 21.

8 *the basement of Pratt's Home Economics building: Annual Report, 1936–1937*, Records of the School of Art and Design, PIA.

8 *"to see the world; to eyewitness great events"*: Luce, "Prospectus."

8 *"We just liked it"*: Dick Cavett Show.

CHAPTER 2 **Kodak Childhood**

Except as otherwise noted, the story of the twins' birth and early childhood comes from TL and ToT, and the quotes come from TL. In TL, Fuffy says they were born six weeks early, and in ToT, Franny says they were two months premature.

9 *But by the fall of 1919:* Details of the pandemic's course in New York City can be found in Pettit and Bailie, *Cruel Wind*, 201–4, and W. Yang *et al.*, "The 1918 influenza pandemic in New York City: Age-specific mortality, timing, and transmission dynamics," *Influenza and Other Respiratory Viruses* 8 (2014), 177–88. https://www.ncbi.nlm.nih.gov/pmc/articles/PMC4082668/

10 *Yet when the twins were barely five months old:* "'Flu' Epidemic Over, Copeland Rescinds Rules," *NYT*, February 14, 1920, 18; "Influenza Beaten, Says Dr. Copeland," *NYT*, February 15, 1920, 14.

10 *She also consecrated herself:* Tomie dePaola, interview with author, February 13, 2020.

10 *Fanatically overprotective:* ToT, 14; Chris Karitevlis, interview with author, August 6, 2022; Tomie dePaola, interview with author, February 1, 2018.

11 *When they were about four:* Otto Sachs, "McLaughlin Twins Bare Souls for *Prattler* and Posterity," *Prattler*, May 8, 1940, 2, Pratt Institute Publications Collection, PIA; ToT, 14.

11 *And so the twins grew up:* dePaola, interview, February 1, 2018; "Morton Downey Dies at 83; Popular Tenor in Radio Era," *NYT*, October 27, 1985. Stories about Downey say that his father was the fire chief and owned the saloon, but dePaola says his uncle Jack owned it.

12 *As the 1919 product catalog claimed: Kodaks and Kodak Supplies* (Rochester, NY: Eastman Kodak Company, 1919), 42, Trade Catalog Collection, Central Library of Rochester and Monroe County, NY.

13 *When the twins graduated from eighth grade:* "Holy Trinity to Graduate Class of 60," *New Haven Register*, June 10, 1933, unpaginated.

13 *"Honor Students at Lyman Hall Are Announced":* "Honor Students at Lyman Hall Are Announced," *Meriden Daily Journal*, Wallingford edition, March 6, 1934, 1.

14 *"As we saw all of our classmates":* TL, 14.

14 *"Mother must have been stage-struck":* FMG, "Notes on My Photographs for the *Vogue* Fashion Book, 1978," unpublished.

14 *They were taught how to sew:* CA interview, 1A, September 13, 1996.

15 *They worked devotedly on the school's magazine: Chronicle: Lyman Hall High School* (Wallingford, CT), December 1933 through June 1937.

15 *"They were two very definite beings":* Mildred Rossi and Julia D'Agostino, interview with author, September 20, 2020.

16 *One of their favorite methods:* Leslie Gill, dau., interview with author, January 23, 2018.

16 *One student they became friendly with:* Lucinda Abbe, interview with author, May 10, 2019; dePaola, interviews, February 1, 2018, and February 13, 2020; Tom Abbe, interview with author, March 21, 2021.

16 *Franny's chief interest:* "Senior Issue," *Chronicle*, June 1937, 47.

16 *in their graduation yearbook:* Ibid., 34.

17 *Their valedictorian-salutatorian double act:* "What Pop Gets for His Money: These Honors Won by Local Boys and Girls Ought to Gladden His Heart," *Brooklyn Daily Eagle*, June 20, 1937, sec. B5.

17 *Their graduation also made the* New York Times: "Twins Win High Class Honors," *NYT*, June 20, 1937, 31.

17 *"It was the happiest day of my mother's life":* CA interview, 1A, September 13, 1996.

17 *"Mother really had lost a lot of money": Twin Lenses*, 5B, KA and JA.

17 *At least, that's what they told:* "Wallingford Twins Win School Honors," *New Haven Sunday Register*, May 16, 1937, 1, 3.

17 *"That was the whole goal":* CA interview, 1A, September 13, 1996.

17 *"We sound like a family of kittens": Dick Cavett Show*.

18 *She also chose a unit whose living room windows:* dePaola, interview, February 18, 2018.

18 *Pratt's annual $170 tuition:* Pratt Institute School of Fine and Applied Arts catalog *Day Courses*, 1937–1938 (Brooklyn, NY), 15.

CHAPTER 3 **An Experimental Education**

21 *It had been founded:* "Pratt Institute for Industrial Education, Brooklyn, N.Y.—the Largest Institution of the Kind in the World," *Scientific American*, October 6, 1888, 1, 210–11, 214–15.

22 *By 1937, when the twins arrived:* Catherine MacKenzie, "Pratt Looks Back over Fifty Years," *NYT*, May 16, 1937, 42.

22 *And in those waning years of the Depression:* Ibid.

22 *"the art which enters every home":* Alexander J. Kostellow, "Industrial Design at Pratt Institute," *Interiors*, July 1947, 99–108, 132, 134.

23 *it was in the science department:* Naomi Rosenblum, interview with author, November 26, 2018.

23 *Most students learned by joining:* Mary Panzer, Sally Stein, emails with author, February 5–6, 2020; Todd Gustavson and Erin Fisher, interview with author, March 12, 2020; Bonnie Yochelson, interview with author, September 17, 2020.

23 *Pratt had begun setting up:* "Special Report: Ten Year Review," from *Annual Report, 1937–1938*, 38, Records of the School of Art and Design, PIA.

23 *The sculptor Beverly Pepper:* Beverly Pepper, email interview with author, September 19, 2018.

23 *the twins were trained in looking: TL*, 20.

24 *Another beloved early instructor:* Like the Bauhaus, Pratt had a "preliminary course" for its first-year students, and Josef Albers, a Bauhaus master who fled Germany in 1933, was also teaching a variant of this class at Black Mountain College in

North Carolina. Carol Kino, "Go Tell It on the Mountain," *Wall Street Journal*, October 10, 2015, 124–29; "Black Mountain College," *JB*, May 1946, 130–33, 178.

24 *Nonetheless, from the students' point of view:* Pepper, email.

24 *Although there was some talk:* "Minutes of Supervisor's Meeting, January 24, 1938," PIA. The November 14 minutes note, wryly, that the New Bauhaus closed shortly thereafter "because of internal friction, principally Mr. Moholy-Nagy's desire to dominate." (However, Moholy-Nagy's wife, Sybil, taught architecture at Pratt for many years after his death.)

24 *Other European artists also joined the faculty:* "Pratt: 125 Anniversary," *Pratt-folio*, May 16, 2012, 29–30.

25 *The twins were soon making forays:* TL, 20.

25 *In 1936 it had mounted a giant survey:* Exhibition of Fantastic Art, Dada and Surrealism, December 9, 1936–January 17, 1937, MoMA.

25 *it opened an enormous Bauhaus show:* The Bauhaus, 1919–1928, December 7, 1938–January 30, 1939, MoMA.

25 *"the bridge over which most of the picture-buying public":* Sallie Faxon Saunders, "Middle Men of Art," *Vogue*, March 15, 1938, 102, 154–55.

26 *Levy wrote in his memoir:* Levy, *Memoir of an Art Gallery*, 203.

26 *Levy's shows also jumbled together high and low:* Ingrid Schaffner, "Alchemy of the Gallery," and Lisa Jacobs, "Chronology of Exhibitions," in *Julien Levy*, ed. Schaffner and Jacobs; Saunders, "Middle Men of Art."

26 *The gallery also showed a lot of women:* Levy, *Memoir of an Art Gallery*, 254; Margaret Case Harriman, "Profiles: A Dream Walking," *New Yorker*, July 1, 1939, 22–27.

27 *one of the few noncitizens:* Dana Miller, ed., *Whitney Museum of American Art: Handbook of the Collection* (New York: Whitney Museum of American Art, 2015), "Defining 'American,'" 25–26.

27 *Kuniyoshi, known as Yas to his friends:* Elena Prohaska, interview with author, March 6, 2021.

27 *He "was born in Japan":* "People and Ideas: Girl Thinking, by Yasuo Kuniyoshi," *Vogue*, October 1, 1936, 74–75.

27 *Another critic, most likely Henry McBride:* New York Sun, January 28, 1939, unpaginated press cutting in scrapbook, Yasuo Kuniyoshi Papers, AAA.

27 *Kuniyoshi was known for being scrupulously:* "Remembering Kuniyoshi: Artists in Their Own Words," AAA blog, April 30, 2015, https://www.aaa.si.edu/blog/2015/04/remembering-kuniyoshi-artists-their-own-words.

27 *His aim as a teacher:* Yasuo Kuniyoshi, notes on teaching, Yasuo Kuniyoshi Papers, AAA.

27 *Kuniyoshi's importance to the twins:* Harry Salpeter, "Painters vs. Pulchritude," *Mademoiselle*, March 1936, 20–21, 36–37, 40, 45.

28 *"The young lady in the picture":* Henry McBride, "Whitney Museum's 'Annual,'" *New York Sun*, November 13, 1937, uncredited, unpaginated press cutting in scrapbook, Yasuo Kuniyoshi Papers, AAA.

28 *his wife "was always mad about something":* Prohaska, interview.

28 *"Marsh considers the girls of 14th Street":* Gordon Ewing, "Reginald Marsh's Women," '47: The Magazine of the Year, May 1947, unpaginated, http://www.oldmagazinearticles.com/pdf/Reginald__Marsh__Article.pdf.

29 *Afterward, they often joined the famous painter:* TL, 22.

29 *cofounded by Lee Strasberg:* The other two directors were Harold Clurman and Cheryl Crawford.

29 *Franny, still crazy about theater:* FMG, 1996 CV, CAC.

29 *Valente's main job now was photographing Broadway actors:* David S. Shields, "Alfredo Valente," "Broadway Photographs," https://broadway.library.sc.edu/content/alfredo-valente.html.

29 *The film,* Art Discovers America*:* This 10:44-minute film can be seen on the AAA website, which holds Valente's archives; Franny appears at about the 10:12 mark. An accompanying blog post dates the film to 1943 and suggests that "few prints were probably ever made or seen": https://www.aaa.si.edu/blog/2010/07/notes-on-the-short-film-art-discovers-america. But a catalog for a 1969 exhibition of Valente's Group Theater photographs at Queens College dates it to 1940, the year Franny studied with Marsh, and says it was "distributed by M.G.M. and shown widely among G.I.'s during WWII." See Neal Richmond, ed., *The Group Theater, 1933–1941: An Exhibition of Photographs of the Group Theatre by Alfredo Valente*, Paul Klapper Library / Art Center, Queens College, NY, 1969.

CHAPTER 4 **The Discovery of Photography**

Except as otherwise noted, the information about the beginnings of the Pratt photography department comes from Pratt's *Annual Reports, 1936–37* and *1937–38*, in the Records of the School of Art and Design. The background about the twins' extracurricular activities comes from an exhaustive reading of student bulletins, school yearbooks (including the twins' own autographed copies), newspapers, and other material in the Pratt archives.

32 *Franny recalled his domain, the photo lab:* CA interview 1A, September 13, 1996.

32 *An assistant who worked with them:* Victoria Bjorklund, interview with author, July 23, 2018.

32 *"We were so persistent":* CA interview, October 3, 1996.

32 *"They knew how to get what they wanted":* Margaretta Mitchell, "Photography's Twin Sisters," *PP*, January 1980, 74–81, 118–19, 182.

32 *Ultimately, every one of the five:* CA interview 1A.

32 *Civardi, his "technical assistant":* It isn't clear how Civardi learned photography, or how he was hired; he had been forced to drop out of college during the Depression and may have learned in a camera club or a commercial studio. He may have heard about the job from his younger brother, J. Walter Sivard, an artist who had studied illustration at Pratt.

33 *Civardi published the book:* Smith, *Sailing Made Easy*, 1–7.

33 *But he mostly devoted himself:* CA interview 1A; Walter Civardi, "Photography Has Become Vital Part of Our Educational System," *Brooklyn Daily Eagle*, August 21, 1941, 25.

33 *they all knew photography was becoming important:* Beverly Pepper, email interview with author, September 19, 2018.

34 *how-to piece that ran in December 1939:* László Moholy-Nagy, "Making Photographs Without a Camera," *PP*, December 1939, 30–31, 167–69. By now Moholy-Nagy had opened a new school in Chicago, the School of Design; it was reorganized as the Institute of Design in 1944 and incorporated into the Illinois Institute of Photography five years later. In the 1940s it became known for teaching photography. https://moholy-nagy.org/teaching/.

34 *The first book on Graflex technique:* Willard D. Morgan and Henry M. Lester, *Graphic Graflex Photography* (New York: William E. Rudge's Sons, 1940), iii–v.

35 *Franny recalled Beverly being "a redhead":* CA interview 1A.

35 *"They looked astonishingly alike":* Pepper, email interview.

35 *"He encouraged us to learn":* TL, 20.

35 *the Industrial Design department developed:* The department's work was later included in MoMA's *Camouflage for Civilian Defense*, August 12–September 13, 1942.

36 *they were clearly getting inspiration from magazines:* "America's Glamour Center," *Glamour of Hollywood*, April 1939, 34–35.

37 *the stockings were spun from nylon:* Sofi Tanhauser, *Worn: A People's History of Clothing* (New York: Pantheon Books, 2022), 183.

37 *Then there was the Eastman Kodak Building:* "Eastman Fabric Fashions at Fair Shown in Drama of Smooth 'Dissolves,'" *WWD*, May 17, 1939, 14; "New Eastman Rayon Style, Fabric Show Draws Well at Fair," *WWD*, July 24, 1939, 8.

37 *Many of these booths and exhibits:* Coe and Gates, *Snapshot Photograph*, ch. 5, "Colorful Cameras," and ch. 6, "Smaller Cameras and Faster Films"; Gustavson, *Camera*, 181–84; Browniecam website, https://www.browniecam.com/walter-dorwin-teague/.

38 *Then came the concept store:* Walter Dorwin Teague, as told to Charles G. Muller, "Modern Design Needs Modern Merchandising," *Forbes*, February 1, 1932, 14–15, 25.

38 *Teague, who believed good modern design:* Lissa Norcross, "How a Famous Designer Chooses to Live," *Good Housekeeping*, October 1941, 146–48.

38 *Fuffy began sneaking out of class: Dick Cavett Show.*

38 *One of Fuffy's old Choate swains:* C. Thomas Fuller, letter to KA, April 12, 1940.

39 *Later he sent them a limerick:* Hallett Lewis to KA and FMG, May 22, 1940.

39 *In the summer of the twins' junior year:* Otto Sachs, "McLaughlin Twins Bare Souls for *Prattler* and Posterity," *Prattler*, May 8, 1940, 2, Pratt Institute Publications Collection, PIA.

39 *Future subjects would include:* Otto Sachs, "*Prattler* Profiles: Isabelle Suarez," *Prattler*, December 8, 1940; Stephanie Masura, "*Prattler* Profiles: Mieko Fuse," *Prattler*, February 5, 1941; R.Z. and S.M., "*Prattler* Profiles: Maurice Hunter," *Prattler*, January 14, 1941, 2, Pratt Institute Publications Collection, PIA. Hunter, who was famously untalkative, preferring his expressive face and body to communicate for him, spun many tales about his origins, one of which was that he was the son of a Zulu chieftain; that story is recounted in this piece.

41 *The gossip columnist announced spring had sprung:* Doris Flax, "Modern Amazons," *Prattler*, April 18, 1940, 3, Pratt Institute Publications Collection, PIA.

41 *After Wrigley gum launched:* Gail Neṣbitt, "Inspiration, Please," *Prattler*, December 4, 1940, 2, Pratt Institute Publications Collection, PIA.

41 *Their presence at parties was noted:* Homer St. John Jr., "First All-Tech School Dance Great Success; Hotel St. George Roof Scene of Gala Affair," *Prattler*, February 8, 1940, 1–4, Pratt Institute Publications Collection, PIA; "Artsmen Dance with Paletteers," *Prattler*, April 18, 1940, 1, 4. Pratt Institute Publications Collection, PIA.

41 *They also got ink when:* "J & J Awards $500 Prizes to Advertising Students," *Prattler*, February 8, 1940, 1, and "Art School Exhibits Professional Posters," *Prattler*, November 20, 1940, 1, Pratt Institute Publications Collection, PIA.

41 *"typical carnival date":* "Brooklyn Contribution," *Brooklyn Daily Eagle*, January 19, 1941, 29.

41 *The* Prattler *reported that:* "Art Students Win Contest," *Prattler*, February 5, 1941, 1, Pratt Institute Publications Collection, PIA.

41 *Some might have considered it cheating:* TL, 20.

CHAPTER 5 *College Bazaar*

Except as otherwise noted, the description of the evolution of the first college shop comes from Estelle Hamburger's *It's a Woman's Business*. (Although Hamburger's book says it opened in 1929, the store's ads and other sources, as noted below, suggest it opened the following year.)

43 *Youth culture had begun:* Peril, *College Girls*, ch. 2, "New Girl on Campus."

43 *even fewer young women attained:* By 1940, more than half of Americans received only an eighth-grade education, and "only 6 percent of males and 4 percent of females had completed 4 years of college." Thomas D. Snyder, ed., *120 Years of American Education: A Statistical Portrait* (Washington, DC: National Center for Education Statistics, 1993).

44 *Lord & Taylor, New York's oldest and grandest:* Clemente, *Dress Casual*, ch. 1, "In the Public Eye"; "College Shops Braced Again for Fall Rush," *NYT*, August 15, 1960, 26.

44 *By the late 1930s:* "Campus Originals Guild Offers Opportunities," *Radcliffe News*, October 4, 1940; "Guild Offers Opportunity to Student Designers," *Radcliffe News*, November 8, 1940.

45 *The magazine had begun in 1935:* "Street & Smith Giving Up 'Pulps,'" *NYT*, April 9, 1949, 19.

45 *In the fall of 1936:* "Barbara's Beautification," *Time*, October 26, 1936, 39; Barbara Phillips, "Cinderella," *Mademoiselle*, November 1936, 22–24, 56–57, 60–61, 67.

46 *Barbara Phillips, the nurse in question:* Helen Josephy, "Let's Make Up," June 1936, 14–15, 40–41, 60.

46 *The stunt made national news:* "Success in Fashions," *Time*, April 15, 1940, 55–56.

47 *His daughter, in an essay:* Frances Scott Fitzgerald, "A Short Retort," *Mademoiselle*, September 1939, 41.

47 *Pratt's Paletteers, the school's girls' arts group:* "Pratt Paletteers Meet to Introduce Officers," *Prattler*, October 9, 1940, 2, Pratt Institute Publications Collection, PIA.

47 *The talk was covered by:* "Pratt Art Students Hear Fashion Expert," *Brooklyn Daily Eagle*, February 27, 1941, 12; "Paletteers at Banquet," *Prattler*, March 5, 1941, 1, 4, Pratt Institute Publications Collection, PIA.

49 *Inspired by the results of:* "College Girl," *HB*, August 1934, 26–31, 106, 108, 115.

49 *"featured the first 'college fashions'":* Snow with Aswell, *World of Carmel Snow*, ch. 9.

49 *Snow had quickly arranged a sitting:* Ibid., ch. 8.

49 *The project seems to have begun:* I have seen the 1939 through 1942 issues. My understanding of the 1938 issue comes from ads in *Harper's Bazaar*, references to it in *Women's Wear Daily* and other trade publications, and interviews with the twins, where they speak of it as the first youth magazine. For 1940 it's a quarterly; the rest are annuals. In 1943, *College Bazaar* was replaced by *Junior Bazaar*.

50 *the transplanted Californian:* Dahl-Wolfe, *Louise Dahl-Wolfe*, 2–6.

50 *Harper's Bazaar had attempted to find:* *HB*, June 1937, 130 (ad), August 1937, 32a, 123, 125 (winners listed).

50 *"During the darkest weeks of midterm exams":* *CB*, March 1940, 3.

50 *"Dear J'Anne," she wrote:* Margaret Hockaday, letter to J'Anne, Duke University, January 21, 1940, David M. Rubenstein Rare Book & Manuscript Library, Duke University.

51 *Her father, Scott, who would be dead:* Eleanor Lanahan, *Scottie: The Life of Frances Scott Fitzgerald Lanahan Smith* (New York: Harper Collins, 1995), 125.

52 *In January 1940, Caroline visited:* "Editor's Guest Book," *HB*, August 1940, 40.

52 *she appeared on* College Bazaar's *first 1940 masthead:* *CB*, March 1940, 3.

52 *Stanford girls sunning themselves:* "Spring Is the Reason" and "We the Students," *CB*, May 1940, 15, 18.

52 *a portfolio of fashion shots:* "The Cotton Pickers," *HB*, June 1940, 101.

52 *By August, after graduation:* "Editor's Guest Book," *HB*, August 1940, 40.

53 *For the same issue of* Bazaar: "The Refugee Children," *HB*, August 1940, 62–63.

53 *Then Caroline became engaged:* George Dern, formerly the sixth governor of Utah, was a progressive Democrat.

53 *Photography "was something she enjoyed":* George Dern, interview with author, September 25, 2019.

53 *They were among four coeds:* Institute News, February 23, 1940, Pratt Institute Publications Collection, PIA.

53 *"After the editors saw us":* Twin Lenses 3, KA and JA.

53 *Hockaday did publish their first:* Hearst Magazines, purchase order to KA. Memo reads, "2 Fashion photographs for use in November College Bazaar. Price $7."

53 *Someone else at* Bazaar: Nancy Nash, *CB*, letter to KA, December 13, 1940.

53 *on an intensive new modernization campaign:* Zuckerman, *History of Popular Women's*, 103–7.

54 *Here's how* Bazaar *breezily:* "The Editor's Guest Book," *HB*, June 1939, 14.

54 *Fuffy got to wear:* College Bazaar, August 1940, 38.

55 *$5 modeling fees:* Hearst Magazines, two check stubs made out to KA, dated July 5, 1940. Memo reads, "Model fee for College Bazaar, 7-3-40, 1 afternoon, photographer Abbe."

55 *"We just thought he was gorgeous":* Twin Lenses 3, KA and JA.

CHAPTER 6 **Prix de Paris**

Except as otherwise noted, the description of the Prix finalists' visit to *Vogue* head-quarters in New York City is drawn from "*Vogue*'s Prix de Paris," *Vogue*, August 15, 1941, 50, 127, 129. The remains of their Prix de Paris entries, described here, are in the Abbe family archives.

57 *The Prix de Paris was launched:* Chase and Chase, *Always in Vogue*, ch. 19; "The Story of the Prix de Paris," *Vogue*, August 15, 1945, 114–15, 169–71, 176; "*Vogue*'s Prix de Paris."

57 *That October,* Vogue *published a letter:* Chase, "*Vogue*'s Prix de Paris," *Vogue*, October 1, 1935, 81.

58 *the middle-class granddaughter of Quakers:* Chase and Chase, *Always in Vogue*, ch. 3.

58 *referred to in the office as* Frog: Seebohm, *Man Who Was Vogue*, 133. The alternative spelling is "*Frogue*."

58 *small jeweled reproduction:* Chase and Chase, *Always in Vogue*, ch. 19.

58 *an accompanying ad explained:* "Prix de Paris" (ad), *Vogue*, October 1, 1935, 30–31.

58 *a rigorous gauntlet of six quizzes:* Quizzes ran in November and December 1935, and January, February, March, and April 1936.

59 *The only entrance requirement was:* "Prix de Paris" (ad).

59 *there were plenty of takers:* "Prix de Paris," *Vogue*, July 1, 1936, 66–67, 86.

59 *In her first, dated December 7, 1938:* Campbell, memo to Nast, December 7, 1938, CNA.

59 *On January 26, in a two-part memo:* Campbell, memo to Nast, January 26, 1938, CNA.

60 *It was the peg for the lead fashion spread:* "Clothes for the Class of '43," *Vogue*, August 1939, 74–82.

60 *Fuffy remembered spending hours on the Prix:* Twin Lenses 11, KA and Tom Abbe.

61 *The twins did indeed recall:* Ibid.

61 *photographed for a big display ad:* "Seniors! Enroll today in *Vogue*'s 7th Prix de Paris" (ad), *Vogue*, October 15, 1941, 110.

62 *"Since we were at Pratt":* CA interview, October 3, 1996.

63 *They helped install the show* Printed Art: *Printed Art: Pictures & Designs That Work*, Brooklyn Museum, May 29–October 18, 1941.

63 *the* New York Sun *ran a photo of Fuffy:* "Art in Printing," *New York Sun*, May 31, 1941.

63 *the museum included the twins':* 51st Annual Exhibition of Photographs, April 14–May 4, 1941. Only Franny is listed in the museum's records as having participated in the show, but both twins' photographs are marked with stickers showing they were included.

63 *Franny even won a prize: Smart Girl* 2, no. 1 (1945): 11.

63 *"Everybody seemed to welcome us": Twin Lenses* 4, KA and JA; *TL*, 23.

CHAPTER 7 **Making the Right Call**

Except as otherwise noted, Franny's description of her job at Montgomery Ward is drawn from interviews with Casey Allen (1A, September 13, 1996, and October 3, 1996). Fuffy's description of her job at Stone-Wright and how she was hired away by Toni, at the end of the chapter, comes from *Twin Lenses* 3.

67 *one of the largest retailers in the country:* According to the *Encyclopedia of Chicago* website, in 1941 Sears had nearly $1 billion in sales, while Montgomery Ward's sales were $600 million. http://www.encyclopedia.chicagohistory.org/pages/2840 .html and http://www.encyclopedia.chicagohistory.org/pages/2895.html.

67 *Ward's had just moved one of its most valued:* "Harriet Higginson Heads Ward's N.Y. Bureau of Style," *WWD*, November 29, 1940, 39; Croswell Bowen, "The New York Woman Advertising Executive (Margaret Hockaday)," *Madison Avenue*, February 1958, 29–33, 38–39.

68 *their new Rolleiflex cameras:* Tina Fredericks, "Franny: Frances McLaughlin-Gill," *Photography*, October 1960, 30–35. It's not clear whether the Rolleiflex cameras were purchases or gifts.

69 *The more time Margaret spent in the mail order business:* Bowen, "New York Woman."

69 *one of the most notorious union busters:* When Avery refused to cooperate with labor agreements negotiated by the War Labor Board, President Franklin Roosevelt ordered the secretary of war to take over Montgomery Ward. http://www.politico.com/news/stories/1207/7557.html.

70 *Her father had died:* Eleanor Lanahan, *Scottie, the Daughter of . . . : The Life of Frances Scott Fitzgerald Lanahan Smith* (New York: HarperCollins, 1995), 134. The agent, editor, and best friend were Harold Ober, Maxwell Perkins, and Gerald Murphy.

70 *the city's first Bauhausler-designed home:* Geoffrey Goldberg, email to author, November 7, 2022; Oral History of Bertrand Goldberg, interviewed by Betty J. Blum, Chicago Architects Oral History Project, 1992, 76–77, Ernest R. Graham Study Center for Architectural Drawings, Department of Architecture, Art Institute of Chicago.

70 *It was also the first commission for Goldberg:* Oral History of Bertrand Goldberg, 32–35.

70 *Higginson danced to her own drum:* Marcia Winn, "Mr. Field Is at Home to Men and Animals," *Chicago Daily Tribune*, April 17, 1938, 1.

70 *gave Franny the idea that a woman:* Leslie Gill, dau., interview with author, June 22, 2018.

71 *Margaret had graduated: Vassar Quarterly*, July 1, 1930, 199.

71 *a copywriting job in the fashion division:* Ibid., March 1, 1937, 29.

71 *Known as the Women's Editorial Department:* Sutton, *Globalizing Ideal Beauty*, 17, 109.

71 *a Peter Pan–ish figure:* Audrey Michaels, "Frills and Furbelows," *Edmonton Journal*, March 26, 1940.

72 *The photographer Sy Kattelson:* Ann Gibbons, "Saugerties Man a Photographic 'Radical,'" *Daily Freeman*, December 11, 2011.

72 *Namuth had fled his native Essen:* Carolyn Kinder Carr, *Hans Namuth Portraits* (Washington, DC: Smithsonian Institution Press, 1999), xiv–xv, 3–19.

72 *He later described his position:* Oral history interview with Hans Namuth, conducted by Paul Cummings, August 12–September 14, 1971, AAA.

CHAPTER 8 **Fuffy's Lucky Break**

Except as otherwise noted, the description of Toni's childhood, early career, and sojourn in Bermuda, as well as the quotes in these passages, are drawn from her unpublished memoir.

75 *Lee Miller, a* Vogue *model turned photographer:* Becky E. Conekin, *Lee Miller in Fashion* (New York: Monacelli Press, 2013), 83.

75 *Toni had learned to make pictures:* Mitchell, *Recollections*, 102.

75 *This was the worst disaster:* "Film Stalked by Death the Met's Feature," *Washington Post*, June 14, 1931, A4.

76 *Toni was basically shy: Twin Lenses* 3, KA and JA.

78 *"more than they'd ever paid any other photographer":* Edward Steichen, *A Life in Photography* (Garden City, NY: Doubleday, published in collaboration with the Museum of Modern Art, 1963), ch. 7. This figure is often quoted as $35,000, but a memo in the Condé Nast Archive from I. V. Patcévitch to Nast, dated February 27, 1942, lists different figures. It states that Steichen made a $15,000 salary between 1923 and 1927 and thenceforth was paid on a per sitting basis, reaching a peak of $33,200 in 1930.

78 *in 1929* Time *called him:* "Art: Steichen*," *Time*, December 2, 1929, 31–32.

78 *Steichen's studio was indoors:* Sterling Patterson, "Fifty Thousand Children," *Better Homes & Gardens*, July 1938, 13–15, 50–52.

78 *Steichen was also expert at outdoor and location work:* Nicholas Haz, "Steichen," *Camera Craft*, January 1936, 3–13.

79 *Once, after she had lumbered down:* Mitchell, *Recollections*, 103. This story is told elsewhere, in slightly different variations.

80 *Although* Vogue *initially made use:* "Snapping the Snappers," *Vogue*, June 15, 1934, 81.

80 *making "what we believe are the first":* "Underwater Fashions in Marineland," *Vogue*, January 1, 1939, 32–37, 85.

80 *Toni one-upped herself by photographing:* "Beauty and the Elements . . . Sun, Wind, and Water," *Vogue*, May 15, 1941, 34–41.

80 *a figure whose "corn yellow hair":* Michael Talbott, "Toni Frissell—Outdoor Specialist," PP, October 1939, 32–33, 108. If she was blond, it may have been from a bottle, for her other photos suggest she was brunette.

80 U.S. Camera, *not to be outdone:* Frank Crowninshield, "American Aces: Toni Frissell," *U.S. Camera*, December 1939, 38–42.

81 *Its pages covered the history of American photography:* Frank Crowninshield, "Vogue . . . Pioneer in Photography," *Vogue*, June 15, 1941, 27–31, 72–73.

81 *Also in that issue was a contest:* "Studio versus Outdoor Snapshot," *Vogue*, June 15, 1951, 42–43.

81 *his growing conviction, based on his discussions:* Seebohm, *Man Who Was Vogue*, 242.

81 *"It was a lucky break for me":* Twin Lenses 3, KA and JA.

81 *On top of that, her new office:* TL, 57.

82 *By that time, Beaton had been forced to resign:* Seebohm, *Man Who Was Vogue*, 209–15; Ronald, *Condé Nast*, 312–16.

82 *"two wonderful models":* Twin Lenses 3, KA and JA.

CHAPTER 9 **The Women's War**

Except as otherwise noted, the description of Toni's house, Sherrewogue, and her departure for Britain to volunteer with the Red Cross are drawn from her unpublished memoir.

85 *"a radio announcer hurriedly broke into the transmission":* Martin Kals, "How Americans First Learned of Pearl Harbor," filmed December 7, 2011, in the William G. McGowan Theater of the National Archives, Washington, DC, in partnership with the Newseum, 9:50, https://www.c-span.org/video/?303099-1/americans-learned-pearl-harbor.

85 *But now, families gathered around radios:* "Talk of the Town," *New Yorker*, December 13, 1941, 19; William K. Klingaman, *The Darkest Year* (New York: St. Martin's Press, 2019), 44. My understanding of these events was also enhanced by discussions with two family friends, Bernard Arfin, who attended the Giants–Dodgers game, and Floyd Asnes, who was out walking with his uncle when he heard the news.

86 *Men had already been lining up:* "'Fighting Mad,' Thousands Try to Join Forces," *NYHT*, December 9, 1941, 16.

86 *The women of New York City leapt into the fray:* "Women in Rush to Aid in Crisis," *NYT*, December 9, 1941, 43.

86 *six thousand women swarmed the Red Cross headquarters:* "N.Y. Red Cross Volunteers Set All-Time Mark," *NYHT*, December 11, 1941, 22.

86 *They were also inquiring about aviation lessons:* "War Work Plans Made for Women," *NYT*, December 12, 1941, 33.

86 *Advisories went out:* "Volunteer List Grows," *NYT*, December 10, 1941, 33; "Barnard Students Urged Not to Volunteer Hastily," *NYHT*, December 10, 1941, 21.

87 *"We knew everybody":* Mitchell interview 1, November 29, 1976.

87 *When Toni finally returned:* TF, letter to Agha, March 6, 1942, CNA. According to this letter, Toni returned from Bermuda on December 18.

87 *"Toni trusted me with responsible tasks":* TL, 57.

88 *the streets of this "virile neighborhood":* Works Progress Administration, *New York City Guide* (New York: Random House, 1939), 64.

88 *only a block away, a new crowd gathered:* "Recruiting at Peak for Armed Forces," *NYT*, December 16, 1941, 31; "'Fighting Mad,'" *NYHT*; "Red Cross Feeds Service Recruits," *NYT*, December 19, 1941, 12.

88 *"The atmosphere in the* Vogue *office":* Ballard, *In My Fashion*, ch. 12, "Living in Fashion in New York."

88 *Margaret Bourke-White's hair-raising experiences:* "The Idle Hour" and Margaret Bourke-White, "I Saw the Moscow Blitz," *Vogue*, February 15, 1942, 56, 62–63, 89-90.

89 *Toni's lighthearted Bermuda pictures:* "Bermuda Takes a Night Off . . . ," *Vogue*, February 15, 1942, 54–55.

89 *Nast wasn't pleased:* Nast, memo to Agha, February 10, 1942, CNA.

89 *Red Cross's new uniform, which had just been revamped:* "The New Red Cross Uniform—Elizabeth Hawes," *HB*, April 1941, 83.

89 *a letter from one of her society friends:* Grace Eustis, letter to TF, December 13, 1941, box 15, folder 6, TF Papers, Manuscript Division, Library of Congress, Washington, DC.

90 *Nast had had a soft spot for her:* "Life in Newport," TF memoir, 61.

90 *"I think it will also help my fashion work":* TF, letter to Nast, January 27, 1942, CNA.

90 *"She was dying to get into the war zone":* Twin Lenses 5A, KA and JA.

90 *He had built it for his sister and her husband:* Maggie Blanck, "St. James, Long Island," *Maggie Blanck* (blog), http://www.maggieblanck.com/StJames /StJames.html; Zach Lemie, "Sherrewogue," December 1, 2009, *Old Long Island* (blog), http://www.oldlongisland.com/2009/12/sherrewogue.html.

91 *likely made with one of Toni's spare minicameras:* Mitchell interview with TF, December 8–9, 1977, transcript, 19.

91 *Toni's tips on how to photograph children:* "To Photograph Children: Toni Frissell Advises an Unposed Subject and a Speed Camera," *Vogue*, June 15, 1941, 58–59.

91 *It was heavily promoted:* "Coming Next—*Vogue*'s Camera Issue," *Vogue*, June 1, 1941, 100.

91 *Making sure her boss stayed organized:* Twin Lenses 3, KA and JA.

92 *she once wrote that she liked to photograph:* "Toni Frissell—photographer" (undated biographical sketch), box 9, folder 17, TF Papers, Manuscript Division, Library of Congress, Washington, DC.

92 *she said she'd enjoyed photographing Fuffy:* Mitchell interview with TF, December 8–9, 1977, transcript, 13.

92 *In Ward's spring-and-summer 1942 catalog: Montgomery Ward Spring and Summer 1942—Chicago* (Chicago: Montgomery Ward, 1942), 47–48.

92 *The more Toni agitated to get to Europe:* Mitchell interview 1, November 29, 1976; *Twin Lenses* 3, KA and JA.

93 *she gave Fuffy a lot:* Twin Lenses 5A, KA and JA.

93 *She may have freelanced, without a byline:* There is no clear evidence that any Condé Nast magazine ever ran work under any of Fuffy's bylines in the 1940s. But a November 27, 1944, profile of the twins in the *Prattler* ("Developing Duet, the McLaughlin Twins") says she was "doing loads of work for *Glamour*." Although the writer may have gotten the twins confused, Franny's bio

in *Glamour*, which had appeared the year before, in December 1943, mentions that models find it confusing to be photographed "in two different places by what looks like the same girl." And Fuffy's friendship with Jane Troxler, a *Glamour* fashion editor, was instrumental in Fuffy's later freelance career.

93 *"My ways of handling people"*: Mitchell interview 1, November 29, 1976; *Twin Lenses* 5A, KA and JA.

94 *"I never lost my interest"*: ICP lecture.

CHAPTER 10 **Civil Service**

Except as otherwise noted, the description of Mayor La Guardia's first speech to the Fashion Group, on March 21, 1940, was taken from "Mayor Urges Dress Men to Give Designers a Break," *WWD*, March 21, 1940, 6, 10, as well as the transcript of his speech in the FGI Records: Mayor Fiorello H. La Guardia, speech at Fashion Group lunch, March 20, 1940, Biltmore Hotel, New York, NY. (The Fashion Group changed its name to the Fashion Group International, Inc., in 1988.)

95 *A week to the day after the attack on Pearl Harbor:* Virginia Pope, "Civilian Defense Uniforms," *NYT*, December 14, 1941, D3.

97 *Anna Rosenberg, director of the regional Social Security Board:* Rosenberg was also the first woman to win the National Medal for Merit.

98 *the occasion "gave American dressmakers":* Margaret Case Harriman, "Very Terrific, Very Divine," *New Yorker*, October 19, 1940, 28.

98 *the advertising consultant Mary Lewis:* Mary Lewis, speech at Fashion Group lunch, July 11, 1940, Biltmore Hotel, New York, NY, FGI Records.

99 *who had recently popularized shocking pink:* Diana Vreeland and Stella Blum, *The 10s, the 20s, the 30s: Inventive Clothes, 1909–1939* (New York: Metropolitan Museum, 1973), 17.

99 *Rockefeller Center's new and richly stocked Museum of Costume Art:* The Museum of Costume Art merged with the Metropolitan Museum of Art in 1946; it became the Costume Institute some years later.

99 *Efforts to that end were already underway:* Sally Kirkland, "McCardell," ch. 3 in *American Fashion*, ed. Lee; Sally Kirkland, "Sportswear for Everywhere," in *All-American*, ed. Fashion Institute of Technology; Martin, *American Ingenuity*, 14.

100 *For years Shaver had predicted:* "Finds Style Centre Here," *NYT*, April 14, 1932, 18.

100 *first prizes going to:* Ironically, following French couture tradition, Clare Potter often used the name Clarepotter on her labels. Harriman, "Very Terrific," 28–32, 35–36.

100 *they had entered Pratt looking "strictly Peck & Peck":* FMG and KA, notes for *Twin Lenses* film, unpublished.

100 *Many were working with a publicist:* A year later, Lambert organized the first New York Fashion Week.

100 *Bonwit Teller, which had anticipated:* "Psychologically, 'The New York Look,'" *WWD*, June 20, 1940, 6.

100 *the* New York Times *proclaimed the shows:* Virginia Pope, "True U.S. Couture Emerges in Shows," *NYT*, September 4, 1940, 25.

100 *"For the first time, the fashion centre":* Edna Wollman Chase, "*Vogue*'s-Eye View of the American Fashion Openings," *Vogue*, September 1, 1940, 41; "7th Avenue," *HB*, September 1, 1940, 42–43.

101 *At one press conference he announced:* Winifred J. Ovitte, "La Guardia Explains Role as Patron of N.Y. Fashions," *WWD*, August 22, 1940, 1, 36.

101 *He made headlines:* "Mayor, Notables Lend Dignity to Store's Showing," *WWD*, September 6, 1940, 1, 36.

101 *The September before Pearl Harbor:* "Uniforms for Civilian Defense in Exposition," *WWD*, September 22, 1941, 3; "Attire for Home Defense Agencies Among Exhibits at Show in N.Y.," *WWD*, September 22, 1941, 4.

101 *Although the mayor's new uniforms:* Mayor Fiorello H. La Guardia, speech at Fashion Guild lunch, September 25, 1941, Hotel Astor, New York, NY, FGI Records.

102 *by the spring of 1942:* Strassel, "Redressing Women," 175.

102 *Franny's boss, Margaret, and her sidekick:* This story and Franny's quotes come from CA interview 1A, September 13, 1996, and CA interview, October 3, 1996.

CHAPTER 11 **Jimmy**

Except as otherwise noted, the story of Franny's meeting with Jimmy is drawn from CA interview 1A, September 13, 1996.

107 *According to the London design magazine:* George Herrick, "Alexey Brodovitch," *Art and Industry,* November 1940, 16–69.

107 *He wasn't at all snobby about his clients:* Andy Grundberg, interview with author, January 23, 2020.

107 *By 1942, mail order catalogs:* "Harry S. Conover, 53, Is Dead; Ran Model Agency 20 Years," *NYT*, 68; Conover, *Cover Girls*, 45.

108 Ladies' Home Journal *cover of Vivien Leigh: LHJ*, September 1940.

108 *a patriotic series: LHJ*, September 1941 (nurse), September 1942 (WAVE), October 1942 (WAAC). The WAACs became the WACs, or the Women's Army Corps, in 1943, when it became an official army unit.

108 *Jimmy's true ambition:* "Memo from the Editor: Contributors," *Mademoiselle,* July 1939, 5.

108 *Dusty Anderson, a corn-fed Ohio brunette:* "Dusty Anderson, Wed a Month, Is Back at a Busy Model's Life," *NYHT*, August 18, 1941, 7.

109 *the Henry Halper drugstore:* Mary Cantwell, *Manhattan When I Was Young* (New York: Houghton Mifflin, 1995), 21; "Best Bets: Goodbye to All That," *New York*, June 10, 1974, 69.

110 *"I was delighted with this chance": Twin Lenses* 3, KA and JA.

110 *A successful small-town photographer:* Pepper, *Limelight*, 11, 14; Mary Blume, "A Photographer Back in the Limelight," *International Herald Tribune*, February 24, 1996, page unknown.

111 *In 1920, drawn by the fledgling movie business:* David S. Shields, "James Abbe," "Broadway Photographs," https://broadway.library.sc.edu/content/james-abbe .html.

111 *In 1922, the movie star Lillian Gish:* "Die Kino-Königin," *Vanity Fair*, November 1924, 58, 82.

111 *"Little did they know":* Pepper, *Limelight*, 22.

111 *While abroad, Papa Abbe:* Ibid., "The Roaring Twenties."

112 *After small, fast minicameras came on the market:* Ibid., "The 'Tramp' Photographer."

112 *"I became a photographer":* "A Pearl of Great Price in Oyster Bay," *Avenue*, October 1992, 122–25.

112 *where for a time he assisted:* Chris Karitevlis to author, January 2022; *Twin Lenses* 4, KA and JA.

112 *Man Ray, whom he had known:* Papa Abbe and Man Ray had studios on the same street. Pepper, *Limelight*, 25; https://www.npg.org.uk/collections/search /person/mp53163/james-abbe.

112 *to New York:* Man Ray, *Self Portrait* (Boston: Little, Brown / Atlantic Monthly Press, 1963), 256–57.

113 *Perhaps that's why: Twin Lenses* 4, KA and JA.

113 *Early in his* Bazaar *career:* Frederic Drake, letter to JA, June 15, 1936; JA, letter to Frederic Drake, April 17, 1936; and Papa Abbe to JA, April 14, 1936, Local History Archives of the Jericho Public Library, Jericho, NY.

113 *The 1936 book:* Paul Vitello, "Patience Abbe, Chronicler of Her Childhood Travels, Dies at 87," *NYT*, March 31, 2012, A24.

114 *He fell for screenwriter Ben Hecht's:* JA III and Lucinda Abbe, interview with author, May 30, 2019. According to Jamie, the actress who rejected him was Edwina "Teddy" Hecht, the daughter of Ben Hecht, the author of *The Front Page*.

114 *"Well sir, it sure does me good":* Papa Abbe to JA, June 19, 1939.

114 *"SHE wants babies, and by me":* Papa Abbe to Phyllis Kennedy, July 26, 1939.

114 *No surprise that Jimmy:* Appointment card for JA with a Dr. Hill, Payne Whitney Psychiatric Clinic, January 23, likely 1936, Local History Archives of the Jericho Public Library, Jericho, NY.

115 *"JAMIES CONDITION SPLENDID":* Frankie Abbe to JA, undated telegram, Local History Archives of the Jericho Public Library, Jericho, NY.

115 *The boys they'd kept company with:* CA interview 1A.

CHAPTER 12 **Living the Photographer's Life**

117 *"It was really opening a whole new door": Twin Lenses* 4, KA and JA.

117 *When the twins met Jimmy:* Mitchell interview 1, November 29, 1976; *Twin Lenses* 13, KA and FMG.

117 *Both were refugees from Paris:* Seidner, "Lisa Fonssagrives-Penn," *Bomb* 12 (Spring 1985), https://bombmagazine.org/articles/lisa-fonssagrives-penn/.

117 *A mutual photographer friend:* CA interview 1A, September 13, 1996.

117 *For a while Jimmy had bunked:* Eli Abbe, interview with author, August 2, 2018; Tom Abbe, interview with author, March 21, 2021.

118 *but now he moved in:* The twins mention in various interviews Jimmy living with the Fonssagriveses when they first met him: CA interview 1A; Mitchell interview 1. Penelope Rowlands recalls Fuffy mentioning it in her interview for *A Dash of Daring.*

118 *Franny also recalled that:* CA interview 1A; *Twin Lenses* 4, KA and JA.

118 *"That's how we all became friends":* CA interview 1A.

118 *Fuffy marveled at the way Lisa's skiwear:* Chris Karitevlis, interview with author, 2021.

118 *They had met and married in Paris:* There are several variations of this story, some of which slightly contradict one another, even when they appear in the same book, as in the two essays in *Lisa Fonssagrives: Three Decades of Classic Fashion Photography.* I have largely followed the story recounted in Seidner's interview with Lisa Fonssagrives in *Bomb* 12 (Spring 1985), in which she herself recounts the story.

119 *His photos found a home among the growing market:* Muir, *Fernand Fonssagrives,* 8.

119 *he was also technically adroit:* Sean Moorman, interview with author, March 18, 2021.

119 *Lisa was exceptionally creative: Twin Lenses* 13, KA and FMG.

119 *The first photograph:* "Le Portfolio de *Vogue,*" French *Vogue,* May 1939; "Evening Fashions," *HB,* September 15, 1939, 72–73.

119 *Lisa hadn't been afraid:* Seidner, "Lisa Fonssagrives-Penn."

120 *He had distracted the policeman:* Blumenfeld, *Eye to I,* ch. 58, "My Most Handsome Model."

120 *Le Vernet, the foul, stinking concentration camp:* Ibid., ch. 61, "Le Vernet d'Ariège"; Yvette Blumenfeld Georges Deeton, interview with author, January 20, 2020.

120 *he was saved once again:* Blumenfeld, *Eye to I,* ch. 64, "How to Get Your American Visa."

120 *the photographer and his family sailed into Brooklyn Harbor:* Blumenfeld Georges Deeton, interview.

121 *The next morning:* Blumenfeld, *Eye to I,* ch. 65, "The Mont Viso."

121 *Top-notch illustrators such as:* Prohaska, *White Fence,* 134.

122 *"He was pristine in his approach":* Mitchell interview 1.

122 *When he needed to be:* Chris Karitevlis, interview with author, November 30, 2020.

122 *"I can't tell you how pleased":* Wilhela Cushman, letter to JA, December 1, 1939.

122 *On that trip, he'd been required: Twin Lenses* 4, KA and JA; *Twin Lenses* 8, KA and JA.

122 *"How America Lives" column:* "How America Lives," *LHJ,* February 1940, 47.

123 *The stories were handled by separate teams:* "Lensman Likes 'Em Pretty; They're Easier to Picture," *Oregonian,* June 20, 1942.

123 *After another quick trip to Hollywood:* "No Time Wasted," *Daily Notes* (Canonsburg, PA), September 11, 1942, 5; "New York Pair Fly Here for Star's Photo," *Los Angeles Times,* February 18, 1943, A9; "N.Y. to L.A. / L.A. to N.Y.," *Variety,* July 1942, 4.

123 *Even New York City's ever-present:* Goldstein, *Helluva Town*, 183–86.

124 *"It was a magical moment":* KA, interview with Adrienne Collins, August 21, 2003, Montauk Library Oral History Program. Courtesy of the Montauk Library, Montauk, NY.

124 *a shingled cottage called Second House:* Rattray, *Story of Second House.*

124 *since its beginnings, Fuffy said:* Ibid.

124 *a wealthy New York clan:* Irene Silverman, "The *Star* Talks To: A Woman of Many Parts," *East Hampton Star*, August 2, 1979.

125 *Fuffy was "dazzled by the array":* KA, handwritten notes in preparation for an interview, reminiscence from summer of 1942, undated.

126 *he got shirts and jackets:* Twin Lenses 3, KA and JA.

127 *A picture of them:* "Kennel Annals," *Town & Country*, October 1942, 98–99.

CHAPTER 13 **Love in Wartime**

Except as otherwise noted, the material about George Davis's salon at 7 Middagh Street in Brooklyn Heights is drawn from Sherill Tippins's *February House*, particularly chapters 3, 7, and the introduction.

129 *They were giving her a hefty percentage:* In June 1957, Franny wrote to Fuffy that her first check, dated October 19, 1942, had been made out to Kitty, for $20, "at the rate of $40 per month when I was earning $30 and $35 per week & you must have done even more in your Frissell money-earning days. Really something when you think of it."

129 *editors liked to send photographers West:* Twin Lenses 3, KA and JA.

129 *a letter filled with "good advice":* KA, letter to JA, February 13, 1943.

129 *Birth control, while not always easy:* Margaret Sanger, "The Status of Birth Control," *New Republic*, April 20, 1938, https://newrepublic.com/article/100850/the-status-birth-control-1938.

130 *"overstepped the conventions":* Dorothy Dunbar Bromley, "Chastity vs. Chivalry," *Redbook*, February 1938, 58–60, 63–64.

130 *In a* Ladies' Home Journal *survey:* Henry F. Pringle, "What Do the Women of America Think about Morals?," *LHJ*, May 1938, 14–15, 49, 51–52.

130 *Mademoiselle's advice columnist:* Dorothy Dayton, "The Facts of Life," *Mademoiselle*, March 1938, 58, 67.

131 *the FBI reported that even teenage girls:* Roger Butterfield, "Our Kids Are in Trouble," *Life*, December 30, 1943, 96–98, 100–102, 105–6, 108.

131 *How did one know if it was really love:* Gretta Palmer, "The ABCs of Love in War," *Cosmopolitan*, April 1942, 35.

131 *the British philosopher and mathematician Bertrand Russell:* Bertrand Russell, "If You Fall in Love with a Married Man," *Glamour*, April 1943, 68, 94, 99–100.

131 *Asked later why he had written it:* Edward Skidelsky, "The Impossibility of Love," *New Statesman*, October 9, 2000.

131 *a popular, titillating, endlessly controversial figure:* "Bertrand Russell Rides Out Collegiate Cyclone," *Life*, April 1, 1940, 23–27.

131 *"War more than anything else":* Russell, "If You Fall in Love."

132 *Although Russell had been divorced:* "Russell Rides Out."

132 *acted as an editorial assistant:* Lowry and Reidel, "Last Stand," xvii.

133 *Jamie recalled his father, Jimmy:* JA III and Lucinda Abbe, interview with author, May 30, 2019.

133 *In some of these missives, they called Jimmy "Daddy":* KA to JA, letter, February 16, 1943; FMG, letter to JA, undated.

133 *Mary Lee "is in California":* KA and FMG, letter to JA, February 3, 1943.

133 *For Valentine's Day the twins collaborated:* FMG and KA, Saint Valentine's Day card to JA, February 2, 1943.

134 *The next day, they sent a joint letter:* FMG and KA, letter to JA, February 3, 1943.

134 *In another joint letter:* FMG and KA, letter to JA, February 9, 1943.

135 *Dr. Agha, the company's longtime art director:* KA, letter to JA, February 13, 1943.

135 *"I guess there's not much use":* FMG, letter to JA, February 1943, undated.

135 *"We are making beautiful Abbé prints":* KA, letter to JA, February 13, 1943.

136 *As the twins had explained to Jimmy:* KA and FMG, postcard to JA, ca. early 1943, undated.

CHAPTER 14 **Leslie**

137 *"Nothing transpired that was anything":* CA interview 1A, September 13, 1996.

137 *"S.L. Gill is fretting mighty plenty":* FMG and KA, letter to JA, February 3, 1943. Leslie's full name was Samuel Leslie.

137 *When Jimmy didn't return in time:* FMG, letter to JA, February 15, 1943; FMG, letter to JA, "Thursday," ca. February 1943.

138 *She also sent Jimmy a poem:* FMG, letter to JA, ca. February 1943.

138 *was swiftly "discovered":* Mary Faulconer's three-page memoir of Brodovitch's early Design Laboratory, which she taught in 1937–38, Mary Faulconer Papers, Cary Graphic Arts Collection, Rochester Institute of Technology; Leslie Gill, dau., interview with author, June 22, 2018.

138 *"His great eye for the beautiful elements":* Irving Penn, Alexey Brodovitch, and unnamed editor, "Leslie Gill: Artist Pioneer," *Applied Photography* (Eastman Kodak) 11 (1958): 1–5.

138 *Leslie had created* Bazaar's *first cover photograph: HB,* December 1935, cover.

138 *including a spread for the beauty column:* "The Cosmetic Urge," *HB,* November 1935, 88–89.

138 *Leslie swiftly abandoned the photogram:* FMG, "Leslie Gill: His Role as an Innovator and Experimenter in Photography," 1971, biography supplied to George Eastman House, Buffalo, NY.

139 *Perfume bottles would sprout:* "The Osmic Urge," *HB,* October 1937, 96–97; "A Worldly Wrist and a Worldly Foot," *HB,* January 1938, 61.

139 *Leslie was said to have come up with:* FMG, "Leslie Gill."

139 *Using this technique:* Carmel Snow, "The Editor's Guest Book," *HB,* September 1, 1939, 32; Virginia Woolf, "The Duchess and the Jeweller," *HB,* May 1938, 74–75; Elizabeth Bowen, "Joining Charles," *HB,* September 1, 1939, 90–91; Mary McCarthy, "Ghostly Father, I Confess," *HB,* April 1942, 52–53.

139 *Born in 1908, in Cumberland, Rhode Island:* FMG, "Leslie Gill"; Lucinda O'Neill, interview with author, September 25, 2020. Both Perelman and West graduated from Brown before Leslie arrived at the school, but Franny says they were "school chums," suggesting he may have known them earlier.

140 *by 1935 he had opened his own studio:* Pamela Thomas, "The Ultimate Material Witness," *American Photographer*, December 1980, 68.

140 *But she and Fuffy would likely:* Peter Kalischer, "Career Wife," *Glamour of Hollywood*, November 1940, 26–28.

140 *a butler:* Carol O'Neill, interview with author, March 4, 2019.

140 *featured in the* U.S. Camera's *annual:* LG, "Wagon Wheels," in *U.S. Camera Annual*, ed. T. J. Maloney (New York: William Morrow, 1935), 62.

141 *becoming known as an experimentalist:* "Rouben Samberg Experiments," *PP*, June 1945, 42–43, 103.

141 *Leslie had been one of the first:* FMG, "Leslie Gill"; Thomas, "Ultimate Material Witness," 75; Miki Denhof, *The Photographic Eye: 4 Points of View*, brochure for show at Guild Hall, East Hampton, NY, September 15–October 7, 1973; Dorry Rowedder Adkins, email to Leslie Gill, dau., August 17, 2014. Denhof writes, "Leslie Gill, Anton Bruehl and Edward Steichen were the three photographers to whom Eastman Kodak sent the first sheets of 8 x 10 Kodachrome color transparency film in 1939." Thomas notes that Paul Outerbridge was part of the group that Kodak selected to experiment with the film; the story also names a photographer called Breuer, likely a typo of *Bruehl*. Adkins mentions receiving Kodachrome eight-by-ten film from Kodak while she worked for LG.

141 *Bruehl, Condé Nast's early 1930s color specialist:* Bussard and Hostetler, *Color Rush*, 58; Seebohm, *Man Who Was Vogue*, 254–57. Kodachrome was introduced in stages, first as 16 mm film for motion pictures and 8 mm for home movies in 1935, then as 35 mm slide film in 1936, and later as sheet film.

141 *Later Leslie became an early adopter:* Thomas, "Ultimate Material Witness," 75.

141 *But things changed in 1937:* "Gill Photographs," *Philadelphia Inquirer*, March 13, 1960.

141 *Pennsylvania Museum and School of Industrial Art:* The school is now part of Philadelphia's University of the Arts.

141 *helped teach the class:* Biography, Mary Faulconer Papers, Cary Graphic Arts Collection, Rochester Institute of Technology, https://archivesspace.rit.edu /repositories/3/resources/1032.

141 *Brodovitch had "arranged for an exhibition":* Faulconer, memoir of Brodovitch's early Design Lab.

142 *She had worked with him:* Rowlands, *Dash of Daring*, ch. 7, "Assembling the Team," and ch. 10, "*Bazaar* Ascendant."

142 *"Because Brodovitch could direct and control":* Faulconer, memoir of Brodovitch's early Design Lab. Irving Penn spoke of LG's influence, too, in "Leslie Gill: His Work and His Influence," *Modern Photography*, January 1959, 83, and "Leslie Gill: Artist Pioneer," *Applied Photography*," November 1958, 1–5, among other sources.

142 *an unpaid position:* Hambourg and Rosenheim, *Irving Penn*, 13.

142 *Brodovitch continued to use:* Freeman and McLaughlin-Gill, *Leslie Gill*, 9.

142 *having younger talents at* Bazaar: Faulconer, memoir of Brodovitch's early Design Lab.

142 *It had begun with the shared goal:* Kalischer, "Career Wife," 26–28.

143 *one argument, at the Cotton Club:* Dilys Wall, undated diary entry.

143 *"To know him was to love him":* Dorry Adkins, email to Leslie Gill, dau., August 17, 2014.

143 *Leslie was often quiet and reserved:* Eliza Werner, interview with author, April 16, 2019.

143 *Yet he could also be a prankster: Twin Lenses* 6, FMG; JA III and Lucinda Abbe, interview with author, May 30, 2019.

144 *Despite his "quiet smile":* Scrapbook cutting from the Moses Brown School yearbook.

144 *And while Leslie could be:* Carol O'Neill, interviews with author, July 31, 2018, and March 4, 2019.

144 *Dilys, on the other hand:* Carol O'Neill, interview with author, March 4, 2019.

144 *She kept long lists:* Lucinda O'Neill, interview with author, January 26, 2019.

144 *Dilys also "had a terrible rep":* Dorry Adkins, email to Leslie Gill, dau., June 25, 2015.

144 *On one occasion:* Carol O'Neill, interviews.

144 *"Leslie seemed to know what was coming":* FMG, "Leslie Gill."

145 "Always, always *carry the camera":* "What They Do," *Condé Nast Ink* 12 (November 1948): 16. Courtesy Robin Muir.

145 *"He worked very quickly":* FMG, "Leslie Gill."

145 *By now Leslie had moved his family:* Carol O'Neill, interviews.

145 *had relocated his studio to the same building:* Freeman and McLaughlin-Gill, *Leslie Gill,* 57.

145 *the heart of Manhattan's antique district:* Jennifer Carlquist, "The Antiquarian Career of J. A. Hyde," MA diss., Cooper-Hewitt and Parsons, 2010. The district was clustered in the upper Fifties between Third and Fifth Avenues.

145 *He rarely returned home, she recalled later:* Thomas, "Ultimate Material Witness," 69.

146 *"I heard that's how it happened":* Eliza Werner, interview with author, April 16, 2019.

146 *Carol, Leslie's elder daughter:* Carol O'Neill, interview with author, July 31, 2018.

146 *But what must have given Dilys pause:* Lucinda O'Neill, interviews with author, January 26, 2019, and September 25, 2020; Carol O'Neill, interviews; Eli Abbe and Jessica Arner, interview with author, November 2017; Bliss Carnochan, "The *Girl in Red* (and Me)," in "Shop Talk: Folk Tales, Favorite Finds," compiled by Elizabeth Pochoda, *Magazine Antiques,* August 17, 2020, https://www .themagazineantiques.com/article/folk-tales-favorite-finds/; David R. Allaway, *My People: The Works of Ammi Phillips,* vol. 1 (catalog) (self-published), 263, https://issuu.com/n2xb/docs/ammi__phillips__-__abstract___thumbnail; memo from Ann Wren to Stacy Hollander, May 1, 1994, Object File *Girl in Red with Cat and Dog,* 2001.37.1, American Folk Art Museum, NY. A memo in the files of New York's Museum of American Folk Art, which owns the painting today, says it was purchased by Leslie. Bliss Carnochan, the collector

who bought the painting from Franny, said in a 2020 story that he was told she was the buyer (although Eli Abbe and his wife, Jessica Arner, who were there for the initial discussion between Carnochan and Jimmy Abbe, don't remember it that way). David R. Allaway's self-published *My People: The Works of Ammi Phillips*, vol. 1, also lists Franny as the sole owner between Lyon and Carnochan. Lucinda O'Neill, Leslie and Dilys's granddaughter, says it was assumed within her family that Franny had some involvement in the purchase of the painting because she later used a check to prove she owned it.

146 *Later "there was some talk":* Carol O'Neill, interview with author, March 4, 2019.

147 *Eliza said later that:* Werner, interview.

CHAPTER 15 **Franny's Lucky Break**

Except as otherwise noted, the story of Franny's interview with Liberman is largely drawn from CA interview 1A, September 13, 1996, as are her quotes, although she also recounted similar versions of this story to others.

149 *"I became so frustrated with fashions":* "Toni Frissell," in "Women Come to the Front," online supplement to *Women Come to the Front: Journalists, Photographers, and Broadcasters During WWII*, September 28–November 18, 1995, Library of Congress, Washington, DC, https://www.loc.gov/exhibits/wcf /wcf0008.html.

149 *Toni's two-year contract:* L. Philips, memo to Agha, May 14, 1942, CNA.

149 *"If all the young men in the studio":* Agha, memo to Nast, May 6, 1942, CNA.

150 *But Toni, still eager to move:* TF, letter to Agha, May 7, 1942; Agha, memos to Nast, May 11, 1942; May 27, 1942; June 18, 1942; and July 8, 1942, CNA.

150 *"For a year and a half":* Chase and Chase, *Always in Vogue*, ch. 25.

150 *"They are marvelous. Never saw better!":* Gertrude Sanford Legendre, letter to Sidney Legendre, December 22, 1942, Lowcountry Digital Library, College of Charleston Libraries, Charleston, SC, https://lcdl.library.cofc.edu/lcdl /catalog/lcdl:68779?tify=.

151 *Legendre had her wish:* Peter Finn, "The Legend of Gertie," *Washington Post Magazine*, September 29, 2019, 20–27.

151 Vogue *published Toni's story:* Toni Frissell, "I Went to England for the American Red Cross," *Vogue*, February 1943, 46–51.

151 *One, of white-robed choirboys:* Toni Frissell, "Picture of the Week," *Life*, December 28, 1942, 15–16.

151 Bazaar *published a picture:* "I Have a Broken Wing," *HB*, March 1943, 105.

151 *Toni became the official photographer:* Toni's Red Cross project had come about through her friendship with the WAACs' commander, Oveta Culp Hobby. "Colonel Ovita [*sic*] Culp Hobby" and "Trip to England—Red Cross," TF memoir, 599–600, 602–3.

151 *Her photographs of these troops:* Sally Kirkland, "The WAACs Take Over," *Vogue*, July 1, 1943, 18–21, 68.

152 *"Do you mind if I don't send you?":* Twin Lenses 3, KA and JA.

153 *She did remember him liking a picture:* "What They Do," *Condé Nast Ink* 12 (1948): 16. Courtesy Robin Muir.

153 *Eventually he looked up and said:* CA interview 1A; Mitchell interview 1, November 29, 1976; "Frances McLaughlin," box 14, folder 12, Kazanjian and Tomkins, AAA.

153 *"I certainly snapped it up":* "Frances McLaughlin," Kazanjian and Tomkins, AAA.

153 *"I think he was a little bit hurt":* Mitchell interview 1.

153 *One new hire had joined the studio:* Ibid.; CA interview 1A.

153 *who until that time had been working for Liberman:* Kazanjian and Tomkins, *Alex*, 139.

154 *Later, Fuffy liked to tell the story:* Twin Lenses 3, KA and JA.

CHAPTER 16 **The Inner Sanctum**

157 *one of the most essential cogs:* "The Studio," *Smart Girl* 1 (March 1945): 6–7. Unless otherwise noted, the description of the studio comes from this story and from Frank Crowninshield, "*Vogue* . . . Pioneer in Modern Photography," *Vogue*, June 15, 1941, 27–30, 72–73.

158 *the socialite Mrs. Vincent Astor:* "People Are Talking About," *Vogue*, October 15, 1944, 114–15.

158 *Each photographer had a separate studio:* CA interview 1A, September 13, 1996.

158 *all the magazines had their own stages:* Robert Freson, interview with author, August 20, 2019.

158 *Mallison, the studio manager:* "Behind the Issue," *Glamour*, January 1944, 31.

158 *More photographers were:* Gilbert, *Illustrated Worldwide Who's Who*, 79–80.

158 *The color specialists Anton Bruehl:* Christopher Phillips, "Edward Steichen and WWII Naval Photography," MFA diss., Rochester Institute of Technology, 1981, 67.

159 *It teemed with teenage boys:* "Army Opens Biggest Induction Center in U.S.," *Life*, November 16, 1942, 51–52, 54, 56, 58.

159 *On the eighth floor, however:* Mitchell interview 1, November 29, 1976.

159 *For the most part, the stable:* CA interview 1A.

159 *worked for a time at British* Vogue: "Behind the Issue," *Glamour*, September 1941, 39.

159 *Then there were the Americans:* CA interview 1A.

159 *Two more arrived the year after Franny:* Mitchell interview 1.

159 *"Art Center School in Los Angeles":* Liberman, *Art and Technique*, 211.

160 *"We were considered a powerhouse":* This section is drawn from FMG, "Notes on My Photos for the *Vogue Fashion Book*, 1978," unpublished; Twin Lenses 5B, FMG; CA interview 1A; CA interview, October 3, 1996.

160 *after a harrowing journey:* The tale of Liberman's escape from Paris and arrival in New York with Tatiana and Francine is largely drawn from Kazanjian and Tomkins, *Alex*, 90–99, 101–5.

160 *he was accompanied by his lover:* See also Vogel, memo to Nast, January 28, 1941, CNA.

161 *Liberman had previously been managing editor:* Unless otherwise noted, the tale of Liberman's arrival at *Vogue* is drawn from Seebohm, *Man Who Was Vogue*, 234–35; Kazanjian and Tomkins, *Alex*, 105–7; and "Alex (on New York Beginnings)," 142–45, Kazanjian and Tomkins, AAA.

161 *Vogel, a committed leftist:* Ronald, *Condé Nast*, 323; Kazanjian and Tomkins, *Alex*, 53; Nast, unsent drafts of letters to Vogel, October 1940, in CNA.

161 *Vogel commended Liberman to Nast:* Vogel memo to Nast.

161 *But once again things did not go well:* Seebohm, *Man Who Was Vogue*, 234. This story is also recounted in Kazanjian and Tomkins, *Alex*, 107; and "Alex (on New York Beginnings)," 145.

162 *A dozen years earlier:* Unless otherwise noted, Agha's history with Condé Nast comes from Seebohm, *Man Who Was Vogue*, 228–32; Kazanjian and Tomkins, *Alex*, 113; and "Mehemed Fehmy Agha," Voguepedia, https://web.archive .org/web/20140109003025/http://www.vogue.com/voguepedia/Mehemed__ Fehmy__Agha.

162 Vanity Fair: *Vanity Fair* was adapted from a men's magazine, *Dress*, which Nast bought in 1913; it thrived in the Jazz Age but was folded into *Vogue* during the Depression. The company revived it in 1983.

163 *Liberman, during his first month on the job:* Kazanjian and Tomkins, *Alex*, 115–16.

163 *So while Agha hoped that the upstart:* Ibid., 135–36.

164 *Liberman set about modernizing* Vogue: "Interview with Alexander Liberman," January 4, 1992, 1167, Kazanjian and Tomkins, AAA; Kazanjian and Tomkins, *Alex*, "No Visions of Loveliness."

164 *Liberman had offered his ideas:* Kazanjian and Tomkins, *Alex*, 124.

165 *Franny—or someone who looked:* The same young woman appears about a year and a half later, modeling a bonnet, in "Bonnets Are Big News," *Glamour*, March 1943, 51.

165 *Liberman was excited by* Glamour's *modernity:* "Alex 3 October 90," box 14, folder 1, 977–78, Kazanjian and Tomkins, AAA.

165 *In 1930,* Vogue *had added:* von Horne, *Antonie von Horn Roothbert*, 6.

CHAPTER 17 **Franny's New World**

167 *Franny's first* Vogue *story:* "A Junior with Full-Fledged Ideas," *Vogue*, November 1, 1943, 88–89.

167 *two years earlier,* Vogue *had run a story:* Pat Arno, "I Have an Allowance," June 15, 1942, 55, 70.

167 *Franny's work was introduced in* Glamour: "Christmas Morning in Short Fur Coats" and "Christmas Sports in Fresh-Air Fashions," *Glamour*, December 1943, 54–67.

168 *The magazine introduced their new photographer:* "Behind the Issue," *Glamour*, December 1943, 48.

168 *Much of Franny's work for both magazines:* CA interview 1A, September 13, 1996.

168 *For* Vogue, *her beat soon expanded:* "Young Stars in Stripes," *Vogue*, March 1, 1945, 136–37.

168 Vogue *had inaugurated its first "Junior Fashions":* "Washington Juniors," *Vogue*, August 1, 1943, 50–55.

169 *Photographers and editors were free: Twin Lenses* 6, FMG.

169 *For one 1944* Vogue *story:* "Junior Suit Plan," *Vogue*, January 1, 1944, 66–69; "Junior Fashions," *Vogue*, May 15, 1944, 101.

169 *the pictures she made for* Glamour: "6 Pages on Suits," *Glamour*, January 1944, 36–41; "Coat to Coat Survey," *Glamour*, February 1944, 66–67; "Weekend in Manhattan," *Glamour*, March 1944, 68–69; "Summer Station Suits," *Glamour*, April 1944, 106–7.

170 *A year after Franny started at the company:* "*Vogue*'s Junior Fashions," *Vogue*, November 15, 1944, 106–10.

170 *"That's why Alex Liberman hired me": Twin Lenses* 5B, FMG; CA interview, October 3, 1996; "Frances McLaughlin," box 14, folder 12, Kazanjian and Tomkins, AAA.

170 *If Liberman didn't like something:* CA interview 1A.

171 *it was a tough time to start out there:* FMG, handwritten notes, undated, CAC.

171 *"You'd have maybe three sheets": Twin Lenses* 5B, FMG.

171 *"You couldn't get new lenses":* Ibid.

171 *"Break or lose a light meter":* FMG to CA, handwritten notes for CA article.

171 *Once on a trip to Connecticut:* Ibid.

171 *Because so many people from the studio: Twin Lenses* 5B, FMG.

172 *Don Honeyman, who'd been put on staff:* The winning girl, Marjorie "Tex" Green, does not seem to have been hired past her internship.

172 *Young women were disappearing:* Ballard, *In My Fashion*, ch. 13; "Bettina Wilson: A Profile," *Condé Nast Ink* 2 (1946): unpaginated.

172 *Cecil Beaton, forgiven his anti-Semitic episode:* "Cecil Beaton: War Photographer," Imperial War Museum, https://www.iwm.org.uk/history/cecil-beaton-war-photographer.

172 *many filling in for the assistants were young women: Twin Lenses* 5B, FMG.

172 *Among the photographers who remained:* Ibid.

173 *"very French fault of too much":* Vogel, memo to Nast, January 19, 1942, CNA.

173 *The results of his first assignment:* Chase, memo to Nast, April 6, 1942, CNA.

CHAPTER 18 **Woman Power**

175 *In 1941, already two years out of college:* "Prize-Winning Pictures from the *Popular Photography* 1941 Picture Contest: Black-and-White," *PP*, December 1941, 18, 59, 128–29.

175 *"Lisa Rothschild is something of an infant prodigy":* "Behind the Issue," *Glamour*, May 1942, 24.

175 *She had three features in the magazine:* "Be a Red Cross Nurse's Aide," "Smooth Formula," and "Rising Star Fashions," *Glamour*, May 1942, 70–73, 66–67, 52–56.

176 *The company quickly decided against:* Vogel, memo to Nast, April 24, 1942; Vogel, memo to Nast, September 2, 1942, CNA.

176 *Next there was some discussion:* Vogel, memo to Nast, September 2, 1942; Chase, memo to Daves, July 2, 1942, CNA.

176 *Agha had missed his chance:* Dahl-Wolfe, *Louise Dahl-Wolfe*, 13–19.

176 *after which management frequently discussed:* Vogel, memo to Nast, September 2, 1942.

176 *they considered her:* Frank Crowninshield, *"Vogue . . .* Pioneer in Modern Photography," *Vogue,* June 1, 1941, 72.

177 *the first woman in America:* "Pratt: 125 Anniversary," *Prattfolio,* 28.

177 *Kay Bell, who had been a fashion editor:* "The Editor's Guest Book," *HB,* June 1947, 62; "Behind the Issue," *Glamour,* April 1942, 30.

177 *The following year, Halley Erskine:* "Behind the Issue," *Glamour,* May 1942, 24.

177 *The third* Glamour *fashion editor:* "Jane Stark, 86, Editor and Jewelry Designer," *NYT,* December 10, 2000, 1–67.

177 *Generally Liberman liked the idea of having:* "Alex, 24 January 1992," 1190, Kazanjian and Tomkins, AAA.

178 *overseen by Dorothy Ducas:* Honey, *Creating Rosie the Riveter,* "The Magazine Bureau."

178 *or, as Franny saw it: Twin Lenses* 5B, FMG.

178 *The bureau produced a bimonthly publication:* Honey, *Creating Rosie the Riveter,* "Magazine Bureau."

178 *It was filled with story ideas: Magazine War Guide* (Office of War Information, Magazine Bureau, Washington, DC), February–March, March–April, and April–May 1943.

178 *That's why, for July 1943:* Monica Penick, *Tastemaker: Elizabeth Gordon,* House Beautiful, *and the Postwar American Home* (New Haven, CT: Yale University Press, 2017), 14.

178 Life *ran a photo: Life,* July 5, 1943.

178 *Apparently he had offered Toni a spot:* "The Photographers: Edward Steichen," TF memoir, 433. "When he became head of the Navy Photographic Corps in the Pacific, he wanted me to join his unit. I said, 'But Steichen, I'm married and have children and can't leave them indefinitely.' 'Nonsense,' said Steichen, 'look at the great Russian women soldier[s] in Stalingrad.'"

179 *"It was just part of the game": Twin Lenses* 5B, FMG.

179 *his psychiatrist had got him classified 4-F:* Eli Abbe, interview with author, August 3, 2020; JA III and Lucinda Abbe, interview with author, May 30, 2019; confirmed by draft board records.

179 *Early on, he had photographed women: Twin Lenses* 3, KA and JA.

179 *When Paul V. McNutt:* "The Margin Now Is Womanpower," *Fortune,* February 1943, 99.

179 *In place of the usual makeovers:* "An Award for Practical Patriotism," *Mademoiselle,* January 1943, 95.

180 *Some of the jobs they profiled became fodder:* "At Home on the Range," *Mademoiselle,* April 1943, 120–21; "Women, Wings and War," *Mademoiselle,* January 1943, 67.

180 Mademoiselle *even published a piece:* Paul V. McNutt, "This Is a Working-woman's War," *Mademoiselle,* October 1942, 65, 146–47.

180 *Condé Nast also leapt into the fray: Magazine War Guide,* July–August 1943, 1; *Vogue,* September 1, 1943, cover; "Why Aren't You Working?" and "Deeds Not Talk," *Vogue,* September 1, 1943, 96–99.

180 *The cover won honorable mention:* "Winners in Magazine Cover Competition Announced at Museum of Modern Art" (press release), September 2, 1943, Museum of Modern Art archives.

180 Glamour, *as its competition entry: Glamour,* September 1943, cover.

180 *the magazine had backed up its tagline:* Ginnie Schnebly, "*Glamour*: Job Special-ist," *Condé Nast Ink* (ca. December 1947), unnumbered, undated, unpaginated, CNA; "Behind the Issue," *Glamour,* January 1943, 15; "*Glamour* Says: You're Doing the Work of a Man . . . Think like One," *Glamour,* January 1943, 17.

181 *For one* Glamour *career story:* "The Girl with a Job . . . as Seen in Hartford," *Glamour,* March 1945, 103–9.

181 *While on the trip, she and her editor: Twin Lenses* 5B, FMG.

182 *returned a dispatch from an American field hospital in Normandy:* Lee Miller, "USA Tent Hospital in France," *Vogue,* September 15, 1944, 138–43, 204–11, 219.

182 *The* Magazine War Guide *had recently advised: Magazine War Guide,* August 1944.

CHAPTER 19 **Fuffy's New World**

My main sources for Fuffy's decision to leave Toni's studio and her move to Jimmy's are *Twin Lenses* 3 and 5A, KA and JA, except as otherwise noted. Details about wartime Montauk come from interviews with David Webb, Richard F. White Jr., and Daniel Vasti conducted in November 2022.

183 Junior Bazaar, *which was the reinvention of* College Bazaar: The launch of *Junior Bazaar* as an insert within *Bazaar* in March 1943 may have prompted *Vogue* to launch its "Junior Fashions" section five months later, in August 1943, just before Franny was hired.

183 *"We knew people," she said:* Mitchell interview 1, November 29, 1976.

183 *She found a friend to take her place:* "Virginia Thoren: Photographer On and Off Location, an Oral History," Virginia Thoren Papers, PIA.

184 *Ginny eventually became a well-known:* Ibid. Ginny notes that her career as a photographer began in the early 1950s when she was working as a freelance ad agency representative in Paris: she secretly covered for the photographer Gene Fenn when he was on vacation, and her pictures were a hit.

184 *"He was a beautiful technician":* Mitchell interview 1.

184 *She had been in Montauk with him:* KA, interview with Adrienne Collins, August 21, 2003, Montauk Library Oral History Program. Courtesy of the Montauk Library, Montauk, NY.

185 *Fernand Fonssagrives, who was out visiting:* Eli Abbe and Jessica Arner, inter-view with author, December 14, 2022.

185 *The plot, a 150-foot-long stretch:* Except as otherwise noted, the description of Jimmy's land and house are drawn from Suzanne Slesin, Stafford Cliff, and Daniel Rozensztrock, and Gilles de Chabaneix (photographer), *New York Style* (New York: Clarkson Potter, 1992), "Cozy Cabin by the Sea," 247–50; Jennifer Landes, "On a Clear Day You Can See Forever," *East Hampton Star* magazine insert, September 2008, unpaginated press cutting; and several interviews, with Tom Abbe, March 21, 2021; Abbe and Arner; and Chris Karitevlis, December 5, 2022.

185 *One hundred dollars later:* Indenture dated October 10, 1943.

185 *"Eddie was really a cabinetmaker of great skill":* KA, interview with Adrienne Collins.

187 *"It was always a joint venture":* Mia Fonssagrives-Solow, interview with author, February 20, 2019.

187 *Mary Lou Malany, the Montgomery Ward assistant:* Mrs. R. D. Walsh, postcard to JA, January 31, 1944.

187 *The same assumption held at Second House:* David Tyson, interview with author, March 9, 2021.

187 *Jimmy's first son, Jamie:* JA III and Lucinda Abbe, interview with author, May 30, 2019, and JA III, interview with author, May 31, 2019.

188 *Indeed, decades later:* Lucinda Abbe, interview with author, March 20, 2022.

188 Women's Home Companion*, one of the country's:* Zuckerman, *History of Popular Women's Magazines*, 107, 201. It was number two or three from the 1920s on, and number one in 1940.

188 *"This isn't a double exposure":* Betty Betz, "Look Who's Talking," *Women's Home Companion*, November 1944, 14.

189 *Another story the next month:* Franny McLaughlin and Fuffy McLaughlin, "We Make Our Own Clothes," *Vogue Pattern Book*, December–January 1944–45, 12–13.

189 *A third story, in the* Prattler: "Developing Duet, McLaughlin Twins," *Prattler*, November 27, 1944, 2.

189 Popular Photography *devoted a cover story:* Etna M. Kelley, "Women in Photography," *PP*, June 1945, 20–23, 56–57, 108–14.

190 *the onetime Lisa Rothschild:* Gilbert, *Illustrated Worldwide Who's Who*, "Appendix D: Names That Changed," 323–25. (In both cases, Lisa and Roy, Gilbert misspells the name Larsen as Larsson.) The appendix includes a long list of photographers who changed their names, "for whimsy, for theatricality, for self-aggrandizement but for most Jews in the twentieth century largely as protective camouflage," including Margaret Bourke-White, Munkácsi, and Gilbert himself.

190 *On one occasion, the magazine:* Kelley, "Women in Photography," 20–23.

191 *Mr. Nast, affronted, had penned an icy memo:* Nast, memo to Penrose, Thompson, et al., February 28, 1941, CNA.

CHAPTER 20 **Victory**

193 *The day Germany surrendered:* "Life Goes to Some V-E Day Celebrations," *Life*, May 21, 1945, 118–21.

193 Vogue's *famous illustrator:* Chase and Chase, *Always in Vogue*, ch. 19; Ballard, *In My Fashion*, ch. 5, "Schiaparelli, Mainbocher, and Other Designers."

194 *Early on in her career:* CA interview 1A, September 13, 1996.

194 *Or, as someone later assigned:* Bernier, *Some of My Lives*, 74.

194 *"We tried to imagine":* E. B. White, "Talk of the Town: Notes and Comment," *New Yorker*, August 18, 1945, 13–14.

194 *Now when troop transports:* "Sober City Awaits the Official V-J Word," *NYT*, August 11, 1945, 1, 9.

194 *As they poured into the city:* "Manhattan," *Yank*, August 31, 1945, Old Magazine Articles, http://www.oldmagazinearticles.com/WW2__New__York__City-pdf.

195 Charm *had something to say:* "You'll Be Together Again," *Charm*, November 1945, 138–39.

195 Charm *addressed that quandary:* Raymond J. Blair, "The Day," *Charm*, October 1945, 113–14, 170, 172.

195 *as another* Charm *story asserted:* Roberta Rogers Bowen, "It's Going to Be a Man's World Again," *Charm*, October 1945, 128–29, 189–90.

196 *The first magazine to test this market:* Massoni, *Fashioning Teenagers*, ch. 1, "The Birth of the Teen Magazine: Delivering *Seventeen* Magazine to the U.S. Marketplace."

196 *"Are you interested only in yourself":* Helen Valentine, "*Seventeen* Says Hello," *Seventeen*, September 1944, 32–33.

196 *The issue included features:* "Hollywood High School," 50–51, 58–59; "British Girls Are Busy," 38–39; "Sinatra," 52–53; and "What Are You Doing about the War?," 54, 56, 84, *Seventeen*, September 1944.

197 *Meanwhile, in advertisements:* "17: The New Magazine That's Needed Now!" (ad), *WWD*, August 9, 1944, 9; Massoni, *Fashioning Teenagers*, 45.

197 *Two months afterward:* "Fourth Estate: Bobby-Sock Form," *Newsweek*, October 30, 1944, 89–90.

197 *aiming at "girls of thirteen":* "Junior Bazaar" (ad), *HB*, October 1945, 146.

198 *Three girls marched purposefully:* "We Want the Best," *JB*, November 1945, 78–81.

198 *"Its appeal is to the younger set":* "Teen-Age Magazine," *Life*, October 29, 1945, 77–80.

198 *The barefoot art director:* Oral history interview with Lillian Bassman, conducted by Steven Watson, October 12–November 16, 2011, AAA; also Vince Aletti, "Junior Bazaar," *Aperture* 182 (Spring 2006): 54–61.

198 *But the cover photo:* Norma Stevens and Steven L. Aronson, *Avedon: Something Personal* (New York: Random House, 2017), ch. 6, "Finding Life through a Lens," Kindle; Gefter, *What Becomes a Legend*, 91–93.

199 *"What he saw":* Snow with Aswell, *World of Carmel Snow*, 139.

200 *Then Jane started using Fuffy:* "6 Working Separates," *Charm*, November 1945, 122–23.

200 *"My life in fashion photography":* Twin Lenses 14, KA and FMG.

200 *which covered subjects such as:* William Carter, "Roads to Tomorrow," *Holiday*, March 1946, 58–60, 62; Edward M. Strode, "Europe's Still There," *Holiday*, April 1946, 49–51; John Edwin Hogg, "Mexico's Fabulous Fishing Hole," *Holiday*, April 1946, 33–35; Russ Davis, "Living War Memorials: This Time There Will Be Playgrounds to Honor the Heroes," *Holiday*, July 1946, 89–90.

200 *"dedicated to the pursuit":* J. Frank Beaman, "Editorial: In Pursuit of Happiness," *Holiday*, March 1946, 3.

201 *First she was given a huge story:* "Fashion, Coast to Coast," *Charm*, February 1946, 132–52; "Fishermen Get Away from It All at a Club Knee-Deep in Biscayne Bay," *Life*, February 10, 1941, 42–44.

201 *Next Fuffy went to Southern California: Twin Lenses* 14, KA and FMG; "Cotton Suits Go to Play or to Work," *Charm*, April 1946, 174–75.

201 Charm *also had a travel column:* Faye Henle, "Two Weeks with Pay," *Charm*, May 1946, 133–35, 214–15.

201 *the magazine sent Fuffy to Cuba:* "Swim Suits," *Charm*, May 1946, 145–48; "For Basking," *Charm*, June 1946, 128–29.

202 *Schnurer's first big hit:* Lisa Lockwood, "Carolyn Schnurer Noveck Dead at 91," *WWD*, March 19, 1998, 8.

202 *Fuffy also photographed:* "Summer Evening Data," 141–43; "Bare a Shoulder," 174–75; and "Good Travelers," 178, *Charm*, May 1946.

202 *back in America, she was making:* "Casual in the California Manner," 152–53; "Take Denim," 155–58: and "First Choice of Dude Ranchers," 154, *Charm*, May 1946.

202 *She created more artful, surrealism-inspired:* "Holiday Heads Are Crowned with Glitter," *Charm*, December 1945, 172–75.

202 *she and Jimmy often stopped by: TL*, 58.

202 *Photography "is at its very beginning":* H. Felix Kraus and Bruce Downes, "Blumenfeld at Work," *PP*, October 1944, 38–47, 88.

203 *Blumenfeld had also developed a portraiture technique:* "Speaking of Pictures . . . Erwin Blumenfeld Creates Fantasies," *Life*, October 24, 1942, 10–12.

203 *Toni played with the children:* Mitchell, *Recollections*, 103.

203 *Still more of Fuffy's pictures:* "Dark Is for Night, Bright Is for Night," 122–23; "Very Cool for Town," 160–61; and "Sunlight and Shadow," 130, *Charm*, June 1946.

204 *One day when Fuffy was posing for pictures:* Elizabeth Fenton, photographer Peggy Plummer, "There's More Than One You," uncredited, unpaginated press cutting.

204 *what their son, Jamie, jokingly called:* JA III and Lucinda Abbe, interview with author, May 30, 2019.

204 *But Jimmy's mother:* Chris Karitevlis, interview with author, November 2021.

204 *Franny once commented:* Tomie dePaola, interview with author, February 21, 2018.

204 *As for the psychiatrist:* Chris Karitevlis, interview with author, February 14, 2020.

CHAPTER 21 **The American Look**

Except as otherwise noted, Franny's reminiscences of the studio are drawn from *Twin Lenses* 6, and her interviews with Casey Allen (CA interview 1A, September 13, 1996, and CA interview, October 3, 1996), while Pat Donovan's recollections of modeling for Franny come from interviews with the author conducted March 25 through July 27, 2020.

207 *"We were so carefree":* KA, interview with Adrienne Collins, August 21, 2003, Montauk Library Oral History Program. Courtesy of the Montauk Library, Montauk, NY.

207 *But for Franny, the postwar years:* Margaretta K. Mitchell, "Photography's Twin Sisters," *PP*, January 1980, 74–81, 118–19, 182; CA interview 1A.

207 *expanded into an annex:* "The Studio," *Condé Nast Ink* 2 (1946): unpaginated.

207 *The photographers typically:* Mitchell interview 1, November 29, 1976.

207 *Sally Kirkland, who had started:* Ballard, *In My Fashion*, ch. 12, "Living in Fashion in New York"; "College Shops Braced Again for Fall Rush," *NYT*, August 15, 1960, 26.

209 *Once, while attending a baseball game:* "Frances McLaughlin," box 14, folder 12, Kazanjian and Tomkins, AAA.

209 *to suggest a countrified setting:* "Junior Fashions," *Vogue*, November 1, 1946, 222; "Who Says Black and White Scotch Is Scarce?," *Glamour*, November 1946, 214–15.

209 *The eminence, long retired:* Steichen retired from Condé Nast in 1938 and became director of MoMA's photography department in 1946.

209 *the American Look:* Kirkland, "McCardell," ch. 3 in *American Fashion*, ed. Lee, 254.

209 *As women began to wear slacks:* Strassel, "Redressing Women," 166, 168–69, 179–82, 194.

210 *Dorothy Shaver, now president:* Dorothy Shaver, "The American Look," press release and press clippings, January 12, 1945, Dorothy Shaver Papers, Archives Center, National Museum of American History.

210 *she appeared on the cover:* HB, March 1943, cover.

210 *The American girl had:* "What Is the American Look? The Girls of the U.S. Have an Air All Their Own," *Life*, May 21, 1945, 87–91.

210 *Franny defined it more simply:* FMG, "My Type Photograph," undated, unpublished notes.

211 *For the August 1946 back-to-school section:* Twin Lenses 5B, FMG; "On Campus, Any Campus," *Vogue*, August 15, 1946, 165, 167; "Young Country Clothes . . . Ideas Added," *Vogue*, November 1, 1946, 220–21.

211 *The second issue of* Condé Nast Ink: "Their Favorite Restaurants," *Condé Nast Ink* 2 (1946): unpaginated.

212 *When none of the magazine's:* "Irving Penn," box 14, folder 53, 2–4, Kazanjian and Tomkins, AAA.

212 *Irving's first color photo:* Vogue, October 1, 1943, cover.

212 *Irving recalled later that Mrs. Chase:* "Irving Penn," box 14, folder 53, 2–4.

212 *"a plainspoken, plain-looking":* Bernier, *Some of My Lives*, "Irving Penn" and "Vogue—First Job."

212 *he'd been her fiancé:* Leslie Gill, dau., interview with author, April 5, 2021.

213 *"I used to go out some with Penn":* Mitchell interview 1; CA interview 1A; similarly, *Twin Lenses* 13, KA and FMG.

213 *"Penn is a very definite person":* CA interview 1A.

213 *Franny's discretion may also have been due:* CA interview 1B, September 13, 1996.

213 *The* New York Times *reviewer envisioned:* Lewis Nichols, "Saga of a Big Rabbit," *NYT*, November 12, 1944, X1.

214 *When the producers sold reproduction rights:* "Harvey, Inc.," *New Yorker*, March 24, 1945, 26.

214 *"They were really looking into you":* CA interview 1B.

214 *"He invested a lot of time":* CA interview 1A; "Frances McLaughlin," box 14, folder 12, Kazanjian and Tomkins, AAA.

215 *"Penn immediately plunged into":* Alexander Liberman, "An American Modern," in *Passage: A Work Record,* by Irving Penn (New York: Alfred A. Knopf / Callaway, 1991), 5–9.

215 *As Bettina Wilson noted later:* Ballard, *In My Fashion,* ch. 16, "Editing at *Vogue.*"

216 *In May 1946 she won plaudits:* "Glamour versus 'Technique,'" *U.S. Camera,* May 1946, 39–41, 50.

217 *Franny's photo had been part of a fashion package:* "Men Scare Easily" and "Men Are Fickle," *Glamour,* February 1946, 150–53.

217 *Called "Young as You Are":* "Young as You Are," *Glamour,* June 1946, 104–9.

217 *By the early 1940s:* Prohaska, *White Fence,* "Post-War Amagansett."

218 *she had originally been discovered:* Will Gompertz, "Carmen Dell'Orefice: Model, Muse and Memorable Handshake," BBC, September 4, 2014, https://www.bbc.com/news/entertainment-arts-29062682.

219 *"She is Carmen Dell'Orefice":* "Teens in the News," *Seventeen,* December 1946, 240.

219 *The need to keep her lips closed:* Gompertz, "Carmen Dell'Orefice."

219 *The following year, at sixteen:* Gross, *Model,* "40 an Hour."

CHAPTER 22 **The Elopement**

221 *The latter issue, especially:* "For Basking," 128–29, and "Water Sprite," 124–25, *Charm,* June 1946.

221 *"the mock-adultery charade":* Prohaska, *White Fence,* "Chester."

222 *Nevada, America's divorce mecca:* McGee and McGee, *Divorce Seekers,* 327–30.

222 *Ria Langham, Clark Gable's second wife:* "Las Vegas Divorce Ranches," Las Vegas, Nevada, https://www.lasvegasnevada.gov/News/Blog/Detail/las-vegas-divorce-ranches.

223 *had time to write him letters:* Jim Tyson, letter to JA, April 8, 1946.

223 *as Jimmy used to recount later:* Eli Abbe, interview with author, August 3, 2020.

223 *Jimmy also used the six weeks':* Twin Lenses 4, KA and JA.

224 *Las Vegas in particular made it painless:* Larry D. Gragg, *Benjamin "Bugsy" Siegel: The Gangster, the Flamingo, and the Making of Modern Las Vegas* (Santa Barbara, CA: Praeger/ABC-Clio, 2015), 75.

224 *"That was a pretty far-out wedding outfit":* Twin Lenses 11, KA and Tom Abbe.

225 *he described the house in some detail:* Donald Stanley Vogel, *Memories and Images: The World of Donald Vogel and Valley House Gallery* (Denton: University of North Texas Press, 2000), 92–93.

226 *When they returned to New York:* Twin Lenses 4, KA and JA.

226 *The planes had gone on the market:* "Macy's Ercoupe at $2,994" (ad), *NYT,* September 23, 1945, 11.

226 *They chose an Ercoupe:* Thomas, *Ercoupe,* 75–78; "Stores Acquire Military Wares for Sale Here," *NYHT,* October 9, 1945, 21.

226 *"More business, more pleasure":* "Macy's Ercoupe at $2,994," 11; "Planes Join Girdles; Jeeps Also on Sale," *NYT,* October 9, 1945, 15.

226 *Originally built as a Works Progress Administration project:* "Air Travel on L.I.," *East Hampton Star,* April 19, 1945; "East Hampton Airport Now Center for Numerous Planes," *East Hampton Star,* August 22, 1946, 1, 4.

227 *before long a story appeared:* "Kathryn and James Abbe with Camera and 'Coupe," *Mademoiselle,* October 1946, 207.

228 *Jimmy had rented the carriage house: Twin Lenses* 11, KA and Tom Abbe; *Today's Woman* press cutting, undated, unpaginated.

228 *"We paid four hundred and twenty-five dollars": Twin Lenses* 11, KA and Tom Abbe; *Twin Lenses* 5A, KA and JA.

228 *George Knoblach had been with them:* George Knoblach, interview with Carole MacDonald Nye, July 7, 2003, Montauk Library Oral History Program. Courtesy of the Montauk Library, Montauk, NY.

228 *Gus Clark had joined them:* Gus's real passion was dance, music, and Ghanaian culture. In 1953, he changed his last name to Dinizulu and formed the Dinizulu Dance company with his wife, dedicated to the dancing, singing, and drumming of the Ashanti people of Ghana, all while continuing to work in the studio; it is said to have been America's oldest African dance company. "Yao Opare Dinizulu, Troupe Founder, 60," *NYT,* February 16, 1991, 1–14; https://web.archive.org/web/20211024085614/https://www.vassar.edu/chronology/records/1981/1981-02-06-third-world-festival.html.

228 Ebony, *a* Life-*like publication:* "Dan Butley's Back Door Stuff," *New York Amsterdam News,* September 15, 1945, A5.

229 *Hal Reiff, a second-generation photographer:* "*Charm*'s Contributors," *Charm,* June 1947, 30, 146.

CHAPTER 23 **European Tour**

Except as otherwise noted, Leslie's activities during the war are drawn from notes, memos, and documents in his Office of War Information (OWI) file, obtained from the National Archives.

231 *a British colonial outpost:* Alastair Wilkie, "WW2 People's War," August 7, 2005 (online archive of wartime memories contributed by members of the public), BBC, https://www.bbc.co.uk/history/ww2peopleswar/stories/24/a4854224.shtml.

231 *Leslie supposedly went out:* Carol O'Neill, interviews with author, July 31, 2018, and March 4, 2019.

232 *"I have had 5 letters from Gill":* Dilys Wall, letter to mother, May 11, 1944.

232 *Otherwise, silence:* O'Neill, interview, July 31, 2018.

232 *Cairo, however, was one of the centers:* Bishop, "Overseas Branch of the Office," "Egypt."

232 *"We included Les Gill"*: William Robinson, chief of Balkans Publications Section, letter to Bartow Underhill, OWI New York, November 10, 1944, copied in an Outpost Service Bureau memo in LG's OWI file, National Archives.

232 Town & Country *published a letter:* Peter Lindamood, "Letter from Rome by T/5 Peter Lindamood," *Town & Country*, February 1945, 122–23, 160–61, 163.

233 Nuovo Mondo, *or "new world":* Bishop, "Overseas Branch of the Office," 167.

233 *The head of their unit:* P. I. Prentice, "A Letter from the Publisher, November 12, 1945," *Time*, November 12, 1945, 17.

233 *The* New Yorker *cartoonist Saul Steinberg:* "Chronology: 1944," Saul Steinberg Foundation, https://saulsteinbergfoundation.org/chronology/1944-yr/.

233 *The American ambassador to Italy, Alexander Comstock Kirk:* Noel F. Busch, "Ambassador Kirk," *Life*, August 13, 1945, 80–82, 84, 86, 89–90, 92.

233 *Rome was also throbbing with:* Lindamood, "Letter from Rome," 122–23, 160–61, 163; Illaria Schiaffini, "It's a Roman Holiday for Artists: The American Artists of l'Obelisco After World War II," *Italian Modern Art Journal* (Center for Italian Modern Art, NY), January 2020, https://www.italianmodernart.org/journal/articles/its-a-roman-holiday-for-artists-the-american-artists-of-lobelisco-after-world-war-ii/.

233 *including a young painter:* Eliza Werner, interview with author, April 16, 2019. For more information about Vespignani, see Patrick O'Higgins, "On Exhibition," *Town & Country*, December 1948, 61; "Renzo Vespignani," Museum of Modern Art, https://www.moma.org/artists/6140; Renzo Vespignani, "Fondaco Auctions and Private Sales," https://www.fondacoaste.com/project/renzo-vespignani-biografia-opere-darte-e-quotazioni/?lang=en.

234 *Leslie's OWI file notes:* James Linen, special assistant to the director in Rome, letter to Frank Bear, Outpost manager, April 20, 1945, copied in an Outpost Service Bureau memo in LG's OWI file, National Archives; Robinson, letter to Underhill.

234 *Dilys was out:* O'Neill, interview with author, March 4, 2019.

234 *"Then we heard the elevator":* Eliza Werner, interview with author, April 16, 2019. The story of Dilys and the other man is from Eliza's interview.

235 *"Divorce is on its way":* Don Romero, "What You Don't Know about Divorce," *Charm*, July 1947, 90–91, 108.

235 *Broadway was full of divorce-themed productions:* "Anita Loos and Leonora Corbett," *HB*, November 1946, 236–37; "Applause in December," *HB*, December 1946, 220–21.

235 Mademoiselle *characterized the children:* Becky Reyher, "Who Gets the Child?," *Mademoiselle*, July 1947, 84–85, 132–33.

235 *Her daughter thinks:* Leslie Gill, dau., interview with author, January 23, 2018.

235 *By then Leslie had been separated:* Pamela Thomas, "The Ultimate Material Witness," *American Photographer*, December 1980, 66–75. Although Franny never met Outerbridge, also a *House Beautiful* contributor, she thought he and Leslie may have continued to share the studio after the war.

235 *Leslie was off his feet with work:* JB, December 1946, cover.

235 *In Leslie's other* Junior Bazaar *photographs:* "Shaker Portfolio," *JB*, January 1946, 68–71, 74–75; "It Looks Like Spring . . . ," *JB*, March 1946, 96–98, 101–2.

236 *"Frances dearest, St. Valentine"*: LG, letter to FMG, February 17, 1947.

236 *Mrs. Snow reported later that she had said:* Snow with Aswell, *World of Carmel Snow*, ch. 15.

237 *They had really gone over-the-top:* Ballard, *In My Fashion*, "Preface."

237 *A handful of daring Americans:* Snow with Aswell, *World of Carmel Snow*, ch. 15; Snow, "Paris Today," report of Carmel Snow's remarks, Hotel Biltmore luncheon, April 18, 1946, 2, FGI Records. Here the quote reads, "Lelong has a new designer—Christian Dior. The collection this year was sensational—full of ideas."

237 *Now, in 1947, a group of forty:* Rowlands, *Dash of Daring*, ch. 12, "New Faces, New Names," 362; Bernier, *Some of My Lives*, "Paris Again."

237 *"#1 as of this week":* This and subsequent quotes are drawn from a batch of letters from LG to FMG written over two months in 1947, at the rate of about one a week starting February 17.

238 *he and Dilys had officially separated:* Lucinda O'Neill, interview with author, January 26, 2019.

239 *what* Bazaar *would later describe:* Frances Keene, "The New Italy," *HB*, July 1947, 30–39, 88, 94.

240 *he had once sent her a mysterious gift:* Leslie Gill, dau., interviews with author, April 5, 2021, and January 23 and June 22, 2018.

241 *"I don't want pictures in the studio":* Michel Guerrin unpublished interview with Richard Avedon for *Le Monde*, 1993, quoted in Gefter, *What Becomes a Legend*, 123.

CHAPTER 24 **Our Little Frances**

245 *in January 1947 they published:* "Photographer Luis Lemus Sketches Too," *Condé Nast Ink* 4 (1947): unpaginated, CNA.

245 *Years ago he had told* Glamour: "Behind the Issue," *Glamour*, March 1943, 31.

245 *"I had to ask him not to do it":* CA interview 1A, September 13, 1996.

245 *Claire Mallison, the devastatingly glamorous:* "Behind the Issue," *Glamour*, January 1944, 31.

246 *"She was just a gracious lady":* Dolores Hawkins Phelps, interview with author, September 30, 2018.

246 *Franny later described working in the studio:* FMG, undated, handwritten notes.

247 *except from Clifford Coffin:* CA interview 1A.

247 *often cutting in front of her:* Twin Lenses 5B, FMG.

247 *Liberman himself would gain:* "Despina Messinessi" and "Tina Fredericks," box 14, folder 1; and "Penn," box 15, folder 13, unpaginated, Kazanjian and Tomkins, AAA.

247 *But with a magazine coming out:* Twin Lenses 5B, FMG.

247 *Sally Kirkland had come up with:* Bernadine Morris, "Sally Kirkland, 77, Editor at *Life*; Brought Readers European Styles," *NYT*, May 3, 1989, D27.

247 *The picture they started out with:* "12 Beauties: The Most Photographed Models in America," *Vogue*, May 1, 1947, 130–31, 176.

248 *The models included Dorian Leigh:* Gross, *Model*, "$25 an Hour."

248 *Franny discovered Lisa: Twin Lenses* 13, KA and FMG.

248 *Yet their friendships endured:* Leslie Gill, dau., interview with author, April 5, 2021.

249 *Irving's use of the word: Twin Lenses* 13, KA and FMG. However, the nickname is more commonly assumed to refer to Irving's *Small Trades* or *Petit Métiers* portraits of workers from 1950–51, as FMG mentions later in some unpublished notes about the studio.

249 *Perhaps it helped that* Vogue: Mrs. Chase still remained on the masthead, however, as editor in chief of the Three *Vogues*.

249 Life *magazine, one of many:* "Flying Ranch Fashions," *Life*, May 26, 1947, 119–22.

249 *Franny, who stayed friendly:* "Texas Flying Ranch," *Vogue*, June 1, 1947, 92–97; "Young Week-End, Plane Commuting . . . ," *Vogue*, June 15, 1947, 36–38.

249 Vogue's *1947 college issue:* "Fashions for Young Ladies in and out of College," *Vogue*, August 15, 1947, 124.

250 *Some American designers, however:* Sally Kirkland, "Sportswear for Everywhere," in *All-American*, ed. Fashion Institute of Technology, 39.

250 Bazaar *kicked off its issue:* "You Can't Be a Last-Year Girl," *HB*, August 1947, 95–99.

251 *Her cover picture features: Vogue*, August 15, 1947, cover.

251 *She was already expert at adapting:* "Print Folio, Skirt Fulness," *Vogue*, March 15, 1947, 200–201; "Nylon: Skin-Thin Young Lingerie," 186–87, and "The Return of the Leghorn Hat," 188–89, 231, *Vogue*, April 1, 1947.

251 *so many yards of China silk:* CA interview 1A, and CA interview, October 3, 1996.

251 *Here Franny hung paper:* Liberman, *Art and Technique*, 218.

252 *one of her photos was chosen:* FMG, "Ski Clothes," and Irving Penn, "Opera Accessories," in *U.S. Camera 1949*, ed. Tom Maloney (New York: U.S. Camera Publishing, 1949), 194–95.

252 *Although the first Invitation Exhibition:* Jacob Deschin, "Women's Exhibit: Show Is Interesting, but Faults Weaken It," *NYT*, November 9, 1947, X13.

252 *a group picture of the* Vogue *photographers:* Irving Penn, "*Vogue* Photographers 1946," https://npg.si.edu/object/npg_NPG.88.70.57.

252 *ran as part of a portfolio:* André Ostier, "Le Photographe Penn," French *Vogue*, September 1947, 80–83.

253 *Franny was very fond of Horst: Twin Lenses* 5B, FMG.

CHAPTER 25 **Cautionary Tales**

Unless otherwise noted, my main source for information on Cipe Pineles's life and career was Scotford's biography *Cipe Pineles*.

255 *Consider the case of Cipe Pineles:* "Woman Editor Plunges Under Times Sq. Train," *NYHT*, June 6, 1946, 23.

255 *Some months before:* Scotford, *Cipe Pineles*, "Getting Started in Design." Golden, who started out along with Pineles at Condé Nast, working for

Agha, is best remembered for having created the CBS "eye" logo, inspired by Shaker design, in 1951. Although Scotford suggests that Pineles's suicide attempt might have been prompted by her inability to get pregnant, or by jealousy about her husband's friendship with another woman, their marriage lasted until his death in 1959.

255 *Jacob Lawrence, the first black artist:* Lawrence's *Migration Series* was shown twice by Edith Halpert's Downtown Gallery in 1941 and acquired by MoMA and the Phillips Collection in Washington, DC, the following year. https://www.moma.org/interactives/exhibitions/2015/onewayticket/jacob-lawrence/16/.

256 *Pineles had also broken barriers:* Joan Cook, "Cipe Pineles Burtin Is Dead at 82; First Woman in Art Directors Club," *NYT*, January 5, 1991, 1–26.

256 *Her bio in the magazine:* "Behind the Issue," *Glamour*, January 1942, 23.

256 *But the general opinion:* "Tina Fredericks," box 14, folder 12, Kazanjian and Tomkins, AAA.

256 *with her name misspelled* Pinelas*: Glamour*, December 1946, 3.

256 *"I didn't leave":* Scotford, *Cipe Pineles*, 51.

256 *Later, Liberman barely seemed to recall:* "Alex 6 (on Priscilla Peck) 19 Oct 88," box 14, folder 1, 157, Kazanjian and Tomkins, AAA.

257 *Once when she had just taken a picture:* TF memoir, "The Siegfried Line," 675–78.

257 *She had photographed the men:* Ibid., "The Red Tailed Mustangs," 690–92.

257 *Liberman regarded her desire:* Carolyn Burke, *Lee Miller: A Life* (Chicago: University of Chicago Press, 2007), 294.

257 *Lee's photographs of the death camps:* "Germans Are like This," 102–3, 192–93, and "Believe It!," 104–5, *Vogue*, June 1, 1945.

258 *Toni had sent a long letter:* TF, letter to Patcévitch, October 26, 1944, box 12, folder 1, TF Papers, Manuscript Division, Library of Congress, Washington, DC.

258 *"It is apparent that your grievances":* Patcévitch, letter to TF, November 3, 1944, box 12, folder 1, TF Papers.

258 *Toni's first photograph:* "We Made It! Arrival at Bradley Field," *HB*, July 1945, 43–45.

258 *Mrs. Snow, normally so sanguine:* Snow, letter to TF, July 6, 1945, box 7, TF Papers.

259 *Toni soon landed an astonishing assignment:* "The Bare Season," *HB*, May 1947, 162–63.

259 *The twins had compared the two photographers many times:* Twin Lenses 3, KA and JA. However, according to a story by Ellen Graham in the *Wall Street Journal*, "Turning 50 in 1950: Harvard Men Reflect on Lives Between the Wars," November 6, 1995, Mac described his marriage to Toni quite differently in his fiftieth Harvard class reunion book. "Possibly Toni Frissell is known to some of you," he wrote of his famous wife. Her career, he noted, "has taken her to distant parts of the globe, including two trips to the European theatre during the war, while the old man took care of the children."

259 *Louise's husband helped paint her sets:* Dahl-Wolfe, *Louise Dahl-Wolfe*, 105.

260 *Fuffy and Franny often weighed up:* Twin Lenses 3, KA and JA.

260 *she had spread assignments:* Kay Campbell, "Clothes to Fit the Clime," *Holiday*, September 1946, 107–9; Margaret Hockaday, "Toni Frissel," *Holiday*, November

1946, 67–80; Margaret Hockaday, "Ski Fashions," *Holiday*, December 1946, 107–10.

260 *Margaret had been passionately interested:* Roxanne E. Neuberger-Lucchesi, "Margaret Hockaday (January 8, 1907–December 18, 1992)," in *Ad Men and Women*, ed. Applegate, 186–94.

260 *While waiting for clients:* Margaret Hockaday, ed., Seymour Robins, art, KA, photography, et al., *Fashion Guide to U.S.A.: What to Wear Where in America*, Fashion Guide Series (New York: Hockaday Walsh, 1947).

260 *Barbara Tullgren, a* Vogue *cover girl:* "Barbara Tullgren Monteiro: The Original Supermodel," https://www.youtube.com/watch?v=NKlPF4MvfQk.

261 *For a chapter called "Weather":* Hockaday et al., *Fashion Guide to U.S.A.*

261 *"It was just my cup of tea": Twin Lenses* 14, KA and FMG.

261 *Rebranded as* What to Wear Where: Information and Fashion Departments, Holiday, *What to Wear Where: Holiday Fashion Guide to the U.S.A., the Islands, and Mexico* (Philadelphia, PA: Curtis, 1947).

261 *a package on cameras and photography careers:* "BGs and Photography," *Charm*, June 1947, 111, 139–42.

262 *Fuffy, presented as a professional photographer:* "*Charm*'s Contributors," *Charm*, June 1947, 30, 146.

262 *For the package, Fuffy photographed:* "The New Camera," 62–65, and "The Subject Is You," 88–89, *Charm*, June 1947.

263 *"Although we shall certainly be disappointed":* JA, letter to Anna Wibberley, undated, ca. December 1947.

264 *Fini's reputation had preceded her:* Levy, *Memoir of an Art Gallery*, 168–69.

264 *After Levy accompanied her:* Ibid., 172.

264 *Fini was now one of the most famous:* Peter Webb, *Sphinx: The Life and Art of Leonor Fini* (New York: Vendome Press, 2009), ch. 4, "Paris: Rue Payenne and Rue de Sévigné, 1946–1959."

265 *Once home, they began supplying:* Jean Chevalier, letter to JA, March 2, 1948.

265 *"so like Greer Garson's":* "Editorial We," *Charm*, August 1945, 150.

265 *In her editor's letter:* "Looking Around with the Editor," *Everywoman*, January 1948, 9.

265 *the magazine somehow managed to run:* Ibid., tear sheet, page number unavailable.

CHAPTER 26 **The Big Change**

267 *A year before:* Senator Claude Pepper, "If Women Want a Better World They Must Get Out and Vote," *Glamour*, November 1946, 218, 268, 270, 272, 279–99.

267 *The focus had shifted:* "These Bright Young Men," *JB*, January 1947, 82–83; "Promising Career Men," *Glamour*, February 1947, 150–51, 168, 170, 172, 174; "Young Men Who Care," *Glamour*, July 1947, 27–29.

268 *Today's sparkling college girl:* "The Way You Look This Spring," 83–88, and Nancy Poor, "Make It a Party," 89, 158–59, 166, *JB*, March 1947; June Lockett, "Aprons over Ski Clothes," *JB*, December 1947, 46–47, 71, 78.

268 *As for the business girl:* "Top Secret: You've a Head on Your Shoulders—Remember?," *Charm*, April 1948, 108–9.

269 *He had also made the portrait:* Kay Torrey, "Pink Is for Girls," *Charm*, April 1948, 130–31, 169.

269 *Fuffy, whose freelance business:* "Follow Your Heart," *Charm*, April 1948, 134–35.

269 *Franny photographed such stories as:* "Mr. & Mrs. Inc.," *Glamour*, April 1947, 170–71; "Careers and Children," *Glamour*, October 1948, 142–45.

269 *Franny photographed plenty:* "Bride with a Career," *Glamour*, April 1947, 136–37.

270 Glamour *began running a seven-part series:* Marynia F. Farnham, MD, "Let's Talk About Modern Woman," *Glamour*, September 1947, 144–45, 198–200.

270 *Thomas Parran, the surgeon general:* Parran was also involved with the notorious Tuskegee syphilis study, which withheld treatment from 399 black men who had contracted the disease to study its effects on human subjects, as well as a similar government-sponsored study of venereal disease in Guatemala.

270 *Subsequent columns addressed:* Marynia F. Farnham, M.D., "Let's Talk About Modern Woman," *Glamour*, November 1947, 114–15, 137–39, 151; December 1947, 110, 130–32; and January 1948, 74, 109, 117.

271 Glamour*'s editors explained:* Farnham, "Let's Talk About," September 1947, 144.

271 *Called* Modern Woman: Ferdinand Lundberg and Marynia F. Farnham, *Modern Woman: The Lost Sex* (New York: Harper & Brothers, 1947), 24–25.

271 *as the anthropologist Margaret Mead wrote:* Margaret Mead, "Dilemmas the Modern Woman Faces," *NYT*, January 26, 1947, BR18.

272 *Its societal prescriptions were developed:* Lundberg and Farnham, *Modern Woman*, 371, 237.

272 Coronet, *which had been transformed:* "Ads in *Coronet*," *Business Week*, March 1, 1947, 21–22.

272 *"The Tragic Failure of":* Marynia F. Farnham, "The Tragic Failure of America's Women," *Coronet*, September 1947, 3–9; Marynia F. Farnham, "Who Wears the Pants in Your Family?," *Coronet*, March 1948, 10–14.

273 *Some were incensed:* Frances Story, "Ask Frances Story," *New York Newsday*, September 3, 1947, 24; Hedda Hopper, "Looking at Hollywood," *Los Angeles Times*, September 15, 1947, A3.

273 *Others professed amusement:* Doris Lockerman, "The Experiment Was Successful: That Woman's Here Again," *Atlanta Constitution*, March 10, 1948, 14.

274 *where she knew all the right people:* JA III, interview with author, May 31, 2019.

274 *Smith liked to boast that he had been:* Dorothy Dunbar Bromley, "A Crusading Publisher Puts Women's Detractors on Spot," *NYHT*, August 3, 1947, A5.

274 *Now, in an editorial entitled:* Harrison Smith, "Woman, the Scapegoat," *Saturday Review of Literature*, January 18, 1947, 18.

274 *In* Cosmopolitan, *in a story:* Philip Wylie, "What's Wrong with American Marriages?," *Cosmopolitan*, June 1946, 26–27, 154–56; Philip Wylie, *Generation of Vipers* (New York: Rhinehart, 1946), 185.

274 *In the summer of 1947:* "Women in Careers Subject of Debate," *NYT*, July 17, 1947, 17; Bromley, "Crusading Publisher," A5.

275 *Jamie, Jimmy's son with Frankie:* JA III and Lucinda Abbe, interview with author, May 30, 2019.

275 *treating the television reporter:* Loren Ghiglione, *CBS's Don Hollenbeck: An Honest Reporter in the Age of McCarthyism* (New York: Columbia University Press, 2008), 203.

276 *Later in life:* Margot Peters, *May Sarton: A Biography* (New York: Alfred A. Knopf, 1997), ch. 20.

276 *Jim Tyson, the husband of Carolyn Tyson:* Jim Tyson, letter to JA, April 8, 1946.

276 *so did Fernand Fonssagrives:* Ibid.; David Tyson, interview with author, March 9, 2021.

276 *the hard-drinking Rolf Tietgens:* JA III, interview with author, May 31, 2019; KA's notes on back of photo of Tietgens.

276 *Rolf had been forced to flee:* Köhn, *Rolf Tietgens*, 116.

276 *"I shall leave it to his psychoanalyst":* Patricia Highsmith, *Patricia Highsmith: Her Diaries and Notebooks, 1941–1995*, ed. Anna von Planta (New York: Liveright / W. W. Norton, 2021), "1949."

276 *At around the time of Fuffy's pregnancy:* Papa Abbe, letter to JA, October 25, 1948.

277 *In person, Marynia must have set:* Lillian Faderman, *Woman: The History of an Idea* (New Haven, CT, and London: Yale University Press, 2022), ch. 11, "Sending Her Back to the Place Where God Had Set Her: Woman in the 1950s."

277 *Indeed, she herself would later:* Mitchell interview 1, November 29, 1976.

277 *Frankie's new husband:* Lowry and Reidel, "Last Stand," "Introduction"; James Reidel, "Robert Lowry," *Review of Contemporary Fiction* 25 (2) (2005): 53–55.

277 *Davis had discovered Bob:* "Mlle Passports: Contributors to this Issue," *Mademoiselle*, October 1947, 22.

278 *"That's when I got parked":* JA III and Abbe, interview.

278 *Fuffy described it:* Mitchell interview 1.

CHAPTER 27 **Twin Lives**

Except as otherwise noted, the story of Franny and Leslie's honeymoon and Franny's subsequent relationship with Dilys are drawn from interviews with Carol O'Neill (July 31, 2018, March 4, 2019, and February 14, 2022) and Eliza Werner (April 16, 2019).

279 *"After a long day at the studio":* TL, 58.

279 *One Christmas, Fuffy and Jimmy:* ToT, rough draft, photo captions.

280 *"Frances and Kathryn believe":* Ibid.

280 *Franny and Leslie kept making plans:* Leslie Gill, dau., interviews with author, July 31, 2018, and April 5, 2021.

281 *a log cabin without heat:* Tom Abbe, interview with author, March 21, 2021; description also taken from photos.

281 *They had planned to drive up:* Gill, dau., interviews.

283 *her relationship with Dilys never improved:* Eliza Werner, interview; Fred Werner, interview with author, August 29, 2018.

283 *Franny and Leslie soon moved:* "Career Houses," *Vogue*, June 1, 1950, 72–73.

284 *By now Franny had become:* *Vogue*, September 1, 1949, cover.

284 *The Hasselblad camera:* "We Test the Hasselblad," *Camera*, January 1949, 39–41.

284 *The result was small, compact, and light:* https://www.hasselblad.com/inspiration/stories/the-very-first-hasselblad-1600f/.

284 *Both twins and their husbands:* "We Test the Hasselblad," 39–41.

284 *Jimmy and Leslie had received:* Jimmy's early tests are mentioned in an unpublished rough draft of Margaretta K. Mitchell's "Photography's Twin Sisters," *PP*, January 1980; Chris Karitevlis, undated interview with author, 2020. See "High Fashion, High Performance," *PP*, June 1952, 26, which includes a photograph of Lisa Fonssagrives, for an example of an ad.

284 *Franny, who had taken up:* ICP lecture; also FMG, memo to Alexandra Penney, "Notes on FMG Photographs for Information for the *Vogue Fashion Book*, 1978," undated, unpublished. Both twins frequently said that Franny received numbers 003 and 008 of the first Hasselblad, the 1600F, while Fuffy had 007, although Hasselblad's biographer, Soren Gunnarsson, writes that 003 was purchased by Christopher Sergel, a Broadway playwright, sports writer, naturalist, and sailor at a camera shop in Chicago. According to the company, there is no good record of the early Hasselblads because most no longer exist; because they were fragile and broke easily, they were replaced under warranty.

285 *She always started out with a "filmic concept":* FMG, memo, "Notes on FMG Photographs."

285 *She began setting up storylines:* "See Yourself in a Man's Appraising Eyes," *Glamour*, July 1949, 28–50.

285 *Franny was earning more, too:* CA interview 1A, September 13, 1996.

285 *Her first trip was a Caribbean cruise:* "Nice Way to Look," *Vogue*, May 15, 1951, 50–57; "Answers to Three Kinds of Evenings," *Vogue*, June 1, 1951, 104–5: "American Resort Idea—the Gibson Girl Dress," 128–29, "The Prevalence of Pants," 130–31, and "One-Piece, or Looking It," 132–33, *Vogue*, November 15, 1951; "Caribbean Cruise Scrapbook," *Vogue*, November 1, 1951, 114–17.

286 *what the magazine called "personality pictures":* "Vogue Spotlight," *Vogue*, September 15, 1946, 247; "People and Ideas: Headliners," *Vogue*, March 1, 1948, 201.

286 *The men had challenged her:* Mitchell interview, November 29, 1975.

287 *Years later, near the end:* Lucinda Abbe, interview with author, July 27, 2018.

288 *But moving out to the country:* Twin Lenses 14, KA and FMG.

288 *Gradually, her former art directors:* Mitchell interview 1, November 29, 1976.

288 *Franny put Fuffy in one of* Glamour's: "How Do They Do It?," *Glamour*, February 1951, 138–41.

289 *The 1950 annual ran her photograph:* KA, "Hands," in *U.S. Camera Annual 1950: International Edition*, ed. Tom Maloney (New York: U.S. Camera Publishing, 1950), 213; KA, "Summer Blonde," and FMG, "Girl in Beach Grass," in *U.S. Camera Annual 1951*, ed. Tom Maloney (New York: U.S. Camera Publishing, 1951), 256, 227, 229.

289 *a number that would continue to dwindle:* By the early 1960s, the percentage of female-to-male photographers was about half what it had been in 1951.

289 *Leslie would photograph an unfinished cathedral:* "The Editor's Guest Book" and "Antoni Gaudí: Architect of Barcelona," *HB*, September 1951, 126, 228–31;

"Nino Caffè: Painter of Priests," *HB*, December 1951, 92–93; "The Editor's Guest Book" and "Heading South from Madrid to Granada," *HB*, January 1952, 58, 100–101.

290 *Franny would stop in Florence:* "Two Coats from the Italian Collections," *Vogue*, August 15, 1951, 172–73; "Italian Ideas for Any South," *Vogue*, November 15, 1951, 124–27, 168.

290 *But for the most part:* "The Editor's Guest Book," *HB*, January 1952, 58.

290 *It had been created:* "The *Independence*," *Life*, February 19, 1951, 52–54.

290 *The cabins boasted modern decor:* "Modern-American-Living Makes Its Bow at Sea" (ad), *Vogue*, February 1, 1951, 228.

290 *Dorry, now married:* Dorry Rowedder Adkins, email to Leslie Gill, dau., June 25, 2015. Dorry's most famous appearance as a model was in Cecil Beaton's 1948 picture of nine beauties modeling evening gowns by the American couturier Charles James, "Worldly Color," *Vogue*, June 1, 1948, 112–13.

291 *an amazing new sort of modern deck chair:* "Modern-American-Living," 228.

291 *the modern American sophisticate:* "There Goes an American," *Vogue*, February 1, 1950, 124–27.

EPILOGUE Love and Luck

293 *Dick Avedon, his* Bazaar *counterpart:* Jonathan Tichenor, "Richard Avedon: Photographic Prodigy," *U.S. Camera*, January 1949, 35–38.

294 Life *had run a picture of Franny:* "French Models Thrive in U.S.," *Life*, July 24, 1950, 53–54, 56.

294 Women's Wear Daily *had called them:* "Paris Openings at Peak: Dior Recalls 'Lined' Contour, Stiff Weaves, Longer Skirt," *WWD*, August 4, 1952, 3.

294 *Franny had a courtyard near the studio: Twin Lenses* 5B; ICP Lecture.

294 *She had been inspired by a trip:* ICP lecture.

294 *Franny was the first magazine photographer:* FMG, "My first assignment at French *Vogue* Magazine in Paris, to photograph fall fashion collections, 1952," fax to CA, undated, ca. 1980s; *Twin Lenses* 7, FMG. Substantiated by additional research in Paris.

294 *"I did have some kick-in lights": Twin Lenses* 7, FMG.

294 *"The gods smiled on me":* "My first assignment at French *Vogue*."

295 *Her section opened with a photograph:* Liberman, *Art and Technique*, 162–69, 218.

296 *a change had overtaken the Condé Nast studio:* "What's Going On Here? Studio Changes," *Condé Nast Ink* 21 (August 1950): 3, CNA.

296 *By 1954 Condé Nast had closed the studio:* FMG, memo to Alexandra Penney, "Notes on FMG Photographs for Information for the *Vogue Fashion Book*, 1978," undated, unpublished.

296 *He and Franny soon had adjoining studios:* CA interview 1A, September 13, 1996.

296 *After the war, Leslie had withdrawn:* Leslie Gill, dau., interview with author, April 5, 2021.

296 *Liberman had once tried to recruit:* "Alex," box 14, folder 12, 782, Kazanjian and Tomkins, AAA.

296 *his "magic realist" abilities in color photography:* Aline B. Louchheim, "Art Directors Show Their Work," *NYT*, May 17, 1953, X11.

296 *He was also a photographer on:* Nettberger-Lucchesi, "Margaret Hockaday (January 8, 1907–December 18, 1992)," in *Ad Men and Women*, ed. Applegate, 190; Margaret Hockaday and Edward J. Wormley, *The Dunbar Book of Contemporary Furniture* (Berne, IN: Dunbar Furniture Corporation of Indiana, 1956), 208.

297 *Charles Kerlee, a commercial photographer:* CA interview 1B, September 13, 1996.

297 *On one trip to Paris:* Tomie dePaola, interview with author, February 21, 2018.

297 *"We had a two or three months' trip":* Mitchell interview, November 29, 1975.

297 *Before the baby was born:* Ibid.

297 *Not long after the birth:* Carol O'Neill, interview with author, March 4, 2019.

298 *"I have a hard time remembering that year":* Mitchell interview.

298 *"It is difficult to over-estimate his influence":* Irving Penn, Alexey Brodovitch, and unnamed editor, "Leslie Gill: Artist Pioneer," *Applied Photography* (Eastman Kodak) 11 (1958): 1–5.

298 *Now, Fuffy said, "She really had to work":* Mitchell interview.

298 *Fuffy cared for the baby on weekends:* CA interview 1B.

298 *Jimmy, who had ulcers:* Tom Abbe, interview with author, March 21, 2021.

298 *Photography "was becoming too much of a trend":* George Lange, "A Pearl of Great Price in Oyster Bay," *Avenue*, October 1992, 122–25.

298 *The* New York Herald Tribune *columnist:* Eugenia Sheppard, "Inside Fashion: The Road to Needlepoint," *NYHT*, March 22, 1961, 19.

299 *the anonymous itinerant portraitist:* Barbara and Larry Holdridge, "Rediscovery: Ammi Phillips," *Art in America*, Summer 1960, 98–103.

299 *Jimmy eventually sold the painting:* Rita Reif, "Auctions," *NYT*, C28; W. B. Carnochan, *Momentary Bliss: An American Memoir* (Stanford, CA: Stanford University Libraries, 1999), "*The Girl in Red.*" The first sale was set in motion when Jimmy visited his youngest son, Eli, in California; Jimmy also stopped in to see one of his clients, Bliss Carnochan, a Stanford University humanities professor, who asked him if he knew the portrait's whereabouts. Jimmy said it was owned by his sister-in-law, Carnochan said he was interested, Franny eventually named her price, and Carnochan met it. The second sale came about after the painting had been exhibited at the Whitney and "reproduced in countless postcards and posters," Carnochan writes, one of which appeared in the closing scenes of the 1981 film *The French Lieutenant's Woman*, and he began to feel nervous about keeping it at home.

299 *While Jimmy still had his studio:* Mitchell interview.

299 *She had already gained a new foothold:* Kathryn Abbé, "Duckling into Swan," *Cosmopolitan*, June 1956, 62–67; "Family Album: *Vogue* Beauties," *Vogue*, February 1, 1956, 160–63.

300 *Many of her pictures ended up in* Coronet: *Coronet* covers, August 1960, September 1961, October 1961.

300 *It was used for the cover:* Diana Edkins and Peter H. Beard, *Animal Attractions* (New York: W. H. Abrams in association with the Humane Society of New York, 1995).

300 *which prompted a critic in the* Daily News*:* Shawn O'Sullivan, "Photo," *Daily News*, May 27, 1995, unpaginated press cutting.

301 *In 1964, Fuffy shared some of her secrets:* KA with Adele Whiteley Fletcher, "When You Photograph Your Child," *Asbury Park Press Family Weekly* (syndicated), August 2, 1964, 12–13.

301 *she often went along as:* Lucinda Abbe, interview with author, July 27, 2018.

301 *They often took along a bag of toys: Twin Lenses* 1, KA and Lucinda Abbe.

301 *the only real direction was:* Lucinda Abbe, interview.

301 *"all-time favorite assignment": TOT,* 174; ICP lecture.

302 *Franny had stopped shooting fashion:* Mitchell interview 2, November 29, 1976.

302 *lecturing in a version of Brodovitch's Design Laboratory:* Jacob Deschin, "Course Honors Teacher," *NYT,* February 12, 1967, 125.

303 *Fuffy was expected: Twin Lenses* 5A, KA and JA.

303 *Franny was represented:* Rosenblum, *History of Women Photographers,* 228–29.

304 *The story Fuffy always told: Twin Lenses* 3, KA and JA.

304 *In 2001, another photograph:* Carmen Dell'Orefice, "Nostalgia," *Vogue,* April 2001, 104, 110.

304 *Fuffy, rather than letting the matter:* "Talking Back: Editor's Note," *Vogue,* July 2001, 48.

304 *By the early 2000s, when:* Leslie Gill, dau., interviews with author, January 23, 2018, and January 29, 2019; Chris Karitevlis, interview with author, February 24, 2023.

305 *But in a conversation with the photographer:* Mitchell interview 2.

Illustration Credits

Frontispiece: Copyright © Estate of Walter Civardi.

2, 3 Montgomery Ward records (8088), American Heritage Center, University of Wyoming

4, 5 Frances McLaughlin-Gill, *Vogue* © Condé Nast

6 Frances McLaughlin-Gill, *Glamour* © Condé Nast

7 Copyright © 2023 Estate of Kathryn Abbe

8, 9 Copyright © 2023 Estate of Kathryn Abbe

10 The Art Institute of Chicago/Art Resource, New York. Copyright © 2023 Estate of James Abbe Jr.

11 Copyright © 2023 Estate of James Abbe Jr.

12 Copyright © 2023 Estate of Leslie Gill. Originally appeared in *Harper's Bazaar,* October 1945. Courtesy of Howard Greenberg Gallery.

13 Copyright © 2023 Estate of Leslie Gill. Originally appeared in *Harper's Bazaar,* July 1947. Courtesy of Howard Greenberg Gallery.

14 Oil on canvas. 30 x 25 in. American Folk Art Museum Collection. Gift of Ralph Esmerian, 2001.37.1.

16 Unknown photographer. Courtesy of the Gill/O'Neill family.

PHOTOGRAPHIC INSERT 3

1 Library of Congress, Prints & Photographs Division, Toni Frissell Photograph Collection, LC-USZC4-4330.

2 Library of Congress, Prints & Photographs Division, Toni Frissell Photograph Collection, LC-DIG-ppmsca-13246.

3–5 Copyright © 2023 Estate of Kathryn Abbe

6 Copyright © 2023 Estate of Kathryn Abbe

7–9 Copyright © 2023 Estate of Frances McLaughlin-Gill

10 *Frances McLaughlin-Gill*, Luis Lemus, *Glamour* © Condé Nast

11 Copyright © 2023 Estate of Frances McLaughlin-Gill. Courtesy of Howard Greenberg Gallery. Originally shot for *Vogue* but not published.

12 Frances McLaughlin-Gill, *Vogue* © Condé Nast

13 Copyright © 2023 Estate of Kathryn Abbe

14 Frances McLaughlin-Gill, *Vogue* © Condé Nast

Index

NOTE: Page numbers referring to photos in inserts are *italicized*. They are shown with the insert number, followed by the photo number.

About the Author

Carol Kino's writing about art, artists, the art world, and contemporary culture has appeared in such publications as the *New Yorker*, the *Wall Street Journal*, the *New York Times*, the *Atlantic*, *Slate*, *Town & Country*, and just about every major art magazine. She was formerly a fellow at the Dorothy and Lewis B. Cullman Center at the New York Public Library and the USC Annenberg / Getty Arts Journalism Program. She grew up on the Stanford campus in Northern California and lives in Manhattan. *Double Click* is her first book.

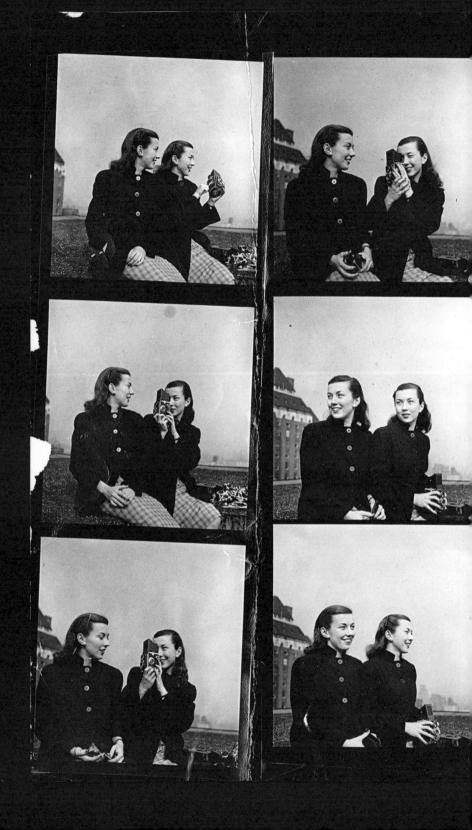